Joseph Stella

Joseph Stella

BARBARA HASKELL

Whitney Museum of American Art, New York
Distributed by Harry N. Abrams, Inc., New York

Published on the occasion of the exhibition *Joseph Stella*
Whitney Museum of American Art
April 22–October 9, 1994

The exhibition and catalogue are supported by a generous grant from The Henry Luce Foundation. Additional funding has been provided by the National Endowment for the Arts, the New York State Council on the Arts, and The Norman and Rosita Winston Foundation, Inc.

Research for this exhibition and publication was also provided by income from an endowment established by Henry and Elaine Kaufman, The Lauder Foundation, Mrs. William A. Marsteller, The Andrew W. Mellon Foundation, Mrs. Donald Petrie, Primerica Foundation, Samuel and May Rudin Foundation, Inc., The Simon Foundation, and Nancy Wellin Brown.

Cover and jacket: *Nativity*, 1919–20 (detail of Fig. 77)

Frontispiece: Man Ray, *Portrait of Joseph Stella*, c. 1920
Vintage gelatin silver print, 9⅝ x 6⅝ (24.4 x 16.8)
Collection of Susan Herzig and Paul Hertzmann, Paul M. Hertzmann, Inc., San Francisco

"The Death of Joseph Stella, November 1946" by Robert Kelly was published in
Spiritual Exercises, Santa Barbara: Black Sparrow Press, 1981

Library of Congress Cataloging-in-Publications Data
Haskell, Barbara.
 Joseph Stella / by Barbara Haskell.
 p. cm.
 Catalog of an exhibition held at the Whitney Museum of
American Art, Apr. 22–Oct. 9, 1994.
 Includes bibliographical references.
 ISBN 0-87427-091-X (WMAA : softcover). —ISBN 0-8109-6813-4
(Abrams : hardcover)
 1. Stella, Joseph, 1877–1946—Exhibition. I. Stella, Joseph, 1877–1946.
II. Whitney Museum of American Art. III. Title. ND237.S685A4 1994
759.13—dc20 93-43033
 CIP

ISBN 0-87427-091-X softcover edition
ISBN 0-8109-6813-4 hardcover edition (Abrams)

Contents

Foreword

As one engages the art of Joseph Stella for the first time, or revisits his view of earlier twentieth-century New York, our understanding of the notion of what constitutes modern art is refreshed and sharpened. Here was a true modern visionary, an artist who sensed the primary conflict of his age as that between the nature of an increasingly technological universe and the spiritual dimension implicit in truly human achievement. In the range and depth of Stella's career as a painter, we see the continuing confrontation with complex notions of identity, perhaps the most compelling theme of twentieth-century art and literature. Most important, this exhibition presents us with the life work of an artist who remained open to change and to the voice of his inner-directed challenge.

As curator Barbara Haskell makes clear in her incisive and penetrating essay, Stella remains to this day a deeply misunderstood artist. Throughout his long and productive career, he was an outsider, recognized for the brilliance of his early work, but denied recognition for the truly profound contribution the full range of his work made to twentieth-century American art. Now, thirty-one years after his first Whitney retrospective, the Museum for the second time surveys the work of this remarkable artist.

The Whitney Museum is deeply grateful to the scores of lenders to this exhibition, and their willingness to allow for such lengthy loans. Their generosity is central to undertakings of this nature.

Funding for this exhibition and catalogue has been provided by a major grant from The Henry Luce Foundation; we have also received significant support from the National Endowment for the Arts, the New York State Council on the Arts, and The Norman and Rosita Winston Foundation, Inc.

Finally, on behalf of the Museum, I would like to acknowledge the curator of this exhibition, Barbara Haskell, whose dedication and singular commitment to American art continues to distinguish her work and this Museum.

DAVID A. ROSS
Alice Pratt Brown Director

The Death of Joseph Stella

ROBERT KELLY, *November 1946*

All night the pictures
he could see with one eye
I held in my hands

This one, and this one,
and this Virgin from Naples
and this silverpoint of a chaste
woman sleeping in an open boat
and these five hundred drawings,
Giuseppe, more than one
for every day in a long year,
images of this final city
growing, all angles and crystals,
the way a star at sunset
takes all the light and raises it
to one exact thing. This
final city, not Queens, not the Bronx,
this real Manhattan where workers
work without sleeping
and the shoppers on the way to Klein's
hurry by your windows,

these hungry bodies that need your light.

But he was afraid
like all sentimental men
and could hardly see his pictures—
not because of the bad left eye
but because he could see so well
behind them and behind me
that ultimate sentimentalist
(the one with no skin and such white teeth)
rattling around the corners of the room.

I kept showing,
he kept trying to look
and Death would not repent.
All night I spread portfolios
and pulled paintings down from racks,
turned them to the strong
light at the bedside so he could see.
And he did see, all night he saw;
the pictures kept him going.
Sometimes he would close his eyes and tremble
and when they'd open again it was on no picture
that he stared. He had seen them all,
seen abstract and realistic,
futurist and mystical, he
had worked all ways and found
only the endless proletariat of light.

No style. Well,
he always thought Death was a sucker for style,
and Death could only catch him if he let
himself be trapped by one style, one trick
of how to do it, how to see.
There is never one thing, he told me,
*never only one thing. What impresses
is to be everyone. I hear them all talking,
all of them. In my pictures no one is not heard.*

Now he was lying in bed, not painting, hardly
able to breathe. Afraid. The style
of silence. All night
I showed him what he had made. *It is not
enough*, he told me, and he died.

BARBARA HASKELL

Joseph Stella

Joseph Stella arrived in America by boat from Naples in 1896, four months before his nineteenth birthday.[1] His experience of displacement never abated; he remained everywhere an outsider, with no permanent social membership in any group. His complex and contradictory allegiances, which isolated him in America as well as in Italy, defined him as a person and as an artist. Deeply loyal to the traditions and culture of Italy, he elevated to a mythic status the character and landscape of his childhood. Yet his simultaneous identification with America's sense of opportunity and modernity made a reverse immigration impossible. As one Italian writer observed in 1932, "Two instincts clash in him, two contrasting elements, two passions; two homelands crowd his creative thought....Having left as a young man with a Latin soul immersed in classical studies, he returns to the old country as an American painter. Two-sided, alienated, he views the greatness of America with the eyes of a European, and the gentleness of the Neapolitan sea with the eyes of a stranger."[2]

Fittingly, it was as an immigrant, sympathetic to the dynamics of immigrant life, that Stella first found his place as an artist. Hundreds of thousands of immigrants flooded to America in the late nineteenth and early twentieth centuries from the predominantly peasant, agricultural societies of Southern and Eastern Europe. As this began to affect the character and composition of the nation, the subject of immigration came to dominate American political debate. Who these immigrants were and the living and working conditions which greeted them were issues of pressing importance, widely discussed in social reform journals and publications. Uniquely positioned to portray the immigrant community, Stella became the pictorial recorder of this new America. The immigrant world formed the milieu in which he lived during his first two decades in America and from which he drew his earliest subject matter and gained his earliest recognition as an artist.

Raised in the medieval, mountain village of Muro Lucano, on the slopes of the southern Apennines, Stella differed from the majority of Italian immigrants by virtue of education and financial position (Fig. 1).[3] His father, a notary and respected member of the Muro Lucano community, was sufficiently wealthy to send all five of his sons to school in Naples. Al-

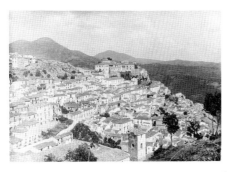

1. Muro Lucano, Italy, c. 1900

though Stella later disparaged his school years, his attendance at the Liceo Umberto I provided him with fluency in English and French and an affection for classical literature, in particular that of Dante and Shakespeare, as well as more modern authors such as Walt Whitman and Edgar Allan Poe, all of whom he would later quote at length.[4] While the Stella family enjoyed more privileged circumstances than that of their neighbors, they were not immune to the abysmal poverty prevalent in southern Italy. By the mid-nineteenth century, the region was plagued by overpopulation, a dearth of agricultural and industrial resources, and a repressive system of taxation. The province of Basilicata, in which Muro Lucano was located, faced particularly harsh conditions: clay soil, hot summers, infrequent rain, and malaria-infested flatlands, which had induced inhabitants since the fifteenth century to settle on hilltops or mountains.[5] Unable to insulate themselves from the surrounding poverty, the Stellas, like their agricultural counterparts, turned to America for the economic and social opportunities that eluded them at home.

Antonio, the eldest of the Stella sons, was the first to immigrate. Less than a year after receiving a medical degree from the Royal University of Naples, he had established a lucrative medical practice in New York's Greenwich Village.[6] A formidable individual, Antonio Stella functioned within the family as a benevolent but nearly tyrannical patriarch.[7] For Joseph, Antonio represented unquestioned authority, albeit not always welcome. It was Antonio who brought Joseph to America and supported him financially during his years as a student and, later, as a practicing but impecunious artist. A prominent figure within the Italian-American community and social reform circles, Antonio provided Joseph with the contacts that led to the artist's first illustration commissions and his first solo exhibition in 1913.

For the Stella family, as for other immigrants, the medical profession seemed an unimpeachable guarantee against ethnic discrimination. Therefore, when Joseph arrived in America, Antonio decreed that he study medicine. Apparently Joseph submitted to the mandate and attended medical school for one year and pharmacy school for another. Neither

proved satisfactory and, after two years, he appealed to his brother to allow him to pursue a career as an artist. Antonio consented, after consulting an artist friend, Carlo de Fornaro.[8]

According to his own account, Stella had painted and drawn constantly as a child.[9] Physically awkward, fat, and lonely, he had developed a secret passion for art, which he viewed with unabashedly physical and romantic yearnings. Art was his "hopeless love," the "eternal fountain of heavenly joy," which existed as "a secret delight," designed "for the consummate pleasures of his senses"; it was "the Holy Friend, the consolatrix whom I must always have loved, and who must always have been smiling upon me, who must always have strewn with roses the path of my life."[10]

Happily for Stella, the refuge he took in art seems to have been matched by aptitude from an early age. According to an often repeated but unsubstantiated story, Stella had been heralded as an artist by the residents of Muro Lucano when he was still in his teens.[11] Aware that the village church lacked a representation of its local Catholic saint, San Gerardo Maiella, Stella had painted an incident in the saint's life. The result so impressed the local residents that they carried the painting with great ceremony to the church, where it was immediately installed in a place of honor. That this incident was probably apocryphal (no record of the painting exists in Muro Lucano) testifies both to the artist's proclivity for falsification and exaggeration of his history as well as to his desire to associate himself with earlier Italian masters: the citizens' accolades and the triumphal procession recall Vasari's well-known anecdote about the *Madonna* that a somewhat older Cimabue had painted for Sta. Maria Novella, Florence, in the late thirteenth century.

Neither Stella's tendency for hyperbole nor his passion for art abated after his arrival in New York or his entry into medical and pharmacy school. Indeed, he managed to attend the Art Students League in November and December of 1897 while simultaneously studying pharmacology.[12] Once he had obtained his brother's approval to study art full time, he enrolled in the New York School of Art, headed by William Merritt Chase.[13] Here, in contrast to what he regarded as the sterile academic curriculum at the League, where new students were required to draw from antique plaster casts for a year, entering students went immediately into classes with nude models.

Chase, who had opened his school in 1897 after leaving the League, practiced a painting style that featured rapid bravura handling of paint and a reliance on value and texture shifts rather than color to achieve illusionistic effects. Although Stella was instinctively averse to

Chase's emphasis on technical virtuosity over content, the young student's accomplished emulation of his teacher's style of rapidly applied brushstrokes won him a tuition scholarship to the school for one year (Fig. 2). It also earned him the public commendation of Chase, who cited him as a second Manet and proclaimed one of his portrait studies the equal of the French master.[14]

2. *Nude,* c. 1899
Oil on canvas
27 x 15 (68.6 x 38.1)
Collection of Mrs. Sergio Stella

3. *Italian Immigrant,* 1898
Graphite and chalk on paper
8¾ x 7½ (22.2 x 19.1)
Thomas Colville Fine Art,
New Haven and New York

4. Jan Van Eyck
Portrait of Cardinal Albergati,
c. 1431–35
Silverpoint on paper
8⁵⁄₁₆ x 7 (20.8 x 17.8)
Staatliche Kunstsammlungen, Dresden

5. *Face of an Elderly Person,* c. 1898
(later inscribed "1907")
Charcoal and chalk on paper
9½ x 7½ (24.1 x 19.1)
Collection of Albert Keck

6. *Old Man,* 1898
Ink on paper
8½ x 8⅛ (21.6 x 20.6)
The Museum of Modern Art, New
York; Gift of Mrs. Bliss Parkinson

Notwithstanding such approbation, Stella's retrospective recountings deprecated his academic years and obliquely criticized Chase. He bridled at Chase's conception of himself as one of the artistic "greats" and resented what he interpreted as Chase's rule forbidding students to paint flowers.[15] This second criticism suggests a degree of misdirected anger: since Chase himself painted flowers, his disapproval of the subject matter seems dubious. A more likely explanation is that Chase's commanding and egotistic personality piqued Stella's deep-seated antipathy for authority. In later texts and statements, he characterized teachers—along with critics—as pernicious parasites, envious and destructive of the creative process. In his 1921 parable "On Painting," he cast them as "little worm[s], born of envious sterility" who "got hold of Art left alone and destitute of means. He chained her, closed her in a dungeon called the 'Academy,' debarred the sun from her view...and for amusement during her slavery, as toys, gave her colored ribbons and tinkling medals...."[16]

Paradoxically, many of Chase's dicta and attitudes found a receptive audience in Stella despite the young student's view that the only object of the "official" modern art which Chase epitomized was "to dazzle the philistines and the people that have a half-knowledge."[17] Chase's belief in the importance of being an artist and his admonitions to "avoid recipes" and to "play with your paint, be happy over it, sing at your work" were central features of Stella's later aesthetic vision.[18] So too were Chase's emphasis on inspiration over method as the source of creative expression, his commitment to careful drawing, and his belief that the study of masterpieces of the past—either directly or through reproductions—could stimulate as well as instruct. Indeed, it was his commitment to furthering his students' knowledge and appreciation of Old Master paintings that encouraged him to begin taking students to Europe in the summer to visit art museums.[19] Although Stella had left Chase's school before the inception of this program, Chase's exhortations to study the masterpieces of the past

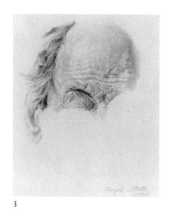

3

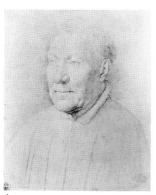

4

5

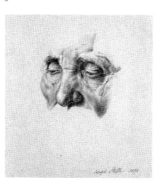

6

profoundly affected Stella, who became a regular visitor to The Metropolitan Museum of Art. According to Stella's autobiographical account, he became fascinated while a Chase student with the work of Dutch, Flemish, and German masters—Van Eyck, Vermeer, Rembrandt, Holbein, Dürer, and Cranach; only later, after he had returned to Italy for a visit in 1909, did he become enthusiastic about the art of the Italian Renaissance.[20]

The work that Stella created during this period reflected his command of Old Master drawing techniques, specifically those associated with the sharp realism of fifteenth- and sixteenth-century Germany and Flanders. In a series of portrait studies of an old man from 1898 (Figs. 3, 5, 6), Stella achieved a style whose precision and nearly microscopic exactitude looked back to the close-range views of the human face perfected by such artists as Dürer and Van Eyck (Fig. 4). Like the draftsmanship of these masters, Stella's minute recording of every facial detail and texture is technically breathtaking while also evoking a psychological empathy and respect for the sitter.

Just as the New York School's emphasis on the Old Master tradition strengthened Stella's stylistic proclivities, so the school's focus on the aesthetic possibilities of the commonplace nourished his interest in quotidian subject matter. Chase's respect for the mundane as a fitting subject for art had become a more formalized feature of the school's program with the recruitment of Robert Henri as an instructor there in 1903. Although Henri's bravura manner of painting resembled Chase's, the younger artist's choice of unglamorous models and action scenes drawn from everyday life contrasted with Chase's relatively conventional portrait and still-life subjects. Henri became a rallying point for younger realists, who gathered around him at the New York School of Art and in New York's art world haunts.

Encouraged by Henri's example, Stella turned for subjects to the denizens of New York's Lower East Side, where he lived. He later de-

7. *Old Man IX*, c. 1900
(later inscribed "1898")
Graphite on paper
7¹⁵⁄₁₆ x 4¼ (20.2 x 10.8)
Collection of Caesar P. Kimmel

8. *Old Man XI*, 1900
Graphite, crayon, and
charcoal on paper
9½ x 7 (24.1 x 17.8)
Collection of Caesar P. Kimmel

9. John Sloan
At the Top of the Swing, 1913
Chalk and ink on paper
15¾ x 13⅛ (40 x 33.3)
Yale University Art Gallery, New
Haven; Gift of Dr. Charles E. Farr

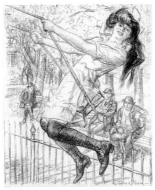

scribed becoming "very busy drawing from the most striking characters that I could hunt in the streets, in the parks and in the lodging houses of the slums. My chief concern then, in rivalry to the stunning revelations of the triumphing Parisian Impressionism, was to catch life flowing unaware with its spontaneous eloquent aspects, not stiffened or deadened by the pose. My preference was going to curious types, revealing, with the unrestrained eloquence of their masks, the crude story of their life." His search for "tragic scenes" that would elicit the "penetrating characterization of Mantegna's engravings" and "the powerful dramas depicted for eternity by Giotto and Masaccio" was expressed in these years primarily in isolated portraits executed in pen and ink, pencil, chalk, crayon, or charcoal (Figs. 7, 8, 10, 11).[21]

Apart from their shared commitment to an art based on firsthand experience of the contemporary world, Stella's characterizations differed markedly from the picturesque genre scenes of the urban realists associated with Henri. The loose, rapid sketches of these artists, often featured in *The Masses* (Fig. 9), recorded "real life" in an unaffected and spontaneous manner that implicitly rejected the very style Stella pursued—that of linear particularity, detail, and analytic precision.

Yet more than technique separated Stella's work from those of his realist contemporaries. His depictions of isolated, single individuals aimed to capture those moments of stillness in which the psychological nuance of personality was laid bare. The outward incidents of life interested him less than the inner ones. In contrast, the Henri-associated artists, known later as the Ashcan group, were unashamedly extroverted and romantic; their vignettes of local color chronicled an optimistic, active world of light-hearted enjoyments and gaiety.[22] Even when their attention turned from narrative moments to individual portraiture, their depictions reverberated with confidence and ebullience. For these artists, the social and economic inequities of poverty, ethnicity, and old age were irrelevant. Indeed, they were attracted to slum life because it offered a greater richness and texture than they could find in their own world. Their search for painting subjects in unfashionable, ethnic neighborhoods was part of an

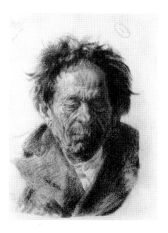

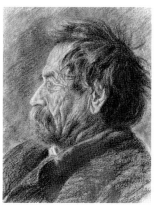

10. *Head of an Old Man*, c. 1905
Charcoal and chalk on paper
14½ x 9¾ (36.8 x 24.8)
Private collection

11. *Head of an Old Man*, c. 1905
Crayon on paper
11½ x 9⅛ (29.2 x 23.2)
Collection of Dr. and
Mrs. Eugene Arum

an effort to celebrate individuality and authenticity; it satisfied their more general quest for freedom and spontaneity in human relations. Unlike political cartoonists, who used proletarian imagery as the site for ideological polemic, the Ashcan artists focused on the specificities of detail and incident. Still, most of their work was heavy with stereotypes and quick characterizations. Part of the problem was that even the more socially conscious of them, like John Sloan and Art Young, were foreign visitors—outsiders— in the culture they chose to depict. Fascinated though they were with the working class and the down-and-out, it was not their world; unable to break down the distance that separated the two domains, they could not escape being voyeurs.[23]

In this regard, Stella occupied a singular position. For him, the inhabitants of the Lower East Side were not only neighbors but fellow immigrants. Although he was spared the oppressive poverty under which most of his countrymen lived, he understood from personal experience the conflicting emotions and physical hardships entailed in accommodating to the conditions and values of a new world; he spoke from within the culture rather than from outside it. As an artist, he was neither seduced by the charms of ethnicity nor motivated by a crusader's zeal to reform the inadequacies of immigrant life. With no political mandate and no social guilt, he could present his subjects as they saw themselves.

In 1905, Stella's drawings of immigrants were brought to the attention of Reverend Lyman Abbott, editor of the social reform weekly *The Outlook*, by Antonio Stella, who functioned as his brother's patron and guardian in these years.[24] Antonio's intervention would have been influential. A highly esteemed physician specializing in tuberculosis and its prevalence among immigrants, he had led efforts to improve living conditions of Italian families in America.[25] Through his involvement in immigration issues, Antonio was respected by the leading social reform figures of the day; by introducing his brother to these individuals, he gave him access to the world of Progressivism.

The Outlook, begun as a Baptist paper in 1867, had shifted its emphasis by 1893 to the broader field of public affairs and arts and letters. With regular contributors including Booker T. Washington, Edward Everett Hale, Jacob Riis, George Kennan, and Theodore Roosevelt, it

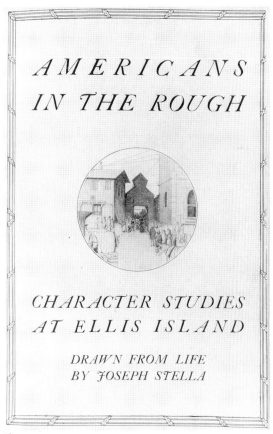

13

14

12

12. Title page of
"Americans in the Rough,"
The Outlook, 81
(December 23, 1905), p. 967

13. *Irish Types*
The Outlook, 81
(December 23, 1905), p. 971

14. *Hungarian Types*
The Outlook, 81
(December 23, 1905), p. 972

15. *A Russian Jew*
The Outlook, 81
(December 23, 1905), p. 973

16. *Italians*
The Outlook, 81
(December 23, 1905), p. 969

17. *A German*
The Outlook, 81
(December 23, 1905), p. 970

18. *A Native of Poland*
The Outlook, 81
(December 23, 1905), p. 968

15

16

17

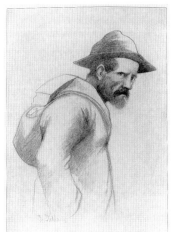

18

played a significant role in American sociological and political affairs in the first two decades of the century.

Not surprisingly, given the magazine's social orientation, the problems of immigration were frequently discussed in its pages. Highly sensitive to the conditions of poverty and congestion under which most immigrants lived, the editors of *The Outlook* nevertheless maintained an anxiety, typical for the time, about the fate of traditional American values and customs in the face of unrestricted immigration. Such views were consonant with those of most Progressives and Socialists, including Jacob Riis, whose photographs and writings often appeared in the magazine. The homogenization process in which ethnic cultures shed their differences and assimilated into American life was seen as critical to the ideology of the melting pot and the preservation of the country's democratic character; this indeed was the message of "Americans in the Rough," *The Outlook*'s editorial of December 1905, for which Stella contributed a series of illustrations:

> *The only way by which the Nation can remain American is for the people to remain Americans. The Nation cannot tolerate within its borders any considerable number of people who are incurably aliens in temper; it is morally bound to see to it that only those aliens are admitted who are potential Americans, who are Americans in the rough. It is this consideration, and only this consideration, which justifies the restriction of immigration...A corollary to this right of exclusion for the preservation of the democratic character of our country is the right to protect alike admissible immigrants and citizens against physical and moral disease.*[26]

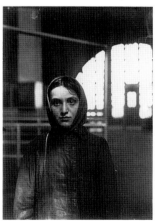

Lyman Abbott's decision to accompany his editorial with a portfolio of seven of Stella's drawings of immigrants at Ellis Island launched Stella as a participant in the country's debates over immigration (Figs. 12–18). Stella's drawings were particularly appropriate vehicles for such controversies. Technically adroit, they reveal his prowess in capturing the minute details of individual physiognomies. He concentrated, as he would in later years, on the eyes—mirrors into the soul, as he called them.[27] Yet despite their proficiency, these drawings verge on caricature, causing one commentator to note that it was "the comedy of funny faces in our land...[not the] sympathies to the problems" of foreigners which characterized these sketches.[28] Nevertheless, while Stella's depictions are not so dramatic as to elicit pity for the plight of the

newly arrived immigrant, they do not entirely obliterate the fear and sadness with which these immigrants passed through the gateway to their new lives. By emphasizing their vulnerability, Stella evoked a sense of their common humanity. In this way, he sought to undermine prejudices and appease those critics who feared that the "alienism" of immigrants would undermine the democratic character of America. Stella's immigrants look like fit candidates for the Americanization process. It was not that he camouflaged their foreignness. Indeed, he corroborated rather than challenged the stereotypical view of ethnic "types": the brooding Russian Jew, depicted in shadows, set against a dark background; the assured, handsome German (Fig. 15, 17). In comparison to the photographs Lewis Hine began taking in 1904 of immigrants at Ellis Island, Stella's subjects appear less heroic and certain. Hine presents the immigrants as intelligent, capable, and dignified; their direct, self-contained, and alert manner predicts their success in meeting the difficulties of assimilation (Fig. 19). Stella's immigrants, in contrast, look out at the viewer with apprehension or with averted eyes and downcast faces.

If the editors of *The Outlook* saw something in Stella's drawings and in his Italian-American identity that encapsulated an aspect of their own views on immigration, so too did those on the more liberal side of the immigrant debate. Among this latter group was Ernest Poole, whose 1906 book about an Italian street singer, *The Voice of the Street*, Stella illustrated. As with "Americans in the Rough," Stella's immigrant status was seen as uniquely enabling him to authentically capture the immigrant experience—in this case the raucous vitality of ghetto life and the hero's urge to transcend it. As expressed by the publishers in introducing Stella's illustrations: "The Italian, reading, listening, watching—now expressed it all in these pictures. Pictures of feelings. They are unlike anything in Italian or American art. Why? Because they are neither Italian nor American. They are both. In them you can see the Italian becoming an American, struggling to express his feelings as he watches this new wild race of American life."[29]

In October of the same year, 1906, *Everybody's Magazine* commissioned Stella to illustrate Poole's article on immigrants at Ellis Island. The article anticipated the celebratory union of races and nations that was immortalized in Israel Zangwill's 1908 drama, *The Melting Pot*. For Poole, as for Zangwill and others, the mixing of cultures in the American "melting pot" was laudatory. "Close squeezed here," Poole wrote, "are races that have been apart for tens of thousands of years—races now to be slowly welded together....They come moved by the deep primeval instinct of man—to get for himself and his family more of the good things of life."[30]

The arrival of vast numbers of immigrants to America between 1890 and 1914 coincided with a period of immense social and economic change in the country, which was fast becoming more urban, modern, and industrial. This in turn affected the life immigrants faced upon arrival. In place of the expected "good things of life," many, particularly those from Eastern and Southern Europe, confronted wretched housing and working conditions. Stella's role as a recorder of these conditions—through inclination and circumstance—aligned him with the era's two dominant artist-reformers, Jacob Riis and Lewis Hine. Riis, a generation older than Hine and Stella, overtly used his writings and photographs as weapons in the campaign against the overcrowded and disease-ridden housing conditions in New York's tenements; Hine, likewise, used his photographs to help promulgate laws governing child labor. In contrast, Stella had no ambitions for social reform. The immigrants who furnished him his subject matter were part of his environment; they held interest for him because of their humanity, not because he was committed to improving their lives.

Almost by accident, Stella was thrown more decisively into the vortex of the immigration question in December 1907, when he was sent to Monongah, West Virginia, by *Charities and The Commons* to document a mine explosion there. More than *The Outlook*, *Charities and The Commons* was in the forefront of the new style of social reform journalism that emerged in the early 1900s. Originally called *Charities*, the magazine had been launched in 1897 by Edward Devine as a weekly review of philanthropic activities dealing with health and welfare. Its scope eventually extended to all manner of social problems and social services, with particular attention given to immigration and its corollary impact on child labor, tenement housing, and tuberculosis. In November 1905, *Charities* merged with *The Commons*, the national organ of the settlement movement, thereby joining on one editorial board such prominent reformers as Riis and Jane Addams.

Charities and The Commons reflected the Progressive reform sensibility of the first two decades of the century. For its editors, "human society is not a collection of isolated members, but an organism of inter-dependent and mutually responsible factors."[31] Believing in the efficacy of facts and in the ultimate benevolence of an informed public, they assumed that if people knew the conditions obstructing social justice, they would act in their collective self-interest to remedy them. Knowledge and action were interconnected. The magazine's insistence on discovering and reporting social conditions as accurately as possible allied it with the muckraking journals of the 1910s. What distinguished *Charities and The Commons* from

the majority of these publications was its unremittingly affirmative tone and its faith in the inevitability of regenerated mankind. "We believe," Devine wrote, "in the inherent nobility and latent tendency towards the good in the human soul. The failure is accidental, partial, temporary. The desire for right living and rational conduct is universal, natural, and in the end dominant."[32]

By sending an artist as well as a reporter, twenty-seven-year-old Paul Kellogg, to Monongah to document the coal mining disaster, Devine was seeking as comprehensible and factual an account as possible. His selection of Stella was partly due to Antonio Stella's association with the magazine through his work on immigration reform and partly to Stella's proven success as a commercial illustrator with a particular affinity for the immigrant community.

The explosion that occasioned the disaster at Monongah took place on December 6, 1907. Its death toll of 348 miners—almost one half of the breadwinners in a population of 3,000—was the highest in the history of American mining. Kellogg's report on the explosion neither attacked the mine owners nor exonerated them. Indeed, his quarrel was not with the company that owned and ran the mines but with more generic inadequacies within the mining industry and social economics in general. Believing that, like war, industrial disasters such as that at Monongah injured a much larger army of "non-combatants" than "combatants" and that the permanent burden—economic and psychic—would fall on the surviving women and children, Kellogg attempted to "estimate the human weights and values in the community's loss."[33]

The inequities surrounding industrial development were inseparable from immigration issues. Since the Homestead and related strikes of the 1890s, it was primarily non-union immigrants who comprised the work force in the bituminous mines and steel mills of West Virginia and Pennsylvania. Stella's on-site encounter with this work force and its insufferable labor conditions poignantly illuminated for him the dark side of the American dream. His response was recorded in his drawings as well as in Kellogg's text:

> There was a group of Italian laborers before the fog hung court house
> in Fairmont, where we took the car in the early morning. They were
> huddling, dark skinned little men from South Italy, such as stand unno-
> ticed; but my fellow traveler was Naples born, big-hearted in his love
> for humble folk, and his ears caught the judgments being passed by these
> peasants from the Abruzzi, from Terra di Lavoro and Calabria. Now
> and then their words broke off in sighs,—sighs, he told me, 'for the

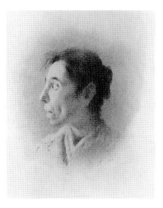

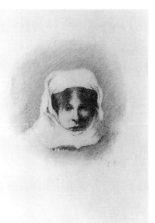

fate met by their brother workers, and for the destitute condition in which so many families had been left. To-day, to-morrow, and God knows till when, these laborers are to be grave-diggers. That is the new mission imposed on them. Ignorant they are, these men, but they know the significance of this new job. They know the treasure of love and hope that they are going to bury along with the mangled bodies from the mines—God knows whose shall be the graves in this America.[34]

Three of the four Stella drawings that accompanied Kellogg's article were figurative studies that strove to assess the human dimension of the catastrophe by depicting the sorrow and resignation evident on the faces of the bereaved (Figs. 20, 21). The fourth drawing, an impression of morning mist at the mouth of the mine, was poetic and eerily romantic (Fig. 22). Like Tonalist artists at the turn of the century who depicted the city—particularly its steam pockets—with blurred, soft-focus effects and a narrow color range, Stella displaced the horror of the scene by veiling it behind a moody atmosphere. His pictorial description stands in marked contrast to the anonymous photographic adjuncts to Kellogg's text, which offer brutal evidence of the aftermath of the explosion (Figs. 23, 24).

Four months after the January 1908 publication of the Monongah investigation, Stella joined Kellogg as part of a thirty-member team undertaking an inventory of the economic and physical conditions of Pittsburgh. Organized under the auspices of the Publications Committee of *Charities and The Commons* and financed by the Russell Sage Foundation, the study—known as *The Pittsburgh Survey*—took a year and a half to complete and was the first major attempt to analyze through team research the entire life of a single community. The findings, published in three special issues of *Charities and The Commons* (January–March 1909), were exhibited at the Pittsburgh Institute and published in a six-volume tract by the Russell Sage Foundation.[35]

Paul Kellogg was *The Pittsburgh Survey*'s director and guiding spirit. Taking his cue from Riis and Lincoln Steffens, Kellogg reported facts rather than abstractions and interwove statistical data and analysis with individual biographies—a course he described as lying between the census at one extreme and "yellow journalism at the other."[36] In his effort to ground his study in actualities, he enlisted Hine and Stella to describe the

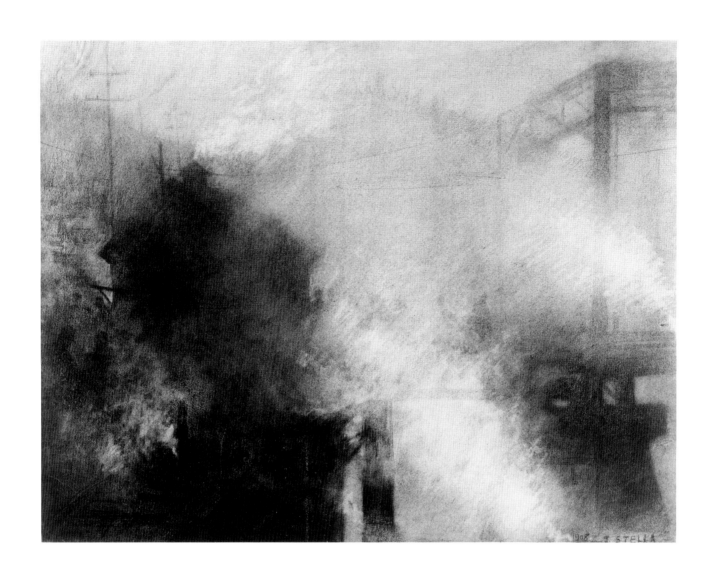

22. *Morning Mist at the Mine Mouth*
(Monongah), 1907
Charcoal on paper
17½ x 23 (44.5 x 58.4)
Jordan-Volpe Gallery, New York

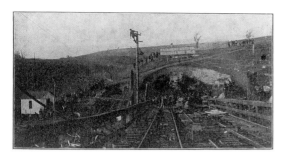

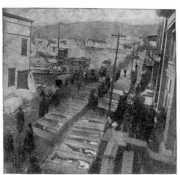

town and its inhabitants "through the eye as well as through the written word."[37] For Hine, the assignment inaugurated the focus on industrial labor and working-class life that would sustain him throughout his career (Fig. 40). Equally pivotal for Stella, *The Pittsburgh Survey* introduced him to the dichotomy between the glamour and majestic power of industry and its destructive effect on humanity—a dichotomy particularly endemic to Pittsburgh where, as one *Survey* writer noted, "the mighty storm mountain of Capital and Labor looms up. Here our modern world achieves its grandest triumph and faces its gravest problems."[38]

Stella's Pittsburgh images primarily took the form of individual portrait drawings, far more detailed and psychologically nuanced than those he had executed earlier (Figs. 26–39, 41). Yet his retrospective verbal account of his experience at Pittsburgh, written in 1946, focused exclusively on the city's industrial landscape rather than on its population—a dichotomy which suggests that he recast his experience of Pittsburgh in the wake of subsequent exposures to American industrial power.

> *I was greatly impressed by Pittsburgh. It was a real revelation. Often shrouded by fog and smoke, her black mysterious mass—cut in the middle by the fantastic, tortuous Allegheny River and like a battlefield, ever pulsating, throbbing with the innumerable explosions of its steel mills—was like the stunning realization of some of the most stirring infernal regions sung by Dante. In the thunderous voice of the wind, that at times with the most genial fury was lashing here and there fog and smoke to change the scenario for new, unexpected spectacles, I could hear the bitter, pungent Dantesque terzina.[39]*

During the period 1905–08, when Stella was building a reputation as an illustrator, he was also forging a career as a fine artist. Public recognition began when his work was included in a 1906 exhibition organized by the Society of American Artists—an inclusion which suggested his continuing association with the circle of artists around William Merritt Chase and the New York School of Art. Following Chase's presidency of the Society, former students and instructors at the New York School of Art such as Henri and Kenneth Hayes Miller became active participants. By

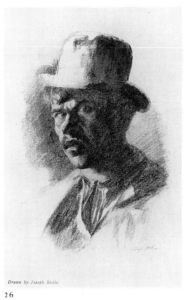

Drawn by Joseph Stella.

26

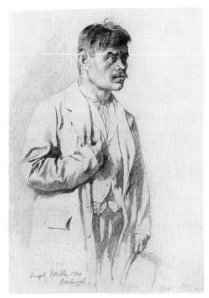

Joseph Stella 1908
Pittsburgh

27

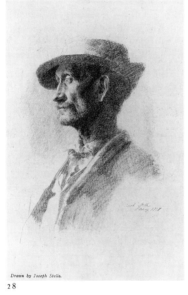

Drawn by Joseph Stella.

28

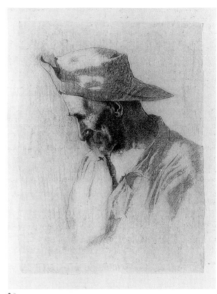

29

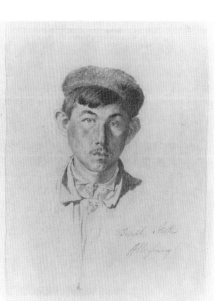

30

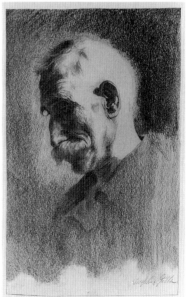

31

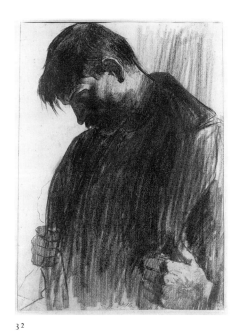

32

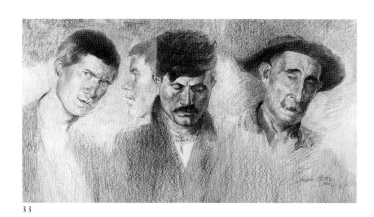

33

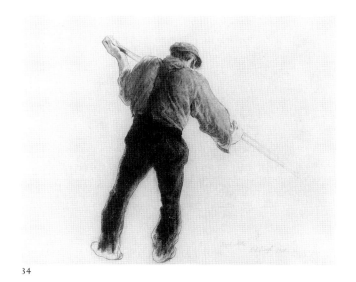

34

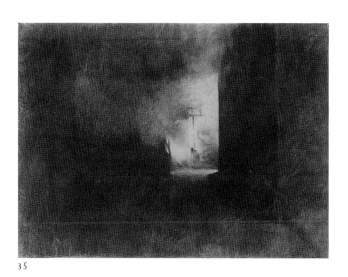

35

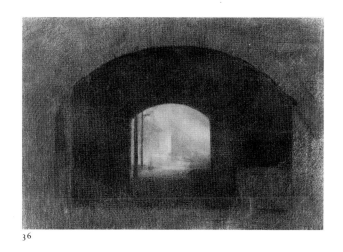

36

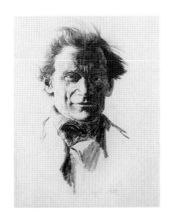

1906, the Society represented the academic side of American art—as confirmed by its merger that year with the National Academy of Design, whose conservative politics had precipitated the Society's formation.[40] Stella's submission to the 1906 exhibition satisfied the jury's insistence that exhibited work be painterly, not linear. Their decision to accept Stella's oil portrait, *Tarda Senectus*, was validated by the critic at *American Art News*, who praised it as among the "best pictures" in the show.[41]

Stylistically, *Tarda Senectus* and other Stella oils from this period—now lost—look back to the past and testify to the intensity with which he studied Old Master paintings at The Metropolitan Museum. Their reliance on the dramatic contrasts of light and dark to provide compositional and emotional force recall Rembrandt and the artists of the Venetian school.

Notwithstanding Stella's burgeoning success, he felt displaced in America. He was as oppressed by the throning crowds, the "merciless climate," and the lack of connection to sky and countryside as he was temperamentally out of sync with the nation's dominant Protestant traditions and values. His difficulty in adjusting to America was not unique. The majority of Italian immigrants dreamed of repatriation—and were encouraged by the Italian government, which opposed the adoption of foreign citizenship by Italian nationals.[42] Nor were dreams of return limited to those in underprivileged circumstances. Within the Stella family, Nicola returned to Muro Lucano in 1918 and ran a pharmacy for five years; Luigi fought under the Italian flag in World War I and eventually settled in Pesaro; and Antonio's widow moved back to Italy after her husband's death in 1927.

Return was nevertheless difficult—for Stella as for others. As one returnee reported, "When I was in Brooklyn, this town of mine, so old and so dear, became like a paradise to me in my imagination. And in the end I had to return....For some inexplicable reason, I did not like the town I found at my return. I was unable to adjust in Italy."[43] Those, like Stella, who found readjustment to Italy impossible, took out their frustration on their adopted homeland. Bitter at having to forfeit the land of his

childhood, Stella became bitter about America. By the 1920s he would write of being "exiled" here, of feeling "martyred" in an environment that drained his energy.[44] In order to reconnect with an idyllic past he could no longer possess, he exaggerated the Italianness of his speech and dress.[45]

In 1909, Stella had been in America for thirteen years—a period which would prove to be his longest uninterrupted residence here. Depressed and lonely, he asked his brother Antonio for financial assistance to return to Italy. "With ever-heightening eagerness during my long period of exile, I awaited this return to my native land. Toward the end, the waiting tore my tormented soul completely to shreds, tortured by the constant pain of an enforced stay among enemies, in a black, funereal land over which weighed, like a supreme punishment, the curse of a merciless climate."[46] In January 1909, Stella sailed for Europe. Unlike American artists who made similar trips, he was not seeking adventure and cultural experiences, but rejuvenation in his homeland. His was not the picturesque Italian pilgrimage that was popular among nineteenth-century artists, but the return of a native—one who had never given up his Italian citizenship.[47]

Stella was not disappointed upon his arrival in Muro Lucano: "What a tremor of joy erupted at last! And how my spirit soared in the radiant light of this supreme happiness. Like an urn overflowing with honey, my heart filled instantly with good feeling....Smiling visions arose like white clouds shining with laughter, and a great chorus of rejoicing, friendly voices intoned a hymn to my return to the land of my ancestors."[48] "Our physical being seems instantly strengthened, reinvigorated as if by magic. Our youthful confidence miraculously restored gives us a deep awareness of our energy, of our power, of our daring to attempt everything, to use to the utmost all the gifts at our command."[49]

Stella spent the first two years of what would be a four-year sojourn abroad in Rome, Florence, Naples, and Muro Lucano. Having come, as he acknowledged, "to renew and rebuild the base and structure of my art," he spent his time studying the masterpieces of Italy's artistic past.[50] He was particularly impressed by the warmth, depth of color, and transparency obtained by fifteenth-century Venetian painters and he began a thorough study of their technique (Figs. 43–46, 50). He also found Cennino Cennini's late fourteenth-century treatise on painting methods helpful and started experimenting with the process of glazing, in which thin coats of diluted oil paint are applied over an initial undercoat

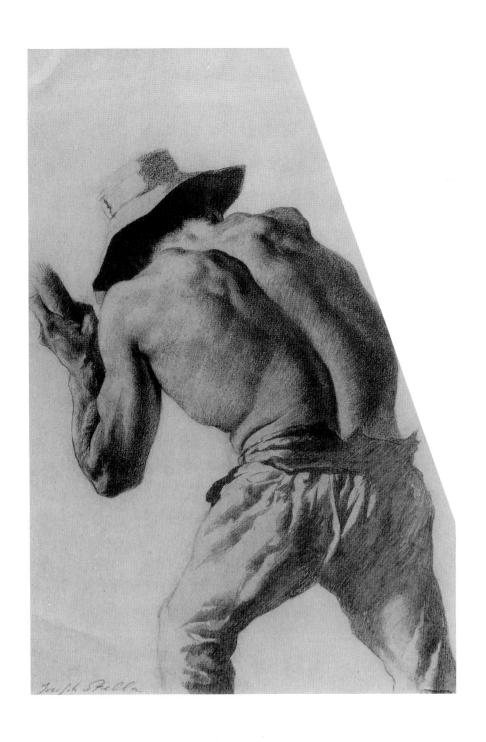

41. *Back of a Man Working*, 1908
Graphite on paper
9¼ x 6⅝ (23.5 x 16.8)
Collection of Bernard and
Dorothy Rabin

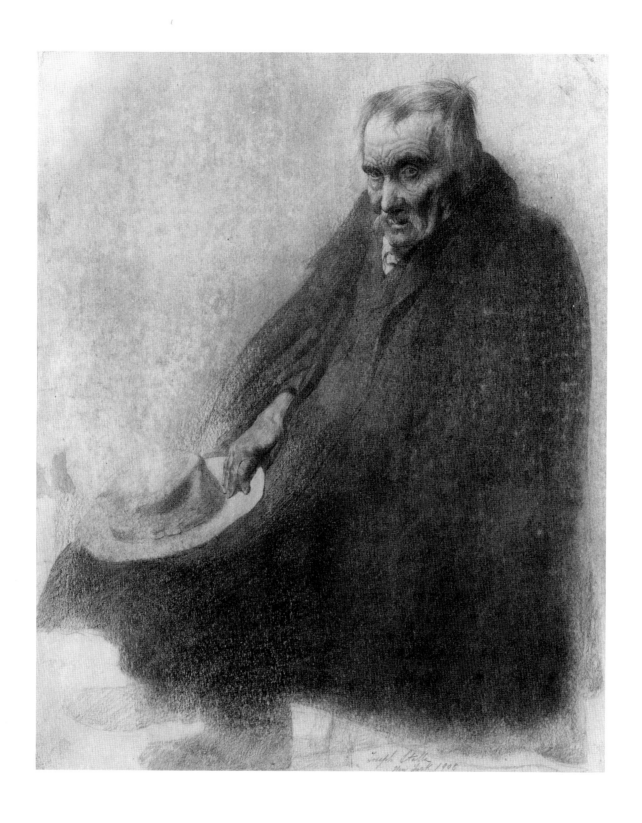

42. *Portrait of Old Man*, 1908
Graphite and colored
pencil on paper
11¾ x 9¼ (29.8 x 23.5)
Sheldon Memorial Art Gallery,
University of Nebraska, Lincoln;
Howard S. Wilson Memorial
Collection

43. *Portrait of a Young Man,*
c. 1909–10
Crayon, oil, varnish on paper,
mounted on paperboard
12 x 9¾ (30.5 x 24.8)
National Museum of American Art,
Smithsonian Instititution,
Washington, D.C.; Transfer from
S. I., National Portrait Gallery

of tempera.[51] Stella worked in this oil and tempera medium for the next three years and achieved great success with it: one of his portraits was purchased by the municipality of Rome and another was mistaken for an original Old Master painting by a customs official, who refused to allow Stella to take the work out of the country until he could prove his authorship of it by producing the sitter.

Despite these affirmations, Stella grew dissatisfied with the glazing technique: he came to feel entrapped by its rules and deprived of the independence and freedom which he considered a requisite for the true artist. As he later confessed, "my enthusiasm for the old art, that was rising higher and higher…got the best of me and I must confess it blinded me in many ways. I began to ignore nature and truth, and I had to consult the old teachers before talking….I understood that glazing, although bewitching, and giving me some very fine results, was depriving me of that liberty of movement that a true artist must have."[52]

Emancipation was sudden: one morning in Muro Lucano, frustrated by the laborious preparations required by glazing, he jettisoned the technique. He was not only impatient with the slowness of the process, but motivated as well by his lifelong rebellion against authority—which marked his art as well as his personality and contributed to the alacrity with which he changed styles in order to accommodate new visions. His hatred of rules accounted for his attraction to Antonio Mancini, a painter he spent a great deal of time with in Rome during this period, whose spontaneity and disdain of convention and restraint Stella glowingly described in a letter to a friend.[53] Stella's aversion to rules and restraint extended beyond aesthetics. He feared all attachments—to individuals as well as to inherited conventions and prejudices. "Love of any sort" he declared, "ends in slavery."[54] This fear accounted for his social eccentricity and for the absence in his life of lasting friendships or relationships. He insulated himself even from the groups in which he participated, always remaining an observer, set apart. Even his verbal descriptions of parties he attended conveyed the impression that he was looking down on the events from the perspective of the ceiling.[55]

Stella's deep-seated need for independence, though personally constraining, aesthetically liberated him. His desire to "reveal something that belonged to me and to me only" gave him the courage to let go of his reliance on tradition and the materials of the past.[56] Resolved to abandon glaz-

ing, Stella was nevertheless in a crisis about what constituted his "genuine language."[57] On the advice of Walter Pach, he set out for Paris in February 1911.[58] "Paris," Stella wrote, "had become the Mecca for any ambitious artist in search of the new verb in art—and in 1911, with great joy I flew to the *Ville Lumière*....At my arrival, Fauvism, Cubism, and Futurism were in full swing. There was in the air the glamour of a battle, the holy battle raging for the assertion of a new truth. My youth plunged full in it. I began to work with real frenzy....No more inhibition of any kind for the sake of inanimate sobriety, camouflaged poverty derived by the leavings of the past art....To feel absolutely free to express this adventure was a bliss and rendered painting a joyful source, spurring the artist to defy and suffer any hardship in order to obtain his goal."[59]

Stella was overwhelmed and dazzled by the modernist art he saw in Paris, particularly its "hyperbolic chromatic wealth," as he called it.[60] His response was understandable given his limited experience of vanguard innovations. The New York art world he had left behind was still ruled by the standards of the National Academy of Design; the only visible insurrection had been the charge led by Henri and the Ashcan artists, but theirs had been a revolution of subject matter rather than of style.[61] The circle in which Stella had moved while in Italy had been equally timid in relinquishing the canons of nineteenth-century aesthetics.[62] In contrast, within Stella's first twelve months in Paris he saw the April 1911 Salon des Indépendants, which included artists such as Robert Delaunay, Albert Gleizes, Fernand Léger, and Jean Metzinger; the 1912 Salon des Indépendants, which featured Cubist paintings; and the "Section d'Or" exhibition of October 1912, which again showcased Delaunay, Gleizes, Léger, and Metzinger.[63]

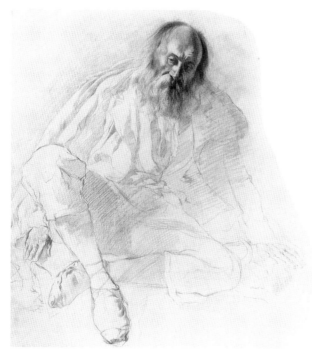

44. *Seated Old Man*, c. 1909–10
Graphite on paper
20½ x 19⅛ (52.1 x 48.6)
Collection of Jeffrey and
Rhoda Kaplan; courtesy
Richard York Gallery, New York

Stella threw himself with fervor into this new adventure. Fortunately, the art world in those days was small enough to afford anyone interested in the new art, particularly one who spoke French as did Stella, access to even the most prominent artists. Stella took full advantage of the opportunities for interaction provided by cafés such as the Closerie des Lilas and Cirque Medrano and soon met the leading figures of modernism—Matisse, Picasso, and Modigliani, among others. Stella's American friend, Pach, was an additional help in facilitating contacts, as he would later be to Arthur B. Davies and Walt Kuhn when they visited

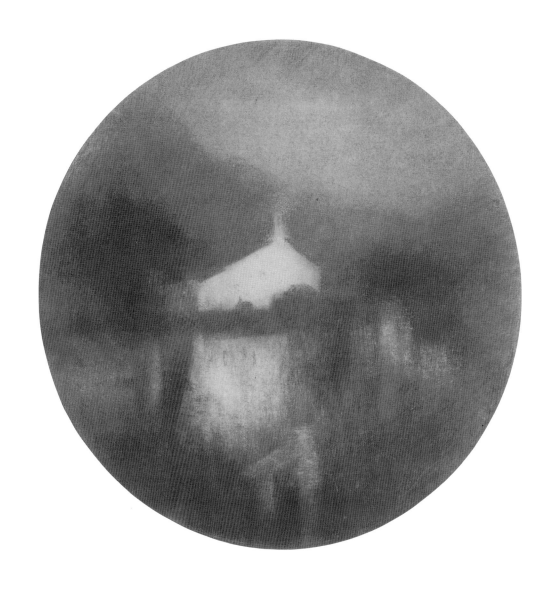

45. *Church and Lake*, c. 1909–10
Charcoal and pastel on paper
11¼ (28.6) diameter
Spanierman Gallery, New York

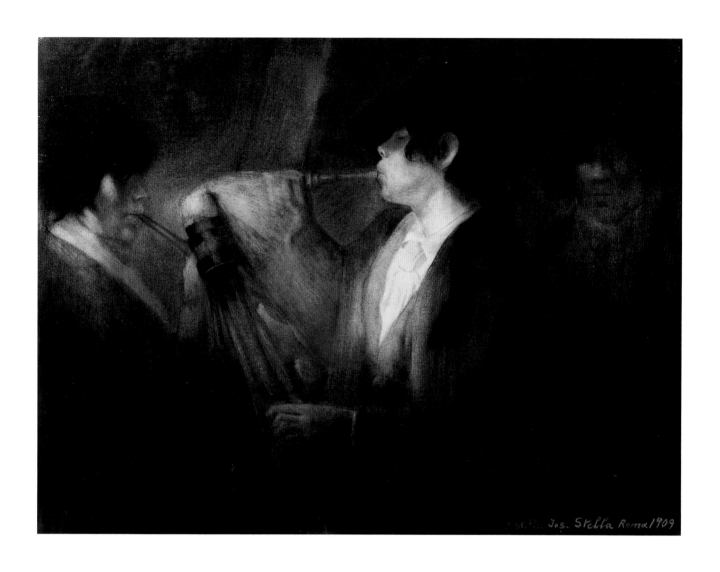

46. *The Bagpipers*, 1909
Charcoal, pastel, and
varnish on paper
26¾ x 35½ (67.9 x 90.2)
Richard York Gallery, New York

Paris to assemble work for the Armory Show. It was Pach, for example, who brought Stella to Gertrude Stein's salon and later served as liaison between Stella and Severini after Stella returned to New York. Stein's memory of Stella was more flattering than Stella's of Stein:

> *Somehow in a little side street in Montparnasse there was a family that had acquired some early work of Matisse and Picasso. The lady of the house was an immense woman carcass austerely dressed in black. Enthroned on a sofa in the middle...of the room where the pictures were hanging, with the forceful solemnity of a pitoness or a sibylla, she was examining pitiless all newcomers, assuming a high and distant pose.*[64]

Stella spent most of his twenty-one months in Paris absorbing the styles and ideas of the new art. Despite his assertion that he was seized by "a beneficent spirit of emulation" that spurred him toward the "most ambitious heights," he was initially so overcome with what he saw that he was unable to work.[65] Emotionally susceptible to absolutes, he was enraptured by the urgency and sense of mission of the new art. It had about it the glamour of a battle—"a holy battle raging for the assertion of a new truth."[66] As he plunged himself into this battle, he began to question his emulation of the Old Masters and, eventually, to regard his imitation of them as false. Unwilling to condemn the past as the Futurists would soon do, he concluded that there were still lessons to be learned from the Old Masters, but that they were ethical rather than stylistic: "how to organize the personal capacities in order to be true to [one's] own self."[67] He eventually determined that the modern artist cannot go back to the past to borrow materials but must "express the civilization he belongs to in his own time."[68] Incapable of living "on the crumbs of the past," the modern artist must venture through untrodden paths in an effort to reflect his own epoch, guided only by his own temperament.[69]

Stella's first efforts to "express his own time" were a group of Post-Impressionist works whose scarcity suggests that it took him quite a while to give up his reliance on Old Master techniques and move toward a new vocabulary. When he did, he adopted a mixture of Fauvist palette and Cézannesque structure that recalls the formulations of other American artists who confronted the panoply of vanguard styles being heralded in Paris (Figs. 47–48). Stella's attempt to pictorially assimilate these styles reveals his sensitivity to high-keyed color and textured surfaces but, as yet, a reluctance to forfeit illusionistic space and the realistic depiction of objects. As such, his Post-Impressionist works represent a major shift away from the Old Masters, but not yet a leap into modernism. They belie his

later description that his work "advanced rapidly with the singing strides of a triumphing march leading to victory."[70] Like many other American artists, he would not pictorially process the information he had gathered in Paris until after his return to America; even then, it would take him almost a year before he developed a fully mature modernist idiom.

Stella returned to New York in late 1912, secure in the conviction that he had been "both spectator and actor in the revolution of modern art in Paris."[71] If the paintings he had created there were only tepid forms of modernism, they nevertheless represented a sufficient break with the past to qualify two of them for inclusion in the Armory Show, which opened in New York in February 1913 (Fig. 49).

Stella's position as an aesthetic moderate was epitomized in April of that year—less than one month after the close of the Armory Show—when one hundred of his works were mounted at the Italian National Club, New York. The show occupied three rooms of the club, each room devoted to a different phase of Stella's career: Old Master-style paintings and drawings in the first room; illustrations of Pittsburgh subjects in the second; Post-Impressionist paintings in the third. However much Antonio Stella's prominence within the club had fostered consideration of Stella as an artist, the exhibition was an unqualified focus of pride within the Italian community; even the Italian ambassador arranged a special trip to attend the opening.[72] As the first exhibition of its kind, it was, as one critic noted,

an event in the history of the Italian colony here. Americans had seen the work done by Italian working men in the subways, the skyscrapers, the railroad. They had heard of Italians as banana kings, peanut kings, great contractors, silk and wine merchants; they had heard of the great and only Caruso. But of art, Italian art cultivated here, they had heard nothing. Then came Stella's exhibition. It was a revelation.[73]

Not only did Stella represent Italian success within an American context, but he had brought his sensitivity as an immigrant to bear on the task of depicting a new America—an America in which separate nationalities

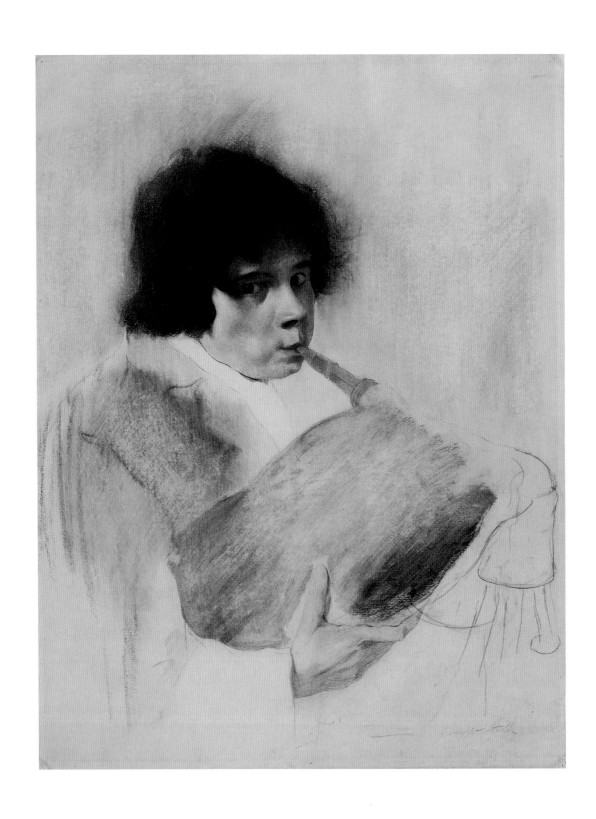

50. *Boy with Bagpipe*, c. 1909
Charcoal, pastel, and
graphite on paper
21¾ x 16⅜ (55.2 x 41.6)
Whitney Museum of American Art,
New York; 50th Anniversary Gift of
Lucille and Walter Fillin 86.59

come together to create a restorative ideal of harmony. In this latter regard, he was, as one reviewer would remark, America's most authentic painter of the melting pot.[74] Critics wrote extensively and favorably on the works in the first two rooms, but gave short shrift to Stella's Post-Impressionist efforts, except to note that he was not an extremist. The consensus was that as a "modern" he was still searching for a personal voice and that even his color was delimited by his academic training. Stella himself acknowledged that he was only on the periphery of modernism several months later in an article he wrote in *The Trend*: "Of course it goes without saying that I have not done much yet along this path. I consider my latest work as only the first experiments of something big that will surely come."[75]

Like others of his generation, Stella had been profoundly affected by the aesthetic explosions of modernism, but he was not yet either aesthetically or socially part of the community of vanguard artists in New York. One reason was his absence in Europe during the formative years of American modernism. He had missed the early exhibitions of non-photographic art at Alfred Stieglitz's 291 gallery—those of John Marin (April 1909, February 1910, February 1911), Marsden Hartley (May 1909, February 1912), Marius De Zayas (January 1909), Max Weber (January 1911), and Arthur Dove (February–March 1912). Nor had he participated either in the 1910 Independents show or in Stieglitz's modernist answer to it, "Younger American Painters." Moreover, the loyalty he retained to his Italian heritage made his battle with the past different from that being fought by his American colleagues. As one reviewer sympathetically remarked, it was hard "for a contemporary Italian either to forget the great traditions of his country's art or to be really individual without being at the same time eccentric."[76] Stella's attempt to recast the Old Masters as models for a set of attitudes rather than specific styles had been a first step in reconciling his individuality with his country's artistic past.

Stella's willingness to move more boldly in the direction of modernism gained greater force as a result of the Armory Show. Having recently returned from Paris, Stella was neither shocked nor surprised by the more avant-garde works in the show. What stirred him to action was less the art than the rhetoric employed to explain it. Press reaction to the modernist inclusions focused, almost without exception, on what was described as "futurist art"—even though the real Futurists had declined to participate in the show. Cubism was described as "static Futurism" or a "subset of Futurism."[77] Descriptions of explosions in a munitions factory joined cartoons of splintering buildings to create an impression that the

entire modernist impulse was Futurist in conception.[78] Since Futurism was clearly a more evocative word than Cubism and since advance publicity for the Armory Show indicated repeatedly that the Futurists were to be included, the confusion was natural.[79] It was reinforced by the inclusion of several works influenced by Futurism, in particular Marcel Duchamp's *Nude Descending a Staircase*, which had become centerpieces of journalistic commentary on the show. Stella could not have been insensitive to the press' impression of Futurism as a major vanguard expression nor to the "glory" such attention bestowed on Italy. It was indeed to such glory that Stella referred in a letter in the early 1920s to the Italian Futurist painter Carlo Carrà.[80]

The attention given to Futurism rekindled Stella's memories of the Futurism he had seen in Paris. For it was here, rather than in Italy, that he had first come in contact with the group of Italian artists with whose work his own achievement would later be associated. Stella had attended the presentation of Futurist work in February 1912 at the Galerie Bernheim-Jeune and undoubtedly had seen the exhibition catalogue, which included reprints of the "Founding Manifesto of Futurism," "The Technical Manifesto," and "The Exhibitors to the Public" statement. At the exhibition, he had met Carrà and probably Boccioni and Severini.[81] Carrà and Boccioni had returned to Italy shortly after the exhibition opened and Stella's contact with them ceased. Severini, however, remained in Paris, where he had lived since 1906, and Stella came to know him through mutual acquaintances—in particular, Modigliani, a fellow countryman and close friend of both Stella and Severini; and Pach, whose status as intermediary between Severini and American artists led to a Severini exhibition at 291 in 1917.[82] That Severini and Stella shared a language and a nationality would, in itself, almost have ensured their acquaintance. On his stop through Paris on his way to Italy in 1909, Stella described seeking out the Italian contingent, and there is no reason to imagine he would not have done the same thing during his longer residence there in 1911–12.[83] It is also evident from Stella's and Severini's correspondence to Pach that the two Italians knew each other.[84] Moreover, that Stella emulated Severini's work rather than that of other Futurists when he began his own Futurist compositions further confirms that their association extended beyond a casual meeting at the Bernheim-Jeune show in 1912.

Stella's appreciation of Futurism was based as much on the movement's manifestos as on its art—a position not unlike that of his European counterparts, whose introduction to Futurist theories preceded Futurist art by several years. What appealed to Stella about Futurism was its

embrace of what was new in modern life: speed, dynamism, and the mechanistic aspects of the contemporary urban and technological environment.[85] The Cubists were interested in motion also; but whereas they presented their subjects as if observed by a single individual from multiple viewpoints, the Futurists emphasized the movement of objects themselves. In principle, this entailed more than physical motion; it involved "physical transcendentalism"—the emotional and psychic extension of objects beyond their physical boundaries.[86] The Futurists did not fracture form for the sake of structural analysis as did the Cubists, but as a means of describing the physical and emotional impact of objects on their surroundings. This formed the core of their ideology: rendering the emotional sensation or state of mind that objects or events induced in them.[87] Like the Symbolists, to whom Stella and they owed allegiance, the Futurists viewed memory and the full panoply of senses—touch, smell, sound, taste, and sight—as affecting this emotional mood. Ideally, this mood need not be limited to concrete phenomena, but could be abstract. Thus, the Futurist's ultimate aim, as Boccioni described it, was to create work "in which color becomes a sentiment and a music in itself...with the least possible references to the objects."[88]

This emphasis on emotional expression over objective portrayal was as important an influence on Stella's art as Futurism's advocacy of explosive dynamism. That it accorded so well with Stella's proclivities was less surprising than was its general acceptance. Perhaps because the equation between art and emotional experience offered a concrete explanation for the pictorial distortion of objective reality, it was applied during this period to all modern art, Cubism included. Echoing a commentator who described Cubism as a "metaphysical art," one critic remarked that "the Cubist does not pretend to paint what he sees but rather that which he feels."[89]

The viability of emotional response as apt subject matter for art was reinforced by Francis Picabia's visit to New York for the opening of the Armory Show. As one of the few participating artists who attended the spectacle, Picabia was widely quoted in newspapers. His acknowledgment that "everything with me is emotion, it is how I 'feel'" and that his work represented the "objectivity of the subjective" reinforced the reigning view that modern artists aimed to portray their subjective sensations.[90] Equally important for Stella was Picabia's endless proselytizing on the beauty and dynamism of New York. New York, of course, was not a new subject for artists. What distinguished Picabia's pronouncements was his advocacy of New York as the paradigm of modernity. In a well-publicized

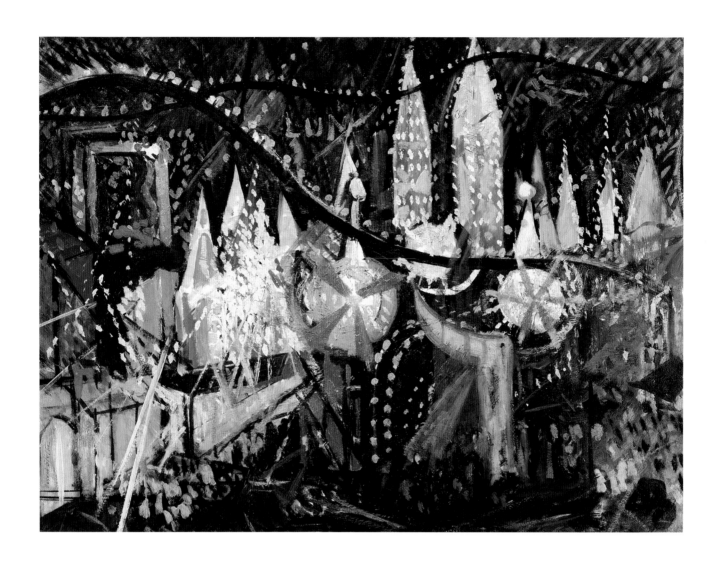

51. *Luna Park*, 1913
Oil on composition board
17½ x 23⅜ (44.5 x 59.4)
Whitney Museum of American Art,
New York; Gift of Mrs. Charles A.
Goldberg 72.147

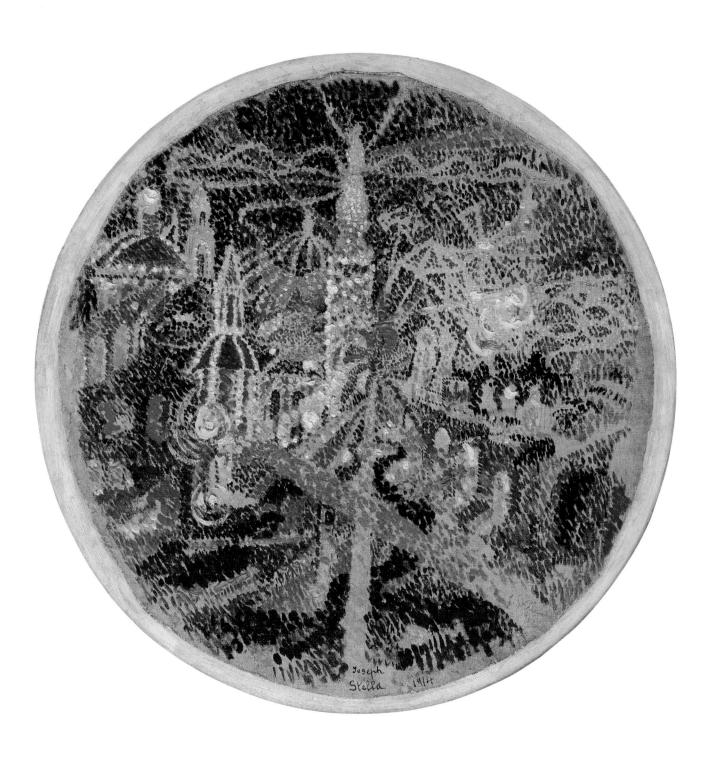

52. *Battle of Lights*, 1913 (later
inscribed "1914")
Oil on canvas mounted on cardboard
20¼ (51.4) diameter
The Museum of Modern Art, New
York; Elizabeth Bliss Parkinson Fund

article in the *New York American*, he called attention to the dynamism and vitality of New York and urged American artists to turn to their own environment for subject matter: "You of New York should be quick to understand me and my fellow painters. Your New York is the cubist, the futurist city. It expresses its architecture, its life, its spirit, the modern thought. You have passed through all the old schools, and are futurists in word and deed and thought."[91]

These ideas were kept current in the press by the opening of Picabia's show at Stieglitz's 291 gallery two days after the close of the Armory Show. In the widely quoted preface to the show's circular, Picabia explained that his new works expressed "the spirit of New York as I feel it and the crowded streets of your city as I feel them, their surging, their unrest, their commercialism, and their atmospheric charm....I see your stupendous skyscrapers, your mammoth buildings and marvelous subways, a thousand evidences of your great wealth on all sides."[92] Although stylistically, Picabia's New York-inspired studies look ahead to his burgeoning abstraction rather than back to his Futurist style, his description of them corroborated the Futurist insistence on dynamism and the urban metropolis as appropriate subjects for art.

Stella had been primed by his experiences in Europe to appreciate that a new pictorial language was needed to reflect the present rather than the past. Although he had abandoned the stylistic claims of bygone epochs, his subject matter had continued to mirror, as he himself acknowledged, "a civilization long since dead."[93] Picabia's ebullience about America as the country of the future had turned Stella's gaze toward his adopted land and encouraged him to look anew at the Futurist's celebration of mechanical dynamism. Once he did, he moved into modernism with an alacrity that was startling.

Stella's epiphany came one night on a bus ride to Coney Island in early September 1913 during Mardi Gras, a post-Labor Day celebration then held annually in the park. As he explained later, "For years I had been struggling along both in Europe and America without seeming to get anywhere. I had been working along the lines of the old masters, seeking to portray a civilization long since dead. And then one night I went on a bus ride to Coney Island during Mardi Gras. That incident was what started me on the road to success. Arriving at the Island I was instantly struck by the dazzling array of lights. It seemed as if they were in conflict. I was struck with the thought that here was what I had been unconsciously seeking for many years."[94] Like a foreign visitor to America, Stella saw the

vitality and dynamism of the country's technology as if for the first time: "a fabulous mine of truly extraordinary motifs for the new kind of art."[95]

Coney Island, with its electric lights, surging crowds, and motorized rides, was a quintessential Futurist subject.[96] Emblematic of the "brilliance and the dynamic energy of modern life so evident in America," it fulfilled the Futurist prescription for agitation and technologically based imagery.[97] Its conjunction of machines with "violent dangerous pleasures" recalled Marinetti, whose "Founding Manifesto of Futurism" had extolled danger, energy, and aggressiveness, along with the intention to "sing of great crowds excited by work, by pleasure, and by riot."[98] For Stella, Coney Island did more than answer the call for a motif that encapsulated technology, pleasure, and turbulence; it invoked associations with the fairs and annual celebrations of the feast days of local Catholic saints which he had experienced as a child. Not only was it a "battle" of lights, it was "a modern kermesse."[99]

Stella began his Coney Island series in the fall of 1913, initially exploring the subject with an enlarged pointillism, or divisionism, in combination with a decorative linearity derived from Art Nouveau (Figs. 51, 52). This reliance on the two stylistic forces behind Futurism allied his efforts with the pre-Futurist paintings of the movement's leading artists, particularly Severini. Stella included three examples of these Coney Island works in a group exhibition of fourteen artists organized by Arthur B. Davies to call attention to Am-

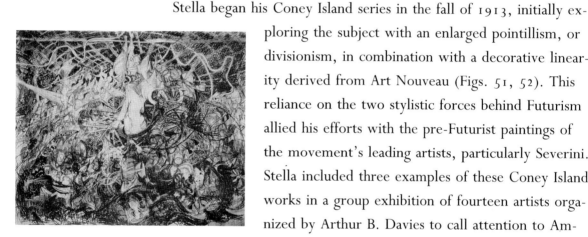

53. *Battle of Lights, Coney Island, Mardi Gras,* as it was reproduced in the Montross Gallery catalogue, February 1914

erican modernism.[100] "American Cubists and Post-Impressionists" opened at the Carnegie Institute in Pittsburgh in December 1913; in February 1914 it traveled to the Montross Gallery in New York, followed by venues in Detroit and Cincinnati.[101] While the show was in Pittsburgh, Stella worked on a large-scale canvas entitled *Battle of Lights, Coney Island, Mardi Gras* (Fig. 57). He must have completed it immediately before the Montross show, for it was not exhibited in Pittsburgh and was represented in the Montross catalogue in a preliminary version only (Fig. 53).[102]

The finished oil was not an objective portrait of an isolated site at the amusement park but rather a depiction of the psychological impression made on Stella by the entire carnival complex—its exotic dancers, crowds, fragments of signs, confetti, noise, electric illuminations, the steel girders of its popular rides, and the bejeweled electric tower and onion domes of Luna Park. Stella forfeited realism in order to portray the park's hedonistic abandon and frenzy because he believed that, "had he merely

represented the physical appearances of the American fiesta...he could not have given the rhythm of the scene, which transforms the chaos of the night, the lights, the strange buildings, and the surging crowds into the order, the design, and the color of art."[103] The painting achieves its modernity not through allusions to the machines of pleasure, but because these machines entered into the rhythm, form, and texture of the composition. To accomplish this, Stella combined vignettes of actual and remembered scenes in a churning arabesque of surface patterns that resonates with the motion, glitter, and brassy mechanical sound of the carnival environment. With the most densely painted areas concentrated in the center, the painting fulfilled the Futurist's admonition to "put the spectator in the center of the picture."[104]

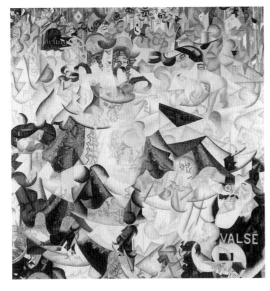

54. Gino Severini
*Dynamic Hieroglyphic
of the Bal Tabarin*, 1912
Oil on canvas with sequins
63⅝ x 61½ (161.6 x 156.2)
The Museum of Modern Art,
New York; Acquired through the
Lillie P. Bliss Bequest

Although Stella's *Battle of Lights, Coney Island, Mardi Gras* owed its ideology to Futurist manifestos, its pictorial style most closely resembled Severini's, especially the latter's *The Pan Pan at the Monico*, which hung in the Bernheim-Jeune exhibition, and *Dynamic Hieroglyphic of the Bal Tabarin*, which Stella could have seen in Severini's studio shortly thereafter (Fig. 54). The two artists shared an interest in festive subject matter—carnival themes in Stella's case and nightlife in Severini's. Moreover, their shared compositional strategies—circular configurations, the interweaving of sinuous forms with faceted, abstract ones, and the introduction of realistic details and disjointed words and letters into an otherwise abstract kaleidoscope of whirling colors and triangular shapes—suggest that Stella had Severini's work in mind as he began his own Futurist explorations.

Yet Stella's work remained quite distinctive: his color is more intense than Severini's, his forms smaller and more compact, and his design more centrifugal and explosive. In many ways, Stella surpassed Severini as a paradigm of Futurism. Indeed, Stella is alone among the Futurists in aligning the subject matter of technological life to a style that encapsulated the dynamism and speed which technology engendered. Advantaged perhaps by his residence in a country uniquely identified with technology, Stella was able—unlike the other Futurists—to escape the bonds of traditional subject matter and fuse the new language of twentieth-century art with a subject matter endemic to it.

The Montross Gallery exhibition was a public and art world sensation.[105] The first presentation of "extremist" art in an established gallery in

New York City, it drew over nine thousand people within its first two and a half weeks and generated sales of nineteen pictures.[106] The "capture of 'Montross' by the cubists," Henry McBride remarked, signaled the arrival of modernism in America.[107] "Since the Fall of the Bastille," he continued, "nothing has been so astonishing....Nature apparently accepts cubism as she accepted all the other things, with complacence, so why shouldn't we?...It is nonsense to pretend it isn't the movement of the day—and still moving." The intensity with which this new art was received caused another critic to declare that these "extremists of the new extreme" were "competing with the 'Tango' in exciting the town."[108]

Of the more than one hundred works included in the show, Stella's *Battle of Lights, Coney Island, Mardi Gras* was the undeniable "star." Larger in size and more compositionally ambitious than any other picture there, it dominated press attention. Its characterization as "a picture as, let us say, an inhabitant of Mars might make after a visit to New York, in an effort to make his fellow Marsmen understand what Coney Island was like when he saw it," was one of the few that indicated an understanding of Stella's ambition to capture the mood produced by the park's cacophonous mix of sound, smell, and sight.[109] More negative interpretations came from critics who compared it to "exploding firecrackers" and a "cross between a painting representing the blowing up of a New Jersey munitions factory and one in which some imaginative genius had tried to put on canvas a post-impressionist impression of the voters of New York, male and female, engaged in the joyous occupation of celebrating the termination of the Hohenzollern dynasty."[110] Stella's painting was apparently responsible for a joke made at the time of the show by someone who burst into a publishers' luncheon at the Century Club with the question, "have you seen the Montrossities up the avenue?"[111] The notoriety surrounding *Battle of Lights* echoed that which had attended Duchamp's *Nude Descending a Staircase* during the Armory Show. As with Duchamp, it launched Stella as a conspicuous figure in the American avant-garde. It was selected as the only color illustration in the seminal, five-part article on modern art in the April 1914 issue of *The Century* and was positioned prominently by Carlo de Fornaro in his cartoon of the Montross show (Fig. 55).[112] Stella understood the work's importance; he priced it at $2,500 and chose it to represent him in the 1917 Independents show and again in the 1921 modernist show organized by Alfred Stieglitz for the Pennsylvania Academy.[113]

55. Carlo de Fornaro
Seeing New York with Fornaro
The Evening Sun, February 9, 1914.

Stella experimented with even more abstract means over the next two years. In some works, he abutted flat, geometrical shapes of high-keyed color (Fig. 60); in others, he relied on a more agitated linearity that recalled the Futurism of Boccioni and Carrà (Fig. 56). Influenced perhaps by the more planar format and elimination of overt representational reference in the art of Picabia and Albert Gleizes, which he would have seen in the January 1915 Picabia show at 291 and in three separate showings of Gleizes' work at the Carroll Galleries that same year, Stella pushed the parameters of Futurism.[114] Inspired by their example, he endowed the kaleidoscopic patterning that had marked *Battle of Lights* with a greater degree of abstraction and flattened space. In February 1916, he included *The Procession—A Chromatic Sensation* in the exhibition of fifty modernists at the Montross Gallery (Fig. 63). Composed almost entirely of relatively small triangular shapes of unmodulated color that spiral up from the lower edge in a dense design to suggest the movement of crowds and slanting, flag-crowned maypoles, this painting was intended as an abstract paean to the "elysian lyricism of the Italian Spring."[115] To emphasize its subject, it was shown in 1921 as *Spring Procession (South Italy)* and referred to in correspondence simply as *Spring*.[116] In 1916, however, presented under the title *The Procession—A Chromatic Sensation*, the motif of fluttering pennants in a procession moving sinuously through spring terrain was less identifiable; one reviewer concluded that the picture portrayed a suffragette parade on 5th Avenue, with its "swirling torrent of yellow banners, white gowns, flowered hats and parasols, hemmed in by crowds waving handkerchiefs, all mixed up with a symbolized snowstorm of ballots—the 'votes for women' motif irrepressibly asserting itself."[117]

It was on the basis of this and other works from the previous three years that Stella has been lauded as America's first Futurist. Indeed, the appellation is justified. While other Americans—John Marin, Max Weber, Frances Simpson Stevens, James Daughtery, and Arthur Dove—were engaged with Futurist themes of dynamism and simultaneity, none matched Stella in invoking the dynamic exuberance of the machine-dominated world. As Stella correctly boasted, his work was the first to "deal with industrial subjects derived from the new civilization."[118]

Surprisingly, Stella resisted any direct association with the Futurist movement.[119] Even before he began his Coney Island series, he had affirmed the need "to paint sincerely without trying to please the futurists or the post-impressionists or to displease the Academicians."[120] Such self-imposed caveats notwithstanding, Stella did attempt to contact the Futurists when he visited Europe in the summer of 1914.[121] The overture must

have failed, for Stella did not participate in the 1914 Galleria Futurista show in Rome, which included Frances Stevens, who was living in Italy then and knew Marinetti. The rejection may have piqued his inherent antagonism to rules and theories; by August of that year he was lamenting "the painter who warbles his credo in long high sounding essays. The picture is the only essay that a painter is entitled to. Lately it has been a fad of the 'Smart Set' to denounce the old masters; and groups or individuals in quest of a cheap notoriety have tried to swell their poor ego with some recent pamphlets advertising their wares."[122]

Stella's allegiance to Futurism and its formal precepts had been of limited duration. What remained the bedrock of his art, however, was the Futurist ambition to paint impressions and moods and to incorporate all the senses into a single image. The Futurist effort to "kindle magic in an unmysterious world"—a by-product of the movement's Symbolist roots—ignited parallel inclinations in Stella.[123]

In order to enter the diaphanous realm of abstract emotionality, Stella turned to music as the supreme communicator of suggestive and metaphysical realities—as had many American artists for whom music provided a theoretical framework for their burgeoning abstraction.[124] The parallel between music and art had initially entered the American consciousness through Whistler, whose elevation of formal values over representational ones by means of musical terminology was transmitted to audiences in this country through various commentaries on his work, particularly those by Arthur Jerome Eddy and Harriet Monroe. Through these literary descriptions, Americans came to appreciate musical analogy as a means to achieve an abstract expression. The 1913 publication in *Camera Work* of Kandinsky's essay on the abstract, spiritual qualities of music enormously furthered this argument, as did Picabia's widely quoted appeals to music as a means to subordinate subject matter in favor of emotional expression.[125]

By the mid-teens, music had come to be accepted as the paradigm for visual abstraction. Artists as diverse as Morgan Russell, Stanton Macdonald-Wright, Georgia O'Keeffe, Marsden Hartley, Max Weber, and Arthur Dove invoked it to support their forays into abstraction (Figs. 64–66). Some, like Weber, considered their abstractions as visual translations of music—a "color music" tangibly manifested in the New York premier of Alexander Scriabin's *Prometheus*. In this performance, the composer concretized the equivalence between the color spectrum and the musical scale by means of an accompanying light show. For most visual artists, however, the musical analogy was more intangible; it came closer to Dove's description

56. *Hippodrome (Ballet)*, 1915
Pastel on paper
17⅛ x 23 (43.5 x 58.4)
Private collection

57. *Battle of Lights, Coney Island,*
Mardi Gras, 1913–14
Oil on canvas
76⅞ x 84⅝ (195.3 x 214.9)
Yale University Art Gallery,
New Haven; Gift of the Collection
Société Anonyme

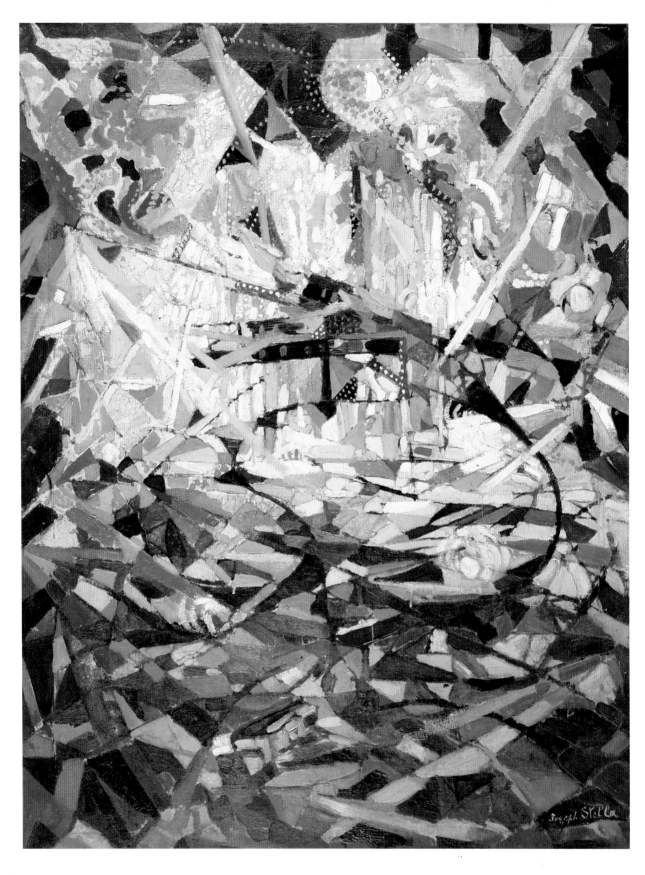

58. *Battle of Lights, Coney Island*,
1913–14
Oil on canvas
39 x 29½ (99.1 x 74.9)
Sheldon Memorial Art Gallery,
University of Nebraska-Lincoln;
F.M. Hall Collection

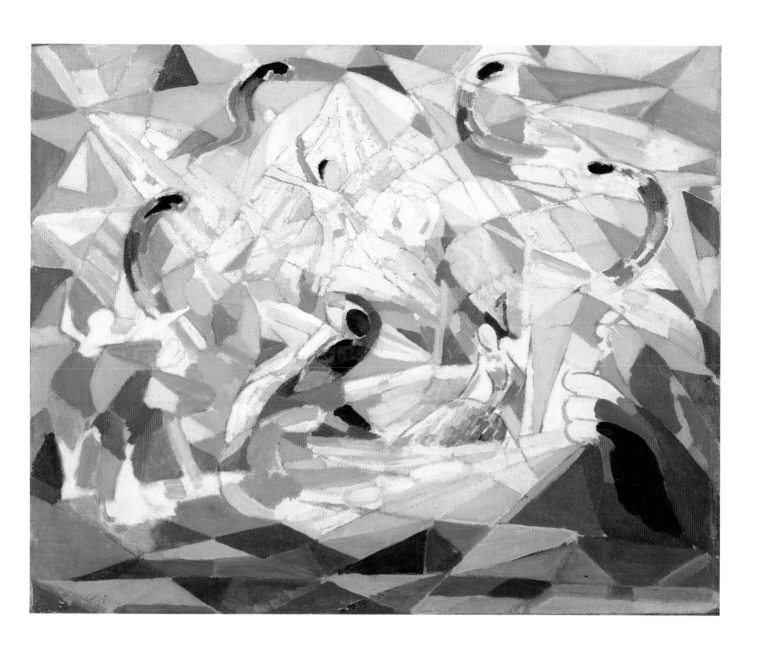

59. *Der Rosenkavalier*, 1913–14
Oil on canvas
24 x 30 (61 x 76.2)
Whitney Museum of American Art,
New York; Gift of George F. Of
52.39

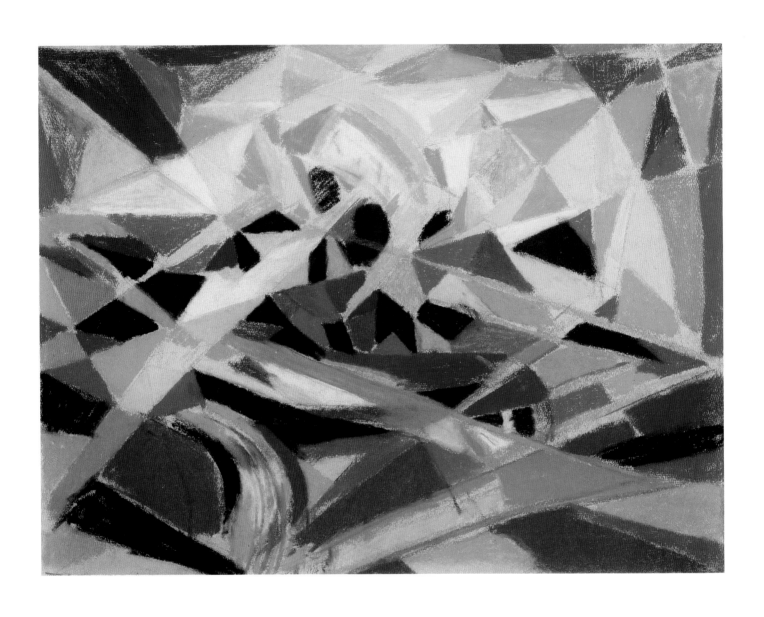

60. *Futurist Composition*, 1914
Pastel and graphite on paper
16⅜ x 21⅞ (41.6 x 55.6)
Barbara Mathes Gallery, New York

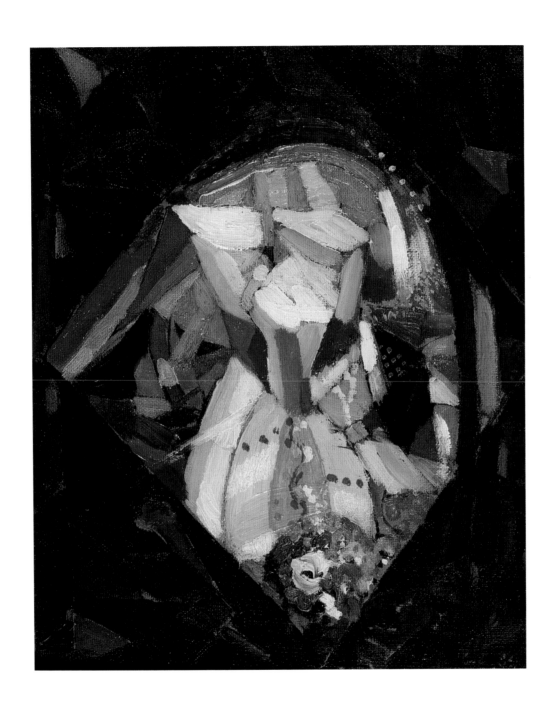

61. Study for *Battle of Lights*, 1914
Oil on canvas
12 x 9½ (30.5 x 24.1)
Collection of Mr. and
Mrs. William C. Janss

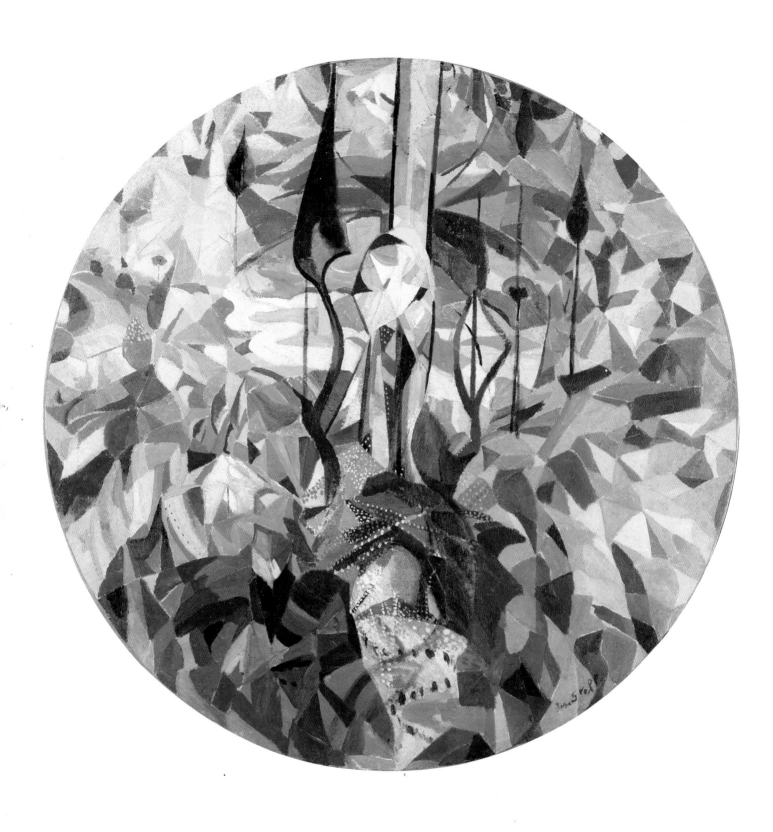

62. *Coney Island (Madonna of Coney Island)*, 1914
Oil on canvas
41¾ (106) diameter
The Metropolitan Museum of Art,
New York; George A. Hearn Fund

OPPOSITE PAGE
63. *Spring (The Procession—A Chromatic Sensation)*, 1914–16
Oil on canvas
75⅜ x 40¼ (191.5 x 102.3)
Yale University Art Gallery,
New Haven; Gift of Collection
Société Anonyme

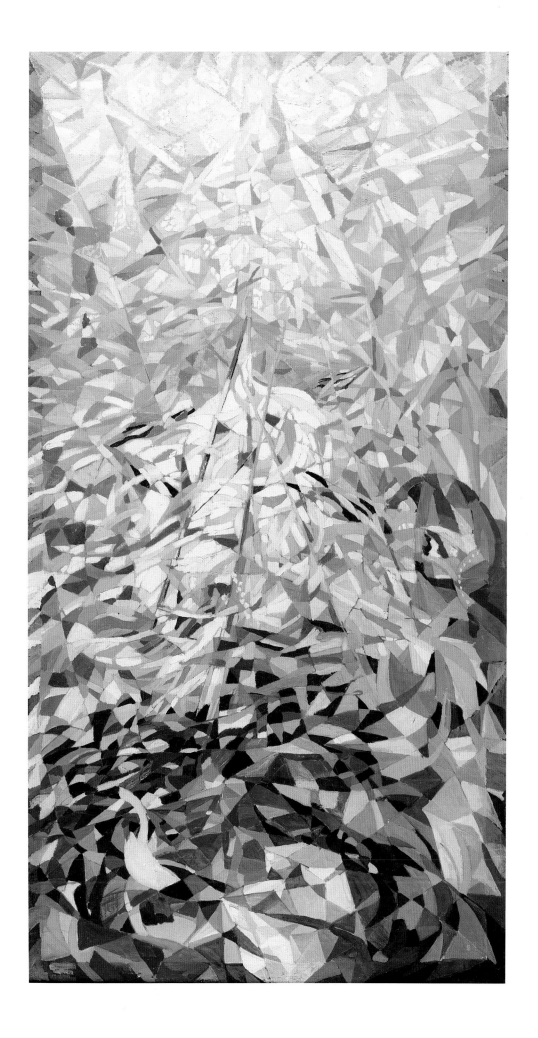

of his abstractions as "nearer to music, not the music of the ears, just the music of the eyes."[126] These parallels between music and art had become so common by 1913 that reviewers of the Armory Show could write about "color music" and McBride could ask a year later, "What was the use kicking because painting had become another form of music?"[127] By 1916, the *New York Sun* was calling the new art movement the "Academy of Music."[128]

Stella too used musical titles to emphasize his depiction of abstract emotional states independent of attachment to subject. Yet even without such hints as *The Procession—A Chromatic Sensation* and *Der Rosenkavalier* (Fig. 59), critics seemed particularly prone to decipher Stella's art by means of musical analogy. They wrote repeatedly of its symphonic aspects, its "sonorous" qualities, and its "harmony."[129] This strategy was invoked even when it proved more obfuscating than illuminating. One baffled reviewer remarked of *Battle of Lights* that "it takes a Beethoven successfully to carry one rapidly through three different keys in chromatic sequence. If Mr. Stella's 'Battle of Lights' were music, the time allowed for it would be less than five minutes, and it would not be Beethoven or Richard Strauss, but someone later and less."[130]

Stella's advocacy of music as a vehicle for emotional expression had been fueled by the conceits of American modernism. But for him, as for all early twentieth-century Italian artists, the Futurists included, its ultimate source was Symbolism. The Symbolists had been the first systematic proponents of synesthesia, a quasi-mystical belief in the subjective interaction of all sensory perception. Convinced that art should express the intangible, they sought to transcend the concrete implications of language by appealing directly to the emotions and sensory experience. To do so, they had called upon the immateriality of sound, smell, and color. Stella's inspiration in these pursuits was Edgar Allan Poe, who shunned the factual and descriptive in favor of the poetic evocation of mood. As Stella described it, Poe bypassed the logical connectives of language in order to achieve an art laced with the passion, drama, and mystery of his inner

vision: "New meanings dash out of his unexpected chromatic blending. The Medusa of Mystery leaps to light with a new physiognomy: new aspects are revealed, new enigmatic blazing hieroglyphics are shrieked by thunder and lightning in livid upheavals of earth and sky. One moves, breaths uplifted to a superhuman atmosphere, to the regions where candor of the domes elevated by Art perpetually radiate against the flaming gold of eternity, where everything becomes redeemed with the transfiguration practiced by abstraction."[131]

With Poe and his Symbolist protégés as models, Stella embarked on a group of works between 1917 and 1922 that mirrored his conviction that the mission of art was the expression of hallucinatory visions; that art "should be so spiritual that it lifts the soul out of the realities of life (Figs. 68–80)."[132] In some works he relied on arabesques of undulating, organic forms that recalled the Orphism of Robert Delaunay, which he had seen in Paris (Fig. 67). In others, such as *A Child's Prayer* and *Song of the Nightingale* (Figs. 68, 78), both originally titled in French to emphasize their enigmatic aura, he invented a vocabulary of form and color which nurtured reverie and spiritual reflection. Drawing on the inherent mysteries of night, he also explored nocturnal themes (Figs. 79, 80, 95). Languorously undulating lines and rich, deep colors created a world with only the most suggestive associations. It was an imaginative realm in which earthbound realities were

transfigured into abstraction through the rarified power of music, perfume, and color.

Following the lead of Poe and the Symbolists, Stella sought to "enclose...in a permanent way the perfumed rhythm...the spiritual *aroma*" of things.[133] He defined the artist's goal: "to catch and render permanent (materialize) that blissful moment (inspiration)...when he sees things out of normal proportion, elevated and spiritualized, appearing

new, *as seen for the first time*."[134] He called upon color, divorced from subject, to stimulate the elusive overtones of abstraction. Unlike Kandinsky, who ascribed specific symbolic meanings to color, or the Futurists, who identified colors with specific visual phenomena, Stella treated color as an independent, poetic trigger of intangible ruminations.[135] Sometimes he summoned color for specific associative purposes, as in *Battle of Lights*, where he utilized "the intact purity of the vermilion to accentuate the carnal frenzy of the new bacchanal and all the acidity of the lemon yellow for

69. *Futurist Abstraction*, c. 1918–19
Pastel on paperboard
15 9/16 x 8 7/16 (39.5 x 21.4)
Pensler Galleries, Washington, D.C.

70. *Untitled Abstraction*, c. 1918
Pastel on paper
28½ x 20⅞ (72.4 x 53)
Richard York Gallery, New York

71. *Abstraction*, c. 1918
Pastel on paper
23 3/16 x 18 (58.9 x 45.7)
Pensler Galleries, Washington, D.C.

72. *Abstraction,* c. 1918–19
Pastel on paper
26⅜ x 20⅛ (67 x 51.1)
Private collection; courtesy Pensler
Galleries, Washington, D.C.

73. *Aquatic Life (Goldfish),*
c. 1917–18
Pastel on paper
30 x 23⅜ (76.2 x 59.4)
Watkins Collection, The American
University, Washington, D.C.; Gift
of the Katherine S. Dreier Estate

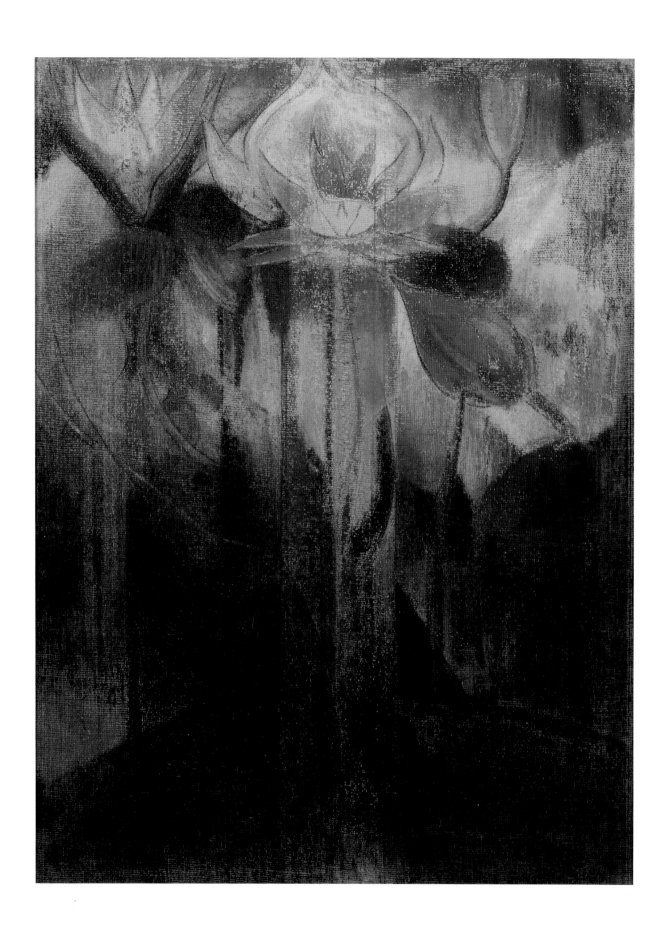

74. *Jungle Foliage*, c. 1918–19
Pastel on paper
25 x 18½ (63.5 x 47)
Collection of George Hopper Fitch

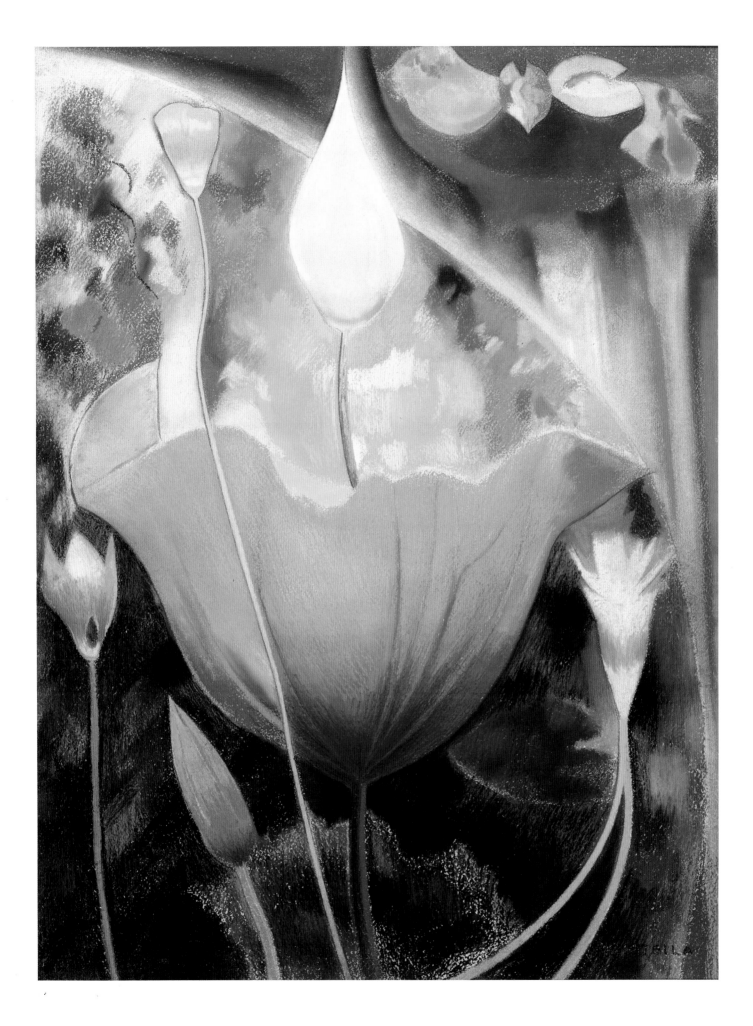

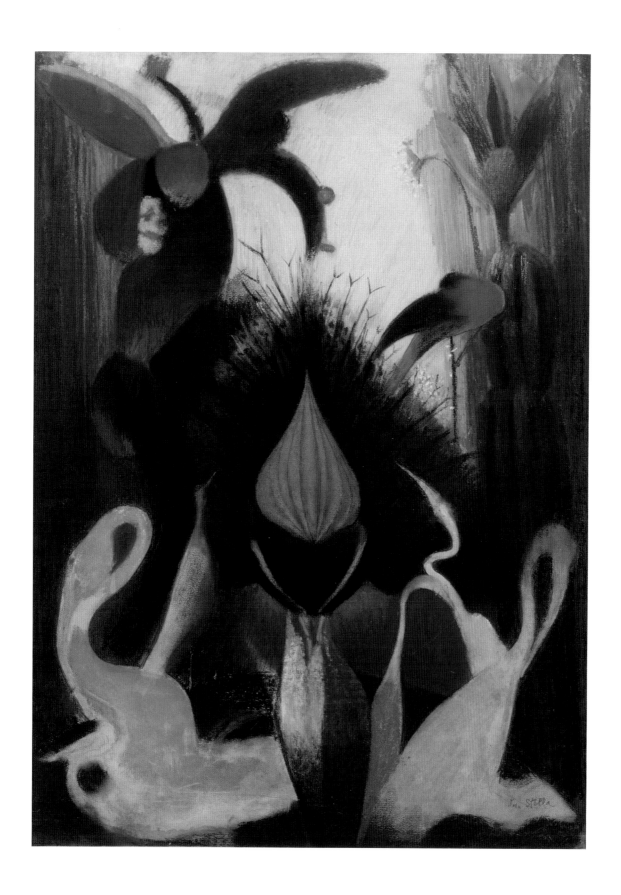

OPPOSITE PAGE
75. *Abstraction*, c. 1918–19
Pastel on paper
39¼ x 29¼ (99.7 x 74.3)
The Newark Museum, New Jersey;
Gift of Mrs. Rhoda Weintraub Ziff

76. *The Peacock*, 1919
Pastel on paper
25¼ x 18¼ (64.1 x 46.4)
Richard York Gallery, New York

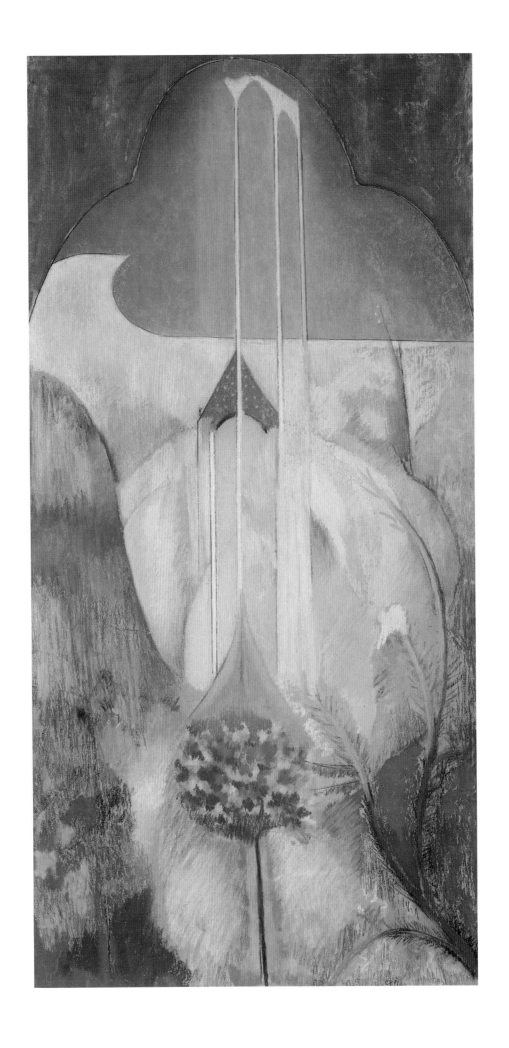

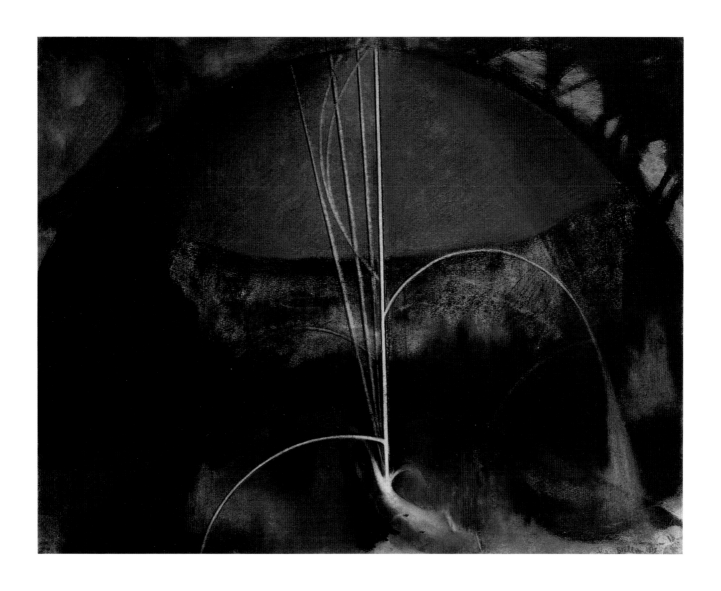

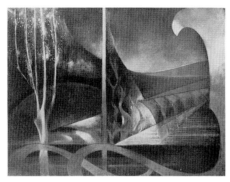

the dazzling lights...."[136] At other times, he adhered more closely to the Symbolist model and demanded that color function as a self-sufficient carrier of meaning. He wrote, for example, of "Blue serenity" and of the "green freedom of my own self."[137] Stella never abandoned his reverence for this kind of non-material, sensory effusion. It permeated his literary and pictorial work, even as he moved from one style and subject to another.

Stella's ideas concerning abstraction held favor within the two dominant vanguard circles that had emerged following the arrival in New York in 1915 of a number of European artists—in particular Marcel Duchamp, Jean Crotti, Albert Gleizes, and Picabia, who had returned to America at the same time. Of these two groups, one centered around Alfred Stieglitz, the other around Walter and Louise Arensberg; Stella was drawn to the Arensberg group.[138] In contrast to the primarily American writers and painters around Stieglitz, who emphasized the transcendental spirituality of nature, the Arensberg salon offered Stella an international community of artists who shared his engagement with the subject matter and stylistic imperatives of the contemporary metropolis. At the evening gatherings that the Arensbergs hosted in their apartment, Stella came into contact with expatriates from Europe such as Duchamp, Picabia, Crotti, Gleizes, Mina Loy, Elsa von Freytag-Loringhoven, and Edgard Varèse as well as the Americans Man Ray, Charles Demuth, William Carlos Williams, Charles Sheeler, Morton Schamberg, Marsden Hartley, Arthur Craven, John Covert, Walter Pach, and Katherine Dreier. This network of friendships informed Stella's major social and aesthetic involvements from 1915 to 1922, even though he remained here, as elsewhere, resistant to full identification with the group.

The Arensberg coterie had a playful, almost irreverent attitude toward art; a belief in the viability of industrial and mechanistic subject matter; and a geometric, impersonal manner of execution. Out of this nexus, a new art and a new poetry was created which came to be called New York Dada. Stella participated actively in this environment. He served on the board of the 1917 Society of Independent Artists exhibition, spearheaded by Arensberg and Duchamp, and was part of the three-member team, along with Duchamp and Arensberg, that purchased the urinal Duchamp submitted to the Independents exhibition under the title

81

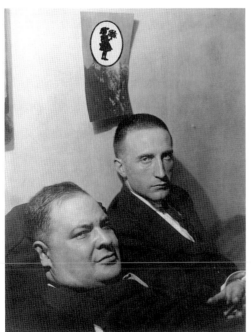

82

83

Fountain.[139] During 1921, when the Dada label was officially applied to activities in New York, Stella was being publicly singled out as an affiliate of the movement (Fig. 81).[140] In January 1921, he was quoted in the first major American newspaper article on Dada, along with Dreier, Duchamp, and Man Ray.[141] Three months later, he unintentionally became the centerpiece of the only public gathering presented under the official auspices of the Dada movement—a lecture, "What Is Dadaism?" organized by the Société Anonyme in April 1921.[142] His apparent amusement during a lecture by an "opponent" of Dada who was trying to argue that Swinburne was the original Dadaist precipitated a disturbance when the speaker stopped and accused "the fat man" of annoying her by laughing.[143]

That same month, Stella was featured as one of two debutantes—along with Hartley—in the zany article "Pug Debs Make Society Bow," which appeared in the only issue of *New York Dada* (Fig. 82).[144] Finally, though postdating the demise of the "official" Dada movement in New York, he was included in the famous Salon Dada organized by Tristan Tzara in Paris in the summer of 1922; in an article on Dada in the September 1922 issue of *Shadowland*, Alfred Kreymborg identified him as one of the three leaders of a "modest little group" of Dadaists in New York.[145] Stella also served on the exhibition committee of Katherine Dreier's Société Anonyme, along with Duchamp and Man Ray.[146] Although Dreier's ambition to chronicle the "coming of the new art" extended far beyond Dada, the participation of Duchamp and Man Ray, co-founders of the Société, gave the organization a pro-Dadaist flair that lasted until the summer of 1921, when they both left for Paris.

Despite these and other friendships with the leading personalities of New York Dada and their shared gallery affiliations—at the Montross, McClees, and Bourgeois Galleries—Stella remained separate from the movement, much as he had from Futurism.[147] Indeed, in his lecture at

the Société Anonyme in January 1921, he disavowed organized movements, claiming that "every declaration of Independence carries somewhat a declaration of a new slavery."[148] For Stella, as for other American artists, Dada represented pleasure and liberation, not attachment. Just as Hartley accepted Dada because of its freedom, humor, and ability to "deliver art from the clutches of its worshippers…and to take away from art its pricelessness and make of it a new and engaging diversion, pastime, even dissipation," so Stella identified Dada with "having a good time— the theatre, the dance, the dinner…it is a movement that does away with everything that has always been taken seriously. To poke fun at, to break down, to laugh at, that is Dadaism."[149]

It was probably this irreverent attitude that led Man Ray, who was more moralistically protective of Dada as a movement, to write this unflattering portrait of Stella:

> *Joseph Stella the Italian painter had joined our Société Anonyme, ingratiated himself with Miss Dreier, saw to it that I photographed his paintings for the exhibition to open soon, and incidentally wanted a portrait of himself. He was very fat. Some of my portraits may have looked like caricatures but in his case whatever turned out was a perfect likeness. He was very vain, considered himself a Don Juan and acted as if he was always involved in some escapade.*[150]

In contrast, Stella and Duchamp were friends (Fig. 83). Stella respected the French artist, owned several of his works (Fig. 88) and retained, throughout his various changes of residence, a photograph of Duchamp's *Stoppages* and the issue of *View* devoted to Duchamp.

Stella's most tangible debt to Duchamp was in the use of glass as a painting support. Whereas American artists such as Hartley had been encouraged by folk art to experiment with glass, Stella was motivated by Duchamp's example (Fig. 86). He would have seen the various works on glass that Duchamp brought with him to America as well as those that Duchamp and Crotti, who shared a studio in the Lincoln Arcade Building, began after their arrival in New York. By April 1916, Stella had sufficiently mastered the material to include two paintings on glass in the group exhibition at the Bourgeois Galleries in which the two French artists also exhibited.[151]

86

87

88

Stella's two paintings, *Man in Elevated (Train)* and *Prestidigitator*, echoed the modernist currents within the Arensberg circle (Figs. 84, 90). The first, an abstraction of a man reading a newspaper seen through the window of an elevated train, re-capitulated the planar, geometricized Cubism of Gleizes and Picabia that Stella had already adapted in oils such as *The Procession—A Chromatic Sensation* (Fig. 63). *Prestidigitator*, a "portrait" of a specialist in sleight-of-hand, was akin to Duchamp's *The Large Glass* and to Picabia's mechanomorphic portraits in its union of mechanistic imagery and abstract por-traiture (Figs. 86, 87). Echoing the allusive titles used by Duchamp and Picabia, *Prestidigitator* drew upon linguistic associations to comment on the artist's ability to transform reality—a message sim-ilar to that which Demuth delivered in his 1919 *Box of Tricks*.

Whereas Duchamp appreciated the imper-sonal quality of glass, Stella was intrigued by its light-reflective properties, and he produced reverse paintings on glass through 1924. His subject matter ranged from urban and industrial themes such as *Chinatown* (Fig. 91) and *Pittsburgh*, to evocative flow-er studies such as *Landscape (Water Lily)* (Fig. 94), which he included in a 1924 exhibition at The New Gallery, alongside examples of stained-glass paintings executed by Mary Wesselhoeft after his designs.

Although Stella resisted the crisp, impersonal execution associated with machine fabrication that Duchamp and other members of the Arensberg circle promoted, he was encouraged by their views of industri-alization to hail the beauty and aesthetic possibilities of modern industrial America. Arriving from a war-shattered Europe, they viewed America as "the country of the art of the future."[152] As Picabia had done in 1913, they urged Americans to find aesthetic inspiration in their own environment rather than in outmoded European traditions. Paradoxically, the technol-ogy and industrialization they admired in America were precisely those as-pects of the culture which had been discounted by those living here. As Harold Loeb asserted, "America regarded from France is not the same America that bustles one from subway to elevator....Your intellectual

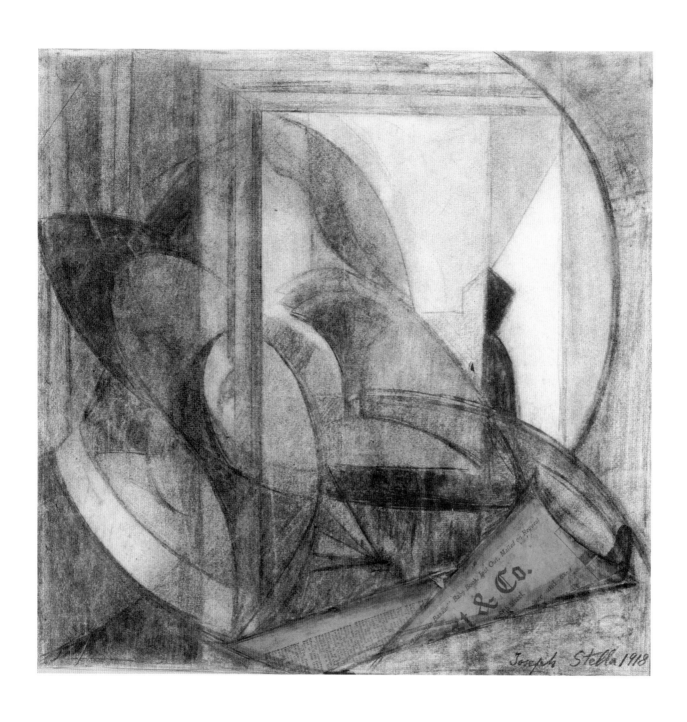

89. *Man Reading a Newspaper*, 1918
Collage with graphite, charcoal, and
newspaper on paper
15 x 15½ (38.1 x 39.4)
Gallery Gertrude Stein

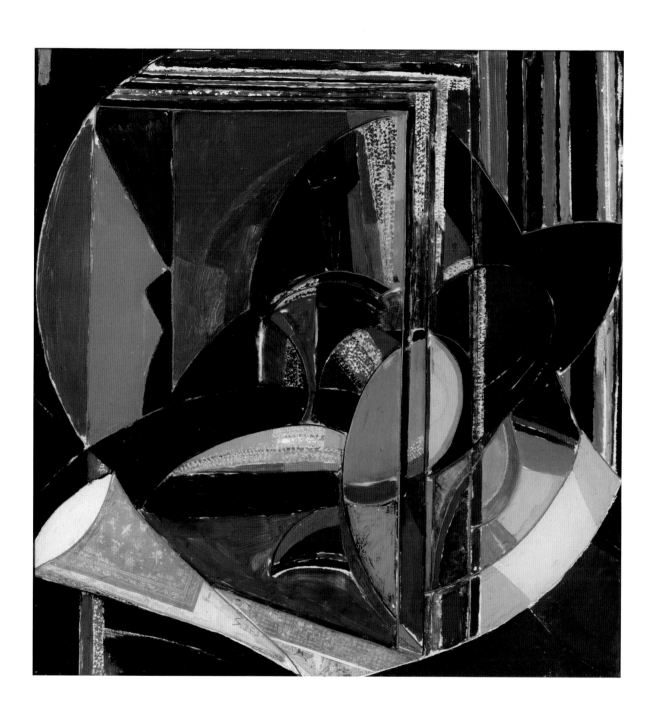

90. *Man in Elevated (Train)*, 1916
Oil and collage on glass
14¼ x 14¾ (36.2 x 37.5)
Washington University Art Gallery,
St. Louis; University purchase,
Kende Sale Fund

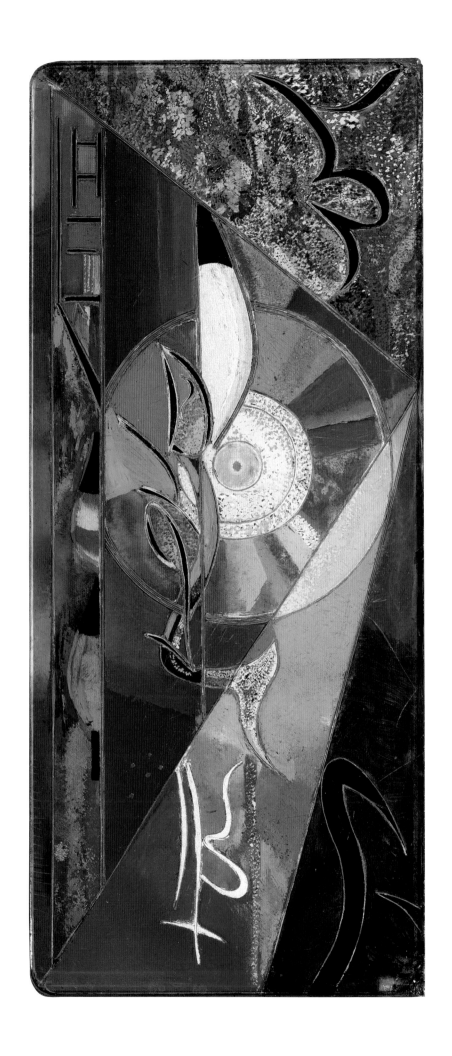

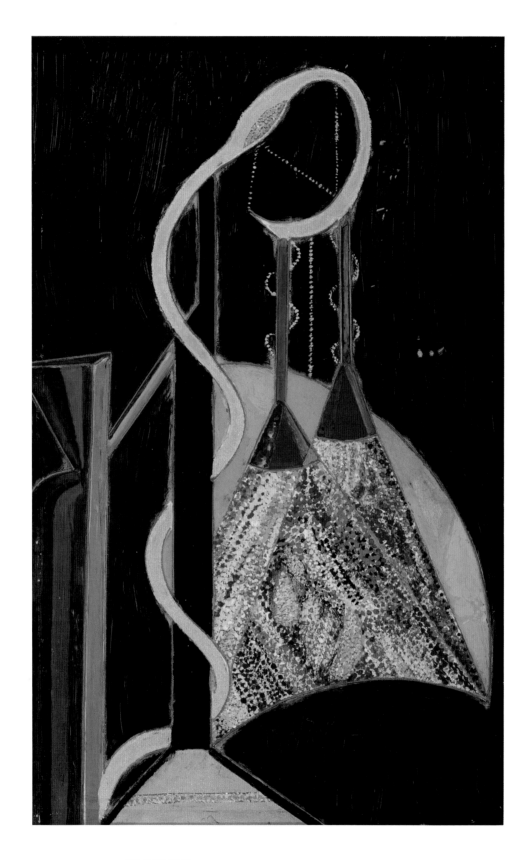

OPPOSITE PAGE

91. *Chinatown*, 1917
Oil on glass
19¼ x 8⅜ (48.9 x 21.3)
Philadelphia Museum of Art; The
Louise and Walter Arensberg
Collection

92. *Prestidigitator*, 1916
Oil and wire on glass
13⁵⁄₁₆ x 8½ (33.8 x 21.6)
Whitney Museum of American Art,
New York; Daisy V. Shapiro Bequest
85.29

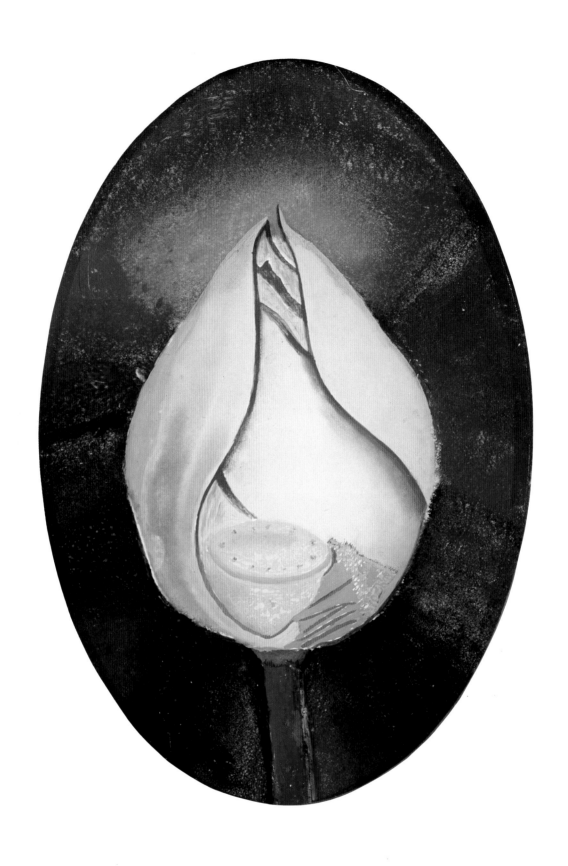

93. *Lotus Flower*, 1920
Oil on glass
11 x 7¼ (27.9 x 18.4)
Collection of Dr. and
Mrs. Martin Weissman

America, yes, it bores me, but that other America of the skyscrapers, of the movies, of the streets, that is admirable."[153]

Most Americans who had even marginally addressed the technological environment had done so with misgivings. Sadakichi Hartmann's 1903 celebration of the "exuberant, violent strength" of New York had been tempered by his simultaneous lament for its "mad, useless Materiality."[154] A similar conjunction of exaltation and fear lay behind Stieglitz's description of the Flatiron building as both "a monster" and "a picture of a new America still in the making."[155] Uncomfortable with the building's modernity, Stieglitz had humanized it in his famous 1903 photograph by enveloping it in an atmosphere of snow. In contrast, the Europeans who congregated around the Arensbergs were unambivalent about the technological dimension of America. Picabia, upon returning here in 1915, had announced that "the genius of the modern world is in machinery" and that he intended to bring it directly into his studio.[156] Duchamp had been similarly exultant. Declaring the skyscrapers more beautiful than anything France had to offer, he rested his defense of *Fountain* on the contention that "the only works of art America has given are her plumbing and her bridges."[157] To Gleizes, the skyscrapers were "works of art. They are creations in iron and stone which equal the most admired old world creations. And the great bridges here—they are as admirable as the most celebrated cathedrals. The genius who built the Brooklyn Bridge is to be classed alongside the genius who built Notre Dame de Paris."[158]

These ideas found a receptive audience among the American members of the Arensberg circle who were independently working toward the recognition and definition of an indigenous American art. *Current Opinion* featured an article in its April 1913 issue on the "Artistic Aspects of the Skyscraper," which heralded architectural achievements such as the Woolworth building as native forms of American expression. And between 1916 and 1917, in the five issues he published of *The Soil*, Robert Coady urged artists to find the sources for their work within the matrix of American culture. He defined American art as still "outside of our art world. It's in the spirit of the Panama Canal. It's in the East River and the Battery. It's in Pittsburgh and Duluth. It's coming from the ball field, the stadium and the ring....There is an American art," he declared. "Young, robust, energetic, naive, immature, daring and big spirited."[159] To illustrate his concern for an art related to the contemporary reality of machine technology, Coady filled the pages of *The Soil* with photographs of machinery juxtaposed against the printed

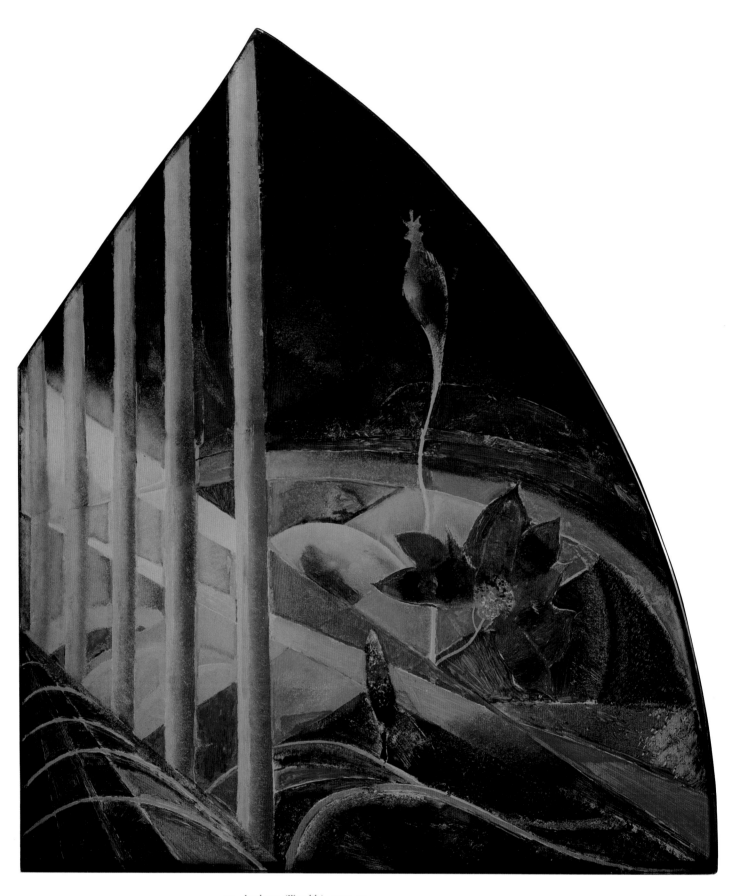

94. *Landscape (Waterlily)*, 1920–24
Oil on glass
30 x 25⅜ (76.2 x 64.4)
Hirshhorn Museum and Sculpture
Garden, Smithsonian Institution,
Washington, D.C.;
Gift of Joseph H. Hirshhorn

95. *Nocturne*, c. 1918
Pastel on paper
23¼ x 17¹⁵⁄₁₆ (59.1 x 45.6)
The Toledo Museum of Art;
Museum Purchase Fund

96. *From the Campagna (Immigrant Girl: Ellis Island)*, 1916
Charcoal on paper
29 x 14⅛ (73.7 x 35.9)
Hirshhorn Museum and Sculpture Garden, Smithsonian Institution, Washington, D.C.;
Joseph H. Hirshhorn Bequest

question, "Who will paint New York? Who?"

For Coady, as for others of his generation, Walt Whitman furnished a singular model for the celebration of indigenous culture. Duchamp's friend Romain Rolland cited Whitman in the opening issue of *Seven Arts* as having first given voice to the American soul. Proclaiming his faith "in the high destinies of America," Rolland admonished Americans "to dare to see yourselves; to penetrate within yourselves…to make of your culture a symphony.…Behind you, alone, the elemental Voice of a great pioneer, in whose message you may well find an almost legendary omen of your task to come,—your Homer: Walt Whitman."[160] Coady, equally aware of Whitman, had modeled his magazine after the lists of facts in Whitman's poetry and excerpted portions of the poet's "Crossing Brooklyn Ferry" as examples of an aesthetic expression appropriate to a culture undergoing radical transformation through technology. William Carlos Williams echoed these citations of Whitman in his own exhortations to American artists to develop indigenous subjects and forms of expression. He called for a new form of national expression based on Whitman's glorification of the dynamism, vitality, and energy of the native environment and his celebration of the machine as an American cultural symbol.[161] Stella's appreciation of Whitman, which he had brought with him from Italy, had primed him to value all aspects of life—including industrialization—as potentially revelatory.[162] Although he was not yet ready to embark on an art that would address the challenges to contemporary life posed by the machine and industrialization, Whitman's consideration of them as symbols of the "new America" would inform his thinking. Indeed, Stella's eventual pursuit of these themes would be guided by Whitman's metaphysical analogy between mechanical energy and divine spirit.

Stella's sensitivity to these issues was peaked by his move to Brooklyn in 1916, to a factory area in Williamsburg, near the Brooklyn Bridge. The move was not voluntary. For Stella, as for all American artists, the years 1916–17 were difficult. "War was raging with no end to it—so it seemed," Stella wrote. "There was a sense of awe, of terror weighing on everything—obscuring people and objects alike."[163] Faced with the grow-

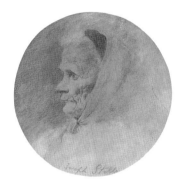

ing likelihood of American entry into World War I, the art world retreated. Stieglitz ceased publishing *Camera Work* and closed 291 following his Georgia O'Keeffe show in the spring of 1917. Stella described the period as one in which "Art came to a standstill, hardly any exhibition and hardly any sale. I felt desperate and at the same time urged by an absolute need of finding something to do for the gain of my living."[164] Financial relief came to Stella in the form of a job, which his brother procured for him, teaching Italian in a Baptist seminary in Williamsburg.[165] Although the remuneration was small, it gave him the freedom to work without "having to submit to the approval of anyone, my brother included."[166] Yet, the ultimate benefit of living in the industrial section of Brooklyn and looking across at the electric lights of New York over the Brooklyn Bridge was the impression of America it reawakened in Stella: "Steel and electricity had created a new world. A new drama had surged from the unmerciful violation of darkness at night, by the violent blaze of electricity and a new polyphony was ringing all around with the scintillating, highly colored lights. The steel …with the skyscrapers and with bridges made for the conjunction of worlds. A new architecture was created, a new perspective."[167] Although Stella did not immediately turn his pictorial attention to this imagery, the vision of the "steely orchestra of modern constructions" remained in his consciousness.

Stella's appreciation of this "steely orchestra" was intensified by several commissions from *The Survey*, the name adopted by *Charities and The Commons* in April 1909 to indicate the magazine's growing emphasis on investigative surveys. His first assignment was to illustrate an article for the May 1916 issue on the immigrants detained at Ellis Island because of the war. Written by Frederic Howe, the New York commissioner of immigration, the article reconnected Stella to the progressive groups with which he had been associated between 1905 and 1909. Radiating optimistic idealism, Howe cited Ellis Island as a "remarkable demonstration of the fact that vice and crime are largely the result of poverty and lack of opportunity.…that the wrong of the world, the evil, the vice, and the criminal actions of

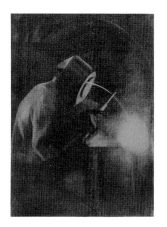

people are traceable back to the environment in which people live...that the evils usually ascribed to the badness of people are social in their origin."[168] Stella's drawings, more detailed and meticulously rendered than anything he had done previously, captured the dignity and patience of these immigrants as they awaited their destiny in the New World (Figs. 96–99).

Two years later, *Survey* editor Paul Kellogg called upon Stella to illustrate four of the magazine's twelve "Reconstruction Numbers," published monthly between November 1918 and November 1919 (Figs. 100–109). These issues aimed to provide a perspective on peacetime America by examining ways in which non-combatant citizens had contributed to the national war effort through the production of ships, uniforms, weapons, munitions and airplanes. In his sketches of shipbuilders and garment workers, Stella more than answered the magazine's implicit mandate to demonstrate how the nation's wartime needs had been served by native and foreign-born Americans working together.[169] That his drawing *The New Race of the New World* (Fig. 102) accompanied the magazine's announcement of its "Reconstruction" series indicated how successfully he had captured the vision of America as a "brotherhood of individuals, of races, of cultures banded together."[170]

In his assignment to illustrate the steel workers of Bethlehem, Pennsylvania, Stella chose not to depict individual members of this heroic "new race," but to portray them in the smoldering environment of fire and steel in which they labored. "To draw the men by themselves was to get them out of focus—just as to draw a landscape and call it 'America' was to get the United States out of focus," the editors reported him as saying. "This was America; these were Americans. The working team in the steel mill is one in which the machine dwarfs the human element."[171] Although Stella's pictorial interpretation of Bethlehem startled the editors, who expected more conventional illustrations, they were bold enough to acknowledge that perhaps his expressionist accountings revealed something more important than if he had followed their directives and objectively portrayed American workers in action. According to the editors, "as a portrayer of American workers in action, Joseph Stella is a trial, but perhaps he has done something more important than his actual commission for us...."[172]

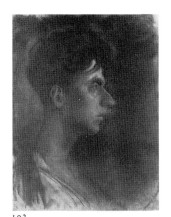

102

In Pittsburgh and Monongah, Stella had focused on the human dimension of industry. He had observed the effects of industrial conditions on the physiognomies of the work force, but he had kept industry itself at a distance. He now turned his dramatic intent to the dark and brooding interiors of steel factories. Here, for the first time, he confronted the awesome and frightening power of machine technology. He saw the collision between man and the machine in religious and mythological terms: "the sudden explosions here and there of the incandescent fires of the ovens seem [like] the insidious lightnings of that perpetual black storm governing those infernal recesses....A new Divinity, more monstrous and cruel than the old one, dominates all around and the phantom like black man of the crane, impossible as Fate...impresses one as the high Priest performing the rites of this new religion...confronted with the presence of the first working man...we loose this sense of religion and terror and we realize the power of Man—all our confidence in him, frustrated and crushed at first,

103

rushed with vehemence into us and we sing...in celebration of Man, the Conqueror, claiming and seizing the Promethean fire...."[173]

Back in Williamsburg, Stella found grim reminders of the sinister reality of industry: "Opposite my studio a huge factory—its black walls scarred with red stigmas of mysterious battles—was towering with the gloom of a prison. At night fires gave to innumerable windows menacing blazing looks of demons—while at other times vivid blue-green lights rang sharply in harmony with the radiant yellow-green alertness of cats enjewelling the obscurity around."[174] Persuaded that such subjects offered a means of portraying the dramatic imperatives of the storms raging in the world and within his psyche, he turned his attention to the industrial American landscape. "My artistic faculties were lashed to exasperation of production," he wrote. "I felt urged by a *force* to mould a compact plasticity, lucid as crystal, that would reflect—with impassibility—the massive density, luridly accentuated by lightning, of the raging storm, in rivalry of POE's granitic, fiery transparency revealing the swirling horrors of the Maelstrom."[175] In May 1919 he exhibited two works that portrayed these themes—an oil entitled *American Landscape (Gas Tank)* (Fig. 111) and a work on glass, now lost, entitled *Pittsburgh*.

104

105

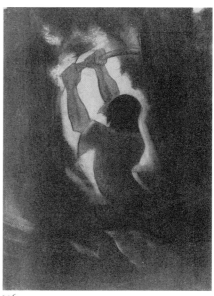

106

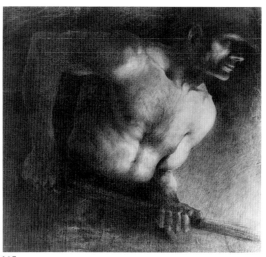

107

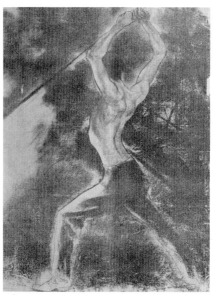

108

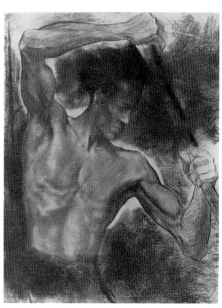

109

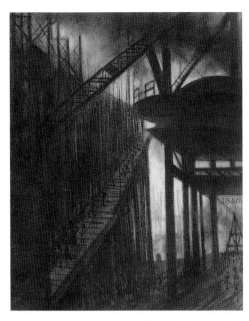

110. *Factory Landscape, Bethlehem,*
c. 1918–19
Charcoal on paper
21 x 16¾ (53.3 x 42.5)
Collection of Mrs. Sergio Stella

In *American Landscape*, Stella utilized the "mysterious depth of night" to convey the contradictory impulses of exuberance and imprisonment engendered by what he would later call the "New Civilization of America."[176] Joining a palette of deep resonant blues, reds, and blacks with the formal devices of fragmentation and force lines common to Futurism, Stella achieved a modernist analogue to the mystical and spiritual grandeur evoked by stained glass.

Fortified by the success of *American Landscape*, Stella turned his attention over the next twelve months to the central icon of American cultural achievement, the Brooklyn Bridge (Fig. 112). He brought to the subject not only an immigrant's desire to celebrate the wealth and awesome grandeur of the New World, but a poet's wish to wrest mythic significance from everyday reality. Armed with a metaphysical temperament nurtured by Whitman and Poe, Stella elevated the bridge into a spiritual symbol at once majestic and monstrous. "Seen for the first time, as a metallic weird Apparition under a metallic sky, out of proportion with the winged lightness of its arch, traced for the conjunction of WORLDS, supported by the massive dark towers dominating the surrounding tumult of the surging skyscrapers with their gothic majesty sealed in the purity of their arches, the cables, like divine messages from above, transmitted to the vibrating coils, cutting and dividing into innumerable musical spaces the nude immensity of the sky, it impressed me as the shrine containing all the efforts of the new civilization of AMERICA—the eloquent meeting of all the forces arising in a superb assertion of their powers, in APOTHEOSIS."[177]

To convey his mystic vision, Stella juxtaposed a palette of resonant blues, reds, and blacks against radiant silver-gray tones. Chromatically, the result alluded not only to light filtering through a stained-glass window but to spiritual illumination emerging from darkness. Stella exploited these religious associations by accentuating the painting's weightless, infinite space and focusing compositional attention at the top center of the canvas in a manner that recalled Baroque portrayals of divine epiphanies. Stella took liberties with the structure of the bridge by adding a third pair of Gothic arches to the two that actually existed and placing each atop the other rather than depicting them in the horizontal plane they would occupy in reality. This configuration, in combination with diagonal lines of white light meeting at a point directly above the highest arch, allowed Stella to emphasize the soaring, heavenly aspect of the upper portion of

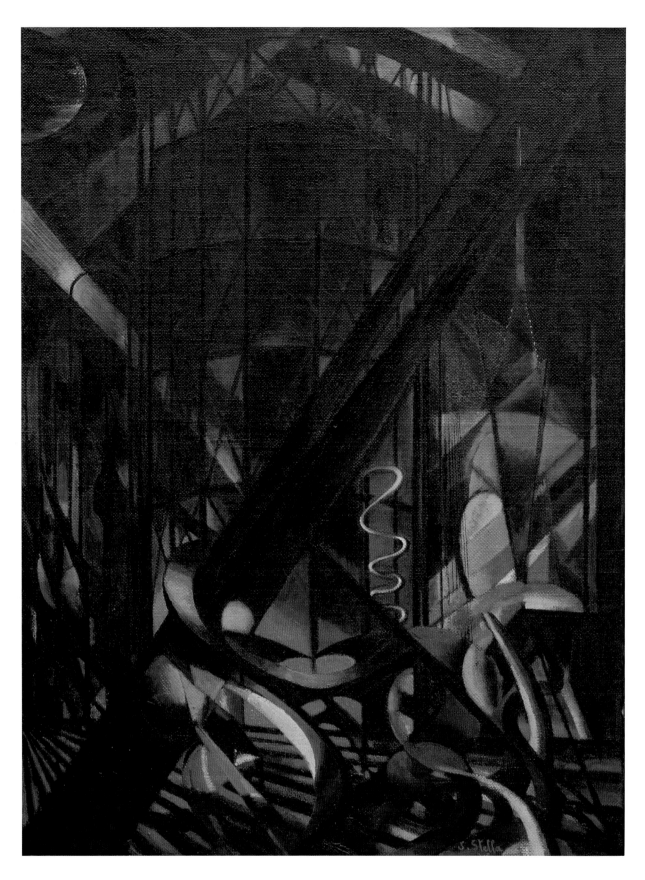

111. *American Landscape (Gas Tank)*
1918
Oil on canvas
40½ x 30 (102.9 x 76.2)
Neuberger Museum of Art, State
University of New York at Purchase;
Gift of Roy R. Neuberger

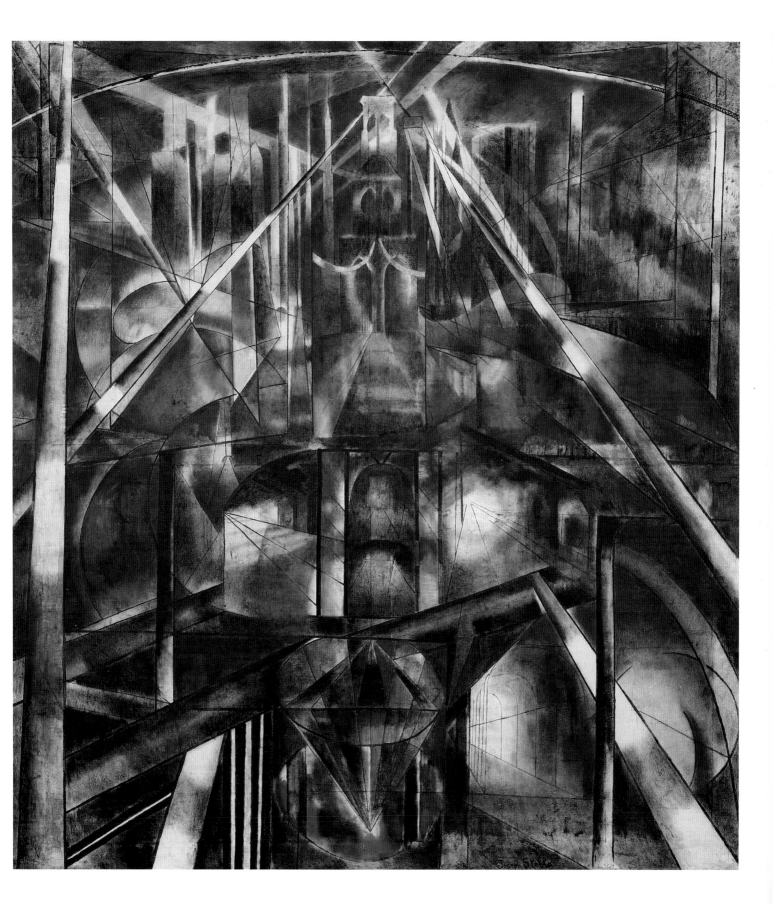

112. *Brooklyn Bridge*, 1919–20
Oil on canvas
84 x 76 (213.4 x 193)
Yale University Art Gallery,
New Haven; Gift of Collection
Société Anonyme

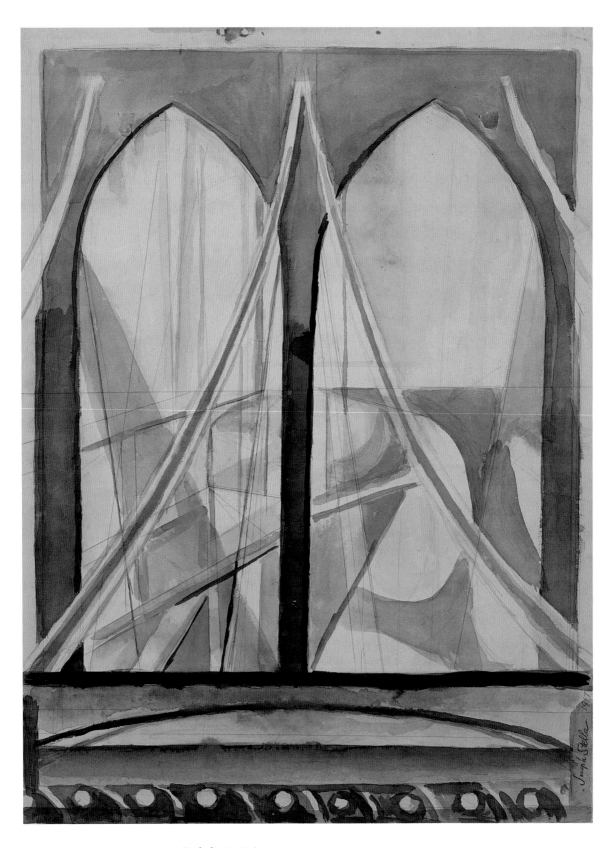

113. Study for *New York*
Interpreted: The Bridge, c. 1919
(later inscribed "1917")
Watercolor and graphite on paper
24 x 18 (61 x 45.7)
Hirshhorn Museum and Sculpture
Garden, Smithsonian Institution,
Washington, D.C.; Gift of the
Federal Bureau of Investigation

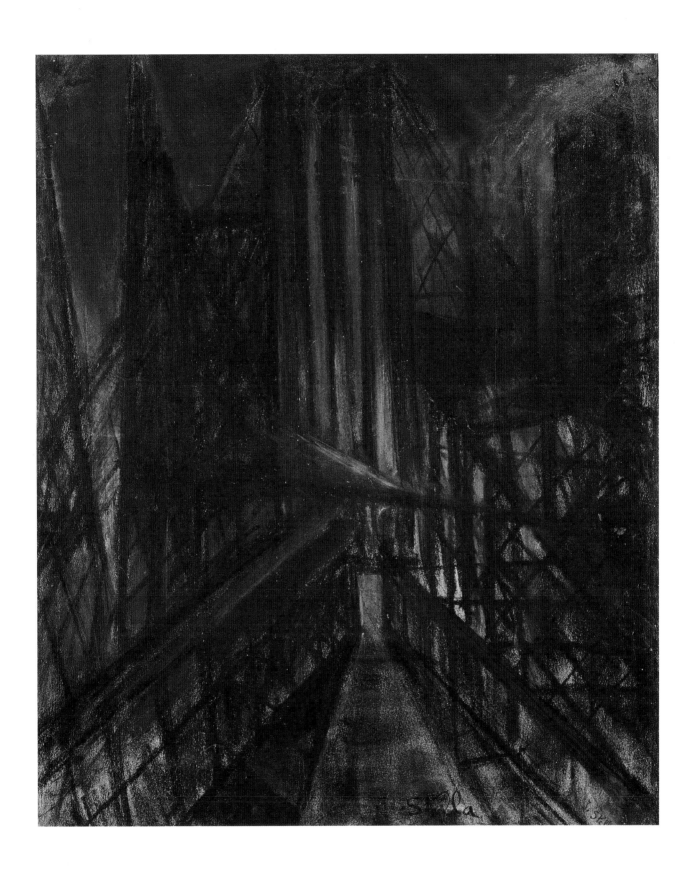

114. Study for *Brooklyn Bridge*,
c. 1919
Pastel on paper
21 x 17½ (53.3 x 44.5)
Whitney Museum of American Art,
New York; Gift of Miss Rose Fried
52.36

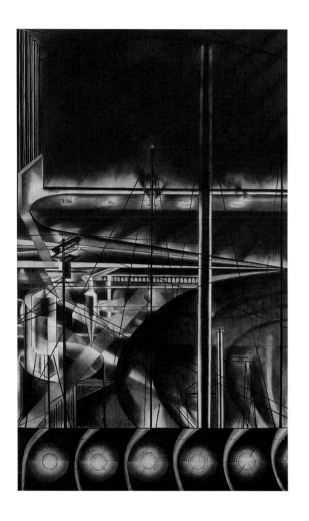

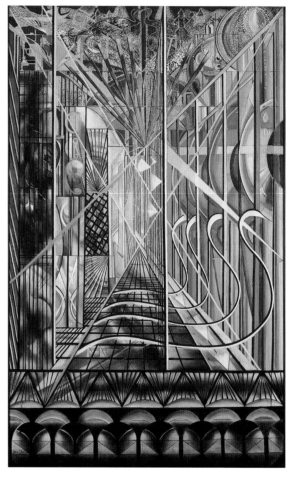

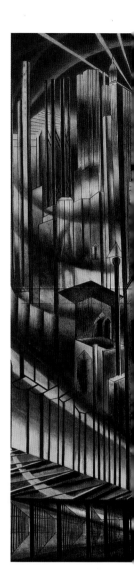

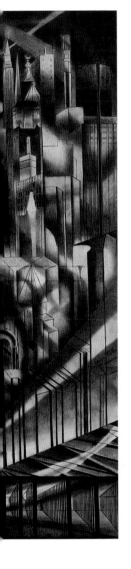
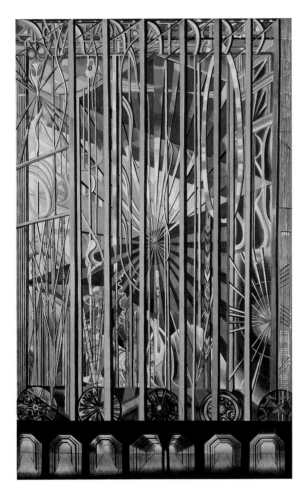
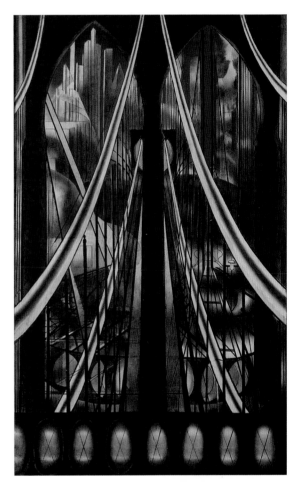

115. *New York Interpreted (The Voice of the City)*, 1920–22
Oil on canvas, 5 panels:

The Port (The Harbor, The Battery), 88½ x 54 (224.8 x 137.2)
The White Way I, 88½ x 54 (224.8 x 137.2)
The Skyscrapers (The Prow), 99¾ x 54 (253.4 x 137.2)
The White Way II (Broadway), 88½ x 54 (224.8 x 137.2)
The Bridge (Brooklyn Bridge), 88½ x 54 (224.8 x 137.2)

The Newark Museum, New Jersey;
Purchase 1937 Felix Fuld Bequest Fund

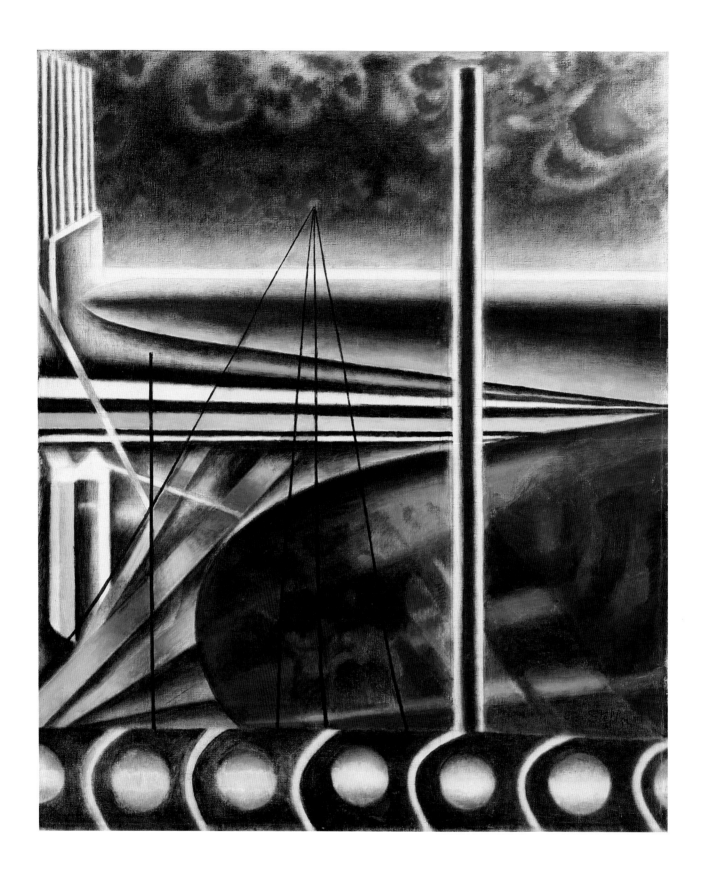

116. *Metropolitan Port*, 1935–37
Oil on canvas
36 x 30⅛ (91.4 x 76.5)
National Museum of American Art,
Smithsonian Institution,
Washington, D.C.; Transfer from
General Services Administration

OPPOSITE PAGE
117. *The Brooklyn Bridge:*
Variation on an Old Theme, 1939
Oil on canvas
70 x 42 (177.8 x 106.7)
Whitney Museum of American Art,
New York; Purchase 42.15

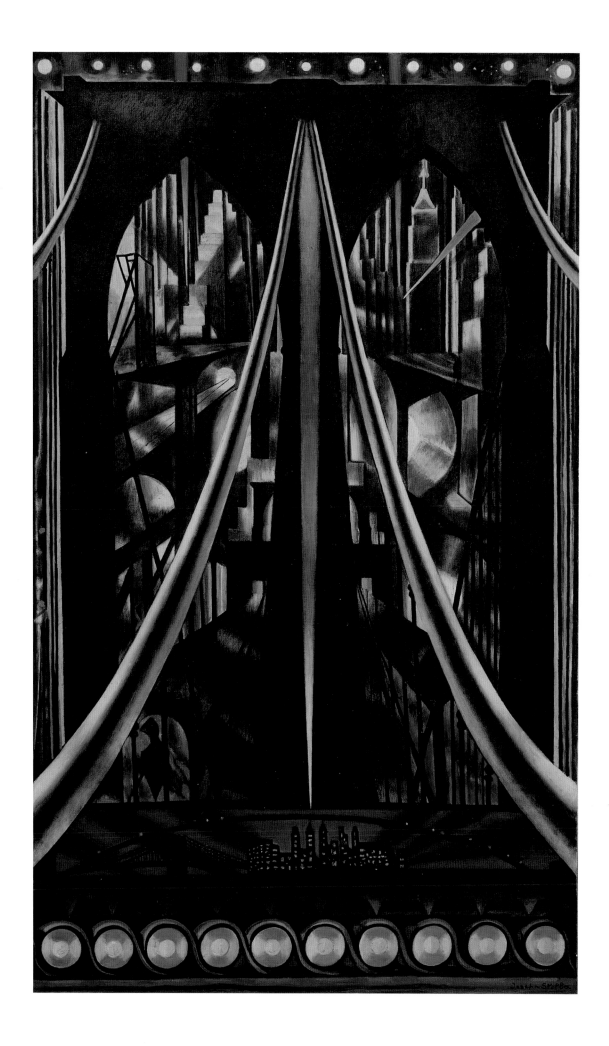

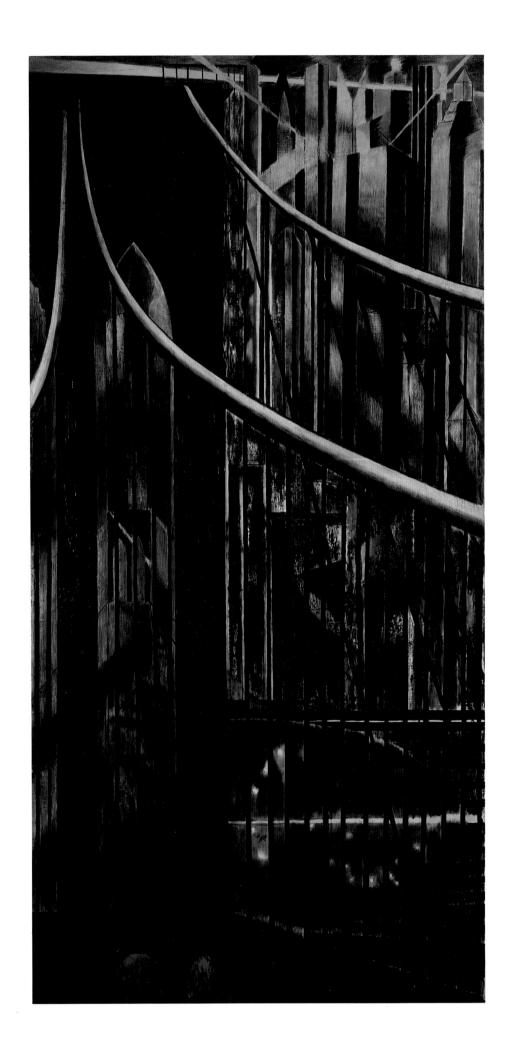

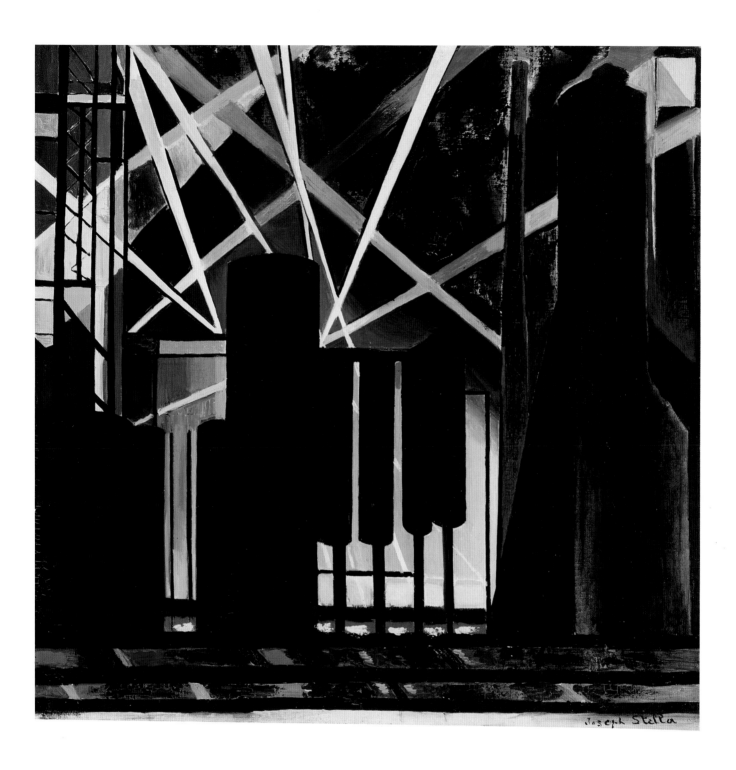

118. *American Landscape*, 1929
Oil on canvas
79⅛ x 39⁵⁄₁₆ (201 x 99.9)
Walker Art Center, Minneapolis;
Gift of the T.B. Walker Foundation

119. *By-Products Plants*, c. 1923–26
Oil on canvas
24 x 24 (61 x 61)
The Art Institute of Chicago; Gift of
Mr. and Mrs. Noah Goldowsky in
memory of Esther Goldowsky

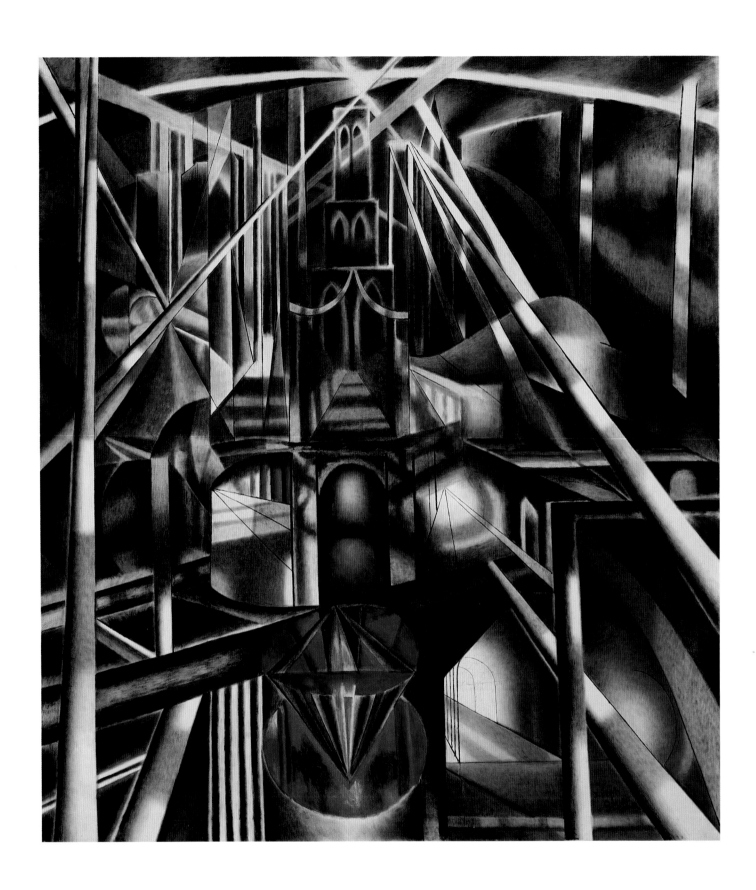

120. *Old Brooklyn Bridge*, c. 1941
Oil on canvas
76 x 68 (193 x 172.7)
Museum of Fine Arts, Boston; gift
of Susan Morse Hilles in memory of
Paul Hellmuth

his painting. Emulating the stratified depictions of heaven and hell in Renaissance and Baroque art, Stella reserved the lower portion of the painting for his description of the underworld. Here, in deep red tones appropriate to the Inferno, he portrayed the subterranean passages and glaring signal lights of the bridge's sunken subway system. This section becomes a metaphor of modern suffering in an urban world. "Many nights I stood on the bridge—and in the middle alone—lost—a defenceless prey to the surrounding swarming darkness—crushed by the mountainous black impenetrability of the skyscrapers...shaken by the underground tumult of the trains in perpetual motion, like the blood in the arteries—at times, ringing as alarm in a tempest, the shrill sulphurous voice of the trolley wires—now and then strange moanings of appeal from tug boats, guessed more than seen, through the infernal recesses below...."[178] Out of this cacophonous and claustrophobic purgatory over which Poe and his bleak vision of urban life presided, Stella constructed a vision of redemption that drew on Whitman's belief in technology as a force for mystic unity. Just as, for Whitman, the Suez Canal, the transatlantic cable, and the railroad provided human communication and thus became metaphors for union with God, so too with Stella, the "telegraphic wires rush to bind distances in a harmonic whole of vibrating love."[179] Guided by such Whitmanesque metaphysics, Stella harnessed the mechanistic forces of modern life to an affirmative vision of the spiritual potential of the new civilization.

The Brooklyn Bridge was a perfect vehicle for such reflections. Ever since its completion in 1883, it had symbolized the "possibilities of the Machine Age" and underscored the emergent belief that the new technology would lead to a perfectibility of the human spirit.[180] Structurally, the bridge offered a visual synthesis of the spiritual and the material, the romantic and the mechanical. Its weblike steel cable system was modern and ethereal; its massive granite piers, with their historicized materials and details that recalled a more spiritual era, were rendered even more ecclesiastically allusive by virtue of their pointed Gothic arches. The stylistic schism between these two antithetical features—the cable system and the piers—gave the bridge a dynamic tension which was not lost on Stella or other observers. Lewis Mumford wrote that the bridge resolved "the old breach between the subjective and the objective, the inner and outer, the vital and the mechanical...in a unified image which restores and re-creates the organic realities that were eliminated in the classic conceptions of mechanics and physics....the perfect symbol of etherealizations released from mechanistic constrictions."[181] Moreover, far from reducing humans into a feeling of insignificance, the Brooklyn Bridge was anthropocentric. Almost

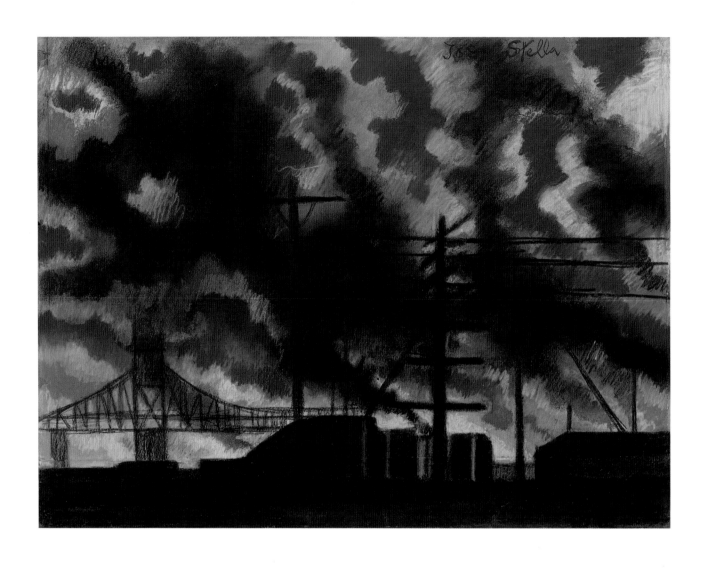

121. *Bethlehem*, c. 1918
Pastel on paper
12 x 16½ (30.5 x 41.9)
The Metropolitan Museum of Art,
New York; Arthur H. Hearn Fund

OPPOSITE PAGE

122. *Factories*, c. 1920–21
Oil on burlap
56 x 46 (142.2 x 116.8)
The Museum of Modern Art, New
York; Lillie P. Bliss Bequest

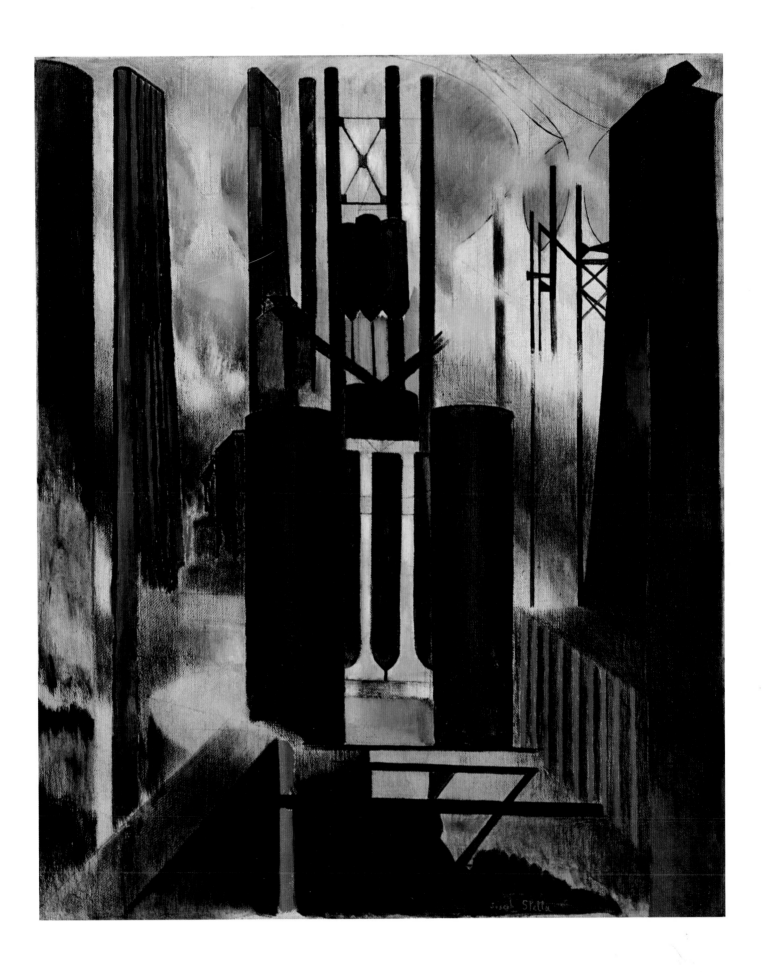

as if in anticipation of the Futurist's admonition "to put the spectator in the center of the picture,"[182] the bridge's unique central walkway effectively placed pedestrians at the center of the structure—a position furthered by the quadripartite cable system, which gave additional linear emphasis to the centrality of the human figure.

The iconic significance of the Brooklyn Bridge as a symbol of modern America had been appreciated early on. In 1903, in *Camera Work*, Sadakichi Hartmann had cited the bridge as giving "as true an expression of our modern civilization as do the temples and statuary of Greece....It is from the bridge, that hammock swung between the pillars of life, that New York seems to become intimate to you. The bridge gives back the thrill and swing to thought and step that nature gives in youth."[183] Like Delaunay's vision of the Eiffel Tower, artists from Joseph Pennell, Childe Hassam, and John Twachtman to Marin, O'Keeffe, and Gleizes had seen in the Brooklyn Bridge a symbol of a new mode of existence (Figs. 124, 126). Yet only Stella employed the bridge as a springboard for the creation of a contemporary myth that reconciled the machine and the human spirit.

Stella's reconciliation of the individual and the machine put him, once again, at the center of the era's most pressing controversies. By 1919, the debates over industrialization and its effect on the human condition dominated the American intellectual community. Arraigned on one side were those who concurred with the Dadaists that the machine was an ally. Such was the message behind the assertion of *Broom* editor Matthew Josephson that "The machine is not 'flattening us out' nor 'crushing us!' The machine is our magnificent slave, our fraternal genius. We are a new and hardier race, friend to the sky-scraper and the subterranean railway as well."[184] To some, Dada was an apt vehicle for countering the numbing effects of technology. Sheldon Cheney, for example, closed his 1922 article "Why Dada?" by arguing that Dada was needed "to destroy our whole mechanized system, which has blindly clamped the acquisitive supply-and-demand principles of business down over the realms of art and spiritual life...."[185] Paul Rosenfeld, Edmund Wilson, Waldo Frank, and Stieglitz disagreed. Wilson typified one view in his warning to the promoters of Dada: "Be careful that the elephants do not crush you! Do not try to make pets of the machines! The buildings are flattening us out; the machines are tearing us to pieces...."[186] Frank's more mystical approach, set forth in his 1919 book *Our America*, voiced the concerns of many Americans who feared that the dehumanizing forces of technology

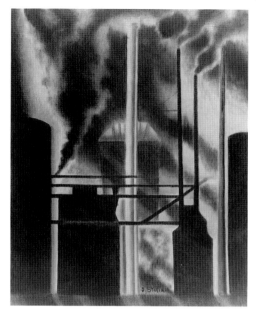

123. *Smoke Stacks*, c. 1920–21
Oil on canvas
41 15/16 x 35 5/16 (104.9 x 89.7)
Turman Art Gallery, Indiana State University, Terre Haute; WPA Federal Art Project Allocation

OPPOSITE PAGE
124. Georgia O'Keeffe
Brooklyn Bridge, 1948
Oil on masonite
47 15/16 x 35 7/8 (121.8 x 91.1)
The Brooklyn Museum, New York; Bequest of Mary Childs Draper

125. *Bridge*, 1936
Oil on canvas
50 1/8 x 30 1/8 (127.3 x 76.5)
San Francisco Museum of Modern Art; WPA Federal Art Project Allocation

126. John Marin
Brooklyn Bridge, 1912
Watercolor on paper
18 1/2 x 15 1/2 (47 x 39.4)
The Metropolitan Museum of Art, New York; Alfred Stieglitz Collection

124

125

would lead to psychic fragmentation and spiritual deprivation. "The imperious structures that loom over us seem to blot us out," Frank asserted. "And if our life is vital, we win our knowledge of it rather in what oppresses us than in ourselves."[187] These disputes dominated the literary magazines *The Seven Arts*, *Secession*, and *Broom*, the last of which once featured Stella's art and writing.[188]

Stella was hardly an advocate of the Dadaist's embrace of technology and the urban metropolis. To him, the city was claustrophobic: "closed in as one is among the buildings, the sky and the countryside blocked off, we are beset from morning to night by the multifarious crowd that weighs down on us, suffocating us like an obsession, like a nightmare."[189] Yet he was equally convinced that it was pointless to turn one's back on the machine. The contemporary artist must use the materials of the present to fashion a universal and timeless art. For him, this meant commandeering images of the machine as metaphors of spiritual transcendence and thereby creating a new mythology appropriate to the age; not to bow to the dehumanizing, impersonal qualities of the machine but to construct a transcendent and rhapsodic mysticism out of the materials of the machine environment.

Stella's inclusion of his 1919–20 *Brooklyn Bridge* in the retrospective exhibition that opened in late March 1920 at the Bourgeois Galleries met with immediate critical approbation. It attracted as much attention as *Battle of Lights, Coney Island, Mardi Gras* had done four years earlier. To Hamilton Easter Field, the painting was "the apotheosis of the bridge. It is not the bridge seen from without, from the East River, but from within, from the central passage way which has been left for us pedestrians....The painting

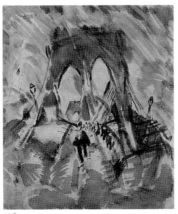

126

to me is more real, more true than a literal transcription of the bridge could be. The impression it has made upon him is not the superficial impression it makes upon the man who crossed it but once. It has the force which only comes to our impressions when the consciousness has been struck many times by the same phenomenon."[190] The painting's success became, in some ways, a troublesome burden. It was heralded as "the most successful piece of American

127. *The Crusher and Mixer Building,*
c. 1918–24
Charcoal on paper
34¼ x 22⅞ (87 x 58.1)
Santa Barbara Museum of Art; Gift
of Wright S. Ludington

modernism that I know of," but it was also cited as an achievement Stella never surpassed.[191] Stella himself fueled the association between his art and the Brooklyn Bridge. He kept returning to the theme throughout his career, each time in an attempt to affirm his connection to America through the image he regarded as epitomizing this country (Figs. 117, 118, 120, 125).[192] The success of these paintings, and Stella's inclusion of various versions of them in his major exhibitions and publications, caused the bridge to be inextricably perceived as his signature image.

Stella's desire to depict "the testimonials" of "American civilization" assumed an even more ambitious form after the close of his Bourgeois Galleries retrospective in April 1920. In a five-panel polyptych he worked on through 1922, Stella created an epic portrait of New York City, variously called *New York Interpreted* or *The Voice of the City* (Fig. 115).[193] Rather than falsify the city by highlighting a single aspect of it, he aimed to capture the full range of its contradictory and multifaceted moods and rhythms. To achieve this synthetic vision, he chose five "acts" or "movements": the skyscrapers, the port, the bridge, and the electric lights of Broadway, the latter in two panels. Each panel had a predella of secondary images—searchlights, theater lights, hallways, subway corridors, and cable casings—forming a continuous frieze along the bottom. Hung together, the ensemble recalled the polyptych altarpieces that had decorated Italian churches since the Middle Ages. These religious associations were reinforced by the colors of the two *White Way* panels, which resembled "the stained glass fulgency of a cathedral," and by the size of the central panel, *The Skyscrapers*, equal in width to the others but about a foot higher, which conformed to the tradition of a larger image in the center of a polyptych —the Madonna, a saint, or a *Crucifixion* scene, for example. Stella further strengthened the suggestion of divine presence by hieratically centering the Flatiron building, exaggerating the linear verticality of the surrounding structures, and topping them with an overarching, silvery halo of lights.

Compositionally, *New York Interpreted* is organized contrapuntally: three panels of nocturnal blues, purples, and blacks punctuating two panels of brilliant yellows, reds, and oranges.[194] Superimposed on this color scheme are the syncopated rhythms of vertical lines and swirling curves— open and relaxed in the two end panels and tight and insistently vertical in the three central ones. The scheme of contrapuntal and syncopated rhythms allowed Stella to abandon the pictorial conceits of Futurism— fragmentation of forms and force lines—without forfeiting the Futurist ambition to express dynamic movement, simultaneity, and the presentation of sounds and abstract moods.

Structured from left to right, like an epic symphony, *New York Interpreted* begins with arrival at the port of Manhattan. From here, the viewer moves to *The White Way I*, Stella's hymn to Broadway's glittering array of lights, colors, and machine-derived pleasures. Using a geometric vocabulary of sunrays, stylized whiplash lines, and zigzag patterns that anticipated Art Deco, this panel and its counterpart, *The White Way II*, captured the exhilaration and density of America's "fairyland" of advertising.[195] Stella's third and central panel pays homage to the skyscrapers of New York, which he called those "brilliant jewel cases of destiny, like flaming meteorites held momentarily motionless in their tracks."[196] Passing through *The White Way II*, Stella culminated his New York odyssey at the Brooklyn Bridge, which "emerges victorious" from "the delirium raging all around"—a triumphant vision of the "new DIVINITY."[197]

Joining together these five symphonic movements into one epic tone poem allowed Stella to portray the dualities of New York; to present the city as both "elusive and concrete" and as "highly spiritual and crudely materialistic alike."[198] By so doing, he captured the contrasts of the age— its claustrophobia and its crudeness; the speed of its mechanisms, and the majestic dignity and grandeur of its engineering achievements and new modes of communication.

The complexities and contradictions in Stella's painting set it apart from other depictions of the American metropolis which began to appear in the early 1920s. Artists such as Charles Sheeler and Louis Lozowick, grouped under the rubric of Precisionism, focused on industrial and urban subjects as a means of highlighting order and stability. For them, industrial mechanization and the planar geometry of the American city provided an "outward sign and symbol" of order, rationality, and organization.[199] The machine was seen as a utopian model for efficient and forward-looking social engineering, a replacement of the transcendental spiritualism of past eras. Although Precisionism latently betrayed some measure of anxiety about the threats to humanism posed by the machine, in general, Precisionist artists accepted industry and the machine as so prevalent within society as to be, in Sheeler's words, "our substitute for religious expression."[200] The single precedent in the visual arts for Stella's synthetic ode to New York was *Manhatta*, the film collaboration of Sheeler and Paul Strand that premiered in 1920. As if anticipating Stella's painting, the film opens with a ferry boat arriving in the port and closes with the sun setting on the Hudson River; in between are views of the Brooklyn Bridge, the harbor, railroad yards, skyscrapers, and buildings under construction. Punctuating these shots were quotes from Whitman's poems "A Broadway

Pageant," "Crossing Brooklyn Ferry," and "Manahatta." The film achieved an epic drama that was at once mesmerizingly contemporary and rhapsodically romantic. These were precisely the dualities that Stella consolidated in his composite panorama of the city.

Yet *New York Interpreted* possessed a literary quality absent even from *Manhatta*. Not surprisingly, it was a poet—Hart Crane—who was Stella's peer in fashioning an affirmative mythology out of the realities of the technological world.[201] Like Stella, Crane wanted to resuscitate contemporary, but decayed, culture by aligning it with the great mythologies of the past. He took the entrenchment of machinery in contemporary life as a challenging responsibility for the poet. The machine was not to be ignored but absorbed into poetry, where its destructive forces would be countered through the creation of an alternative myth.[202] Like Stella, Crane was encouraged in these pursuits by an evangelical temperament and by the debates over machine culture within the literary community.[203] Guided by Whitman and contemporary mystical thinkers like Waldo Frank, Crane infused technological culture with transcendent ecstasy. By unifying legends about American history—Columbus, Pocahontas, Cortés, Rip Van Winkle—with contemporary reality—railroads, subways, warplanes, office buildings—he aimed to construct "a mystical synthesis of 'America'" which would achieve "a mythic transfiguration of current values."[204] The bridge for him was an emblem of unification—a passage between the ideal and the transitory sensations of history.

Both Crane and Stella used the Brooklyn Bridge as a motif for the construction of a contemporary transcendent myth—Stella in his Brooklyn Bridge paintings and Crane in his 1928 poem, "The Bridge." Because Crane did not begin working on his poem until the winter of 1923, after Stella had completed and exhibited both his 1919–20 *Brooklyn Bridge* painting and *New York Interpreted*, scholars have argued that Stella's work influenced Crane's.[205] Indeed, although Crane lived in Cleveland through the spring of 1923 and would not have had occasion to see either of the paintings in person, it is probable that he saw the 1919–20 version reproduced in the autumn 1922 issue of *The Little Review*, which also included his letter to the magazine's editor, Jane Heap. Since Crane avidly followed the events of the New York intellectual world from Cleveland, it is equally as likely that he saw the reproductions of the *Brooklyn Bridge* and *Skyscrapers* panels of *New York Interpreted* in the February 1923 issue of *The Arts*. According to Crane, he first saw the paintings in late 1928 when Charmion von Wiegand showed him a copy of Stella's privately printed monograph *New York*, containing Stella's essay on the Brooklyn Bridge and reproductions of

128

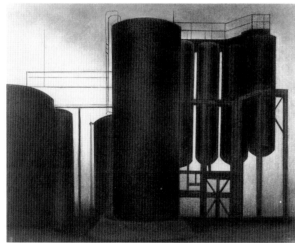

129

130

New York Interpreted. Shortly thereafter, Crane wrote to Stella from Paris asking permission to reproduce the essay and three of the paintings—*The Bridge, The Port,* and *The Skyscrapers*—in the magazine *Transition* as well as to use *The Bridge* section of the polyptych as the frontispiece to the published version of his poem, which was to be released by Black Sparrow Press.[206] "It is a remarkable coincidence," Crane wrote, "that I should, years later, have discovered that another person, by whom I mean you, should have had the same sentiments regarding *Brooklyn Bridge* which inspired the main theme and pattern of my poem."[207]

What is ultimately more important than the question of influence, however, is that the two artists responded in similar ways to the same compelling issues. Indeed Crane, before beginning "The Bridge," had already tentatively probed the relationship between technology and the human spirit in his poem "For the Marriage of Faustus and Helen." Both he and Stella sought to animate and spiritualize the industrial scene by countering the pessimist vision of Poe with the exultant optimism of Whitman. Tragically, both artists found their visionary affirmations difficult to sustain. By 1929, Stella would claim that, of the two poets, "Poe has more truth. I see Poe everywhere [in America]....In America you feel the frightful loneliness, the black melancholy the moment you arrive. Poe could only be American."[208] Crane's defection would be more severe; in 1932, he committed suicide by jumping off the side of a boat.

New York Interpreted was initially not the immediate success that *Brooklyn Bridge* had been. In depicting the city's frenzy and modernity, Stella had identified aspects of the urban experience that not all observers wished to acknowledge. It was precisely such features that Waldo Frank lamented: "American is a joyless land. And nowhere is this so crying-clear as in the places of New York—Broadway, the 'movies,' Coney Island—where Joy is sought."[209] Disappointment in the painting seemed greater given the high expectations the art world had for it. McBride began his review by remarking that "so far, more people have asked me what I thought of Joseph Stella's new work at the Société Anonyme than have

inquired into any other event of the season." But even he wondered if the pictures "were what we were all waiting for?" He acknowledged that "there is an enormous amount of aspiration, an enormous amount of intellectual energy in them and generalship in execution—but also a lot that offends."[210]

Undeterred by the mediocre critical response, Stella continued to direct his attention to the American industrial landscape through 1924. Typically, he set close-cropped images of steel mills and blast furnaces within a shallow pictorial space so that they loomed as hieratic, commanding presences (Figs. 122, 123). He reinforced the oppressive weightiness of these factory structures by scumbling his pigment with a dry brush and limiting his palette to dark tones with occasional highlights of bright color. This chromatic strategy was even more powerful in the group of charcoal drawings of Pennsylvania's coal by-products plants that Stella used in 1924 for his final commission for *The Survey* (Figs. 127–131). The drawings accompanied the magazine's issue on "Giant Power," an intensive investigation into the social, political, and practical issues surrounding coal and hydroelectric power.[211] Assembled between March 1923 and March 1924, the issue included interviews with Henry Ford and Herbert Hoover, photographs by Lewis Hine, and articles by the governors of Pennsylvania and New York. Stella's drawings, presented as an independent section within the magazine, silhouetted the monumental forms of grain elevators, storage tanks, and coal piles against dark night skies. Exploiting the soft textures and rich tonalities of charcoal, he transformed these inanimate structures into dramatic, monumental entities. They appeared, as one reviewer noted, "like a mountain to the earth...and with the...very same caresses upon [them] that had previously been reserved exclusively for mountains...."[212] Stella converted these quotidian shapes of industry into symbols of the beneficent transformation of the world through science and industry. To one observer, the drawings engendered "great confidence.... The times are susceptible to poetry in spite of the croakings of the pessimists....engineers...[are now] vindicated by a genuine artist."[213] These drawings joined *Brooklyn Bridge*, *Battle of Lights*, and *New York Interpreted* on the list of what Stella considered his most well-respected works.[214]

Already by 1919, however, competing themes had begun to command Stella's attention. Immediately after finishing *Brooklyn Bridge*, he had started *Tree of My Life* (Fig. 133), a large painting that looked back to what he remembered as the Elysian landscape and experiences of his youth in Italy. That even Stella recognized these childhood memories to have been

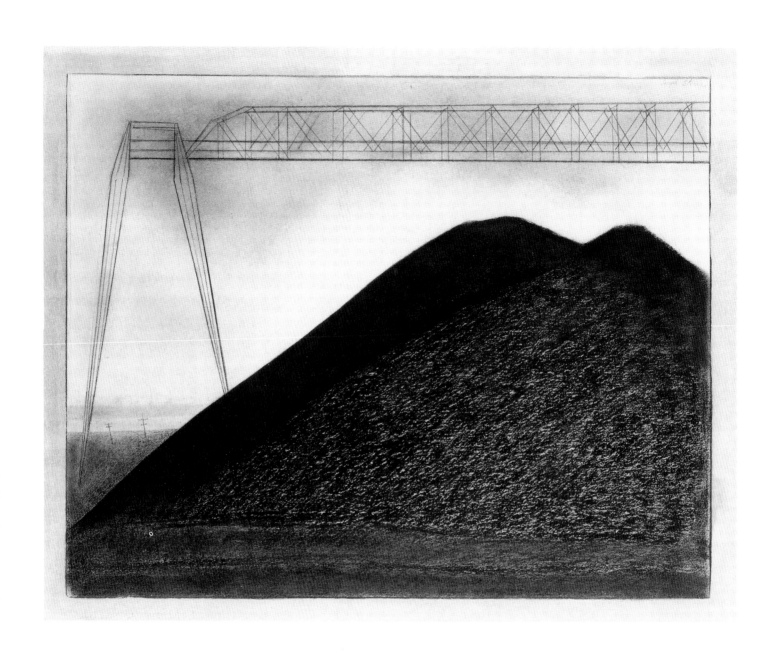

131. *Bituminous Coal Storage Piles,*
c. 1918–24
Charcoal on paper
20 x 26 (50.8 x 66)
The Metropolitan Museum of Art,
New York; The Elisha Whittelsey
Collection, The Elisha Whittelsey
Fund

transformed and ennobled by nostalgia did not diminish the rapturous ecstasy with which he portrayed them. Out of his recollections of the joy and comfort of his homeland, Stella fashioned an earthly paradise of sunshine, youth, and abundance. He was seeking to reclaim some of the innocence and peace that eluded him in New York—to elicit from the world of nature a more serene and uncomplicated joy than seemed possible with industrial subjects. "Unexpectedly," he wrote, "from the sudden unfolding of the blue distances of my youth in Italy, a great clarity announced PEACE—proclaimed the luminous dawn of A NEW ERA."[215]

To effect this vision of innocence and joy, Stella turned to flowers, plants, and birds—subjects which had long enjoyed a significant place in art as carriers of symbolic meaning. For Stella, their symbolic connotations reached further back than fin-de-siècle Symbolism; Baudelairian associations with evil motivated him less than did the symbolic purposes to which flowers had been put by fifteenth-century Italian and Flemish painters. Yet even here, he was less impressed by the artists' iconographic references than by their use of opaque or disguised symbolism in general, which bestowed an aura of revelation on objects of the real world even if the symbolic allusions were not always understood. Just as disguised symbolism had earlier allowed artists to transfer supernatural events from symbolic settings to the everyday world, so did it permit Stella to depict every detail of his floral and bird subjects with maximum concreteness while simultaneously implicating them symbolically. He preferred the vague aura of association, the "perfumed rhythm" of meaning, as he called it, over concrete iconography.[216] Only on rare occasions did he evoke a specific symbol—as when he wrote of the rose as an omen of happy events.[217] What he desired was the sense of revelation, not the revelation itself. Yet some images, like the lily, appear so often in Stella's repertoire that it is tempting to speculate that he was aware of the flower's symbolic association with purity and perfection.

If Stella did not intend specific symbolic references, he certainly intended the general association of flowers with "spiritual life" or joyous innocence. To him, the "light, gay painting of a flower" was a "good omen," an insurance "that all our days may glide by serene, sunny...."[218] Such connections came to Stella naturally, by way of Italian Catholicism. Whether for St. Francis of Assisi or Muro Lucano's San Gerardo Maiella (Fig. 182), or a host of others, flowers served in Catholicism as symbolic reinforcements of the sublimity of God and the devotion of the faithful. Stella recalled, "In Assisi—I remember—the festive colors of flowers, freshly cut and constantly renewed, cordon every spot in which a miracle by Saint Francis and Saint Clare took place."[219]

Stella created out of the plant kingdom an anthropomorphic equivalent, replete with the vulnerability and conflicts of life. Large-bodied and awkward himself, he identified with tree trunks. His description of the "robust" trunk in *Tree of My Life* as having been "already twisted by the first fierce struggles in the snares that Evil Spirits set on our path" conveys an autobiographical message.[220] Yet Stella's will for transcendence triumphed in *Tree of My Life,* and mystic elation prevailed over disquieting anxiety.

Tree of My Life, like *Brooklyn Bridge*, was baroque and operatic. But whereas *Brooklyn Bridge* resonated with the dark, gestural harmonies and Manichaean themes of Wagner, *Tree of My Life* radiated the delicate, filigreed lyricism of late Verdi. Stella's work had always been essentially linear. But the opulent, linear intricacy with which he composed the "resounding chords," "deep adagios," and "sumptuous floral orchestration"[221] of *Tree of My Life* was new—a portent of the detailed, decorative mannerisms that would soon become a central feature of his work.

As before, it was to fourteenth- and fifteenth-century Italian and

132. Hubert and Jan Van Eyck
The Adoration of the Mystic Lamb
(detail), from the
Ghent Altarpiece, 1432
St. Bavo, Ghent

Flemish painters that Stella looked for inspiration. In the delicate floral patterns that embellished the work of these artists, he found a model for decorative complexity and microscopic precision. Compositionally, *Tree of My Life* drew from this tradition as well. For as Stella sought to endow his natural paradise of birds and flowers with an overlay of otherworldly revelation, he again called upon images of the Holy Spirit. With its large blue orb atop a dominant, central vertical axis, *Tree of My Life* in particular recalled *The Adoration of the Mystic Lamb* from the Ghent Altarpiece (Fig. 132). The mixture of pagan pantheism and Franciscan veneration of flowers and birds that permeated *Tree of My Life* reverberated even more strikingly in later Stella works. Less minutely detailed and imagistically packed, paintings such as *Apotheosis of the Rose, Flowers, Italy*, and *Dance of Spring,* with their Gothic arches and exaggerated verticality, emulate the architecture of religious devotion (Figs. 166, 203, 213). Gone from these works are references to landscape; instead, within a shallow space, long-necked birds and flowers stand as if in a chapel or on an altar. These paintings radiate the joy and innocence that Stella identified with "the holy marvels sung by Lippi and the Divine Fra Angelico."[222] Yet their effect is more pagan than Christian. It is less God's immanence in nature that is celebrated than nature itself, which is treated as both an object and agent of worship. This quality of pagan pantheism was even more apparent in *The Heron*, of which Stella executed two

133. *Tree of My Life*, 1919–20
Oil on canvas
83½ x 75½ (212.1 x 191.8)
Mr. and Mrs. Barney A. Ebsworth
Foundation and Windsor, Inc.,
St. Louis

134. *Peaches*, c. 1919
Silverpoint and crayon on paper
10 x 13 (25.4 x 33)
Collection of Remak Ramsay

135. *Berries*, 1919
Silverpoint and crayon on paper
11 x 9 (27.9 x 22.9)
Richard York Gallery, New York

136. *Sparrow and Lilies*, c. 1920
Crayon, graphite, silverpoint, and
gouache on paper
28½ x 22½ (72.4 x 57.2)
The Cleveland Museum of Art;
The Delia E. Holden Fund

137. *Lilies and Blue Hydrangea,* 1919
Silverpoint and crayon on paper
28 x 21½ (71.1 x 54.6)
Collection of Aaron I. Fleischman

138. *Lupine*, 1919
Silverpoint and crayon on
prepared paper
27½ x 21½ (69.9 x 54.6)
Private collection

139. *Gladiolus and Lilies,*
c. 1919–20
Silverpoint and crayon on paper
28½ x 22⅜ (72.4 x 56.8)
Mr. and Mrs. Barney A. Ebsworth
Foundation and Windsor, Inc.,
St. Louis

140. *Hyacinth and Sparrow,*
c. 1922–25
Silverpoint and colored
pencil on paper
27 x 10¼ (68.6 x 26)
Southwestern Bell Corporation,
San Antonio, Texas

141. *Slender Green Stalk*, 1919
Silverpoint and crayon on paper
21 x 7 (53.3 x 17.8)
The Huntington Library, Art
Collection and Botanical Gardens,
San Marino, California

142. *Lily and Green Squash,*
c. 1920—22
Silverpoint and crayon on paper
21¼ x 28 (54 x 71.1)
Private collection

versions (Fig. 185).[223] Using monumental, crisply delineated forms and flat color areas set against an unmodulated background, he created a fantasy world populated by birds and flowers engaged in an obscure, mystic ritual.

By taking liberties with the scale and juxtaposition of the picture's constituent elements, he endowed the ensemble with spiritualistic pre-Christian overtones.

In 1919, in connection with *Tree of My Life*, Stella began the silverpoint and wax-crayon sketches of flowers, vegetables, and occasionally butterflies and birds that would occupy him for the remainder of his life (Figs. 134–143). As if aware of the vulnerability of flowers, he protected them from life's "snares" and "Evil Spirits" by floating deracinated images on sheets of paper. The resulting delicacy and spareness of these silhouetted, floating specimens is Oriental in feeling. At the same time, the almost scientific accuracy and illusionistic veracity with which Stella rendered his subjects recalls eighteenth-century botanical illustrations. Like these prototypes, Stella played with anti-scientific juxtapositions and arrangements to create whimsical and anthropomorphic fantasies rather than focus on organic relationships and natural settings. Whether of a Siva-like lupine or a lily blossoming atop a zucchini plant, Stella's botanical drawings accorded with the pre-Darwinian view of nature as a composite of perfect but separate truths.[224] Like the Franciscan reverence for the simple and humble parts of nature, these depictions suggest that the separate parts of nature reveal God's presence as much as do their interactions. It was this that distinguished his botanical drawings from Audubon's complex and realistic arrangements of plant and bird specimens.

Stella's choice of the silverpoint medium established further links with the Old Master artists who had mastered the difficult technique centuries earlier. "In order to avoid careless facility," Stella said about his experience with the medium, "I dig my roots obstinately, stubbornly in the crude untaught line buried in the living flesh of the primitives, a line whose purity pours out and flows so surely in the transparency of its sunny clarity. Rivaling the diamondlike block fashioned by the free, generous hand of the sovereign art of Tuscany, prodigious pollinator of life, I dedicate my ardent wish to draw with all the precision possible, using the inflexible media of silverpoint and goldpoint that reveal instantly the clearest graphic eloquence."[225]

Silverpoint allowed Stella to attain lines of incredible thinness and purity that shimmered as they caught and reflected light.[226] Unlike charcoal

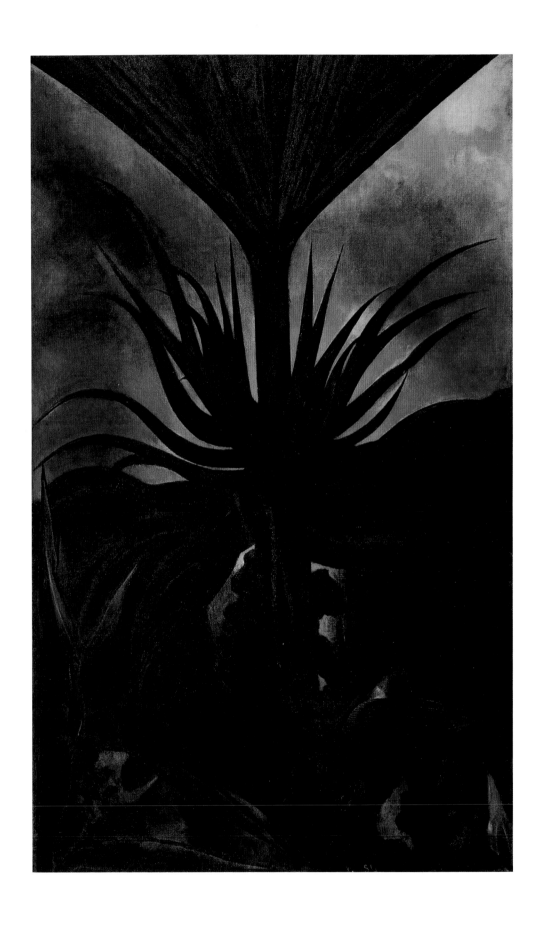

144. *Tropical Sonata*, 1922
Oil on canvas
48 x 29 (121.9 x 73.7)
Whitney Museum of American Art,
New York; Purchase 63.63

145. *Portrait of Marcel Duchamp,*
c. 1923–24
Silverpoint and oil on paper
27½ x 21 (69.9 x 53.3)
Private collection

or chalk, which encouraged a painterly style, silverpoint was essentially linear. Its fine, pale, gray line produced little if any variation in thickness or value; increased pressure yielded a darker but not a broader line. Tonal changes or three-dimensional modeling required parallel strokes or cross- and contour hatching. Silverpoint lines, which Stella produced with a silver

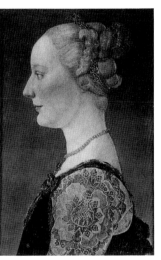

146. Leonardo da Vinci
Bust of a Warrior, c. 1475
Silverpoint on paper
11¼ x 8³⁄₁₆ (28.5 x 20.8)
British Museum, London

147. Attributed to Antonio
Pollaiuolo
Portrait of a Lady
Tempera on wood
21⅝ x 13⅜ (55 x 34)
Galleria degli Uffizi, Florence

wire inserted into the case of a pencil, tarnish over time. The color assumes a soft luminosity as the silver changes from a pale gray to a warm, mellow brown. By 1920, when Stella began his drawings, silverpoint had largely disappeared as a technique—a disappearance due, in part, to what Stella characterized as the "unbending inexorable silverpoint."[227] Silverpoint was indelible; impossible to erase or cover up, it accommodated neither accident nor fudging. In addition, it demanded more preparation than did graphite drawing, for the ground had to be slightly abrasive or textured to capture the particles of metal impressed on the paper. Considering commercially prepared papers unsatisfactory, Stella made his own by thinning zinc white gouache to a consistency of light cream and applying it unevenly onto paper with a swipe of his brush, as had been done in the Renaissance. To achieve greater tonal contrasts, he often added a successive coat around the image. This splotchy white background animated the composition and created the illusion that the image floated on the surface of the sheet. Stella also combined silverpoint with colored wax pencils, which have a similar slight sheen. When applied over colored pencils, the silverpoint took on a richer and deeper tonality; when color was applied over silver, it obscured the stroke and softened the contrast.

In addition to botanical studies, Stella employed the silverpoint technique in the series of portrait studies of friends that he executed between 1920 and 1924 (Figs. 145, 148, 149). His exquisitely detailed renderings of facial features and reliance on profile poses recall the portrait style practiced by Renaissance artists whose work he knew and owned in reproduction—Domenico Veneziano, Piero della Francesca, Antonio and Piero Pollaiuolo, and Leonardo (Figs. 146, 147). At the same time, the icy classicism of his portraits bespoke his emulation of the impersonal, linear style favored by Duchamp and other members of the Arensberg circle.

148. *Portrait of Marcel Duchamp,*
C. 1921
Silverpoint on paper
27¼ x 21 (69.2 x 53.5)
The Museum of Modern Art, New
York; The Katherine S. Dreier
Bequest

149. *Portrait of Edgard Varèse,*
C. 1922
Silverpoint on paper
20¼ x 14⅝ (51.4 x 37.1)
The Baltimore Museum of Art;
Purchase Fund

150. *Portrait of Kathleen Millay,*
c. 1923–24
Crayon and graphite on paper
27⅜ x 22⅜ (69.5 x 56.8)
The Lowe Art Museum, The
University of Miami, Coral Gables;
Bequest of Ann Eckert Keenen

Stella's portrait drawings were the only time he revealed in his art even the most rudimentary aspects of his personal life, in this case his circle of friends. His adamant aversion to aesthetic self-revelation accorded with the secrecy with which he maintained his personal biography. Convinced that the "artist must remain a mystery," he purposefully obfuscated the events of his life through exaggeration, falsification, and by withholding information.[228] Some of the misrepresentations were self-delusive—as when he claimed intimacy with the Futurists or reported that Matisse identified him as the best artist in America.[229] Yet other information was withheld or distorted for no apparent reason other than to camouflage. Basic details about his birth date, the dating of his paintings, and whether or not he was married and, if so, for how long and to whom, were subjects about which he gave, at best, conflicting information.[230]

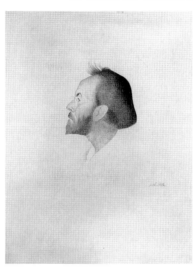

151. *Louis Eilshemius*, c. 1920
Graphite on paper
28⅜ x 21⅝ (72.1 x 54.9)
Whitney Museum of American Art,
New York; Gift of Gertrude
Vanderbilt Whitney 31.581

Stella's reverence for the seemingly insignificant parts of life, which had its roots in Franciscan Christianity, manifested itself in the collages that he created from the late teens until his death (Figs. 154–163).[231] Made out of dirty, torn, wrinkled, and stained bits of paper and leaves, they were the urban, industrial equivalent of the simple and humble parts of nature that the Franciscans embraced. Encouraged by the linguistic games that prevailed within the Arensberg circle, Stella clarified the analogy between technologically derived collages and nature through language. Calling them "macchine naturale," he linguistically corrolated their identity with "natural constructions" of the machine age.[232] Like leaves from a tree, scraps of paper fall to the ground and are subjected to decay and decomposition. Just as he had done with industrial subjects, Stella converted these castoffs of urban life into objects of union and affirmation through the transformative power of art. As before, he was guided in this endeavor by Whitman, for whom every aspect of life was fuel in the quest to restore mankind's wholeness. By redeeming and transforming the lowly and discarded parts of urban life through art, Stella proposed another means of reconciling the needs of the spirit and the industrial character of the age.

Stella's decision to incorporate the materials of the real world into art was not without precedent. Following Picasso and Braque, the inclusion of quotidian materials had became an accepted art-making strategy for modernist artists from the Futurists to the Dadaists and Constructivists. Stella seems initially to have followed Cubist models rather than the

readymade, the more radical form of appropriation that was countenanced within the Arensberg circle. The stylistic similarity between Stella's first collage of 1918, *Man Reading a Newspaper* (Fig. 89), and Cubist and Futurist *papiers collés* speaks for an initial emulation of these vanguard master-

works (Fig. 152). As he became more immersed in the intellectual pursuits of the Arensberg coterie, however, he put his collage technique in the service of more conceptual play. *Study for Skyscrapers*, one of the two collages that was reproduced in *The Little Review* in 1922, was an "abstract" equivalent of a skyscraper. Assembled from four ragged scraps of paper, its use of a paid receipt—marked PAID in perforated letters—as the cornerstone of the building whimsically alluded to the relationship between art and commerce that was a common theme among Stella's Arensberg cohorts. *The Bookman*, the companion reproduction to *Study for Skyscrapers*, was an abstract portrait of a writer for the *New York Tribune* whose weekly column was called "Book-man's Daybook."[233] The representational content of these two collages distinguished them from the others Stella created and suggests that they were among his first experiments with the technique.

Stella's subsequent, more abstract, collages remained untitled during his lifetime—a silence that underscored their essentially abstract nature.[234] Although Stella often included theater tickets, tobacco wrappers, leaves, fragments of magazine and newspaper articles, envelopes, and reproductions of his earlier work, all these pieces remained thematically isolated. Like words liberated from a sentence, they were independent concepts with no intellectual cohesion to a larger context. Most often Stella seemed content to explore abstract properties of color, texture, and shape. This was as true of recognizable images as of the irregular pieces of soiled paper that he tore and rubbed with pigment or tempera. Typically, he silhouetted a limited number of these elements on a sheet of paper or silver foil, which was itself often silhouetted on paper or foil. The formal simplicity of his collages echoed the sparse elegance and decorative sensitivity of his botanical drawings. Likewise, his exploitation of mottled textures and irregular shapes recalled the meticulous depictions of bark and tree trunks that he executed throughout his career.

The emphasis in these collages on texture and formal simplicity

154. *Macchina Naturale #18 (American Number)*, after November 1938
Newspaper and photo
mounted on paper
12 3/8 x 9 1/8 (31.4 x 23.2)
Private collection

155. *Mecca I*, 1940
Collage with paper, tinfoil, and
tempera on paper
13⅛ x 14¹⁵⁄₁₆ (33.3 x 37.9)
National Museum of American Art,
Smithsonian Institution, Washington,
D.C.; Museum Purchase

156. *Adriatic Figs*, after 1937
Collage on paper
14 x 15¹⁵⁄₁₆ (35.6 x 40.5)
Whitney Museum of American Art,
New York; Gift of Mr. and
Mrs. Benjamin Weiss 79.66.61

157. *Untitled (Mantegna as a Mystic)*, n.d.
Collage on paper
10⅝ x 13⅜ (27 x 34)
Collection of David Nisinson

158. *Macchina Naturale #4, (Skyscrapers)*, after November 1923
Collage on paper
11⅝ x 9⅛ (29.5 x 23.2)
Private collection

159. *Macchina Naturale #9*, after
August 1936
Collage on paper
11¾ x 13 (29.8 x 33)
Private collection

160. *Macchina Naturale #30*, after
summer 1928
Collage on paper
15¼ x 11 (38.7 x 27.9)
Private collection

distinguished them from those of Stella's contemporaries. Because of their shared repertoire of materials—cut and torn paper, printed labels, tickets, envelopes, stamps—they seem closest in mood to the Merz collages of Kurt Schwitters (Figs. 153). Stella would have seen Schwitters' work in the exhibition at the Société Anonyme in November–December 1920 in which both artists participated. But Stella's efforts are so antithetical to Schwitters' dense, overall designs and painted transitions between elements as to question the German artist's influence.

Given the acceptance of collage within the modernist arenas in which Stella circulated, it is surprising that he never exhibited his efforts during his lifetime and reproduced them only once—in the Autumn 1922 issue of *The Little Review*. They remained private and intimate. Like a string quartet, they offered Stella a respite from his more dramatic, symphonic works, and he continued to execute them throughout his life. Indeed, collaged fragments of newspaper articles dated 1938 confirm a post-1938 date for several collages (Figs. 154, 161, 163), two others include pages from the publication *France-Illustration*, which did not appear under that title until August 1944.[235]

161. *Macchina Naturale #28 (Griebl Flees Country)*, after May 1938
Collage on paper
14 x 11 (35.6 x 27.9)
Private collection

162. *Macchina Naturale #25 (Transition)*, after summer 1928
Collage on paper
10⅛ x 7½ (25.7 x 19.1)
Private collection

In the spring of 1922, following the completion of *New York Interpreted*, Stella returned to southern Italy for eight months—his first visit home in ten years. According to his retrospective account, he spent his time in Naples, Capri, Pompeii, Herculaneum, and Paestum in "a state of grace, painting from morning to night."[236] From these experiences evolved a series of figurative paintings of literary and mythological heroines. Executed in crisply delineated areas of flat, bold color, works such as *The Birth of Venus, Undine, Leda and the Swan, Lady with Veil, Sirenella*, and *Ophelia* reveled in a decorative opulence that looked back to the Middle Ages (Figs. 164, 165, 168, 169, 171). The influence was not Oriental, as some scholars have claimed, but Italian—a heritage rich in decorative splendor and ornamental embellishments which Stella came by naturally (Fig. 170).[237] Neither the connection with Italy nor that with the Middle Ages was lost on critics. McBride's comment that "had these panels come to us from the Middle ages...they would not astonish so much" was amplified by the critic of *The New York Times*: "To think of Italy as in the

days of the Renaissance or the transition between Middle Ages and Renaissance, with her love of pageantry and beauty, her glorious jewels and fabrics,...her women with childlike foreheads, all the swarming, brilliant vivacious life of an art-loving, beauty-worshipping people, to think of this Italy sleeping quietly for centuries in the minds of successive men and floating freshly...is to get the impression of the recent art of Joseph Stella...."[238]

163. *Macchina Naturale #13 (Reich Hits Back)*, after November 1938
Collage on paper
12¾ x 7½ (32.4 x 19.1)
Private collection

Although Stella's unusual union of classical figuration, occult symbolism, and stylized decoration was at odds with American mainstream aesthetics as well as with his former modernism, it paralleled the revival of classicism that had gained momentum in France and Italy during World War I and spread rapidly after peace was declared. The carnage and disruption of the war had led to a longing everywhere—even in America—for the stability and proven value of tradition. The apparent failure of modernity and progress associated with the war engendered on the part of many artists an aggressive desire to recapture the civility and conceits of high culture and tradition, which seemed endangered by the rapid and often devastating effects of nineteenth-century industrialization and the materialistic emphasis on progress. As an antidote, the classical tradition seemed to offer a haven of tranquility and order—a means by which to escape the uncertainty and equivocation of the age. In postwar America, this impulse found expression in Precisionism; in Italy and France it emerged as a more specific reinterpretation of classical imagery and naturalistic styles. Turning away from the strategies and ideology of abstraction, artists such as Picasso, Derain, and de Chirico idealized the present and made it more resonant by filtering it through the subject matter and styles of the past.

Stella's classicist proclivities were nourished, in particular, by the New Classicism that he encountered on his visit to Italy in 1922. In the art journal *Valori Plastici*, published in Rome between 1918 and 1922, he would have read arguments in favor of metaphysical paintings, the "return to order," and the distinctive qualities of Italian historical art—as contrasted with contemporary French work and the fragmented style of Futurism.[239] He also would have seen reproductions of the work of Carrà, Severini, and de Chirico, among others, which attested to their newly found reverence for earlier Italian traditions. For these artists, the Trecento and the Quattrocento represented the ideal—pure in form and mysterious and spiritual in content. Their goal was not to copy the past,

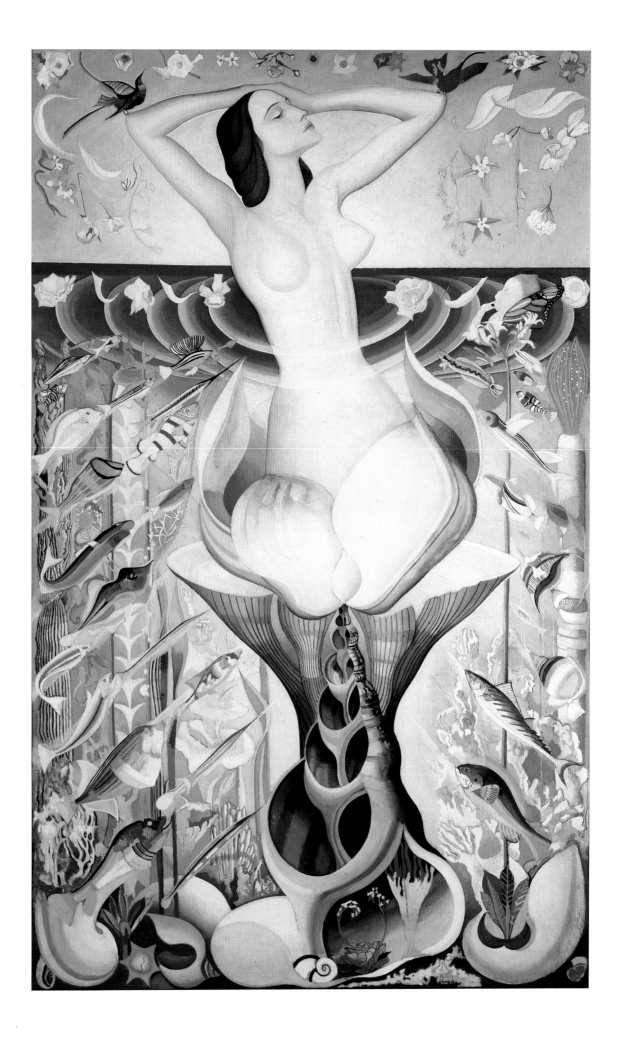

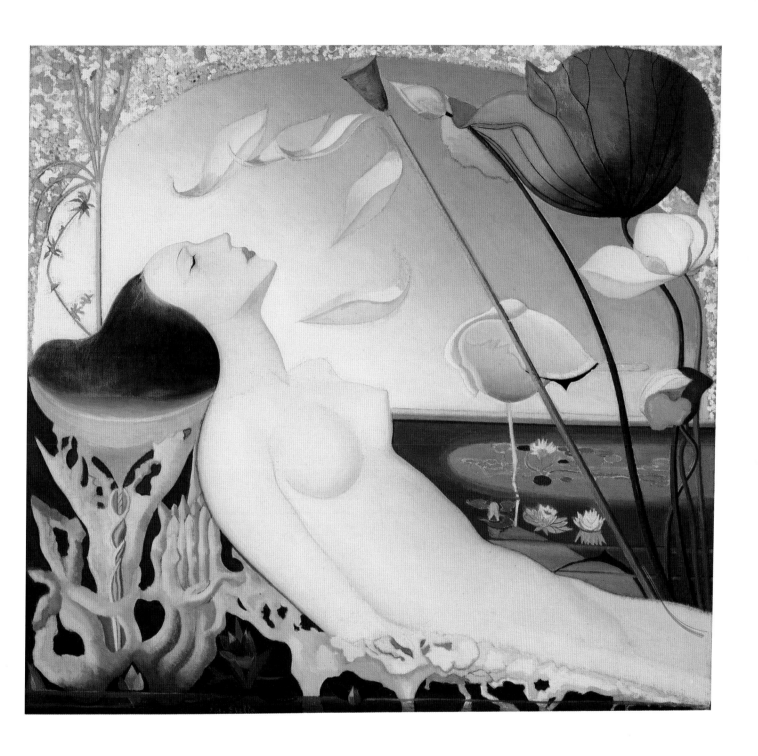

164. *The Birth of Venus*, 1925
Oil on canvas
85 x 53 (215.9 x 134.6)
Iowa State Education Association,
Des Moines

165. *Undine*, 1924–25
Oil on board
36 x 38 (91.4 x 96.5)
Collection of Jane Forbes Clark

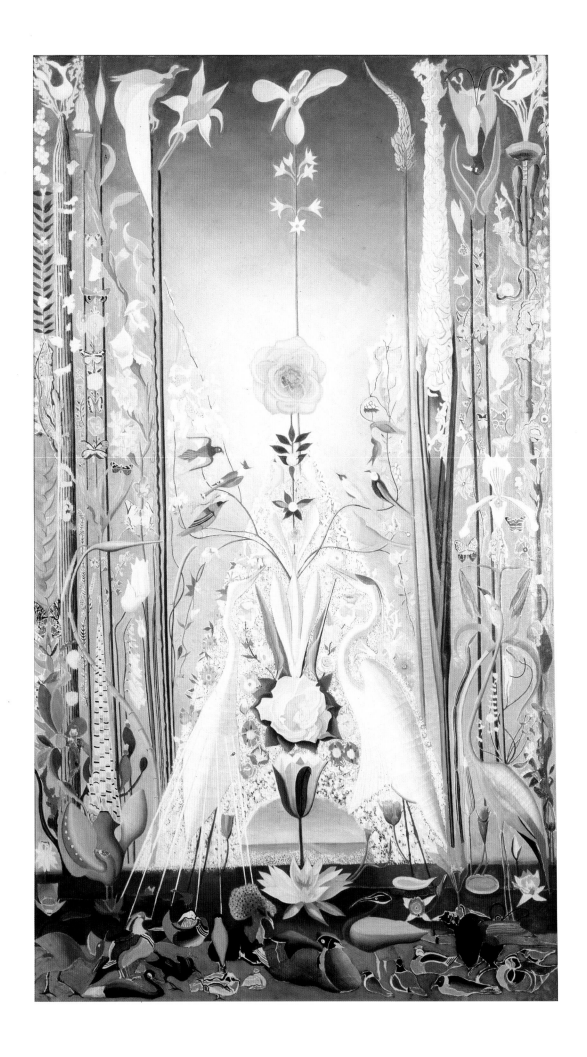

OPPOSITE PAGE
166. *Apotheosis of the Rose*, 1926
Oil on canvas
84 x 47 (213.4 x 119.4)
Iowa State Education Association,
Des Moines

167. *White Swan*, 1924–25
Oil on canvas
39 x 48¾ (99.1 x 123.8)
Private collection

but to assimilate it to the present—to marry the artistic traditions of the Middle Ages and the Italian Renaissance to the plastic concerns of contemporary art and thereby to engender a sense of continuity between past and present.

These ideas found a receptive ground in Stella's imagination. No longer convinced that art should reflect the salient features of a specific age, he had come to believe that art had to be "free of any bondage of time and locality."[240] "Modern" and "ancient" were no longer legitimate categories; art was a continuum, an "endless chain of rings representing various periods and schools."[241] Persuaded that "our epoch is only a point in the immensity of Time," he argued that even "a masterpiece cannot be a final word...it is only a phrase of continuous speech running through the centuries."[242]

Like the Italian Neoclassicists, Stella turned for inspiration to the fourteenth and fifteenth centuries. "Modern artists prefer Giotto to the Renaissance artists," he averred. "There is far greater force in the work of primitive painters than is ever found in more mature and decadent epochs."[243] His reawakened interest in Giotto led Stella—as it had Carrà and de Chirico—to adopt an overtly archaic style of figuration which emphasized spirituality and stillness. In his flat treatment of space and his figures' immobile gestures and impassive expressions, Stella expressed his admiration for the formal yet transcendental quality of early Renaissance art.

What was singular in Stella's figuration—apart from its decorative opulence and high-keyed palette—was his use of literary subjects to evoke a world of archaic innocence and chaste sexuality. Just as earlier he had sought to incorporate sound into his art, so now did he attempt to bridge the world of literature and the visual arts. He had already confronted the challenge in 1923 through his decorations for stage productions—for Georgette Leblanc Maeterlinck's production of *Tree of My Life* and for Clarence MacKay's staging of Ivan Norodny's monodrama *Skygirl.*[244] Choosing literary subjects offered Stella a means of alluding to narrative subject matter without the need for depicting sequence. Central to him were myths of emotional and sexual purity. In portraying them, he drew on the ancient concept of the Mediterranean world as Arcadia, an earthly paradise protected from the materialism of modern life and thereby free of its strife and tension. With Bacchus "reinstated as the new tutelary deity of my art," the mood he created was not one of Christian piety but of pagan ritual and occult symbolism.[245]

In their unexpected juxtapositions of images, these works anticipated Surrealism, which emerged after the publication of André Breton's

Surrealist manifesto in 1924. Paradoxically, given the visual similarities between Stella's work and later Surrealist efforts, particularly those of René Magritte, Stella was not directly influenced by the movement—or by Magritte, whose first Surrealist paintings date from late 1925. Since no formal conception of Surrealist painting existed prior to Breton's manifesto, what Stella would have encountered in 1922 was the *époque floue*, as it was called by members of the Parisian vanguard—the "indistinct" period

168. *Leda and the Swan*, 1924–25
Oil on canvas
42 x 47 (106.7 x 119.4)
Spanierman Gallery, New York

of transition that lasted from 1922 to 1924. His work shared with Surrealism a commitment to subjects of a visionary, poetic, and hence metaphoric order—to "poetic painting" as opposed to "pure painting." Yet, ideologically, Stella remained averse to Surrealism's central tenets, particularly its courting of the irrational and emphasis on the hidden meanings that automatism, free association, and dreams could extract from the unconscious. Disinclined to overthrow authority and established standards, he had not conjoined images in order to wrest new meanings from them, but because their juxtapositions were, for him, cosmologically coherent. Nor did his use of literary subjects owe to their Jungian or Freudian reverberations, but to his personal attachment to them as symbols of innocence, beauty, and virginal sexuality. This was even true of Venus, whom Stella identified not as the goddess of love, but as the goddess of spring—the embodiment of physical and artistic fecundity, an association that went back to Roman mythology.

Stella's aversion to the Freudian dialectic of Surrealism notwithstanding, his depiction of female protagonists such as Leda, Ophelia, Venus, and the water spirit Undine revealed complex and contradictory attitudes toward women and sexuality. Psychologically domineering and implacable, Stella's female nudes testified to his deification of woman as virgin as well as to his unresolved erotic impulses, which manifested themselves in the streak of vulgarity that friends noticed in his character. He often reminisced in later years to his friend August Mosca about his affairs with women and his prodigious feats of sexuality, although Mosca never knew him to be involved with women.[246] To Bernard Rabin, he described "orgies...women with women, men with men, men and women, and animals, everyone fucking everybody, fucking and sucking everybody else." Rabin commented that "it was all in his imagination."[247] It was as if Stella had difficulty reconciling sexuality and love[248]—as is suggested in an undated text, in which he wrote of the:

169. *Lady with Veil*, c. 1926
Location unknown

first red fruits of [my] sensuality—harsh, bitter, yet filled with wild and delicious perfume. Deep, dark, bloody red, they clutched violently at the tender blue and yellow of noble spiritual delight, and my whole being, overwhelmed as if by a sudden squall, trembled and shook like a slim tree trunk in a March wind, taken by surprise by the violence of renewed stormy gusts....Desire erupted imperiously, its demands sharper and more cutting with each day. It claimed the immediate gratification of its needs. Conquest, driven by hunger and thirst, became my daily purpose. In the torment of the silent, relentless chasing after women, there came a pause in which my whole being seemed painted violently red. In the sleepless nights, like smoldering tinder, like an eternal fire, I burned with the vision of virgin nipples, firm as a glistening crystal globe, tips erect, pink, tempting. I lay them before me on a marble table and in my excited imagination I caressed them, my trembling fingers noting their velvet smoothness and rounded fullness. I sharpened the knife of my violent desire which cut and opened them like mysterious fruit, feeling in that moment a spasmodic voluptuousness of relief and liberation.[249]

Fearful of the slavery he associated with emotional attachment (see p. 30 above), Stella sublimated this ardent sexuality into art. The intensity with which he "transfigured" and "spiritualized"[250] his physical desires lent his figurative work an undercurrent of latent eroticism.

Notwithstanding the ubiquity of psychoanalysis and Freudian interpretations in the 1920s, few observers noted anything striking about the sexual content of Stella's nudes.[251] The only suggestion that a degree of psychological anxiety underlay them came from a critic who asked, "Why Stella, of all painters, refuses to idealize the human form we cannot understand....An interesting analytical study could be made of Stella and his interpretation of the female form. There is a spot of fear there that to us mars an otherwise perfect execution."[252]

Singular as Stella's figurative works were in the context of American art in the 1920s, they catapulted him to a new level of eminence when they were exhibited at Dudensing Galleries in 1925. He seemed at the apex of critical acclaim—from the success of his Dudensing show to the "high praise" Picasso expressed for his work and the widely quoted remark by Augustus John that he was the only worthy artist in America.[253] Affiliation with Valentine Dudensing, the dealer for Matisse, André Derain, Miró, Picasso, Braque, Kandinsky, and Soutine, consolidated

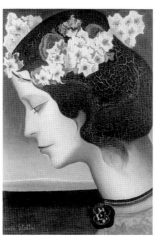

170. Pisanello
Ginevra d'Este, 1435–40
Tempera on panel
16⁵⁄₁₆ x 11¹³⁄₁₆ (43 x 30)
Musée du Louvre, Paris

171. *Sirenella,* 1924–25
Oil on canvas
21³⁄₈ x 15¹⁄₈ (54.3 x 38.4)
Private collection

Stella's "secure place in New York art life."[254] That Dudensing was an unequivocal advocate helped; according to one reporter, he did not stop speaking all season of Stella, his "one great love."[255] Yet there were others, less convinced about Stella's new direction, whose voices eventually dominated critical discourse. Dreier privately characterized the pictures as "rotten," and McBride, astonished at their garish color and occult subject matter, felt obliged to caution that "they are an interesting phase in the work of one of our most important artists....If these are a bit difficult there is all the more reason to go to them. When we have an ambitious artist in our midst who is making a great effort we too should make an effort."[256] Two years later, McBride remained wary but affirmative: "Unsure as I am about the ultimate worth of his experiments, nevertheless, I would feel more sure of this community if it gave Stella his due of respect."[257]

The hesitancy of former supporters was offset by the emergence of a new patron for Stella—Carl Weeks, a drug and cosmetics multimillionaire from Des Moines, Iowa. In addition to setting a record price for Stella's work—$5,000 for *The Birth of Venus* (Fig. 164)—Weeks commissioned the artist to paint a mural-size canvas for his home. The result, *Apotheosis of the Rose* (Fig. 166), led directly into the artist's decoratively embellished religious images of the latter 1920s.

Stella's commitment to an art of metaphor and symbol remained central to his achievement over the next four years as he turned from literary subjects to single portraits. Unlike the detailed, individualized descriptions that had marked his silverpoint drawings and 1923–24 series of wax crayon portraits (Fig. 172), he now accentuated his subjects' archaic, idealized qualities. The stillness and monumentality that resulted from his emphasis on broad planes of flat color, geometric austerity, and two-dimensional space linked these works with *The Heron* (Fig. 185). Dispensing with literary subjects allowed him to shift from narrative to symbolic portraiture. The immobile, erect female in *A Vision* (Fig. 174), silhouetted against a flat blue-white background, dressed in a translucent gown of bright orange and framed by two attenuated flower stems with open buds, was iconographically enigmatic—"as much like a tulip-bud as like a vision of

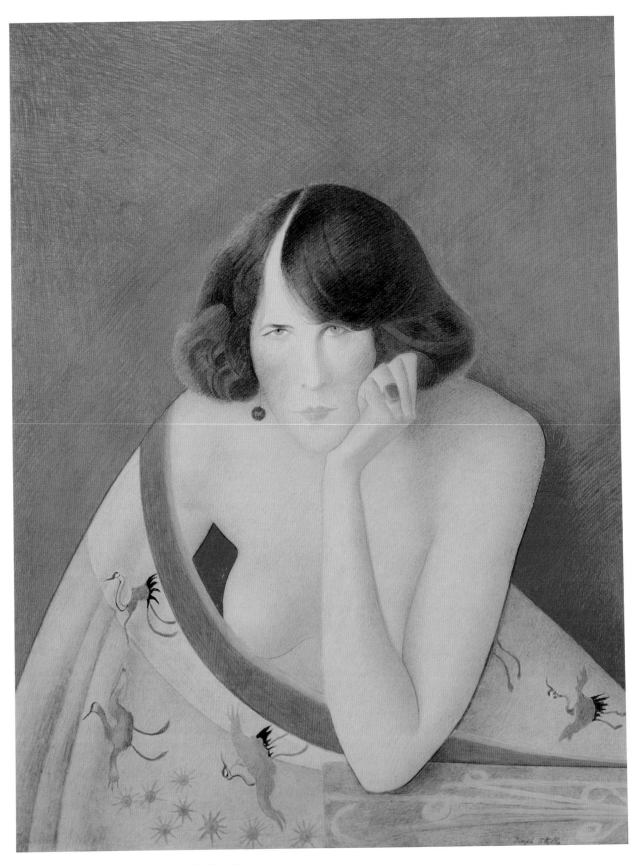

172. *Kathleen Millay*, c. 1923–24
Crayon and metalpoint on paper
28 x 22 (71.1 x 55.9)
Cheekwood Museum of Art,
Nashville; Gift of the 1989
Collectors' Group with matching
funds through the bequest of Anita
Bevill McMichael Stallworth

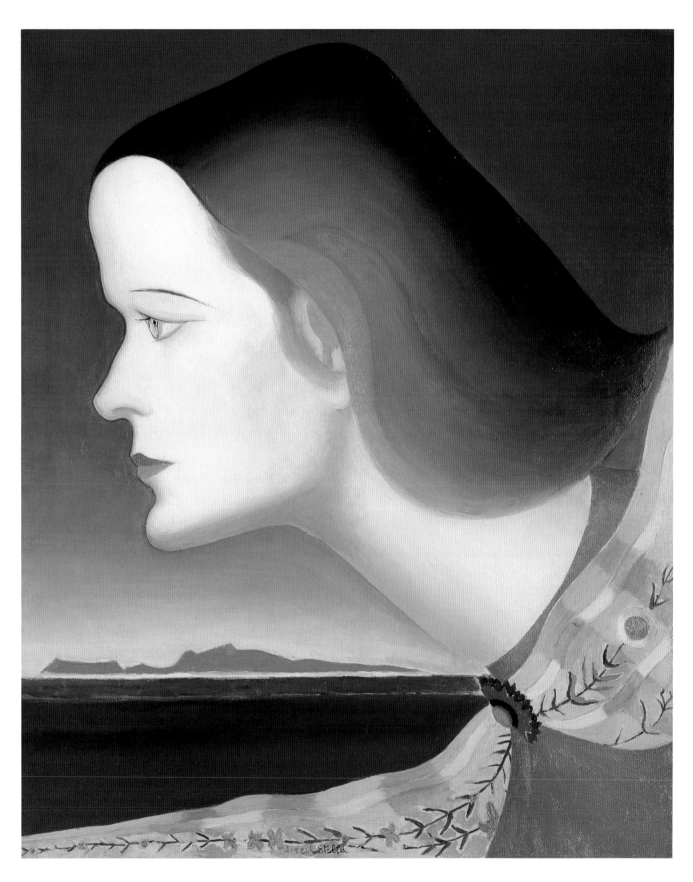

173. *The Amazon*, 1925–26
Oil on canvas
27 x 22 (68.6 x 55.9)
The Baltimore Museum of Art;
Purchase with exchange funds from
the Edward Joseph Gallagher III
Memorial Collection

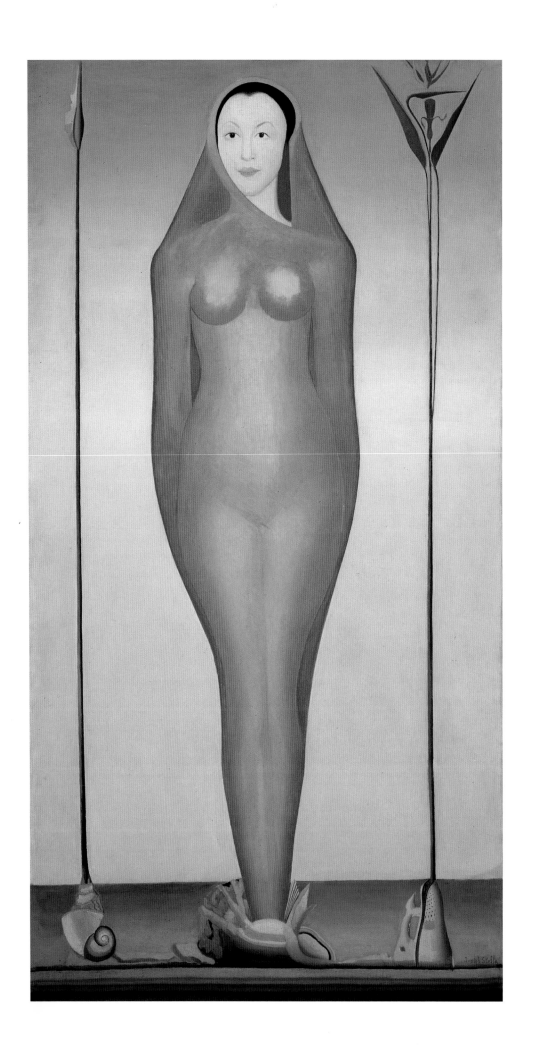

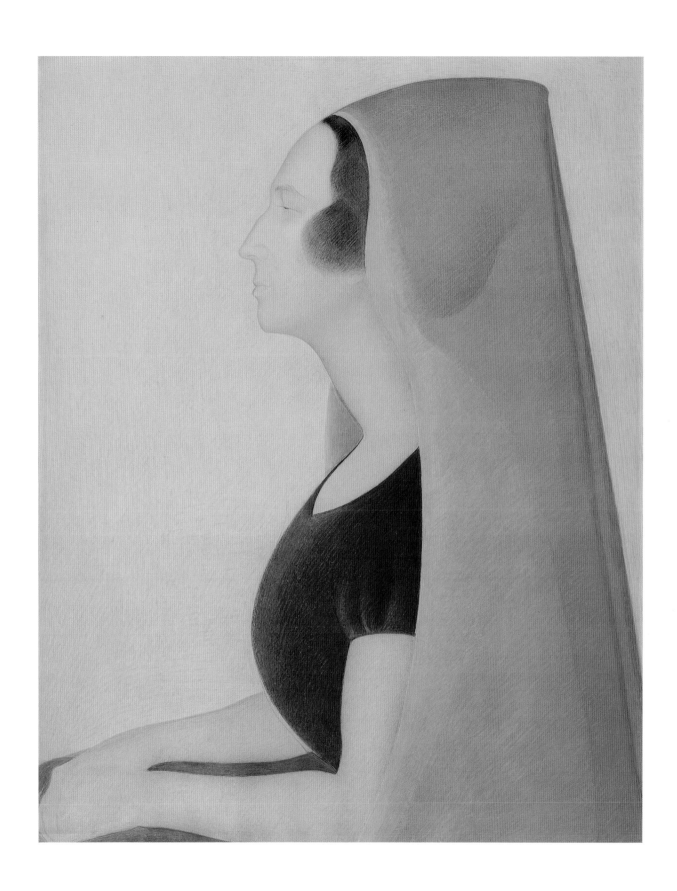

OPPOSITE PAGE
174. *A Vision*, 1925–26
Oil on canvas
80 x 40 (203.2 x 101.6)
The Art Institute of Chicago;
through prior gift of the Albert
Kunstadter Family Foundation

175. *Mrs. Stella (Portrait of the
Artist's Wife)*, 1925
Crayon, colored pencil, and
graphite on paper
27 x 21 (68.6 x 53.3)
Yale University Art Gallery, New
Haven; Anonymous Gift

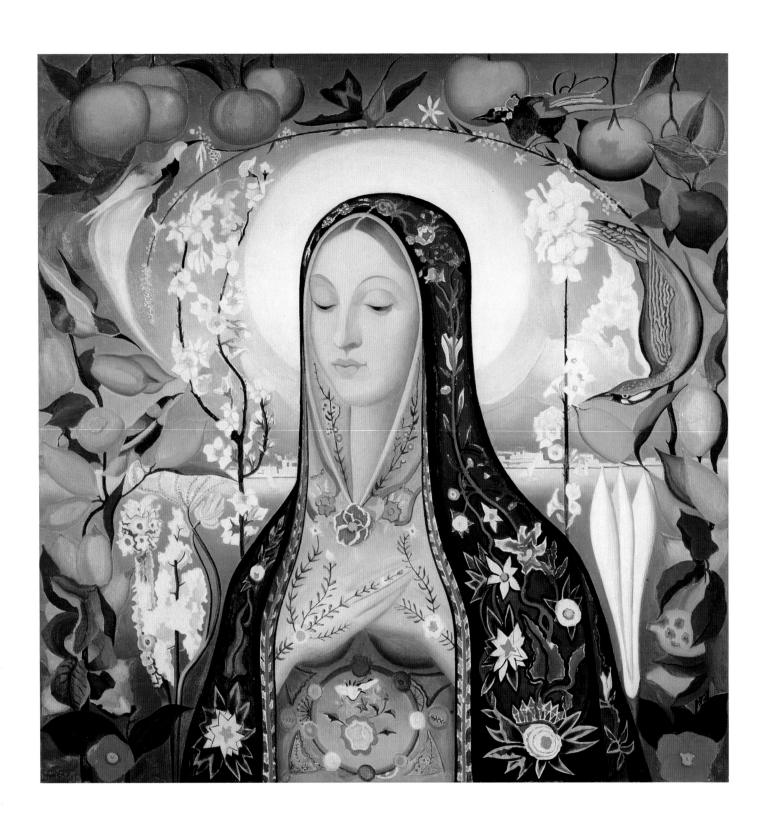

176. *The Virgin*, 1926
Oil on canvas
39⁹⁄₁₆ x 38¾ (100.5 x 98.4)
The Brooklyn Museum, New York;
Gift of Adolph Lewisohn

OPPOSITE PAGE
177. *Purissima*, 1927
Oil on canvas
76 x 57½ (193 x 146.1)
Snyder Fine Art, New York

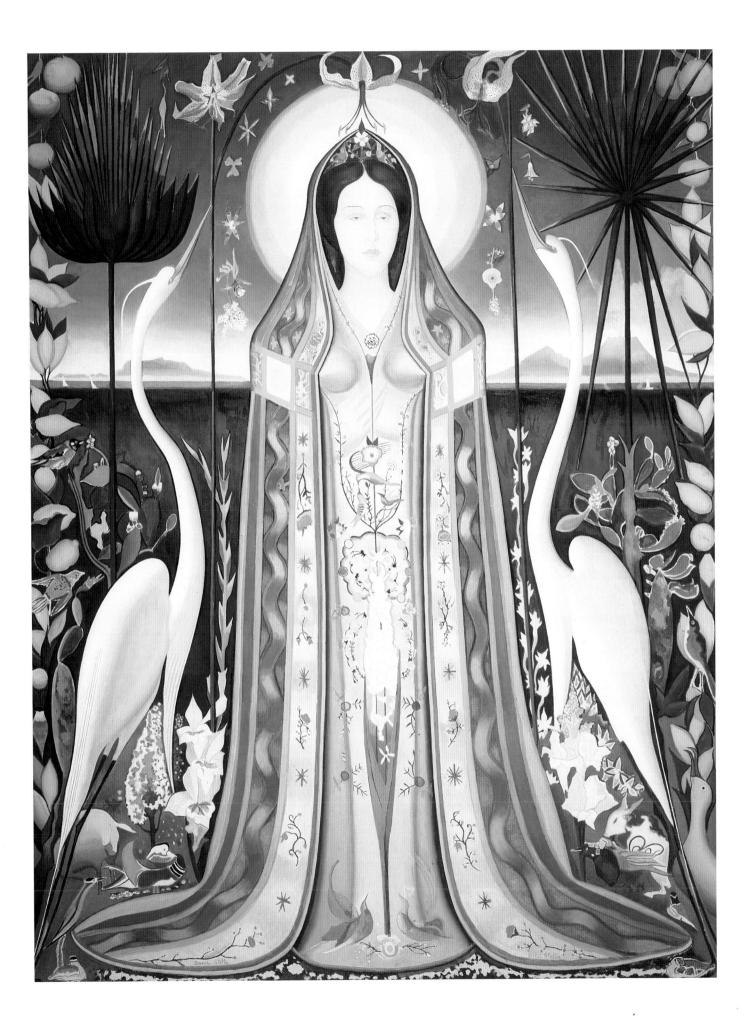

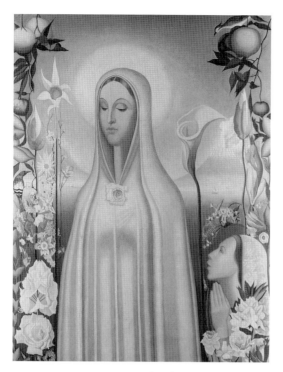

178. *Virgin of the Rose and Lily*, 1926
Oil on canvas
57½ x 44¾ (146.1 x 113.7)
Collection of The Honorable Joseph
P. Carroll and Mrs. Carroll

budding womanhood," as one critic remarked.[258] *The Amazon*, an idealized image of American women whose efficiency and beauty had impressed Stella upon his return to this country in 1922, was more self-consciously iconic (Fig. 173). By means of stylized, monumental forms and symbolic color associations, he transformed the profile of Kathleen Millay (Fig. 150) into the image of a "GODDESS," whose legendary "PRESENCE" he proclaimed by setting her against a background image of Capri and rendering her bust as "a volcanic pedestal refulgent of power as an ORIFLAMME."[259] Highly saturated colors, contained within sharply delineated areas, ensured the modernity of the portrait, while its color symbolism, decoratively embellished cloth, and treatment of background space as a foil for objects in the foreground recalled the past, particularly the art of the Trecento and Quattrocento.

Four years later, in 1929, Stella created a counterpart to this glorification of American womanhood. *The Ox* (Fig. 184), with its white, profiled head looming monumentally over the Italian countryside, was an oblique self-portrait—an alter ego that embodied the "bull-dog tenacity" Stella identified as one of his salient characteristics.[260] Whatever the traditional associations of the ox, Stella seems to have treated the animal primarily as a symbol of masculinity—an association that was reinforced, if not instigated, by Kenneth Burke's 1924 short story "The White Oxen," in which Burke equated the ox with the masculine aesthetic.

In August 1923, Stella became an American citizen. Three years later he went back to Europe, where he spent most of the next eight years, returning to New York only to arrange exhibitions and renew his passport. The first year abroad he was primarily in Italy, living in Naples and traveling from there to other Italian cities. He was as ecstatic to be back on native soil as on his first return visit in 1909; his aesthetics had changed, but not his love of homeland or his dream of creating a new art and a new mythology out of the Italian past. "Italy is a great joy and a great inspiration to me," he confessed in a 1929 letter.[261] "The beauty which smiles all around, here, in Italy, from innumerable masterpieces, spurns [*sic*] me to create a new Beauty equal in power to the old one."[262]

Inspired by the imagery he encountered on his pilgrimages to Siena, Florence, Perugia, Assisi, and Ravenna that first summer, Stella embarked

on a series of Madonna paintings. He had already considered the idea of transforming religious imagery into modern form: in 1925, while visiting the Weeks' home in Des Moines in preparation for *Apotheosis of the Rose*, he had been asked to paint two religious pictures by the local Catholic priest; the following year, he included another work, *Christ in the Temple*, in his exhibition at the Dudensing Galleries.[263] Echoing the strategy of inclusivity that had guided *Brooklyn Bridge*, Stella called upon the salient features of Italian culture to create in his Madonna images a symbolic portrait of his homeland—one that honored its complex mixture of paganism and Christianity, voluptuousness and spirituality. As he had done before with his figurative portraits, he drew on earlier prototypes. The garlands of fruits and flowers that surrounded his Madonnas and their embroidered garments of lacy floral patterns recalled the work of the fifteenth-century Venetian Carlo Crivelli (Fig. 179), while their impassive countenances, downcast eyes, and long, slim hands folded under translucent cloaks owed a debt to the Dugento

179. Carlo Crivelli
Madonna della Candeletta, c. 1490
Tempera on panel
85¹³⁄₁₆ x 29½ (218 x 74.9)
Pinacoteca di Brera, Milan

masters Cimabue and Duccio.

Yet Stella's paintings were equally influenced by the flat, naive, and colorful images of the Madonna that proliferated in the popular devotional images and folk art of Southern Italy. As in Catholic communities elsewhere, particularly in the Southern hemisphere, Italian artisans had, for generations, transformed the exalted, grand manner of the Old Masters into the kitsch expressions of popular culture—in prayer sheets and books, scapulars, and ex-votos as well as in the profusion of silk and plastic flowers on altars and religious images (Figs. 182, 183). McBride alluded to this aspect of Stella's paintings when he wrote that "they have nothing that interferes for an instant with a peasant's dream of heaven. The very lavishness of the adornment, to people who have been forced to lead simple lives, seems heavenly."[264] It was likewise this quality that elicited comparisons with the religious expressions of Mexico which, like those of Italian popular culture, merged pagan and Christian religious themes.[265] Like these folk art images, Stella's Madonnas exuded a paganistic reverence for the sacred and mysterious powers of nature. As much fertility goddesses as Christian deities, they embodied the dual allegiance felt by most southern Italians to pagan pantheism and the mysticism of Catholic devotion.[266]

A similar mixture of pantheism and mysticism permeated the scenes of Capri that Stella executed immediately after the Madonna images—in 1927 and 1928 (Figs. 186, 187). Painted in high-key, flat colors appropriate to the landscape that Stella once called "the eternal siren," these scenes paid homage to the lyricism and spiritual dimension of nature.[267] In them, exotic plants and birds inhabited a Dionysian kingdom of serenity and happiness. By means of outstretched palm leaves or orbs of light, positioned like halos, Stella visualized the explosive energy of nature. More pagan than the similarly composed landscapes of O'Keeffe and Dove (Fig. 192), Stella's nature portraits unlocked, as he once commended Thoreau for having done, "the secrets confided to him by Pan."[268]

Exhibited in April 1928 at the Valentine Gallery, Stella's Madonnas and Italian landscapes were greeted with almost universal critical ac-

claim. Their archaic classicism, inventive color, and decorative brilliance appealed to a community that yearned for reassurance that originality and tradition were not contradictory, and that the past could be successfully assimilated into the present. Alone among Americans in drawing stylistic inspiration from the Italian primitives, Stella had married two predominant desires of the 1920s: for order and clarity, and for a spirituality that seemed lacking in the frenzied materialism of the jazz age.

180. Gino Severini
Two Pulcinellas, 1922
Oil on canvas, 36¼ x 24 (92 x 61)
Gemeentemuseum, The Hague

181. *Pulcinella*, 1928–29
Oil on canvas
Location unknown

Stella's New York success was echoed in Naples the following year, 1929, where his large solo show was considered "the great event" of the season.[269] Despite the resemblance of some of his work to Severini's, critics lauded him for uniquely conjoining American drama with Italian lyricism and for symbolically representing the salient aspects of the Neapolitan "soul": Vesuvius, the sea, and the mask (Figs. 180, 181).[270] From the perspective of Europe, even Stella could appreciate what America had contributed to his art. Like Demuth, who attributed his aesthetic invention to the difficulties of being an artist in America, Stella affirmed that "Here in Europe, in spite of my birth, I feel to have become American—with a capital A—I am really proud to have had the opportunity of strengthening my will power by my long residence in America—."[271] Nevertheless, while he credited America with having fueled his will and daring, his personal loyalties remained unalloyed. "Italy is my

only true inspiration," he affirmed. "The artist is like a tree: growing older, bent under the weight of its fruit, it presses always closer to the maternal womb that gave it birth. Despite everything, thirty years and more of America have succeeded only in making more solid and firm the latin structure of my nature."[272]

Stella's affection for Italy notwithstanding, France still ruled the aesthetic landscape of Europe. Mindful of career opportunities and anxious to escape the Depression that had already begun to cripple the Italian economy, Stella returned in 1930 to Paris, where he remained for most of the next four years. Not surprisingly, the art scene had changed dramatically since his last extended stay in 1909. In the aftermath of World War I, two dominant trends had emerged: Neoclassicism and Surrealism. Paradoxically, given Stella's earlier stylistic proclivities, neither movement seems to have had much impact on him during his four-year Parisian residence. Indeed, the period saw him abandoning the style that allied him with these movements in favor of planar depictions of Paris rooftops and expressionist fantasies of birds and foliage derived from a trip to North Africa in 1930. In these latter paintings, the smooth planes of chromatically "vulgar" color in his Madonnas and Caprian landscapes gave way to a dark, brooding palette and heavily encrusted paint. Birds and foliage, hieratically positioned around a central axis, still provided the subject matter. But, as in *Red Flower*, where two birds stand like votaries in heraldic posture on either side of a gigantically proportioned blossom, the effect was no longer rapturously euphoric, but somber (Fig. 195). This and other works from the period gained in intensity and power of expression what they lost in exuberant and carefree gaiety. Through richly glowing, brooding color, and expressive paint handling, they conjured up a world of mystery and poetic drama that recalled Stella's Symbolist affinities—particularly with Mallarmé, whose evocation of longing and loss Stella pictorialized in the *Black Swan* (Fig. 196). As *The New York Times* critic Edward Alden Jewell noted appreciatively: "the artist mixes his paint with mysterious ingredients known only to alchemists. He has learned how to make color glow through dark, opaque forms....This is fire that does not burn. It is a little eerie. His brush, one fancies, may have been dipped in the caldron where witches brew the aurora borealis."[273]

182. Holy Card, Muro Lucano, *San Gerardo Maiella* Joseph Stella Papers, Archives of American Art, Smithsonian Institution, Washington, D.C.

183. *The Madonna Being Taken from Her Church to Visit the Aelian Isles* Photograph by Mario Tschinki in Frances Toor, *Festivals and Folkways of Italy*, 1953

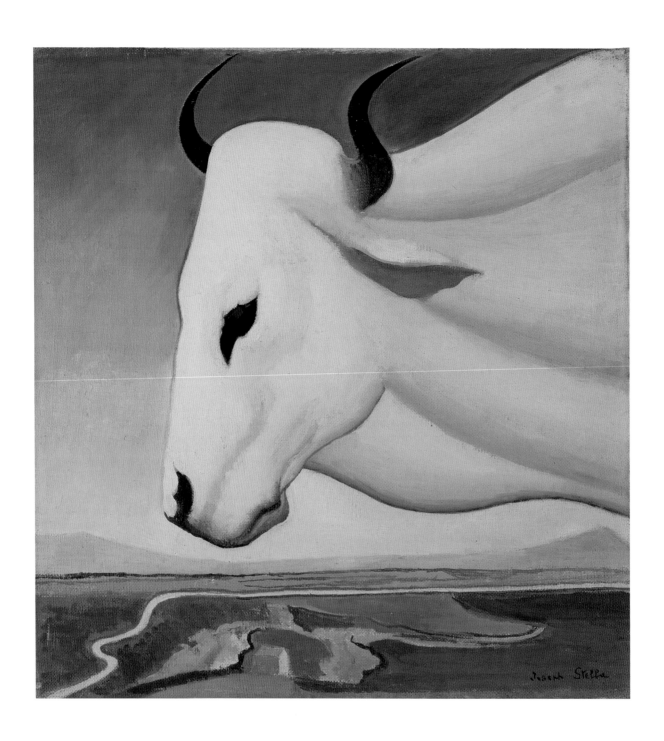

184. *The Ox*, 1929
Oil on canvas
20 x 19 (50.8 x 48.3)
Bayly Art Museum, University of
Virginia, Charlottesville

OPPOSITE PAGE
185. *The Heron*, 1925
Oil on canvas
48 x 29 (121.9 x 73.7)
The Warner Collection of Gulf
States Paper Corporation,
Tuscaloosa, Alabama

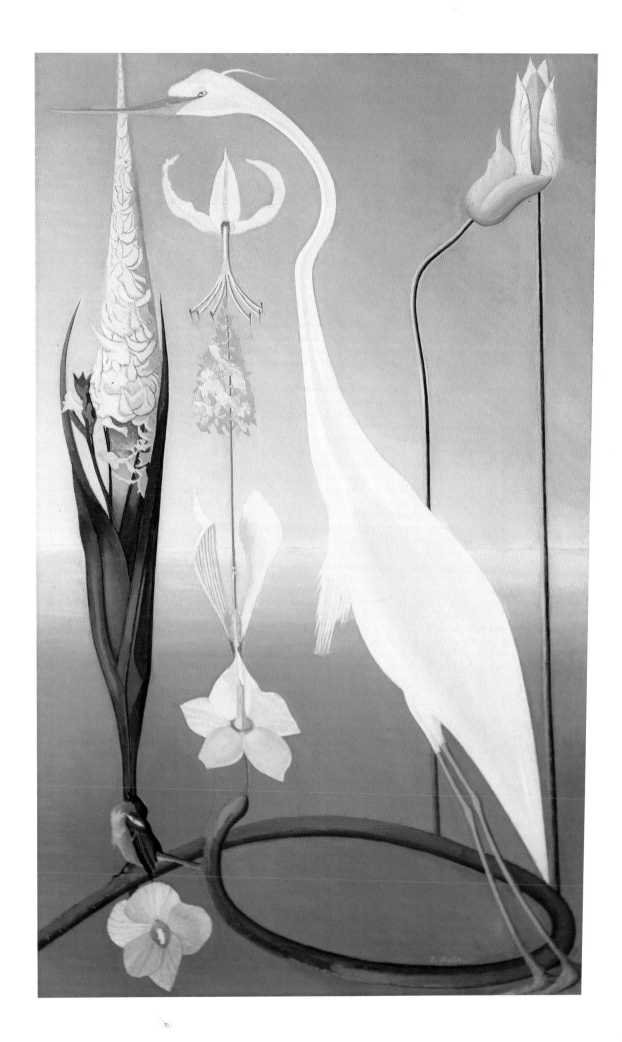

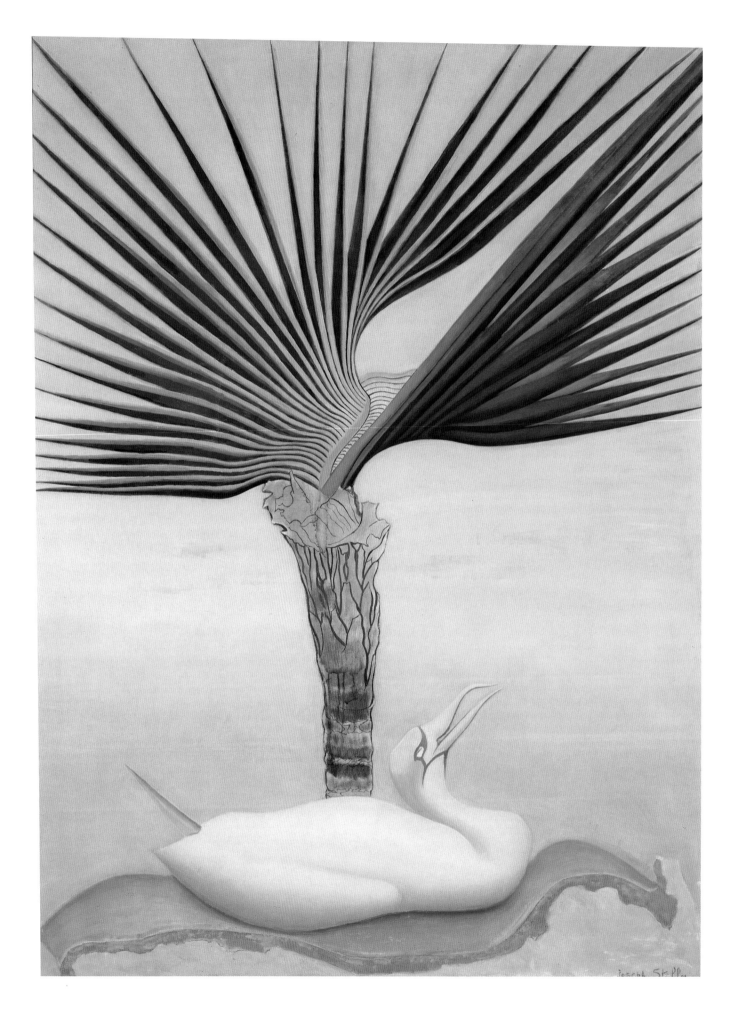

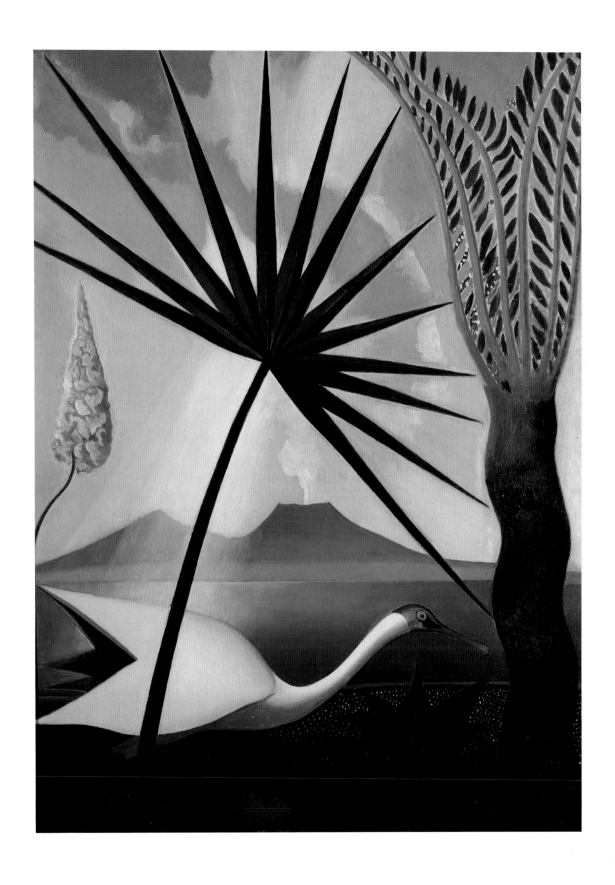

OPPOSITE PAGE
186. *Palm Tree and Bird*, 1927–28
Oil on canvas
54 x 40¼ (137.2 x 102.2)
Collection of Mrs. Sergio Stella

187. *Neapolitan Song*, 1927–28
Oil on canvas
34¼ x 28¼ (87 x 71.8)
Collection of Harvey and Françoise
Rambach

157

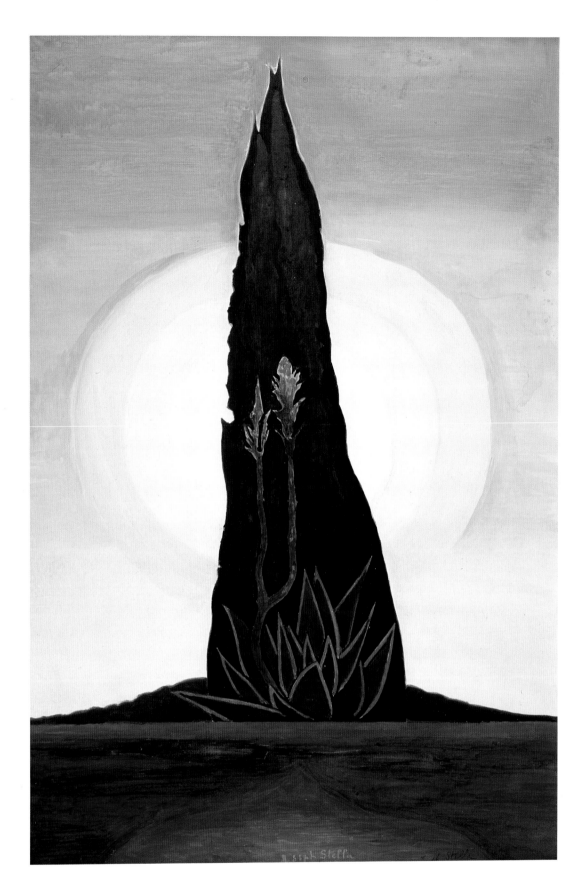

188. *Tree, Cactus, Moon*, 1927–28
Gouache on paper
41 x 27 (104.1 x 68.6)
Reynolda House, Museum of
American Art, Winston–Salem,
North Carolina

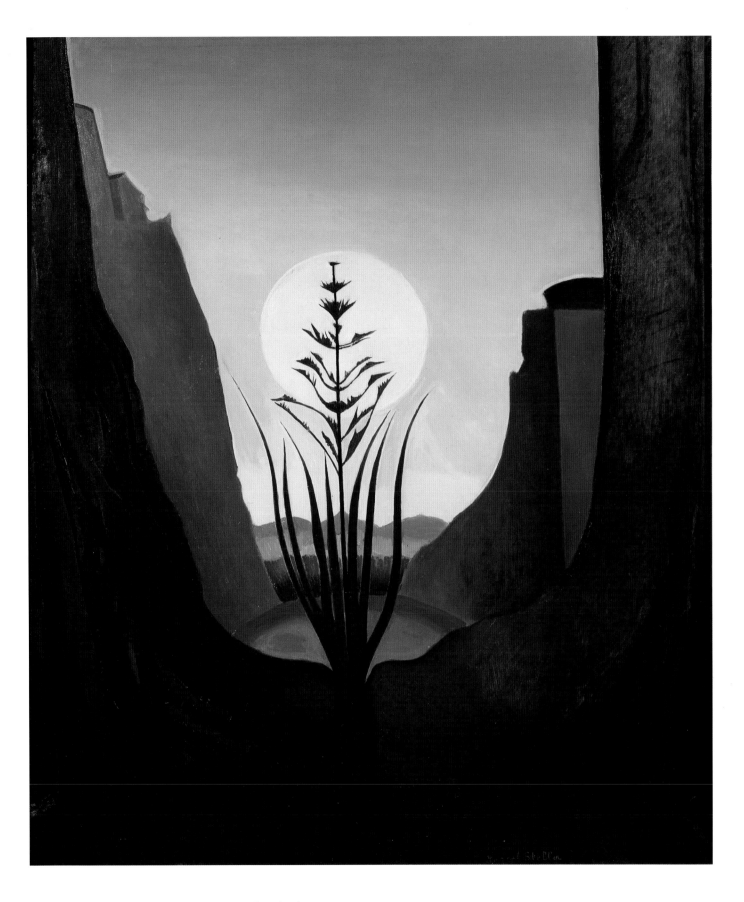

189. *The Little Lake*, 1927–28
Oil on canvas
40 x 34 (101.6 x 86.4)
The Montclair Art Museum, New
Jersey; Gift of Bernard Rabin in
memory of Nathan Krueger

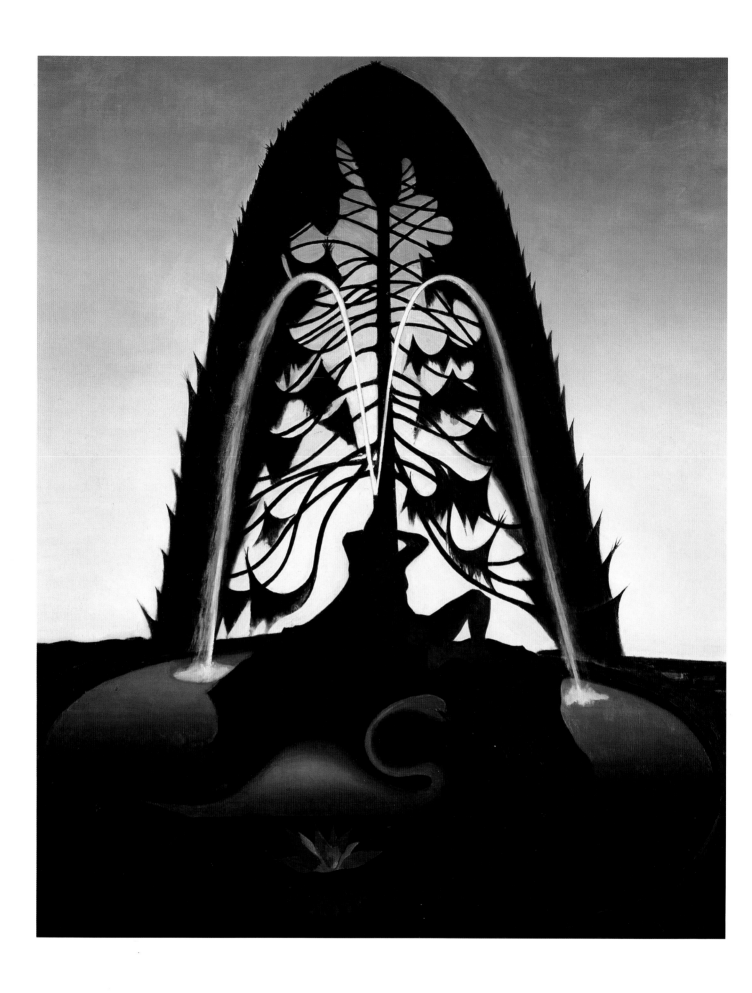

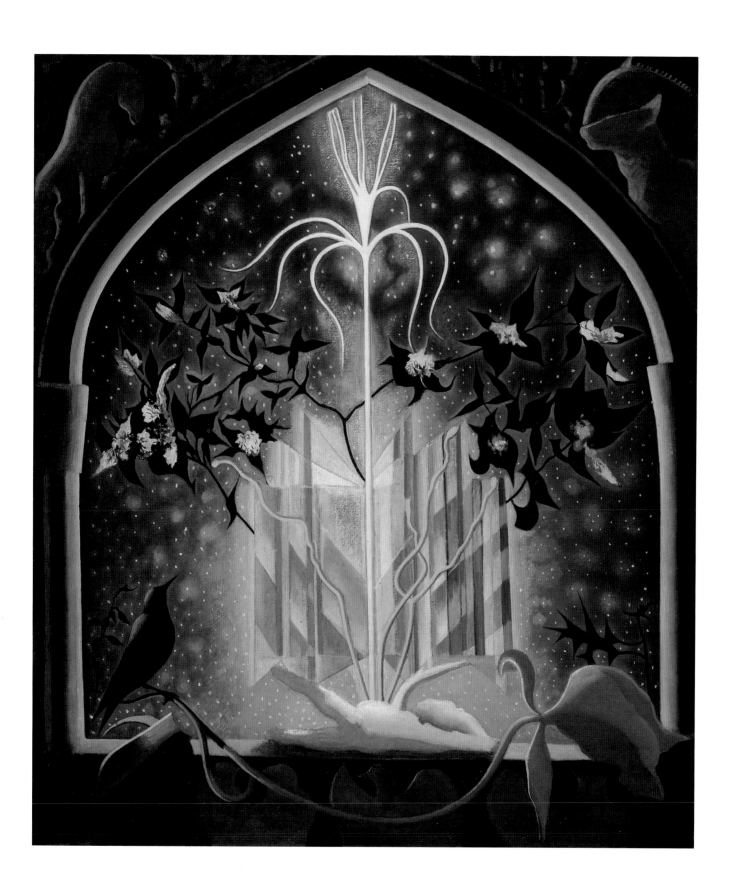

OPPOSITE PAGE

190. *Fountain*, 1929
Oil on canvas
49 x 40 (124.5 x 101.6)
Collection of Drs. Sandy M.
Bushberg and Michelle B. Rabin

191. *Serenade: A Christmas Fantasy*
(La Fontaine), 1937
Oil on canvas
43⅛ x 37⅛ (109.5 x 94.3)
Hirshhorn Museum and Sculpture
Garden, Smithsonian Institution,
Washington, D.C.; Gift of
Joseph H. Hirshhorn

Unhappily, this new maturity and depth in Stella's work did not accord with greater self-awareness. Indeed, as he grew older, Stella became more self-centered and narcissistic. Those who knew him described him as temperamentally mercurial, irascibly opinionated, and prone to sudden and irrational rages.[274] "Almost anything could get him upset," one friend remarked. "One had always to choose [one's] words when talking to him or else become the object of his sudden rage."[275] Along with a character that was joyous and full of laughter—one which Hamilton Easter Field once likened to a "southern wind"—Stella had an exaggerated sense of self-importance.[276] Firmly convinced of his greatness, he would become irrational when confronted with opposition. This accounted, in part, for his radical shifts in mood and extreme reactions to things—refined and sentimental one moment, vulgar and vitriolic the next. It also led to the sudden severing of friendships throughout his life.

Stella's outsider status in the Parisian art world exacerbated these characteristics. His violent altercation there in January 1932 with American artist Boris Aronson suggests something of his narcissism and temper, both of which would eventually isolate him from the artistic community. The incident was occasioned by Stella's exclusion from a survey exhibition of American artists living in Paris. The outraged Stella was convinced that

192. Arthur G. Dove
Moon, 1935
Oil on canvas
35 x 25 (88.9 x 63.5)
Mr. and Mrs. Barney A. Ebsworth
Foundation and Windsor, Inc.,
St. Louis

Aronson, the show's organizer, had led "a campaign of propaganda" against him.[277] "It is quite certain," he wrote to Dreier, "that a holy League of Divine Silence was organized."[278] According to contemporary accounts, Stella sought out Aronson in the Café du Dôme and began to shake him by the lapels while shouting accusations at him—among them that he was a "filthy little Jew."[279] Another artist, Arty Stillman, tried to protect Aronson and he and Stella began hitting each other with canes. The waiters summoned the police when Stella knocked Stillman unconscious and hit another artist, Albert Chollet, over the head with a chair. Stella was taken to the police station where charges, later dropped, were brought against him. Although the incident was dismissed by pro-Stella advocates as an innocuous expression of the rivalry between conservative and modernist factions in Paris, the story dogged Stella. As late as 1941, questions were still being raised about it—which Stella dismissed as nothing but mere slander.[280]

Stella's megalomania, however unpleasant to his friends, worked to his advantage aesthetically, for it led him to identify himself with the wide sweep of art history. In competition with the masters of the past rather

than with those of the present, whom he dismissed as inferior, Stella turned again to the religious subjects upon which the supremacy of Italian art was based. In a series of individual portraits of Christ and other saints, executed in 1933, he attained an expressionist intensity comparable to the achievements of Titian or Ribera (Fig. 193). Modeled in tones of light and dark, his portraits anticipated in expressionist fervor Marsden Hartley's Archaic Portraits, executed a few years later (Fig. 194). Both artists abandoned elegance for the sake of emotional content and let authenticity of expression prevail over refinement and delicacy. In *The Crèche* (Fig. 202), Stella's mural-size painting from this period, he turned from portraiture to crèche scenes that drew for inspiration on fifteenth-century sources—from the outdoor platform-altar in Van Eyck's *Adoration of the Mystic Lamb* (Fig. 132) to the profiled figures and grotto-like landscapes found in Italian *Nativities* from Giotto to Botticelli.

Twelve of these paintings were featured in an exhibition of religious art held in Rome in 1934. Heralded by its organizers as "representative of Fascist Italy," the exhibition implicitly allied Stella with the Fascist politics of Mussolini.[281] Despite his tacit complicity, Stella was never a consistently outspoken partisan of Mussolini, as were the Neoclassic artists involved in the Milanese Novecento movement. His support was more reflexively patriotic than political. He saw Mussolini as restoring Italy's respect and dignity. "Mussolini's masculine shape cuts a sharp profile against the clear horizon of today's political arena, and his speech—like an arrow strikes a perfect score in all the American social classes....every [Italian] immigrant," he averred, "considers Mussolini a savior and holds him with the highest regard...."[282] Yet even Stella's support wavered after war began to decimate Italy. Some friends remember his fierce denunciations of the Italian leader, while others recall his approbation. His apparent indifference to political realities mirrored his acceptance of the late Romantic glorification of art and the artist as morally and spiritually superior to the concerns of everyday life. That aesthetics, for Stella, were not politically ideological is indicated by the appearance of his Pittsburgh drawing of c. 1908, *Miners* (Fig. 39), in the August 1937 issue of the Communist party journal, *The Fight.*

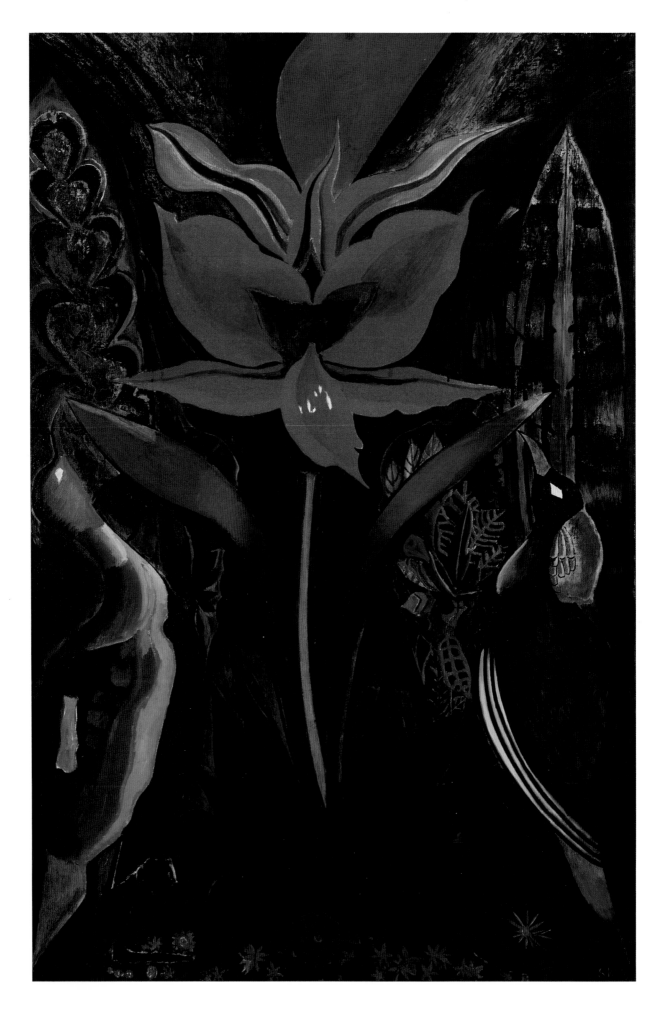

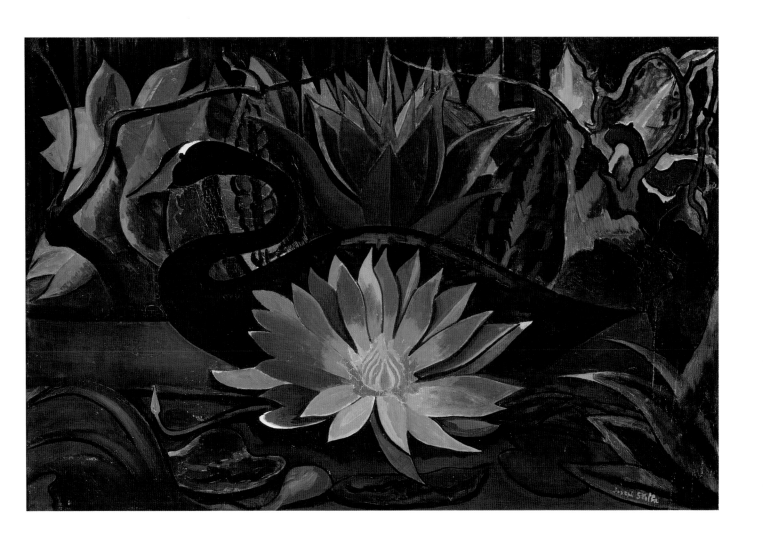

OPPOSITE PAGE
195. *Red Flower*, 1929
Oil on canvas
57½ x 38⅜ (146.1 x 97.5)
Collection of Felisa and Nick Vanoff

196. *Black Swan (The Swan of
Death)*, 1928–29
Oil on canvas
20¾ x 31 (52.7 x 78.7)
Private collection

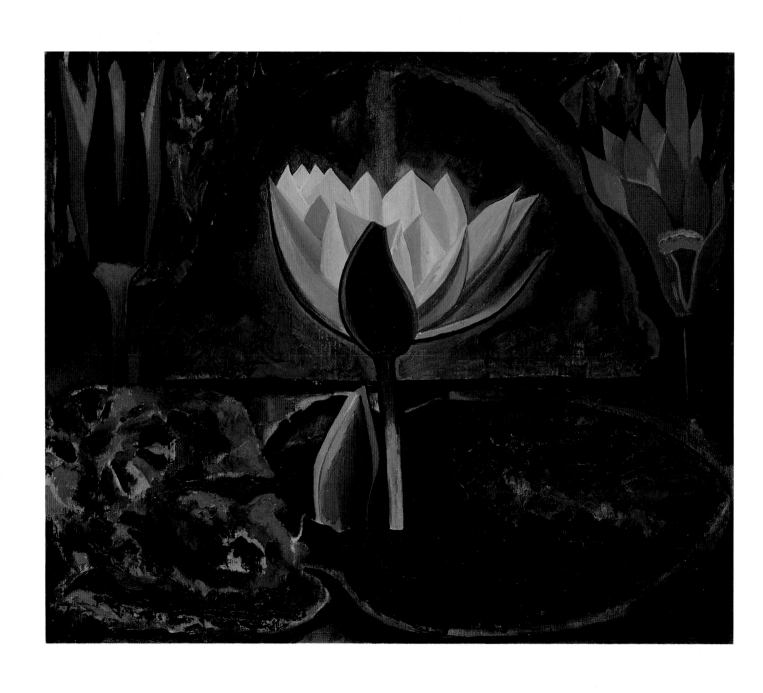

197. *Lotus*, 1929
Oil on canvas
21½ x 25¾ (54.6 x 65.4)
Hirshhorn Museum and Sculpture
Garden, Smithsonian Institution,
Washington, D.C.; Gift of Joseph
H. Hirshhorn

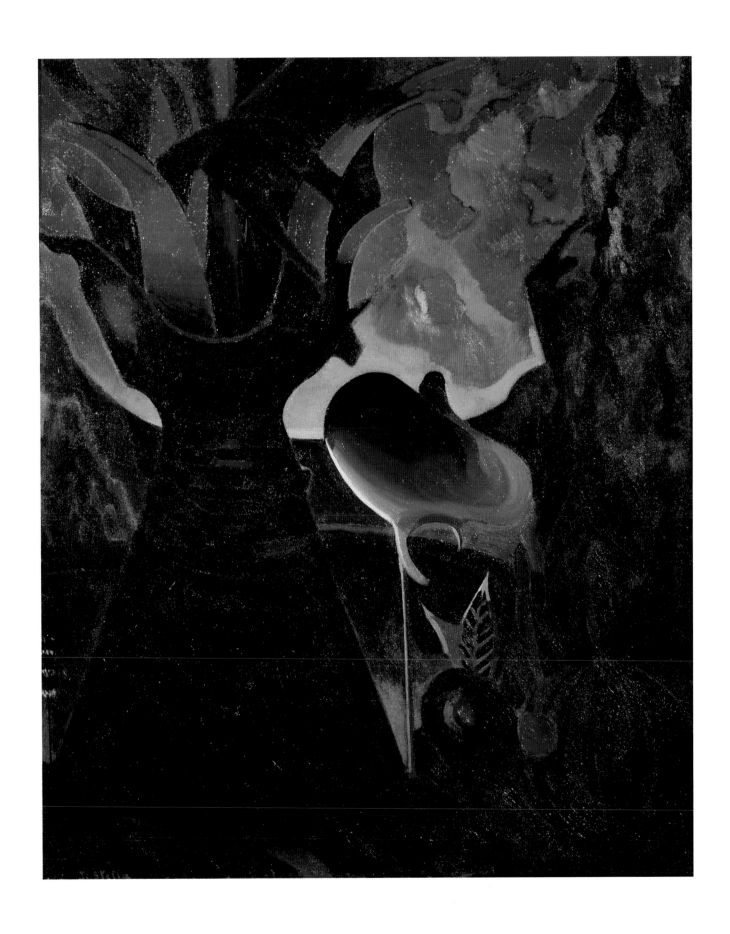

198. *Nocturne*, 1929
Oil on canvas
34 x 24½ (86.4 x 62.2)
Collection of Mr. and
Mrs. William C. Janss

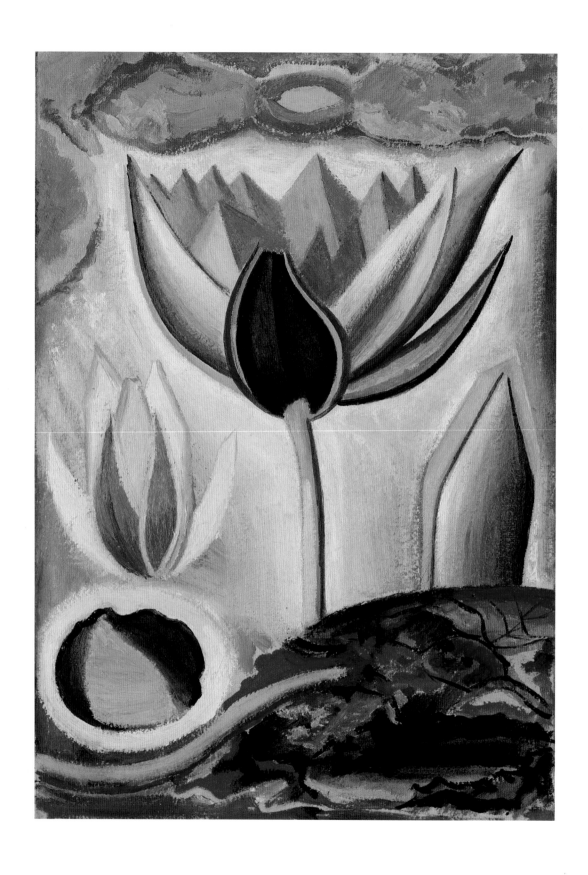

199. *Tropical Flower,* c. 1928–29
Oil on paper mounted on canvas
20 x 14 (50.8 x 35.6)
Private collection

200. *Tropical Flowers*, c. 1925–30
Oil on paper mounted on canvas
29 x 22 (73.7 x 55.9)
Private collection

By 1934, conditions in Europe, even for those indifferent to the moral tenor of contemporary politics, had become intolerable. In France, the social unrest and constant fear of agitation that had enveloped the country after the Stavisky riots early in 1934 reached a new plateau with the October assassination in Marseilles of King Alexander of Yugoslavia. The explosiveness of the ensuing political situation, coupled with an economy in severe disorder, markedly lessened the desirability of remaining in Paris. Italy offered even less respite. The economic depression which had begun in 1930 had not improved, and with the Italian invasion of Ethiopia in 1934 the country had shifted to a wartime mentality. Although Stella does not seem to have been homesick for America, he was drawn back to this country by economic demands and the practical necessity of having to renew his passport every year.[283]

The art community Stella returned to in October 1934 differed markedly from the one he had left eight years before. For most artists and intellectuals, the decade's social and economic problems demanded a socially responsible art. Moreover, the Depression had fostered a pervasive nationalism that did not readily accept Stella's Italian personality or the Italian character of his paintings. Nor were the friendships that had nourished him earlier still intact. The Arensbergs had moved to California and the artists involved in their salon had dispersed; Stella's brother, Antonio, had died in 1927; Dreier had ceased supporting his art; Varèse had broken with him in 1928; and Stella had lost contact with Helen Walser and her two children, with whom he had lived for four years in the early twenties.[284] His only link with the past came through his reconnection with his wife, Mary Geraldine Walter French, with whom he had not lived for thirty years.[285] How, or for what reason, they renewed their marriage is unknown, but upon his return to this country, he apparently moved into an apartment with her in the Bronx, across from the Botanical Garden.

Three months after Stella's return to America, in January 1935, the Valentine Gallery mounted what would be its last show with the artist whose work they had supported for ten years. Valentine's rejection was not singular. Reeling from the pressures of a nation in crisis, critics found Stella's work puzzling if not incomprehensible. As Lewis Mumford wrote: "I have seen the fissure between his realism and fantasy widen into an abyss....What makes Stella so difficult to fathom is that one cannot put one's hand on the place where these two sides of his personality come together....In short, a puzzling painter, whether good or bad, going or coming. Time, and not I, will have to do the telling."[286]

201. *Tree of Nice*, c. 1930
Oil on canvas
32 x 26 (81.3 x 66)
Collection of Mr. and Mrs. Meyer
P. Potamkin

202. *The Crèche*, c. 1929–32
Oil on canvas
61 x 77 (154.9 x 195.6)
The Newark Museum, New Jersey;
Purchase 1940 Wallace M. Scudder
Bequest Fund

Stella aggravated rather than eased his re-entry into the American cultural community. Angry and embittered at being back in what he would describe as the "stinking slough of America" where one "moves like a worm…one is forced to bite one's tail to get an inspiration," he dismissed American art and artists.[287] Boastful while abroad of the potential of America to produce great art, he now isolated Yasuo Kuniyoshi and Albert Pinkham Ryder as the only American artists with any talent.[288] Having made no overtures of friendship, he had no constituency to turn to; gone were the days when McBride could write of the art community's "general affection" for Stella.[289]

Financially adrift, Stella enrolled in the easel division of the newly created Federal Art Project, Works Progress Administration. Desperate to reclaim a measure of the success and critical approbation he had enjoyed a decade earlier, he executed a number of canvases for the WPA based on the *Brooklyn Bridge* and *Port* panels of *New York Interpreted* (Figs. 116, 125). Despite his return to these "testimonials to American civilization," he was unhappy in New York.[290] Anxious to escape the city's cold climate and claustrophobic, gray landscape, he lobbied for mural projects in the tropics—in Puerto Rico and the Virgin Islands.[291] But, by 1935, the WPA was facing financial difficulties; not only were Stella's requests ignored, but his very employment with the WPA was in constant jeopardy.[292]

Stella's repeated assertion to WPA officials that he wanted to execute murals was not merely a matter of convenience. As early as 1926, he had argued that "architecture is like a goblet containing wine and sculpture and painting are the wine that glows through the glass."[293] By the early 1930s, encouraged by the renewed commitment to mural painting of Italian artists like Severini and Carrà, he was listing it as among his highest priorities. In the absence of commissions, however, he played out his ambitions on large-scale canvases (Fig. 203). His efforts, exhibited by the Mural Society of America, failed to unite him with the community of American muralists whose ambitions in the 1930s were political and whose subject matter was social. For them, murals offered a means of effecting a new historical and political consciousness—of bridging social and economic class distinctions and encouraging solidarity among people. For Stella, in contrast, murals offered a means of re-engaging with his Italian heritage. On his application for a Guggenheim grant in 1936, he identified the study of Giotto's frescoes in Padua and Assisi as his reason for wanting to travel to Italy.[294] Only by studying fresco painting did he believe the technical demands of the "revived mural painting" in America could be met.

203. *Flowers, Italy*, c. 1930
Oil on canvas
75 x 75 (190.5 x 190.5)
Phoenix Art Museum; Gift of Mr.
and Mrs. Jonathan Marshall

Stella finally found himself in the tropics in 1937, but not for the reason he had hoped. Desperately ill with diabetes, Mary French Stella had asked him to take her home to her native Barbados. By December, they were settled on the island. For Stella, it was a joyous reawakening such as he had experienced in Italy:

> The darkness becomes lighter....The fresh, balmy air and the clarity of the dawn full of young joy, open up the portal of our soul, lighting it up within, chasing away the shadows thickened during the horrible time in ugly America. It comes as the Resurrection of all our Being. There resounds once more the song of Hope and Joy. The blood rushes through our veins; truly young and with full confidence in our skill, facing the most arduous challenges, our artistic powers rise, magically reawakened in the presence of unexpected natural wonders, ready for the highest flights. We have left behind the stinking slough of America. That place, compared to the Great Light that surrounds us now like a true halo...appears very distant, like a rough outline of shapeless mud.[295]

Stella remained in Barbados only five months. During that time, he drew in pastels (Figs. 209, 210)—mostly green and black—and absorbed motifs that would fuel his art for the next three years. By July 1938, having placed Mary French Stella under a doctor's care, he was back in Paris to attend the landmark exhibition "Three Centuries of American Art" at the Jeu de Paume.[296] Despite the brevity of his tenure in Barbados, the trip marked a significant return to an existentially nourishing climate—"the homeland of his emotions," as Hilton Kramer noted.[297] Neither his love of the tropics nor his dreams of returning ever abated. Only the danger of Nazi submarines curtailed his plan to revisit Barbados for several months in early 1940. He then turned his gaze to Central and South America and began to study Spanish in the hope of traveling there in 1941.

The Barbados paintings that Stella began to execute upon his return to America in late 1938, like those which Gauguin produced in Tahiti, radiated the innocence and guileless sensuality that Stella associated with the "ardor of youth" (Figs. 204–207).[298] While relying on the central vertical axis that had become a compositional characteristic of his art, these paintings eschewed symbolism and mysticism in favor of the rhapsodic celebration of sunshine and joy. The effect, as Hilton Kramer observed, was "that of a sensuous dream."[299] The several versions that Stella executed of *Joy of Living* recall his Madonna portraits, but allusions to the grand tradition of religious portraiture are replaced with more overt emulations of the raw,

bright color and simplicity of execution of folk art (Figs. 204, 205). Not unjustifiably, Stella considered them the "best of my entire production."[300]

Stella's health and critical fortunes sank in the ensuing years. Emotionally cut off from the New York art world, even his retrospective exhibition

204. *Joy of Living*, 1940
Oil on canvas
43 x 34 (109.2 x 86.4)
Collection of Bernard Rabin

at The Newark Museum in the spring of 1939 failed to reestablish him. Though successful as a presentation, the show was less enthusiastically reviewed than Stella had anticipated and he later complained of not being able to induce anyone living in New York City to see it.[301]

However disappointing the retrospective's lukewarm response, it was a minor irritation compared to the critical condemnation that greeted his large-scale show at the Associated American Artists gallery in 1941. Deriding it as "the fortnight's problem exhibition," *The Art Digest* reviewer questioned "how much of Stella's work represents valid research in painting, and how much, if any, is merely occultish indulgence in posterish picture-making."[302] Even McBride, habitually gracious, lamented that "it is easy to agree that Stella has talent, but it is not so easy to agree on the use that is to be made of it....When [he] hits a tune that is suitable the result is terrifically effective,...when [he] hits the wrong tune then there is nothing to do but to stop up your ears."[303] For most viewers, Stella's palette was simply too strident and his stylistic exuberance too great. Few could appreciate Stella's belief that time would dull his colors and create a patina that would bring them in closer harmony.[304] The unrestrained emotionality and "orgiastic delivery" that Stella had attained in his work had finally become a barrier to full appreciation of it.[305] So much so that Charmion von Wiegand felt compelled to argue that his art must not be judged by the standards of contemporary aesthetics: "He is rooted in the soil of Italy as no other living painter in America is; he works in the tradition of his blood, of the lands that the Moors overran. Stella sees life intensely with a modern eye, but he records his vision in the pure color and form of Southern Italy."[306]

Von Wiegand's appeal was ignored by Alfred Barr, director of The Museum of Modern Art, who excluded Stella's work from an important survey exhibition of contemporary painting he had organized for the museum. Outraged, Stella protested "against this violation of Justice," which he attributed to "dwarfs vainly conspiring against imperative creative force."[307] The "weight of abuse" was too great, however, and he

205. *Joy of Living*, 1938
Oil on canvas
44¼ x 31 (112.4 x 78.7)
Collection of Andrew Crispo

206. *Song of Barbados*, 1938
Oil on canvas
58 x 37 (147.3 x 94)
Collection of Mr. and
Mrs. James A. Fisher

OPPOSITE PAGE
207. *Full Moon, Barbados*, 1940
Oil on canvas
36 x 24 (91.4 x 61)
Richard York Gallery, New York

208. *Tropical Flowers*, c. 1929
Watercolor and casein on paper
25 x 18 (63.5 x 45.7)
Private collection

209. *Tropical Plants*, 1938
Pastel on paper
23⅛ x 17¾ (58.7 x 45.1)
Collection of Mr. and
Mrs. William C. Janss

appealed in writing to Barr's "sense of HONOR and of justice and to that Friendship toward me that you so strongly profess"; to McBride he demanded that "fair play alone be practiced and all sectarian darkness removed."[308]

Stella's psychic disgrace was exacerbated by his 1942 and 1943 shows at the Knoedler and ACA galleries, neither of which engendered affirmative reviews or sales. Even the galleries' decision to employ McBride and Dreier as catalogue essayists backfired: both wrote warm appreciations of Stella as the preeminent painter of urban America, but avoided commenting on his recent art. McBride even acknowledged that he had undertaken the assignment out of "great respect for certain pictures" in Stella's earlier exhibitions and in hope that Stella might "repeat" these previous achievements.[309]

Adding to Stella's distress were increasingly debilitating physical problems. He had developed heart disease in 1940 and a thrombosis in the eye in 1943. Both conditions intermittently confined him to bed and forced him to give up his studio. In pain and troubled by failing eyesight, he grew progressively despondent. "I cannot sleep," he complained to August Mosca. "I feel at night horribly nervous, and I do not know why, a real terror. To be all day practically all alone—and not have any more the comfort of art."[310] Plagued by solitude, he developed a morbid anxiety about his declining physical powers and his health, even resisting shaking hands with people because he feared contracting some skin disease. Although terrified at the thought of death, he nevertheless produced a number of oil still lifes, pencil drawings, and flower studies in crayon and pastel. In these, as in earlier work, he drew from the real world—from the model, from flowers in the Bronx Botanical Garden, and from the fabrics, seashells, figurines, pottery, and illustrations of Old Master paintings and birds that he had collected over the years. It was not until a twenty-foot fall down an elevator shaft in April 1945, while serving as a judge for the "Portrait of America" show, that his production ceased.[311] Twenty months later, on November 5, 1946, he succumbed to heart failure.

At the time of his death, Stella had already been relegated to history. In March 1946, eight months before he died, the Whitney Museum of American Art had mounted a large exhibition devoted to the early pioneers of abstract art in America. While the show heralded Stella as the first American Futurist and the preeminent painter of the Brooklyn Bridge, it paid no attention to his post-1923 work. Such exclusive emphasis on his early achievement would persist in the ensuing years, as he came to be perceived as an artist whose major aesthetic accomplishments

had been completed before 1923. So much was Stella's later work forgotten and his identity as an artist linked exclusively with the Brooklyn Bridge that even as careful and astute a partisan of early twentieth-century American art as Kramer could be astonished, over forty years after Stella's death, that the artist had produced other work.[312]

The misconceptions about Stella's work were exacerbated by his 1963 retrospective at the Whitney Museum. Coming as it did at the height of the most ardently formalist decade in American art history, the exhibition was a critical disaster. The most virulent attack came from *The New York Times* critic John Canaday, who cited *The Amazon* and *Black Swan* (Figs. 173, 196) as "two of the most embarrassing pictures ever included in the public exhibition of an artist with a major reputation," and proclaimed that if Stella's standing as an artist could survive his retrospective it was only because people were blind.[313] Canaday was severe but he was not alone; in 1963 few observers could appreciate work that was so unabashedly operatic and metaphoric and so overtly challenged the modernist canon. The "reckless energy, generous humanity and candid joy in the sensuous world" that Charmion von Wiegand had earlier noted had not yet been incorporated into the American painting tradition.[314] Stella's view of art as an endless chain of interconnecting rings running through time had empowered him to reject the constraints of aesthetic progress and consistency in favor of an inherently theatrical art of drama and decorative opulence. It is perhaps only now, in a postmodernist era, that the baroque exuberance and unrestrained theatricality of Stella's art can be fully understood and embraced.

210. *Tropicalia: The Croton*, 1938
Pastel on paper
26 x 20 (66 x 50.8)
Collection of Margery and
Maurice H. Katz

211. *Flowering Tropical Cactus,*
c. 1938
Watercolor on paper
24¾ x 18½ (62.9 x 47)
Courtesy Doris Bry

212. *Purple Water Lilies*, 1944
Pastel and charcoal on paper
17½ x 23⅜ (44.5 x 59.4)
Richard York Gallery, New York

1. Stella gave various accounts of his birthdate and place of birth. For example, on his Declaration of Intention for the U.S. Department of Labor (April 13, 1921) and his Petition for Naturalization (May 1, 1923) he stated that he was born in Potenza, Italy, on June 13, 1877. In his 1933 application for a Guggenheim Foundation grant, he wrote that he was born in Muro Lucano, Italy, on June 13, 1883. His 1936 application for the Guggenheim Foundation grant stated that he was born in Muro Lucano, Italy, on June 13, 1880. Francis Naumann traveled to Muro Lucano on behalf of this project and found Stella's birth certificate, which confirmed that he was born in his house in Muro Lucano on June 13, 1877. (While the certificate gives the date of birth as June 14, 1877, city officials in Muro Lucano confirmed to Naumann that birth certificates were often filed the day after the birth.) Copies of all documents cited are in the Joseph Stella artist's file, Whitney Museum of American Art, New York.

2. Antonio Aniante, quoted in Irma B. Jaffe, *Joseph Stella* (Cambridge, Massachusetts: Harvard University Press, 1970), p. 2.

3. For Stella's descriptions of Muro Lucano, see "Autobiography: Muro Lucano," p. 216 below.

4. The story most often told of Stella's school years first appeared in Stella's 1921 "On Painting," p. 203 below. It was retold in Carlo de Fornaro, "A Forceful Figure in American Art," *Arts & Decoration*, 19 (August 1923), p. 17:

> At the age of eight he was sent to school, which he hated with an intense, white rage, since he believed schools were a punishment for man's original sin. One day he was looking out of his window towards a cherry tree in full bloom. A bird flew into the classroom. Young Beppino thought the bird was singing to him, "Come and have some fun outside." Impelled by a power greater than discipline, he rushed up to his teacher.
>
> "I have to go out," he shouted excitedly.
>
> "And why?" asked the amazed pedagogue.
>
> "He is calling to me!"
>
> "Who is calling to you?"
>
> "A bird!"
>
> The teacher struck him a blow over the shoulders, but young Stella bit savagely into the man's hand and rushed madly out of the school to join the joyful little bird.

In later years, friends described Stella as being able to quote long passages from his favorite authors. Stephan Bourgeois (in Jaffe, *Joseph Stella*, p. 70) recalled that, upon request, Stella would play the role of Desdemona, reciting a passage from *Othello*.

5. For southern Italian life, see Carlo Levi, *Christ Stopped at Eboli: The Story of a Year* (New York: Farrar, Straus and Company, 1947).

6. Antonio Stella was formidable. For information on him, see "Dr. Antonio Stella Dies at 59 Years," *The New York Times*, July 4, 1927, p. 15; Antonio Stella, "L'immigrazione degli italiani negli Stati Uniti," *La Basilicata nel Mondo*, 1 (August 1924), p. 61; Antonio Stella, banquet speech, published in *La Basilicata nel Mondo*, 3 (August 1926), pp. 178–82; Giovanni Petraccone, "Il Dottor Antonio Stella," *La Basilicata nel Mondo*, 4 (January 1927), pp. 3–6; Giovanni Petraccone, "Antonio Stella," *La Basilicata nel Mondo*, 4 (January 1927), pp. 274–76. Even today in Muro Lucano, it is Antonio Stella who is considered the most successful brother—his birthplace is marked by a plaque; information courtesy of Francis Naumann.

7. Michael Stella, Antonio's nephew, describes being told to kiss his uncle's hand in greeting when he entered the room and reported that he and his brothers trembled when Antonio was scheduled to pay a visit; conversation with the author, July 20, 1993.

8. It was Carlo de Fornaro who assured Antonio that Joseph was talented; see Carlo de Fornaro, "Joseph Stella: Outline of the Life, Work, and Times of a Great Master," p. 15, typescript, Bernard Rabin Papers, Cranberry, New Jersey.

9. See "American Artist in Barbados," *Barbados Advocate*, March 1, 1938, p. 9.

10. Stella, "Awareness of Art," p. 217 below.

11. For the first recounting of this story, see Fornaro, "A Forceful Figure in American Art," p. 17.

12. The records of the Art Students League indicate that Stella attended the antique drawing class in November and December 1897.

13. Although there are no extant records for the New York School of Art, most of Stella's official documents indicate that he studied at the New York School from early 1898 to 1900 and that he received a scholarship for the school year 1898–99. The major discrepancy is the 1933 Guggen-

heim grant application, where he wrote that he attended the New York School of Art from 1907 to 1910 and received a scholarship in 1909. This cannot be accurate since he departed for Europe in 1909. Furthermore, this grant application states that he received a diploma from a school in Naples in 1906, by which time he had been in New York for almost ten years. Subsequent Guggenheim grant applications (1936, 1937) support his attendance at the New York School from early 1898 to 1900. See Stella, "Autobiographical Notes," p. 211 below; John Simon Guggenheim Memorial Foundation, New York, Fellowship Application Forms for the years 1933, 1936, 1937, copies in the Joseph Stella artist's file, Whitney Museum of American Art.

14. According to the undocumented story, Chase "at once noted Stella's strong talent, did not hesitate to characterize him a second Manet, when at Shinnecock Hills, [he] saw one of Stella's portrait studies. He said before the class: 'Manet couldn't have done it any better.' All the pupils broke into applause" ("Notes About Joseph Stella," Joseph Stella Papers, AAA). Although Irma Jaffe (*Joseph Stella*, p. 238 n. 6), assumed the above text to be by Stella, it appears more likely—in tone and language—to have been written by Carlo de Fornaro and based on conversations with Stella. The possibly apocryphal incident has been repeated in subsequent Chase and Stella literature. See, for example, Ronald G. Pisano, *William Merritt Chase: A Leading Spirit in American Art*, exh. cat. (Seattle: Henry Art Gallery, University of Washington, 1983), p. 181; John I.H. Baur, *Joseph Stella* (New York and London: Praeger Publishers, 1971), p. 25.

15. Stella's attitude is recounted in a newspaper article that apparently used Stella's words; it is unclear from the text whether the rule forbidding students to paint flowers was the school's or Chase's; "Artistic Evolution of an Italo-American Painter: Exhibition of Works of Joseph Stella at Italian National Club Revelation to Americans and Italians," *The Sun*, May 25, 1913, pp. 11–12. Jaffe, *Joseph Stella*, pp. 11–12, associated Stella's resentment of the rule with the Art Students League experience, and it has subsequently been cited as such. However, since Stella drew from antique casts during his matriculation at the League, the story must concern the Chase School.

16. Stella, "On Painting," p. 203 below.

17. Stella, "The New Art," p. 201 below.

18. Ronald G. Pisano, "The Teaching Career of William Merritt Chase," *American Artist*, 40 (March 1976), p. 63.

19. On just such a trip to Europe under Chase's tutelage, Charles Sheeler became impressed with the structural solidity of the Old Masters and began to adapt it to his own art.

20. See Fornaro, "Joseph Stella," p. 20, who corroborates that Stella was not interested in Italian masters until after his return to Europe.

21. Stella, "Autobiographical Notes," p. 211 below.

22. The term Ashcan is here used to encompass a larger group of urban realists than those associated with The Eight. It refers to the kind of images Art Young had in mind when he lamented artists who painted (for *The Masses*) "pictures of ash cans and girls hitching up their skirts in Horatio Street" without the benefit of a caption; Young, quoted in Rebecca Zurier, *Art for The Masses: A Radical Magazine and Its Graphics, 1911–1917* (Philadelphia: Temple University Press, 1988), p. 140.

23. The psychological distance between socially conscious artists and their subjects was expressed by the editor of *The Masses*, Max Eastman, who confessed: "I could not deceive myself that in the mass, and still less in idea, the industrial workers were my comrades or brothers, or the special repositories of my love"; quoted in Zurier, *Art for The Masses*, p. 143.

24. Stella later wrote that he had "made several scenes of immigrants at the Barge Office, scenes liked very much by the great Rev. Lyman Abbott"; Stella, "Autobiographical Notes," p. 212 below. Moser, among others, suggested that it was Antonio Stella who brought the drawings to the attention of Abbott; Joann Moser, *Visual Poetry: The Drawings of Joseph Stella*, exh. cat. (Washington, D.C.: National Museum of American Art, Smithsonian Institution; Fort Worth: Amon Carter Museum, 1990).

25. See "Dr. Antonio Stella Dies at 59 Years," p. 15. Antonio Stella was the president of the Italian Medical Society, the Italian National Club, the Roman Legion of America (an organization of Americans of Italian birth who aided the United States government in World War I), and was decorated a number of times by the Italian government.

26. Lyman Abbott, "Americans in the Rough," *The Outlook*, 81 (December 23, 1905), p. 956.

27. See August Mosca, "Memories of Joseph Stella," 1961, p. 3, August Mosca Papers, AAA. Stella "claimed the eyes were the soul of the person and should be seized at once." Accordingly, he would begin each portrait "with the eyes."

28. Albert Keck, "Joseph Stella," unpublished Fine Arts thesis, 1965, pp. 10–11, Bernard Rabin Papers, Cranberry, New Jersey.

213. *Dance of Spring*
(Song of the Birds), 1924
Oil on canvas
42⅜ x 32⅜ (107.6 x 82.2)
Collection of Mr. and
Mrs. William C. Janss

29. Ernest Poole, *The Voice of the Street* (New York: A.S. Barnes & Company, 1906), p. ix.

30. Ernest Poole, "The Men Who Are to Vote," *Everybody's Magazine*, 15 (October 1906), p. 436.

31. "Congestion of Population," *Charities and The Commons*, 19 (April 4, 1908), p. 38.

32. Quoted in Clarke A. Chambers, *Paul U. Kellogg and the Survey: Voices for Social Welfare and Social Justice* (Minneapolis: University of Minnesota Press, 1971), p. 29.

33. Paul U. Kellogg, "Monongah," *Charities and The Commons*, 19 (January 4, 1908), p. 1313.

34. Ibid., p. 1314.

35. For *The Pittsburgh Survey*, see *Catalogue of The Pittsburgh Survey Civic Exhibit*, exh. cat. (Pittsburgh: Carnegie Art Galleries, 1908), and Chambers, *Paul U. Kellogg*, pp. 33–45.

36. Paul Kellogg, quoted in Alan Trachtenberg, "Ever the Human Document," *America & Lewis Hine: Photographs 1904–1940* (Millerton, New York: Aperture, 1977), p. 126.

37. Ibid.

38. John R. Commons, "Wage Earners of Pittsburgh," *Charities and The Commons*, 21 (March 6, 1909), p. 1051.

39. Stella, "Autobiographical Notes," p. 212 below.

40. For the Society of American Artists and its merger with the National Academy of Design, see "Merge Art Societies," *New York Daily Tribune*, March 7, 1906, p. 7.

41. "In the Art Schools," *American Art News*, March 24, 1906, p. 2.

42. For these Italian attitudes towards immigration, see Dino Cinel, *The National Integration of Italian Return Migration, 1870–1929* (Cambridge, England: Cambridge University Press, 1991), p. 96.

43. Ibid., p. 120.

44. Stella, "My Birthplace," p. 218 below; Stella, "The Poinsettia," p. 221 below, as translated in Irma B. Jaffe, "Joseph Stella's Tropical Paintings: Ode to Nature," in *Joseph Stella: The Tropics*, exh. cat. (New York: Richard York Gallery, 1988), p. 10.

45. Stella habitually wore a rope belt and spoke with a strong southern Italian accent. Bernard Rabin, Stella's dealer after 1936, believed that Stella spoke like a southern Italian peasant in order to show that he was not ashamed of being Italian; conversation with author, June 12, 1993. As late as 1941, Harry Salpeter would note that Stella never Americanized as a person or as an artist. He seemed "still a Southern Italian, as a person and in the character of his paintings....emotionally incapable of making the adjustment and meeting the conditions which would fully qualify him [as an American artist]....After all these years in the new world, Stella appears to be fully at ease only among those who are themselves immigrants....[His] ways of dress, as of speech [are] old-fashioned, not to say anachronistic"; Harry Salpeter, "Stella: Art's Poetic Gladiator," *Esquire*, 16 (July 1941), pp. 92, 107.

46. Stella, "My Birthplace," p. 217 below.

47. For American artists visiting Italy in the late nineteenth and early twentieth centuries, see Judith Hayward, *The Italian Presence in American Art, 1860–1920*, exh. cat. (New York: Richard York Gallery, 1989).

48. Stella, "My Birthplace," p. 217 below.

49. Stella, "Nostalgia," Joseph Stella Papers, AAA; Italian text in Jaffe, *Joseph Stella*, pp. 136–37.

50. Stella, "Autobiographical Notes," p. 212 below.

51. Ibid.

52. Stella, "The New Art," p. 201 below.

53. Stella to Alfredo Schettini, n.d., Joseph Stella Papers, AAA; Italian text in Jaffe, *Joseph Stella*, pp. 142–43.

54. Ibid.

55. Bernard Rabin, conversation with the author, June 12, 1993.

56. Stella, "The New Art," p. 201 below.

57. Stella, "Autobiographical Notes," p. 212 below.

58. Most scholars have assumed that Stella did not go to Paris until February 1913, immediately before the Futurist show at Galerie Bernheim-Jeune. However, correspondence between Walter Pach and Alice B. Toklas suggests that he arrived in February 1911, after being detained for a short time by the Italian immigration office, which created some difficulty about his passport. Pach to Toklas, February 14, 1911, Walter Pach Papers, AAA.

59. Stella, "Autobiographical Notes," p. 212 below.

60. Ibid.

61. The major exhibitions of modern art presented in New York were those at Alfred Stieglitz's 291 gallery. Between January 1907, when Stieglitz showed drawings by Pamela Colman Smith, and January 1909, when Stella left for Europe, the only non-photographic shows Stieglitz mounted were one of Rodin drawings (January 1909) and another of Matisse's lithographs,

watercolors, and etchings (April 1908). None of these would have given Stella an idea about the revolutions in color and form being undertaken in Europe.

62. The aesthetics of Antonio Mancini, who befriended Stella in Rome, were limited to an Impressionist-influenced style with bright colors and broad brushstrokes.

63. For the "Section d'Or," see R. Stanley Johnson, *Cubism & La Section d'Or: Reflections on the Development of the Cubist Epoch, 1907–1922* (Chicago: Klees/Gustorf Publishers, 1991).

64. Joseph Stella, "Modern Art," Joseph Stella Papers, AAA; quoted in Jaffe, *Joseph Stella*, p. 34. Though Stein thought Stella was boisterous, he reminded her of Apollinaire, and she found both of them sarcastically witty; James R. Mellow, *Charmed Circle: Gertrude Stein & Company* (New York: Praeger Publishers, 1974), p. 181.

65. Stella, "Autobiographical Notes," p. 212 below. An unidentified writer (probably Henry McBride) indicated that Stella could not work for nearly six months after confronting Parisian modernism; judging from how little modernist art he produced, it was probably longer than this; see "Artistic Evolution of an Italo-American Painter."

66. Stella, "Autobiographical Notes," p. 212 below.

67. Ibid., p. 212 below. These same sentiments were repeated in Stella's "The New Art," p. 202 below.

68. Stella, "Notes," June 1923, p. 205 below.

69. Stella, "The New Art," p. 202 below. These ideas were also expressed in Stella, "Notes," p. 205 below; "On Painting," p. 203 below; and "Autobiographical Notes," p. 212 below.

70. Stella, "Autobiographical Notes," p. 212 below.

71. Stella, "Memories," p. 218 below. Stella was back in New York by December 1912, according to a letter that Kenneth Hayes Miller wrote to his mother, December 22, 1912, Kenneth Hayes Miller Papers, AAA.

72. "Artistic Evolution of an Italo-American Painter." For Antonio Stella's prominence within the Italian American Club, see "Antonio Stella Dies at 59 Years."

73. "Artistic Evolution of an Italo-American Painter."

74. "Joseph Stella: Painter of the American Melting-Pot," *Current Opinion*, 64 (June 1918), pp. 423–24.

75. Stella, "The New Art," p. 202 below.

76. Henry McBride, "Stella's Charcoal Drawings His Best," *The Sun*, April 11, 1913, p. 9. McBride at this date was not yet signing all articles he wrote in *The Sun*, but this review of the Italian National Club exhibition was most probably written by him.

77. For a contemporaneous discussion of Futurism, see J.A. Fitzgerald, "Flying Wedge of Futurists Armed with Paint and Brush Batters Line of Regulars in Terrific Art War," *New York Herald*, February 23, 1913. The Futurists had declined to participate in the Armory Show because they apparently wanted a separate room, feeling that it was confusing to group them among the Cubists. Also, they had several exhibition opportunities available to them in Europe, which Marinetti felt were more worthwhile than the Armory Show; see Margaret Reeves Burke, "Futurism in America, 1910–1917," Ph.D. diss. (Newark, Delaware: University of Delaware, 1986), pp. 5253.

78. For relevant reviews of the Armory Show, see "Extreme Art Draws Crowd at Opening," *New York Herald*, February 18, 1913; Fitzgerald, "Flying Wedge of Futurists."

79. For the Futurist publicity surrounding the Armory Show, see Burke, "Futurism in America," pp. 51–52.

80. Joseph Stella to Carlo Carrà, early 1920s, Joseph Stella Papers, AAA; quoted in Jaffe, *Joseph Stella*, pp. 30, 141.

81. Stella's letter to Carrà, ibid., begins, "We met at the Bernheim Gallery in Paris, at the first Futurist exhibition...and perhaps you will not remember me, as we have not seen each other again."

82. It was originally through Pach, and then de Zayas, that Severini had his exhibition at Stieglitz's 291; see Burke, "Futurism in America," p. 60; Joan M. Lukach, "Severini's 1917 Exhibition at Stieglitz's '291,'" *The Burlington Magazine*, 113 (April 1971), pp. 196–207.

83. For Stella's association with the Italian artists in Paris, see Stella, "Autobiographical Notes," p. 211 below. A further, more speculative, connection between Severini and Stella was through Paul Fort, the Symbolist poet who became Severini's father-in-law in 1913, and whom Stella saw almost every Friday at the Closerie des Lilas café in Montparnasse.

84. Severini to Pach, September 6, 1917, and Stella to Pach, July 20, 1914, Walter Pach Papers, AAA.

85. The first and second Futurist Manifestos had declared, respectively, that the world's "magnificence has been enriched by a new beauty; the beauty of speed" and that "all subjects previously

used must be swept aside in order to express our whirling life of steel, of pride, of fever and of speed"; F.T. Marinetti, "The Founding and Manifesto of Futurism" (1909), in Umbro Apollonio, ed., *Futurist Manifestos* (New York: The Viking Press, 1973), p. 21; Umberto Boccioni, Carlo Carrà, Luigi Russolo, Giacomo Balla, and Gino Severini, "Futurist Paintings: Technical Manifesto" (1910), ibid., p. 30.

86. For physical transcendentalism, see Umberto Boccioni, Carlo Carrà, Luigi Russolo, Giacomo Balla, and Gino Severini, "The Exhibitors to the Public" (1912), ibid., p. 48.

87. Ibid., p. 49.

88. Boccioni, quoted in Joshua C. Taylor, *Futurism*, exh. cat. (New York: The Museum of Modern Art, 1961), p. 35.

89. Aaron Sheon, "1913: Forgotten Cubist Exhibitions in America," *Arts Magazine*, 57 (March 1983), p. 100.

90. Francis Picabia, "How New York Looks to Me," *New York American*, March 30, 1913.

91. Ibid.

92. Ibid.

93. Stella, "I Knew Him When," p. 206 below.

94. Ibid.

95. Stella, "Memories," p. 218 below.

96. Coney Island was identified as the quintessential American symbol by others. In Jules Huret's *L'Amérique moderne* (1910–11), a view of Coney Island was included because it demonstrated that Americans amused themselves in the same energetic, frenzied way that they worked; see Burke, "Futurism in America," p. 110. When Maxim Gorky saw Coney Island on his visit to America, his response matched Stella's: "With the advent of night a fantastic city all of fire suddenly rises from the ocean into the sky....Fabulous beyond conceiving, ineffably beautiful, is this fiery scintillation"; quoted in Edo McCullough, *Good Old Coney Island: A Sentimental Journey into the Past* (New York: Charles Scribner's Sons, 1957), p. 315.

97. Walter Pach, "The Point of View of the 'Moderns,'" *The Century*, 87 (April 1914), n.p.

98. Quoted in Apollonio, *Futurist Manifestos*, p. 22.

99. Stella, "New York Interpreted," unpublished manuscript, Bernard Rabin Papers, Cranberry, New Jersey.

100. For these exhibitions of modernist work, see Sheon, "1913: Forgotten Cubist Exhibitions in America."

101. Stella's works in the Pittsburgh show were *Battle of Lights No. 1, Coney Island Mardi Gras; Battle of Lights No. 2, The White Way; Battle of Lights No. 3, Coney Island, The Towers.* In addition to these oils, Stella also included pastel drawings in the Montross Gallery show.

102. The hypothesis is that the picture was not finished when the Montross catalogue went to press and that Stella had a large photograph of it taken in its incomplete state, which he drew on in ink to provide the main features of the composition. The reworked photograph was used for publication. The reproduced work does not echo, in every detail, the finished oil. The size of the signature on the drawing suggests a work no smaller than several feet across. This proposal was first made in Eleanor S. Apter, Robert L. Herbert, and Elise K. Kenney, *The Société Anonyme and the Dreier Bequest at Yale University: A Catalogue Raisonné* (New Haven: Yale University Press, 1984), p. 629.

103. Pach, "The Point of View of the 'Moderns,'" n. p.

104. Quoted in Apollonio, *Futurist Manifestos*, p. 28.

105. "'Faddists' at Montross Gallery," *American Art News*, February 7, 1914, p. 3.

106. "Notes of the Art World," *New York Herald*, February 24, 1914, p. 9.

107. Henry McBride, "At the Montross Gallery," *The Sun*, February 8, 1914, p. 2; reprinted in Daniel Catton Rich, ed., *The Flow of Art: Essays and Criticisms of Henry McBride* (New York: Atheneum Publishers, 1975), p. 52.

108. "'Faddists' at Montross Gallery," p. 3.

109. "New York Galleries Show Modernist Art," *The Christian Science Monitor*, February 14, 1914, p. 11.

110. "'Faddists' at Montross Gallery"; Frederick James Gregg, "Interesting Exhibition of Modern Art Shows a Reaction from Modernism," *The New York Herald*, November 17, 1918, section 3, p. 3.

111. Ibid. That the joke referred to Stella's painting is clear from Fornaro, "Joseph Stella," p. 35.

112. Pach, "The Point of View of the 'Moderns,'" n. p.

113. For Stella's price, see Walter Pach's notations in the catalogue of the Montross Gallery exhibition, Walter Pach Papers, AAA.

114. Several commentators have suggested that Stella's more abstract Futurist work was influenced by Severini's exhibition at 291 in 1917. While it is true that Severini's style became more classical, it echoed rather than anticipated the shift in Stella's, which, by 1917, had moved beyond Futurism into other arenas.

115. Stella, "Autobiographical Notes," p. 215 below.

116. Stella noted that *Spring* was—like *Dance of Spring*—based on the "lyricism of the Italian Spring"; see his handwritten addition to the manuscript for "Autobiographical Notes," Joseph Stella Papers, AAA. The painting appeared in the 1921 Whitney Studio Club show as *Spring Procession* and was referred to in correspondence with Katherine Dreier as *Spring*; Stella to Dreier, February 8, 1942, Société Anonyme Papers, Beinecke Rare Book and Manuscript Library, Yale University, New Haven.

117. "New York Art Exhibits and Gallery News: Fifty Moderns at Montross's," *The Christian Science Monitor*, February 19, 1916.

118. Stella to Conger Goodyear, n.d., Joseph Stella Papers, AAA.

119. In the early 1920s, Stella wrote that "Art with thesis is bound to decay and death....History proves that all art definitions and theories are absurdities"; see "Notes," p. 206 below.

120. Quoted in "Artistic Evolution of an Italo-American Painter," p. 11.

121. Stella to Pach, Walter Pach Papers, AAA. Stella says that he had written to the Futurist center in Milan, a reference to the Futurist headquarters Marinetti established in his home.

122. *Detroit Sunday Times*, August 3, 1914.

123. Taylor, *Futurism*, p. 13.

124. For discussion of the parallel between music and art, see Howard Risatti, "Music and the Development of Abstraction in America: The Decade Surrounding the Armory Show," *Art Journal*, 39 (Fall 1979), pp. 8–13.

125. Stella echoed these ideas throughout his career. Bernard Rabin noted that Stella repeatedly identified his artistic goals as the interpretation of sound in pigment; conversation with the author, July 23, 1993. On the relationship between music and art, Picabia declared that "the attempt of art is to make us dream, as music does. It expresses a spiritual state..."; quoted in Risatti, "Music and the Development of Abstraction in America," p. 10.

126. Arthur Dove, 1929, quoted in Barbara Haskell, *Arthur Dove*, exh. cat. (San Francisco: San Francisco Museum of Art, 1975), p. 135. For a discussion of Max Weber in this context, see Burke, "Futurism in America," p. 129.

127. Quoted in Risatti, "Music and the Development of Abstraction in America," p. 12.

128. Ibid.

129. See "Exhibition of Modernist Paintings at Montross Galleries Includes Many Interesting Productions," *The New York Times*, February 8, 1914, p. 15; James Britton, "The 'Fifty' at Montross's (By the Second Viewer)," *American Art News*, February 19, 1916, p. 6.

130. "Exhibition of Modernist Paintings at Montross Galleries," p. 15.

131. Stella, "For the American Painting," p. 210 below.

132. It is tempting to link Stella's Symbolist works to those of Redon, for both artists desired to create a dream world of the imagination. However, although Stella would have known Redon's work from the Armory Show, where it was viewed with great favor by the press, there is no indication that Stella was particularly drawn to it.

133. Stella, "Notes," p. 205 below.

134. Ibid.

135. For the color symbolism of the Futurists, see Carlo Carrà, "Futurist Manifesto, Milan," August 11, 1913, reprinted in Pontus Hulten, *Futurismo & Futurismi* (Venice: Palazzo Grassi, Società Azione Palazzo Grassi, 1986), pp. 443–44.

136. Stella, "Autobiographical Notes," p. 213 below.

137. Stella, "Questionnaire," p. 208 below; Stella, "The BROOKLYN BRIDGE (A Page of My Life)," p. 206 below.

138. It was probably Pach who took Stella to meet the Arensbergs just as he took Duchamp there immediately after his ship docked in New York. For the Arensberg circle, see Francis Naumann, "Cryptography and the Arensberg Circle," *Arts Magazine*, 51 (May 1977), pp. 127–33; Patrick L. Stewart, "The European Art Invasion: American Art and the Arensberg Circle, 1914–1918," ibid., pp. 108–12.

139. For Stella's participation in the purchase of the urinal, see William Camfield, "Duchamp's Fountain: Aesthetic Object, Icon, or Anti-Art?," in Thierry de Duve, ed., *The Definitively Unfinished Marcel Duchamp* (Halifax: Nova Scotia College of Art and Design, 1991), p. 136. For the Society of Independent Artists, see Robert K. Tarbell, "The Society of Independent Artists," in

Avant-Garde Painting & Sculpture in America 1910–25, exh. cat. (Newark, Delaware: Delaware Art Museum, 1975), p. 25.

140. The label "Dada" was only introduced in 1921 and then just for the one issue of the magazine *New York Dada* and the lecture "What Is Dadaism?" organized by the Société Anonyme in April 1921. The "official" existence of the movement was brief, lasting only through the summer of 1921, when Duchamp and Man Ray left New York for Paris. Its impact, however, extended well into the 1920s.

141. Margery Rex, "'Dada' Will Get You If You Don't Watch Out: It Is on the Way Here," *The New York Evening Journal*, January 29, 1921; reprinted in Rudolf E. Kuenzli, ed., *New York Dada* (New York: Willis Locker & Owens, 1986), pp. 138–39.

142. For a contemporary account of the lecture, see an unidentified newspaper account quoted in Francis Naumann, "The New York Dada Movement: Better Late Than Never," *Arts Magazine*, 54 (February 1980), p. 146.

143. As described in the press, "Joseph Stella, the cubist, was seated in the center of the room with a group of friends and apparently found it difficult to take this seriously. The lady who was reading from Swinburne broke off suddenly and said, 'I wish that fat man,' indicating Mr. Stella, 'would say something. He has been annoying me during my reading by laughing'"; quoted in Naumann, "The New York Dada Movement," p. 146.

144. *New York Dada*, edited by Marcel Duchamp and Man Ray, appeared in April 1921. It consisted of a cover and four pages with photography by Alfred Stieglitz and writings by various people, including Tristan Tzara.

145. The other two leaders were Man Ray and Edgard Varèse; see Alfred Kreymborg, "Dada and the Dadas," *Shadowland*, 7 (September 1922), p. 43.

146. Herbert, Apter, Kenney, *The Société Anonyme*, p. 626. Stella joined Duchamp and Dreier in a question-and-answer period after a series of three lectures, sponsored by the Société Anonyme, given by Dreier, ibid., p. 5.

147. Stella showed regularly with Stephan Bourgeois, a collector who had lent works to the Armory Show and who opened a gallery in early 1914 to handle "old and modern masters." He showed Seurat and Van Gogh but was particularly responsive to the artists who gathered around Arensberg, exhibiting the works of Marcel Duchamp and Jean Crotti. Stella also participated with the Dadaists at the McClees Gallery in Philadelphia in 1916, in a show organized, in part, by Morton Schamberg. The exhibition included Crotti's *Mechanical Forces of Love in Movement*, Duchamp's *King and Queen Surrounded by Swift Nudes*, Picabia's *New York*, and Man Ray's *Nativity*. I am grateful to Francis Naumann for bringing this show to my attention.

148. Stella, "On Painting," p. 203 below. See also Stella's remarks quoted in n. 119 above.

149. For Hartley, see "The Importance of Being 'Dada,'" in Marsden Hartley, *Adventures in the Arts* (New York: Boni and Liveright, 1921), p. 249. Stella's remarks are quoted in Rex, "'Dada,'" p. 140.

150. Man Ray, *Self Portrait* (Boston: Little, Brown and Company, 1963), p. 93.

151. It has been assumed until now that Stella did not begin his glass paintings until 1917–18. However, two examples were included in the April 1916 exhibition at the Bourgeois Galleries, as well as at the McClees Gallery the following month.

152. "If only America would realize," Duchamp exhorted, "that the art of Europe is finished—dead—and that America is the country of the art of the future instead of trying to base everything she does on European traditions!"; "The Iconoclastic Opinions of M. Marcel Duchamp Concerning Art and America," *Current Opinion*, 59 (November 1915), p. 346, quoted in Dickran Tashjian, *Skyscraper Primitives: Dada and the American Avant-Garde, 1910–1925* (Middletown, Connecticut: Wesleyan University Press, 1975), p. 50.

153. Harold Loeb, "Foreign Exchange," *Broom*, 2 (May 1922), p. 178.

154. Sidney Allan [Sadakichi Hartmann], "The 'Flat-iron' Building—An Esthetical Dissertation," *Camera Work*, no. 4 (October 1903), p. 40.

155. Stieglitz, quoted in Dorothy Norman, *Alfred Stieglitz: An American Seer* (New York: Random House, 1973), p. 45. For turn-of-the-century artists depicting urban subjects, see Karen Lucic, *Charles Sheeler and the Cult of the Machine* (Cambridge, Massachusetts: Harvard University Press, 1991), p. 26; Wanda Corn, "The New New York," *Art in America*, 61 (July–August 1973), pp. 59–65; and Donald Kuspit, "Individual and Mass Identity in Urban Art," pp. 67–77. Kuspit argues (p. 68) that the traditional manner in which these artists treated untraditional subjects suggested a resentment of and estrangement from modernity.

156. Quoted in "French Artists Spur on an American Art," *New York Tribune*, October 24, 1915, section 4, p. 2. For the entire text of this article, see Kuenzli, *New York Dada*, pp. 128–35.

157. Duchamp, "The Richard Mutt Case," *The Blind Man*, no. 2 (May 1917), p. 5.

158. Quoted in "French Artists Spur on an American Art," p. 2; Kuenzli, *New York Dada*, p. 130.

159. R[obert] J. Coady, "American Art," *The Soil*, 1 (December 1916), p. 3; *The Soil*, 1 (January 1917), p. 55.

160. Romain Rolland, "America and the Arts," *The Seven Arts* (November 1916), pp. 47–51.

161. William Carlos Williams, "America, Whitman, and the Art of Poetry," *The Poetry Journal*, 8 (November 1917), pp. 27–36.

162. For a general discussion of the esteem with which Whitman was held in Italy, see Charles S. Grippi, "The Literary Reputation of Walt Whitman in Italy," Ph.D. diss. (New York: New York University, 1971).

163. Stella, "The BROOKLYN BRIDGE (A Page of My Life)," p. 206 below.

164. Stella, "My Sermon About Christ," p. 215 below.

165. Carlo de Fornaro recorded that Antonio Stella had accepted as true the implicit criticisms of Stella in the *New York Herald* (Frederick James Gregg, "Interesting Exhibition of Modern Art Shows a Reaction from Modernism," *New York Herald*, November 17, 1918, pp. 3–4) and had cited it as proof that Stella was an artistic failure; Fornaro, "Joseph Stella," p. 37.

166. Ibid. Although Stella chafed at his brother's success and was convinced that it was he, as an artist, who would be remembered by posterity, he was not unmindful of his brother's support. The first edition of his privately printed monograph *New York*, which appeared in 1928, a year after his brother's death, was dedicated "to Dr. Antonio Stella."

167. Stella, "Autobiographical Notes," p. 213 below.

168. Frederic C. Howe, "Turned Back in Time of War: Ellis Island Under War Conditions," *The Survey*, 36 (May 6, 1916), p. 152.

169. The magazine's goal was implied in its statement that it wanted to show "incidentally how Slav and Italians, foreign born and native born, have worked shoulder to shoulder"; *The Survey*, 41 (November 30, 1918), p. 262.

170. Rolland, "America and the Arts," p. 50.

171. "Bethlehem," *The Survey*, 41 (February 1, 1919), p. 617.

172. Ibid.

173. Stella, "Pittsburgh Notes," p. 204 below.

174. Stella, "The BROOKLYN BRIDGE (A Page of My Life)," p. 206 below.

175. Ibid.

176. Ibid., and Stella to Mr. Henchel, January 7, 1943, Joseph Stella Papers, AAA.

177. Stella, "The BROOKLYN BRIDGE (A Page of My Life)," p. 206 below.

178. Ibid., p. 207 below.

179. Stella, "Autobiographical Notes," unpublished version, Joseph Stella Papers, AAA.

180. Martin Filler, "The Brooklyn Bridge at 100," *Art in America*, 71 (Summer 1983), p. 142. For a discussion of the mythology of the Brooklyn Bridge, see Filler's essay and Alan Trachtenberg, *Brooklyn Bridge: Fact and Symbol* (Chicago: The University of Chicago Press, 1965).

181. Quoted in Filler, "The Brooklyn Bridge at 100," p. 148, from Mumford, *The Myth of the Machine: The Pentagon of Power* (1970).

182. See Apollonio, *Futurist Manifestos*, p. 28.

183. Allan [Hartmann], "The 'Flat-Iron' Building," pp. 38–39.

184. Quoted in Tashjian, *Skyscraper Primitives*, p. 128.

185. Quoted in Naumann, "The New York Dada Movement," p. 148.

186. Edmund Wilson, Jr., "The Aesthetic Upheaval in France," *Vanity Fair*, 18 (February 1922), p. 100.

187. Waldo Frank, "Vicarious Fiction," *The Seven Arts*, 1 (January 1917), p. 294.

188. The December 1921 issue of *Broom* reproduced three Stella paintings and published his essay "On Painting."

189. Quoted in Irma B. Jaffe, "Joseph Stella and Hart Crane: The Brooklyn Bridge," *The American Art Journal*, 1 (Fall 1969), p. 107.

190. Hamilton Easter Field, "Joseph Stella's Brooklyn Bridge," *The Brooklyn Daily Eagle*, April 1, 1920.

191. "Notes Concerning Current Displays," *The Sun*, April 13, 1946; Alfred M. Frankfurter, "O Pioneers!" *Art News*, 45 (April 1946), p. 35.

192. In 1920 Stella told a reporter that as he "moved like an atom amidst its [the bridge's] colossal network...I said to myself, 'This is America. This is what, some day, somehow, must find expression in our modern art'"; "Joseph Stella, Futurist," *The Christian Science Monitor*, April 5, 1920, p. 14. In a later letter, he was still referring to the bridge as "the testimonials offered by the American civilization"; Stella to Conger Goodyear, n.d., Joseph Stella Papers, AAA.

193. This painting was originally shown at the Société Anonyme, New York, in January–February 1923 as *New York Interpreted*. In an article in *The Survey*, 49 (November 1, 1922), it was cited as *Voice of the City*. Stella referred to it in the handwritten version of his autobiography as *New York Interpreted* or *The Voice of the City*; Joseph Stella Papers, AAA.

194. For a full compositional analysis of the panels, see Wanda Corn, "In Detail: Joseph Stella and *New York Interpreted*," *Portfolio*, 4 (January–February 1982), pp. 40–45.

195. In 1925, at a lecture at the Philadelphia Art Center, Stella noted that "advertising with its lights and color has made Broadway the realization of the artists' dreams. There are no calms here. This fairyland must be painted by the modernists"; *Bulletin of the Art Center*, 3 (June 1925), p. 271.

196. Quoted in Corn, "In Detail," p. 44.

197. Joseph Stella, "The BROOKLYN BRIDGE (A Page of My Life)," p. 207 below.

198. Stella, "Autobiographical Notes," p. 214 below.

199. Lozowick epitomized the confident attitude artists had toward the machine age: "beneath all the apparent chaos and confusion is...order and organization which find their outward sign and symbol in the rigid geometry of the American city"; Lozowick, "The Americanization of Art," *The Little Review*, 12 (May 1927), supplement, p. 18.

200. Quoted in Constance Rourke, *Charles Sheeler: Artist in the American Tradition* (New York: Harcourt, Brace and Company, 1938), p. 130. The idolization of the machine during the 1920s was exemplified by Calvin Coolidge's statement: "The man who builds a factory builds a temple. The man who works there worships there"; quoted in Lucic, *Charles Sheeler*, p. 188. Lucic provides a full discussion of the religious reading of the machine; see also Susan Fillin-Yeh, "Charles Sheeler and the Machine Age," Ph.D. diss. (New York: The Graduate Center, City University of New York, 1981).

201. For an analysis of Hart Crane's "The Bridge," see Tashjian, *Skyscraper Primitives*, pp. 143–64, and Trachtenberg, *Brooklyn Bridge*, pp. 143–65.

202. Tashjian, *Skyscraper Primitives*, pp. 154, 153.

203. As early as 1923, Crane had thanked *Secession* editor Gorham Munson for his suggestion that the "mechanical manifestations" of today be used as subjects for "lyrical, dramatic, and even epic poetry"; see George Knox, "Crane and Stella: Conjunction of Painterly and Poetic Worlds," *Texas Studies in Literature and Language*, 12 (Winter 1971), p. 697.

204. Crane, quoted in Tashjian, *Skyscraper Primitives*, pp. 149, 150.

205. For Stella's purported influence on Crane, see Jaffe, "Joseph Stella and Hart Crane."

206. For some reason, Stella's painting was replaced by Walker Evans' photograph of the Brooklyn Bridge in the final layout of the book.

207. Quoted in Knox, "Crane and Stella," p. 692.

208. Quoted in Jaffe, "Joseph Stella and Hart Crane," p. 109; Bruno Barilli, "Stella," *L'Ambrosiano*, September 8, 1929.

209. Quoted in Tashjian, *Skyscraper Primitives*, p. 119.

210. Henry McBride, "Modern Art," *The Dial*, 74 (April 1923), p. 423.

211. These charcoal drawings are undated. I have assumed on the basis of their style that Stella executed them between 1918 (one was published on the cover of *The Survey*, 41 [February 1, 1919]) and March 1924, when *The Survey*'s "Giant Power" project began. They appeared in a number of exhibitions soon after this. Although these charcoal drawings resemble certain of the anonymous photographs that appeared alongside Stella's *Pittsburgh Survey* illustrations published in *Charities and The Commons* in 1909, it is less likely that he used these photographs as sources than that he traveled to the same or similar industrial sites in Pennsylvania for the later commission.

212. "International Show of Black and Whites," *New York Sun*, undated clipping (c. 1924), Joseph Stella artist's file, Whitney Museum of American Art.

213. Ibid.

214. Stella, "Life Notes," p. 204 below.

215. Stella, "The BROOKLYN BRIDGE (A Page of My Life)," p. 207 below.

216. Stella, "Notes," see p. 205 below.

217. Stella, "Autobiographical Notes," see p. 213 below.

218. Stella, "Thoughts, II," p. 220 below, and "Pensieri," quoted in Jaffe, *Joseph Stella*, p. 149: "Perchè la nostra giornata scorra serena e lucida, bisogna iniziarla con lo studio di un fiore."

219. Stella, "Thoughts, II," p. 220 below; see also the related text in "Pensieri," quoted in Jaffe, *Joseph Stella*, p. 149.

220. Stella, "L'albero della mia vita," translated in Jaffe, *Joseph Stella*, p. 84.

221. Ibid.

222. Stella, "Autobiographical Notes," see p. 214 below.

223. Stella wrote to Katherine Dreier in 1939 that he had executed the first version of *The Heron* in 1918, but in a 1942 letter to her he gave 1922 as the year; Stella to Dreier, July 7, 1939, and Stella to Dreier, February 2, 1942, Société Anonyme Papers, Beinecke Rare Book and Manuscript Library, Yale University, New Haven. The painting was included neither in his 1920 retrospective at the Bourgeois Galleries nor in his 1921 mini-retrospective at the Whitney Studio Club. Every other painting of importance was. This, coupled with the painting's stylistic affinity to works from 1922, suggests that Stella completed it in that year, shortly before Dreier purchased it from him.

224. For this view of flower painting in America, see Ella M. Foshay, *Reflections of Nature: Flowers in American Art*, exh. cat. (New York: Whitney Museum of American Art, 1984), pp. 55–57.

225. Stella, "Confession," p. 220 below.

226. For a full discussion of Stella's silverpoint technique, see Bruce Weber, "Silverpoint Drawing," *American Artist*, 50 (March 1986), pp. 36–39, 77; Jane Glaubinger, "Two Drawings by Joseph Stella," *The Bulletin of The Cleveland Museum of Art*, 70 (December 1983), pp. 382–95.

227. Stella, "Autobiographical Notes," p. 214 below.

228. It was Bernard Rabin, conversation with the author, July 17, 1993, who recalled Stella's remark. Stella's attitude, while similar to that of his friend Duchamp (who also masked himself and was reticent about revealing his personality), relied more upon prevarication and exaggeration. For example, Stella's report to August Mosca that he and his wife had had a child who died several years after birth is a tale that family members and friends such as Bernard Rabin believe to be false. The absence of any birth or death records confirms its falsehood.

229. "Matisse told him [Stella] he was the most sensitive draughtsman and colorist of any artist in Paris or America he had ever seen"; August Mosca, "Memories of Joseph Stella," p. 2.

230. For example, Stella's family never met his wife and there is uncertainty among them about whether she was mulatto or English. Carlo de Fornaro, his purported friend and biographer, never even knew he was married.

231. The Franciscan literature found among Stella's papers included a copy of *Frate Francesco, Rivista di Coltura Francescana*, Milan, March–April 1929 and Italian newspaper clippings about St. Francis; Jaffe, *Joseph Stella*, p. 252 n. 13.

232. The allusions in "macchine naturale" have been discussed by Joann Moser, "The Collages of Joseph Stella: *Macchie/Macchine Naturali*," *American Art*, 6 (Summer 1992), pp. 62–63. She notes that eliminating the "n" in "macchine" yields the Italian word "macchie," plural of "macchia," which means spot or fragment, something accidental or produced by chance. As Moser hypothesizes, Stella undoubtedly understood the further intellectual word play that the simple deletion of the letter "n" engendered; "macchia" is the root of Macchiaioli, the group of mid-nineteenth-century Italian painters known for intimate landscapes of the Italian countryside, small in scale, unfinished in appearance, and dependent on the effects of nature for inspiration.

233. For an analysis of *The Bookman* as an abstract portrait of Burton Rascoe, I am indebted to Moser, "The Collages of Joseph Stella," p. 67.

234. Stella's collages were unknown until 1960–61, when they were included in a show at the Zabriskie Gallery and in The Museum of Modern Art's exhibition "The Art of Assemblage." Virginia Zabriskie titled them in the order that they were received into the gallery; Andrew Crispo, who bought a large number from Stella's friend Mosca in the 1970s, did the same.

235. Moser, "The Collages of Joseph Stella," p. 60.

236. Stella, "Autobiographical Notes," p. 215 below.

237. Regarding Oriental connections, see Jaffe, *Joseph Stella*, p. 107, who interpreted Lachaise's friendship with Ananda Coomaraswamy as an influence upon Stella. That this second-hand friendship was less an influence on Stella than was his Italian heritage is corroborated by his exclusion of Oriental art from what he called his "Sacred Trinity of Art," which included Egyptian, Greek, and Italian art; Stella, "La mostra di maestri italiani: capolavori impareggiabili," *Corriere d'America*, February 11, 1940.

238. See Henry McBride, "Joseph Stella's Startling Art," *The New York Sun*, April 11, 1925; Review, *The New York Times Magazine*, April 12, 1925, p. 19.

239. For discussion of the classical revival in Europe, see Elizabeth Cowling and Jennifer Mundy, *On Classic Ground: Picasso, Léger, de Chirico and the New Classicism 1910–1930*, exh. cat. (London: The Tate Gallery, 1990). Stella articulated his appreciation for Italian art in two published articles that he wrote in *Corriere d'America*: "La mostra di maestri italiani," February 11, 1940, and "I capolavori italiana all' 'Arte Moderna,'" February 18, 1940.

240. Stella, "Notes," p. 205 below.

241. Ibid.

242. Ibid.; "Questionnaire," p. 208 below.

243. "Stella, Dicksee and Watrous," *The Art News*, 26 (February 4, 1928), p. 9.

244. Stella designed the set for Maeterlinck's *Tree of My Life* in March 1923. For the Norodny production, see Stella to Dreier, July 26, 1923, Société Anonyme Papers, Beinecke Rare Book and Manuscript Library, Yale University, New Haven.

245. Stella, "The Poinsettia," p. 221 below.

246. August Mosca, "Memories of Joseph Stella," p. 5.

247. Bernard Rabin, interview by "TBW," February 21, 1970, transcript, p. 5, Bernard Rabin Papers, Cranberry, New Jersey.

248. To some extent, Stella's attitudes about sex echoed those of Marinetti, who confused sex and violence; see Hulten, *Futurismo & Futurismi*, p. 19.

249. Stella, "Budding Passion," as translated in Jaffe, "Joseph Stella's Tropical Paintings," p. 16; see also p. 218 below.

250. Stella, "Birth of Venus," see p. 209 below.

251. The ubiquity of Freudian interpretation is epitomized in the ironic complaint of Susan Glaspell, a Greenwich Village habitué, that "you could not go out to buy a bun without hearing of someone's complex"; quoted in Glaspell, *The Road to the Temple* (New York: Frederick A. Stokes Company, 1927), p. 250.

252. "Art," *The New Yorker*, April 18, 1925, p. 17.

253. For Picasso, see Stella to Dreier, undated, Société Anonyme Papers, Beinecke Rare Book and Manuscript Library, Yale University, New Haven; for Augustus John, see "Art," *The New Yorker*, April 18, 1925, p. 17.

254. McBride, "Joseph Stella's Startling Art."

255. For Dudensing as an advocate, see *The New Yorker*, May 2, 1925, p. 17; for Dudensing's talk of Stella, see "Art," *The New Yorker*, March 14, 1925.

256. Dreier to Duchamp, June 19, 1925, Société Anonyme Papers, Beinecke Rare Book and Manuscript Library, Yale University, New Haven; McBride, "Joseph Stella's Startling Art."

257. Henry McBride, "Daring Work of Joseph Stella Seen as an Effort to Interpret Ideals of the Time," *The New York Sun*, April 17, 1926.

258. "A Vision of Color," *The New York Times*, April 18, 1926, p. 15.

259. Stella, "Autobiographical Notes," p. 215 below.

260. Stella, "Questionnaire," p. 207 below.

261. Stella to Edith (last name unknown), March 30, 1929, Société Anonyme Papers, Beinecke Rare Book and Manuscript Library, Yale University, New Haven.

262. Stella to Dreier, September 26, 1926, Société Anonyme Papers, Beinecke Rare Book and Manuscript Library, Yale University, New Haven.

263. Stella to Weeks, September 19, 1925, Carl Weeks Papers, Iowa State Education Association, Des Moines.

264. Henry McBride, "Modern Art," *The Dial*, 84 (June 1928), p. 535.

265. McBride, "Daring Work of Joseph Stella," for example, commented that *Apotheosis of the Rose* "is so unquestionably exotic that my mind wavered between St. Rose of Lima and the new religion that D.H. Lawrence says...is being planted upon Mexico. For a land in search of a new religion, and more especially a religion stuffed with symbols and thus appealing to artistic natures, the State of Mexico it seems to me could easily do worse than to adopt this Stella panel as is."

266. For dual qualities of Christianity and paganism, see Antonio Porpora, "Giuseppe Stella: Un pittore futurista di Basilicata a New York," *La Basilicata nel Mondo*, 3 (September 1926), p. 230.

267. Stella, "Autobiographical Notes," p. 215 below.

268. Stella, "For the American Painting," p. 211 below.

269. Giovanni Artieri, "Cronache napoletani," *Emporium*, 69 (June 1929), p. 379.

270. "Mostra del pittore Giuseppe Stella," *La Tribuna*, May 18, 1929.

271. Stella to Weeks, June 1, 1929. Demuth voiced a similar refrain: "America doesn't really care—still, if one is really an artist and at the same time an American, just this not caring, even though it drives one mad, can be artistic material;" Demuth to Stieglitz, August 15, 1927, Stieglitz Collection, Collection of American Literature, Beinecke Rare Book and Manuscript Library, Yale University, New Haven.

272. Stella to Ferdinando Santoro, 1928; quoted in Jaffe, *Joseph Stella*, p. 109.

273. Edward Alden Jewell, "New Colors in Stella's Palette," *The New York Times*, December 3, 1931, p. 32.

274. Bernard Rabin, conversation with the author, June 13, 1993; August Mosca, conversation with the author, April 20, 1993; Edgard Varèse, quoted in Jaffe, *Joseph Stella*, pp. 2–3. Being Stella's friend was often a one-sided affair. Mosca recalled an incident involving his own exhibition

at the Rabin and Krueger Gallery, Newark, in 1942. In conjunction with the show, Stella wrote an article on Mosca's work. But it was so unenthusiastic that Mosca told Stella that what he had written was worse than his not having written at all.

275. Mosca, "Memories of Joseph Stella," p. 8.

276. [Hamilton Easter Field], "Joseph Stella," *The Arts*, 2 (October 1921), p. 26.

277. Quoted in Jaffe, *Joseph Stella*, p. 113.

278. Stella to Dreier, July 7, 1939, Société Anonyme Papers, Beinecke Rare Book and Manuscript Library, Yale University, New Haven.

279. Betty Foster (Vytlacil) to her mother, January 26, 1932, courtesy Martin Diamond. For other accounts of the fight, see Jaffe, *Joseph Stella*, p. 113; Samuel Putnam, *Paris Was Our Mistress: Memoirs of a Lost & Found Generation* (New York: The Viking Press, 1947), p. 4; Meyer and Eli Levin, "Stella: Portrait of a Modern," *The Sunday Star-Ledger, Every Week Magazine*, October 4, 1956, p. 6; *Paris Tribune*, January 24, 1932, p.1.

280. Stella to Harry Salpeter, February 20, 1941, Joseph Stella Papers, AAA.

281. As documentation for his application for passport extension, Stella cited a letter from de Vecchi di Val Cismon, which asserted that the exhibition was representative of the art of Fascist Italy; de Vecchi di Val Cismon to Stella, October 20, 1932, U.S. Department of State, Passport Services.

282. Arturo Lancellotti, "Mussolini ha salvato gli emigranti (Conversazione col pittore Joseph Stella)," unidentified, undated clipping, Joseph Stella Papers, AAA.

283. In 1926, 1928, and 1930, Stella received passport extensions for the maximum of two years. Probably due to tensions in Europe, when he applied for extensions on July 27, 1932, and again on August 2, 1933, the passports were only extended for a year at a time; passport application, Joseph Stella artist's file, Whitney Museum of American Art.

284. See Mosca, "Memories of Joseph Stella," p. 6.

285. Reportedly, French was born in Barbados and came to America, settling in Philadelphia when she was in her teens. She supposedly lived with several of her siblings. Mary French died in Barbados on November 29, 1939; see Jaffe, *Joseph Stella*, p. 96. No marriage or divorce records were found relating to Stella and Mary Geraldine Walter French.

286. Lewis Mumford, "The Art Galleries: Americans and Americana," *The New Yorker*, January 19, 1935, p. 70.

287. Quoted in Jaffe, *Joseph Stella*, p. 116; Fornaro, "Joseph Stella," p. 74.

288. Mosca, "Memories of Joseph Stella," p. 6.

289. McBride, "Modern Art," *The Dial*, 74 (April 1923), p. 423.

290. Stella to Conger Goodyear, n.d., Joseph Stella Papers, AAA.

291. Holger Cahill later referred to Stella's requests to go to the tropics; Cahill to Stella, July 13, 1937, Joseph Stella Papers, AAA.

292. Cahill to Stella, July 1, 1937, Bernard Rabin Papers, Cranberry, New Jersey. Earlier, Cahill had expressed similar sentiments in another letter to Stella, November 12, 1935, Joseph Stella Papers, AAA.

293. Quoted in Helen Lorenz Williams, "Joseph Stella's Art in Retrospect," *International Studio*, 84 (July 1926), p. 76.

294. John Simon Guggenheim Memorial Foundation, New York, Fellowship Application Forms, Joseph Stella, completed October 1935; copy in the Joseph Stella artist's file, Whitney Museum of American Art.

295. Quoted in Jaffe, *Joseph Stella*, p. 116.

296. Stella continued to support his wife financially until her death in November 1939, although he never saw her again.

297. Hilton Kramer, "The Other Stella: The 'Tropics' Reveals an Artist We Hardly Knew," *Art & Antiques*, 6 (January 1989), p. 98.

298. Stella, "The Poinsettia," p. 221 below.

299. Hilton Kramer, "Art: Joseph Stella, A Puzzling Show," *The New York Times*, February 8, 1977.

300. Stella to Valentine Dudensing, December 3, 1938, Joseph Stella Papers, AAA.

301. Bernard Rabin, conversation with the author, July 7, 1993.

302. "Fifty-Seventh Street in Review: The Need for Self-Editing," *The Art Digest*, 15 (January 15, 1941), p. 18.

303. Henry McBride, "Joseph Stella's Power," *The New York Sun*, January 11, 1941.

304. Stella's claim was reported by August Mosca to Emily Genauer, October 28, 1963, August Mosca Papers, AAA.

305. The words are Marsden Hartley's: "[Painting] is essentially a paroxysm of intelligence coupled with orgiastic delivery"; quoted in Barbara Haskell, *Marsden Hartley*, exh. cat. (New York: Whitney Museum of American Art," 1980), p. 60.

306. Charmion von Wiegand, "Opinions Under Postage" (letter), *The New York Times*, February 23, 1941.

307. Stella to McBride, April 21, 1941, Bernard Rabin Papers, Cranberry, New Jersey.

308. Stella to Barr, April 20, 1941, Bernard Rabin Papers, Cranberry, New Jersey; Stella to McBride, April 21, 1941, Henry McBride Papers, Beinecke Rare Book and Manuscript Library, Yale University, New Haven.

309. Henry McBride, "Joseph Stella," in *Joseph Stella: Exhibition of Paintings*, exh. cat. (New York: Knoedler Galleries, 1942).

310. Stella to Mosca, September 2, 1942, Joseph Stella Papers, AAA.

311. The surgical operative sheet from The New York Hospital, April 27, 1945, reported that Stella fractured his "right humerus, right radius, and right os magnum"; Joseph Stella Papers, AAA.

312. Kramer, "The Other Stella," p. 97.

313. John Canaday, "Stella Versus Stella," *The New York Times*, October 27, 1963. Canaday's other review of the exhibition, "Art: Works of Joseph Stella Seen in Retrospect," *The New York Times*, October 23, 1962, was equally negative.

314. Wiegand, "Opinions Under Postage."

Selected Writings

The writings are published here in chronological order; the group beginning with "Jottings" (p. 215), however, is undated. The idiosyncrasies of Stella's orthography and English usage have been retained. In the citations of sources, AAA, JSP = Archives of American Art, Smithsonian Institution, Washington, D.C., Joseph Stella Papers; Jaffe = Irma B. Jaffe, Joseph Stella (Cambridge, Massachusetts: Harvard University Press, 1970). Many of Stella's Italian texts were partly quoted in English translation in the essay section of Jaffe's monograph. The full texts published here, which make use of Jaffe's translations, are the work of Moyra Byrne.

The New Art (1913)

The "official" modern art—the art that the academicians like and praise; the art that wins prizes and medals at the annual exhibitions—has nothing to do, for seriousness, tone, depth of color and grasp of character, with the ancient art.

We call it art, yet the real designation should be "trade"—work skilfully done from the standpoint of mere cleverness. Its object is to dazzle the philistines and the people that have a half-knowledge.

Cleverness of the brush—a mechanical accomplishment that almost anyone can acquire after a few years of practice—a superficial likeness, thinness of color and drawing and above all a truly lamentable banality of composition, these are the qualities that largely go to please the general mass of the people.

In reaction from this cheap production, I went to the old masters, though I never spent days and days vainly trying to copy the Museum pictures. I believe that a masterpiece is too holy and divine a thing for anyone to try to duplicate. The best mechanical reproductions are unable to translate that indefinable something we call genius.

The only reason that urged me at the time to leave the modern and go to the masters of old, was to try to forget the stupid language that the men of the schools impose on one, taking advantage of the natural timidity of the beginner whose artistic conscience is not yet formed; and in order to learn the new vocabulary, I had to consult and read books that spoke of a science now practically ignored.

I took up glazing in the real way, with an under-painting of *tempera*, like the Venetians. The subjects I treated lent themselves most readily to my new conception of painting.

In color I searched for warmth, depth and transparency emphasized by that *impasto* enamel—like that the ancient called *smalto*—and in composition I tried to be very stern and severe, hating all the bric-brac and the charming bits of color that people want.

My enthusiasm for the old art, that was rising higher and higher on account of the vulgarity of the current exhibitions (of course I had not been in Paris) got the best of me and I must confess it blinded me in many ways. I began to ignore nature and truth, and I had to consult the old teachers before talking.

Love of any sort ends in slavery—my motives were soon exhausted and I understood that glazing, although bewitching, and giving me some very fine results, was depriving me of that liberty of movement that a true artist must have.

What made me finally leave glazing was the experience I had in a journey to the South of Italy—to my native town.

When a child I had made drawings, and some of them I still consider my best things. After years of experience in foreign countries, here I was back to the scenes that had given me my first emotions—and what a change!

No more that divine innocence, whose loss we cannot miss enough, but formulas, schemes, and so many pictures had I seen! I tried to forget all schooling of any sort, and see if I could reveal something that belonged to me and to me only. But in spite of my efforts, prejudices and conventions would tie me down. I felt then all the antagonism that anyone should have against the schools.

A dear friend of mine a fine artist and a true, sincere man, Mr. Pach, urged me to go to Paris to renew myself. In need of help, I soon went to the realm of modern art.

For the first time, I realized that there was such thing as modern art (not the "official") and as true and great as the old one. It was for me the revelation of truth and gave me a great shock.

Although I couldn't grasp all at once the greatness of Cézanne, I realized what was false in my production, and for the first time I really understood the old masters. The best lesson that

they can give is to be free and to go to nature and try to get from it the nourishment for your temperament (provided that you have one) as they did themselves.

I took up post-impressionism, not as a fad but as a necessity at the time. I felt by following this path that I could express myself in ideas not transferable to canvas in the methods practised before. Technically speaking, the question of values and color interested me the most. The color of Matisse haunted me for months: I could feel in it a great force and a great vitality not dreamed of.

"A thing of beauty is a joy forever," and therefore let the painter be preoccupied first to create something really beautiful from the graphic standpoint. In art the aesthetic qualities should predominate.

All the masterpieces that mark the epochs of art are replete with those qualities. A true work of art is an organism that lives for itself, and in itself are to be found the reasons of its existence. Its source ties in nature, but it remains independent of nature. It is the old principle of true art come back again; what has been termed creation.

Of course it goes without saying that I have not done much yet along this path. I consider my latest work as only the first experiments of something big that will surely come. Cubism and futurism interest me to a very great degree. Although they resemble in many ways from an exterior point of view and they both strive for some similar points, they are apart in many ways. Cubism is static. Futurism is dynamic. Cubism tries to find and finds its descendence in the work of some of the old masters. Futurism strives to be absolutely free of any tradition: its effort chiefly lies in creating a new sort of language apt to express the feelings and emotions of the modern artist.

The futurists style themselves primitive artists of an art that is bound to come. Where do these new movements tend? is the question of the scoffers and the unbelievers. The essence of life is movement.

Stagnation is death. The artists that claim that we must be the result of tradition and nothing else are those whose spiritual life is at an end, are the weak that form the crowd of the mediocres, who try always to prevent progressive ideas from going on. They are unable to realize that we, in this epoch, experience many sensations and emotions that the ancients could not feel. A true art is always more or less the reflection of everything that is going on during its epoch, and therefore cannot live on the crumbs of the past.

The futurists and the cubists try to find a new sort of language and it is logical that this language at the start should be chaotic. Our epoch is the transitional but perhaps the more vital and important because all of the seeds of a gigantic futurist achievement are now being put into the soil.

France understood all this and as a result marched triumphantly in the front. I think that America should follow this glorious example—America which is so young and energetic and has the great futurist work first achieved by Walt Whitman.

To my mind the American artist who deserves more credit than anyone else that I know is Mr. Arthur B. Davis. What he accomplished with the great exhibition of the "Armory Show" is really wonderful, and the future artistic generations of this country will be greatly indebted to him. He has smashed all the little provincial churches of the patriotic art, and has given to the willing-one a freedom of speech never dreamed before.

The "Armory Show" was not a display of futurist work, although everybody was speaking of futurism. Of course there was, among the cubists, some work, like the girl playing the piano by Jacques Villon, that was futurist on account of the movement given according to the dictum of the Indian futurists.

Published in The Trend, *5 (June 1913), pp. 393–95.*

On Painting (1921)

Painting is joy.

Hear the story.

One day Jupiter had a tremendous headache: Minerva was in earnest to spring forth from his brain. He looked around—all the Gods, silent around—

"Can any of you do something to help me?"

"Darling"—rushed Venus.

"Oh, no. Very sorry—why to-day is Sunday and I have proclaimed already the blue law."

Then Apollo, the beautiful Apollo, realizing his chance, with his ukelele, advanced.

"I hear you calling me…"

"Shut-up"—thundered Jupiter—"You make me more sick with your moaning. Go back to the Greenwich Village."

In the meantime that little son of gun of Cupid was monkeying with some colors given to him by Vulcan, who was using them to avoid the rust of his arms. All of a sudden screaming with joy, the little rascal splashed some red, blue and green on the glossy plasticity of Venus. Jupiter bursted in a laughter which made tremble sky and earth. The headache disappeared. Minerva had to behave that day and Painting was born.

I am more than sure that each one of us has had some experience somewhat related to the one of Cupid and that has happened of course in the rosy childhood when sky and earth welcomed us with smile. Now the whole trouble of painting and of art in general lies with this: The artist wants to preserve intact his personal emotions and his personal ideas and for the full expression of them he wants to have the same freedom of movement that he enjoyed when he was left alone as a child. There were lucky epochs, the golden epochs: Art sprang then with the vehemence unexpected like a natural form—and the artist elevating temples, chiselling stones, lavishing colors with the same prodigality of Flora enjoyed to the full extent the dionysian joy of creating.

But then a little worm, born of envious sterility, began to crawl: it became gigantic and pestiferous: The graces, horrified, flew from his evil eye and he got hold of Art left alone and destitute of means. He chained her, closed her in a dungeon called the "Academy," debarred the sun from her view (since then the north light for the studios) and for amusement during her slavery, as toys, gave her colored ribbons and tinkling medals. Besides he built a kind of martial court house. A crowd of parasites got employed and self appointed judges enthroned themselves at the entrance of sighs through which the artist had to go to give a daily account of his doings.

You could call this worm with various names: chaperon, censor, or better, aesthete, critic, teacher—I don't know why but when I look at the face of an aesthete, critic, teacher, I provoke the same feeling of immense sadness as when I see wax-tears sliding gentle upon a coffin. I was eight years old and my hatred for the school was assuming alarming proportions. By the way I have always considered the school as punishment for our original sin—in a glorious day of May the window was open and I was looking at the blossoms of a cherry tree in full bloom. A bird came. I thought he was saying "Come and have fun outside." As pushed by the imperative force of fate I rushed straight to the teacher.

"I have to go out."

"Why?"

"He is calling me."

"Who?"

"The bird."

He struck me, but I got hold of one of his spongy fingers. I chewed half of it and runned away. That's exactly what has happened with modern art. The dungeon still exists and some day we hope that it will be declared a national monument. Cowards are still satisfied with ribbons and medals, but the living ones are all outside and the judges have the sad appearance of kings in exile.

The motto of the modern artist is freedom—real freedom. We cannot have enuf of it because in art license doesn't exist. The modern painter knowing that his language deals with form and colour proclaims above all the purity of his own language and repudiates the assistance of all those red-cross societies with which camouflage themselves: literature, philosophy, politics, religion, ethics. Although many prejudices still cling to him—and generations have to pass before he will reach the absolute freedom, he has lost that idiotic religious feeling which urges fanatics to nominate a leader, a pope. He recognizes personalities and not their derivations, the schools. But while he recognizes merit and he has respect for it, no matter what period and what race it belongs to (it is to modern art the credit of having enriched the knowledge of beauty to be found in the most glorious forgotten periods) he is far from feticism because his chief interest lies in the venture through the untrodden path knowing that he belongs to his own time, he does not only accept it but he loves it—and therefore he can't go back to any past to borrow material. He does not feel obliged to follow any tradition; only tradition lies in him. The only guide to follow is his own temperament and that's the reason why abstractions and representations in the strict sense of the word don't mean anything. Rules don't exist. If they did exist everybody would be artist. Therefore he can't recognize as modern artists those who having left an old slavery are chained by a new one. In other words chinasism, indianism, persianism, negro sculpture with Cézannism and Renoirism—which most prevail nowadays—cannot but disgust him. If Cubism has declared the independence of Painting, by suppressing representation and in order to purify the vision is gone back, with abstractions, to geometry, the source of the graphic Arts, he feels that every declaration of Independence carries somewhat a declaration of a new slavery. And according to his credo he will always prefer the emotions as expressed by a child to the lucubrations of those warbling theorists who throw harlequin mantles on insipid soapy academic nudes or to those anatomocial forms

in wax chopped a sang froid by necrophiles. When we think that our epoch, like every other epoch, is nothing else but a point in the immensity of time, we have to laugh to those standards that people consider eternal. The masterpiece—a phrase of the infinite speech running through the centuries can't be the final word it is supposed to be. You cannot consider a phrase no matter how perfect it is, complete and final when the whole sentence is not finished.

Innumerable are the roads leading to heaven and innumerable are the treasures in the illimitable ocean of Art to be unsealed to light by the master hand.

Master is the rolling mountainous wave which darts in challenge to the Gods, against the blue of heaven, the suspected fantastic floor wrested from the abyss, and fame is the shell which preserves the thunder of the vehemence of this wave in dashing against the dead dunes of oblivion the monuments of the continuous wrecks of idiocy in grotesque opposition to its full sweep.

Speech delivered in 1921 at the Société Anonyme, New York. Published in Broom, *1 (December 1921), pp. 119–23.*

Life Notes (c. 1921–25)

Born in Italy (South, Muro Lucano) forty five years ago. Classical education and at 17 in America. A great bent for the graphic arts since childhood. Scarcely any academic training—mostly a persistent direct drawing from life in the parks, on the elevated trains, in the public libraries, in the slim—One year in the life class of the New York School of Art Scholarship never used—First exibition at the Art Students's League—"Head of an old man"—and contribution of drawings to the "Outlook," "Everybody's Magazine," "Century," etc. Working in Pittsburgh for the "Survey" in 1908. Result—scores of drawings of the steel mills' and working men published by the Survey and exibited in Pittsburgh, New York, Chicago—then in Italy and France for five years. Three paintings at the famous "Armory Show" in 1913 and few months after one man show at the Italian Club which attracted great attention and drew large praises from the press. One year after a big canvas entitled "Coney Island"—Mardi Gras: Battle of lights canvas which exibited all over the United States with all the first modern American paintings. Made the name of the artist known here and abroad—Since then three one man shows and innumerable contributions to the most important shows in this country. Among the pictures which had the greatest success, mostly all large canvases—"The Tree of my Life," "The Brooklyn Bridge," Five panels: "New York," "Nocturne," "Swans," "Venus," "The Singing of the Nightingale," "Serenade," "Undine," and five large drawings representing the By product plants.

Paul Kellogg Papers, Folder 194, Social Welfare History Archives, University of Minnesota Libraries, Minneapolis.

Pittsburgh Notes (c. 1921–25)

The initial step in a steel mill is taken with a crescendo of awe, terror, towering black steel structures menancingly surge all around and the sudden explosions here and there of the incandescent fires of the ovens seem the insidious lightnings of that perpetual black storm governing those infernal recesses. One is reminded violently of those sensations of terror felt in reading Poe's most poignant pages or in apprehending some of the misterious ancient macabre rites and sacrifices performed in homage to monstrous divinities—

A new Divinity, more monstrous and cruel than the old one, dominates all around and the phantom like black man of the crane [?], impossible as Fate, towering in his mobile cage with a [?] look above the white, foam-like smoke arising out of the power of the fire in subduing the brutal force of the metal impresses one as the high Priest performing the rites of this new religion—

But it is only when we are suddenly confronted with the presence of the first working man—his naked perspiring shining torso in dramatic agitation against the glare of the ovens—that we loose this sense of religion and terror and we realize the power of Man—

All our confidence in him, frustrated and crushed at first, rushed with vehemence into us and we sing a paean in celebration of Man, him, the Conqueror, claiming and seizing the Promethean fire and marching ever forward to new conquests.

Paul Kellogg Papers, Folder 194, Social Welfare History Archives, University of Minnesota Libraries, Minneapolis.

Notes (c. 1921–25)

Hystory proves that the Art which emerges and lives for all times is the art abstract. Lately there has been a great confusion about abstract art. Many think that when a painting is not representative, objective, is abstract. For me abstraction is purity of painting itself.

Any painter, who preoccupies himself chiefly with the orchestration of these elements (lines, form, color) will achieve abstract art, no matter what his inspiration, his subject will be. An artist must be free in choosing any subject to draw his inspiration from and what counts it is what he can make out of it.

The subject matter is dictated by purely individual taste—it is well understood but there is no doubt that the nature of the subject plays a prominent and effective part in a work of art. In order to not be misunderstood, we assert that we do not claim that nobility in a work of art is derived by great historical facts or by those so-called big moral and religious ideas: Faith, Rebellion, Emancipation, Purity, etc—Art with thesis is bound to decay and death—

What we mean is this: the true artist, who loves eternally, is always the one who selects for his translation in the permanent realm of Art only what is essential, eloquent for all times—Painting is high poetry: things must be transfigured by the magic hand of the *artist*. The greatest effort of an artist is to catch and render permanent (materialize) that blissful moment (inspiration) of his when he sees things out of normal proportion, elevated and spiritualized, appearing new, *as seen for the first time.*

To enclose, set in a permanent way the perfumed rythm of things must be his chief concern. This spiritual *aroma* must be enclosed in the most appropriate vase. The artist who wants to preserve intact forever this scent, in order to be able to build up the permanent *abode of his feelings, his dreams, his emotions,* must obey to the dictation of Giotto "Nulla dies sine linea (Not one day without a line)" in order to acquire the necessary training.

To translate in its entirety all what he has got to say, the language of the painter must be precise and elusive in the same time, to convey any delicacy of feeling. His style must be clear and terse, transparent as a still profound water mirroring the wealth of the blues of the heavens. The lines must be drawn firm and cutting—as those setting the caracter of the objects lit by sunlight set upon the luminous background of the sky—and the form, dressed in the most magnificent lustrous clear color, must be full, in plenitude, ready to blossom.

Paul Kellogg Papers, Folder 194, Social Welfare History Archives, University of Minnesota Libraries, Minneapolis.

Notes (c. 1921–25)

The work of Art arises misterious, prompted by a force more misterious. It partakes of the same inevitability inherent to a natural force. Ovidius says: Est Deus in nobis agitant: calesci[ciurs] illo (There is a God in us, agitating us: we don't know him)

Hystory proves that all art definitions and theories are absurdities. The field of Art is so illimited that to enclose in a given space what is destined to live and move freely in the immensity of space is a futile childish prank—

For me, at present, Art must be free of any bondage of time and locality. I must be universal and belonging to all times. In speaking of modern Art, we seem to forget that our epoch is only a point in the immensity of Time.

Paul Kellogg Papers, Folder 194, Social Welfare History Archives, University of Minnesota Libraries, Minneapolis.

Notes (June 1923)

My firm "credo" is that the true modern artist must express the civilization he belongs to in his own time. His field is illimited and for inspiration he must look forward to the present and to the future and not back to the past. By saying this we don't want to minimize the great work that has been accomplished. On the contrary, we believe that the initial step must inevitably spring from lessons given by the past and following the immutable principles governing the work of Art of all formes. The experience must be free and untrameled and the expressions derived thereby new—Therefore we condemn every imitation, every following after the footsteps of masters ancient or modern alike. What has been said cannot be repeated—To my mind at present America offers more than any other country a wealth of material to the true modern artist, because nowhere else what we call modern civilization reaches the same climax—

Paul Kellogg Papers, Folder 194, Social Welfare History Archives, University of Minnesota Libraries, Minneapolis.

I Knew Him When (1924)

For years I had been struggling along both in Europe and America without seeming to get any-where. I had been working along the lines of the old masters, seeking to portray a civilization long since dead. And then one night I went on a bus ride to Coney Island during Mardi Gras. That in-cident was what started me on the road to success.

Arriving at the Island I was instantly struck by the dazzling array of lights. It seemed as if they were in conflict. I was struck with the thought that here was what I had been unconsciously seeking for many years.

The electrical display was magnificent. On the spot was born the idea for my first truly great picture: "The Battle of Light."

Published in Daily Mirror, *July 8, 1924.*

The Brooklyn Bridge (A Page of My Life) (1928)

During the last years of the war I went to live in BROOKLYN, in the most forlorn region of the oceanic tragic city, in Williamsburg, near the bridge.

Brooklyn gave me a sense of liberation. The vast view of her sky in opposition to the narrow one of NEW YORK, was a relief—and at night, in her solitude, I used to find, intact, the green freedom of my own self.

It was the time when I was awakening in my work an echo of the oceanic poliphony (never heard before) expressed by the steely orchestra of modern constructions: the time when, in rivalry to the new elevation in superior spheres as embodied by the skyscrapers and the new fearless au-dacity in soaring above the abyss of the bridges, I was planning to use all my fire to forge with a gigantic art illimited and far removed from the insignificant frivolities of easel pictures, proceeding severely upon a mathematic precision of intent, animated only by essential elements.

War was raging with no end to it—so it seemed. There was a sense of awe, of terror weigh-ing on everything—obscuring people and objects alike.

Opposite my studio a huge factory—its black walls scarred with red stigmas of mysterious battles—was towering with the gloom of a prison. At night fires gave to innumerable windows menacing blazing looks of demons—while at other times vivid blue-green lights rang sharply in harmony with the radiant yellow-green alertness of cats enjewelling the obscurity around.

Smoke, perpetually arising, perpetually reminded of war. One moved, breathed in an atmo-sphere of DRAMA—the impending drama of POE's tales.

My artistic faculties were lashed to exasperation of production. I felt urged by a *force* to mould a compact plasticity, lucid as crystal, that would reflect—with impassibility—the massive density, luridly accentuated by lightning, of the raging storm, in rivalry of POE's granitic fiery transparency revealing the swirling horrors of the Maelstrom.

With anxiety I began to unfold all the poignant deep resonant colors, in quest of the chro-matic language that would be the exact eloquence of steely architectures—in quest of phrases that would have the greatest vitriolic penetration to bite with lasting unmercifulness of engravings.

Meanwhile the verse of Walt Whitman—soaring above as a white aeroplane of Help—was leading the sails of my Art through the blue vastity of Phantasy, while the fluid telegraph wires, trembling around, as if expecting to propagate a new musical message, like aerial guides leading to Immensity, were keeping me awake with an insatiable thirst for new adventures.

I seized the object into which I could unburden all the knowledge springing from present experience—"THE BROOKLYN BRIDGE."

For years I had been waiting for the joy of being capable to leap up to this subject—for BROOKLYN BRIDGE had become an ever growing obsession ever since I had come to America.

Seen for the first time, as a metallic weird Apparition under a metallic sky, out of proportion with the winged lightness of its arch, traced for the conjunction of WORLDS, supported by the massive dark towers dominating the surrounding tumult of the surging skyscrapers with their gothic majesty sealed in the purity of their arches, the cables, like divine messages from above, transmitted to the vibrating coils, cutting and dividing into innumerable musical spaces the nude immensity of the sky, it impressed me as the shrine containing all the efforts of the new civiliza-tion of AMERICA—the eloquent meeting of all forces arising in a superb assertion of their powers, in APOTHEOSIS.

To render limitless the space on which to enact my emotions, I chose the mysterious depth of night—and to strengthen the effective acidity of the various prisms composing my Drama, I em-ployed the silvery alarm rung by electric light.

Many nights I stood on the bridge—and in the middle alone—lost—a defenceless prey to the surrounding swarming darkness—crushed by the mountainous black impenetrability of the sky-scrapers—here and there lights resembling the suspended falls of astral bodies or fantastic splendors of remote rites—shaken by the underground tumult of the trains in perpetual motion, like the blood in the arteries—at times, ringing as alarm in a tempest, the shrill sulphurous voice of the trolley wires—now and then strange moanings of appeal from tug boats, guessed more than seen, through the infernal recesses below—I felt deeply moved, as if on the threshold of a new religion or in the presence of a new DIVINITY.

The work proceeded rapid and intense with no effort.

At the end, brusquely, a new light broke over me, metamorphosing aspects and visions of things. Unexpectedly, from the sudden unfolding of blue distances of my youth in Italy, a great clarity announced PEACE—proclaimed the luminous dawn of A NEW ERA.

Upon the recomposed calm of my soul a radiant promise quivered and a vision—indistinct but familiar—began to appear. The clarity became more and more intense, turning into a rose. The vision spread all the largeness of Her wings, and with the velocity of the first rays of the arising Sun, rushed toward me as a rainbow of trembling smiles of resurrected friendship.

AND *one clear morning in April I found myself in the midst of joyous singing and delicious scent—the singing and the scent of birds and flowers ready to celebrate the baptism of my new art, the birds and the flowers already enjewelling the tender foliage of the new-born tree of my hopes—"The Tree of My Life."*

Privately printed by Stella under the title New York, 1928; *published in* Transition, *16–17 (June 1929), pp. 86–88.*

Questionnaire (1929)

1. What should you most like to do, to know, to be? (In case you are not satisfied).
I am thoroughly satisfied to be a painter. I never repent to be one. I love, of equal love, all the other ARTS—and I may dip, now and then, into LITERATURE, but PAINTING remains my chief concern: PAINTING IS MY CONGENITAL DISEASE.

2. Why wouldn't you change places with any other human being?
I would not like to change place with any other human being, because impossible—and even possible, I would not move, for I agree with Baudelaire that all our misfortunes happen because we want to change place. Gladly I accept and enjoy fully my own identity, and gladly I place it in the center of UNIVERSE, to gratify the wishes of my friends and enemies alike. Marvelous identity! Not quite clear to me, rather, a perpetual mystery. But trying to discover myself and realize all the possibilities that possibly I can bring to light, is my grateful spiritual sport.

3. What do you look forward to?
I look forward to the full realization of all my desires in Art—to find my Rose of Bakawali—to attain Serenity: Life, transfigured by Art, descending into the glow of sunset with the calm rhythm of a rainbow.

4. What do you fear most from the future?
To become weak and dependent. I would like to fall in the plenitude of Strength, like an oak struck by lightning.

5. What has been the happiest moment of your life? The unhappiest? (if you care to tell).
The moment that I have felt that, at last, I could proceed alone, really independent, without any support, spiritually and financially speaking. I do not care to remember, and to relate, any unhappy moment: memory of pain is pain itself, and pain is a pest to be avoided at any cost.

6. What do you consider your weakest characteristics? Your strongest? What do you like most about yourself? Dislike most?
The belief, still firm, never shaken, in the Blithe Myths that rose-colored our youth to provoke the march of our life; TRUE LOVE—TRUE FRIENDSHIP—REAL HUMAN GOODNESS. I consider my strongest characteristic the bull-dog tenacity of mine in clinging to what my desire leaps upon, never relinquishing its bite to the bleeding possession of it.

The most I like about myself is that ever growing indifference of mine for the opinions of others. What I dislike the most is that quick following, because taken unaware to exercise control, of those blind impulses which lead fatally to bitter disappointment.

7. What things do you really like? Dislike? (Nature, people, ideas, objects, etc. Answer in a phrase or a page, as you will).

I like everything which can procure the greatest enjoyment to all my five sense, not one excluded. Our senses are the only sure means that we have got with which to apprehend the treasures of Life. Joy, as vital as the Sun, unseals the golden massive plasticity of Life for the solid base of Art. Only through Blue serenity can Art weave the airy luminous sonority of its music. I abhor anything that humanity—for the sake of its salvation—has invented and is using with the lamentable result of fostering unhappiness. Like Diogenes, I may ask one simple thing: to be left free to face the Sun, for the sipping of life, without the massive support of any Alexander the Great to obstruct light. To be broken then, all those ties of sacred lies that crucify us as ridiculous Lachohoonts.

8. What is your attitude toward art today?
My attitude toward Art to-day is for independance: —independance of schools, of great names, past and present alike, used as stumbling blocks to hinder personal endeavour; of any chaperoning and patronizing by the self-appointed guides and judges—recruited among the boisterous failures— squeaking at the entrance of Art;—and above all, of the missionary work, of all the useless advices lavished by our dear friends acting as uncalled-for sponsors.

Art escapes any definition: theories are only appropriate to the *vient de paraître* advertising artistic trash.

A masterpiece cannot be a final word, even for a generation: it is only a phrase of continuous speech running through the centuries. Innumerable are the roads leading to Art—but great is the joy of venturing through virgin soils.

9. What is your world view? (Are you a reasonable being in a reasonable scheme?)
St. John says that men prefer obscurity to light. Truth is a jewel to enjoy in secrecy. Compromising with our dear brothers is compelled by our vital necessity to secure and preserve peace.

10. Why do you go on living?
I abandon myself to the flow of Life, without asking any quo vadis: Life is the only tangible good thing that we have got after all. The future will take care of itself: experience proves that events destined to us cannot be checked by our will.

After spending a beautiful day, sleep comes easy. Let us hope then that our worship for Beauty makes our Life decline gently, close up quietly, like those water-lilies folding silently their splendors at twilight, at the waning mumblings of leaves and birds falling to sleep. AMEN.

Published in The Little Review, *12 (May 1929), pp. 79–81.*

Interview with Bruno Barilli (1929)

One evening I was in that horrible city of Brooklyn, an industrial inferno. I warn you—a place to run away from with both feet flying.

Snow covered everything. A snow that was blackened with coal: everything so icy and slippery that you were in danger of falling and breaking your bones at every step.

In short, glass on the ground and glass in the air. Not a soul out at that hour. Not even a dog around.

The houses and shops in that anonymous neighborhood were locked and bolted. And everywhere a deathly darkness, a pitiless silence.

I was waiting for a bus. Cold. Alone.

To warm myself I tried to move a few steps on the slippery walk.

I saw nearby a bright light shining through the snow. Not bad, I thought, it must be a bar open, a café, or perhaps a restaurant.

Happily I went over toward that area of bright light that seemed to rise up through the shadows.

Slowly, slowly, I reached the corner, and as I turned it I was almost blinded by a kind of electric furnace.

It turned out to be a dreadful window of a funeral parlor that vomited a white fire from a hundred dynamos over the snow on the street. In the middle of the window there was a coffin of white enamel, lined with white silk. On the coffin was a card reading: "As you like it?"

This is America of the iron fists and steel nerves.

Italian text published in Jaffe, pp. 144–45, "Incontro con Bruno Barilli," from L'Ambrosiano *[Milan], September 8, 1929.*

The Birth of Venus (1941)

A true artist in order to create the work which shall live as a "joy forever" in many ways resembles the ascetic who selects as an altar for his profound devotion the green remoteness of the woods.

After having removed himself from the sordid doings of the common daily life and having broken all evil contacts with infesting crowds liable to contaminate, he feels uplifted into superior regions where everything appears transfigured, spiritualized by supernatural light. It is the atmosphere of fire, the state of grace, the moment for the miracle, the moment encircling with a glorious halo the life of St. Francis.

Suddenly the solitude is struck by the lightning of REVELATION and the artist is seized with ecstasy—ecstasy at a whole [series] of visions unfolding inexhaustible wealth of forms and colors through unlimited blue of Heaven. It is then that Inspiration begins to sing with vehemence, it is then that all the energies of the artist—unorganized before—arise linked in a superb effective unity prompted to action by the same law of inevitability of the natural forces.

Various and dissimilar are the visions. Some gleam afar, starlike tokens of incomparable treasures to be some day unsealed in their plenitude; some appear and disappear at the same time, but leaving in our memory an ache forever quivering with the music of their passage, and some reveal themselves in fragments to reappear in their fullness, to be pursued and seized little by little by a patient, obdurate daily practice: *Nulla dies sine linea* (not one day without a line) (GIOTTO). But some, in a vivid precise definition of the whole, remains for days as hunting marvels, tyrannical in their dominion of the soul, imperatively exacting an immediate translation into the eternal idiom of Art.

It is the vision like the fruit falling while ripe; the Vision born—undetected—at the bottom of the unconscious, secretly fed for years by the ardent pursuit of Art and showing itself at the opportune moment at the full growth of the artistic faculties. Sometimes it is the word of fire by a cherished poet or a painting portraying some of our dreams that acts as the magic voice of appeal generating this miracle: for real Art has force of expansion of continuity into future harvests. The work of Art, the artist—carrier of fire—is a seed of perennial fecundity confided to the GODDESSES OF JOY presiding at the CELEBRATION OF BEAUTY in the ever green fields of ART.

The first idea of painting Venus suddenly occurred to me when I was struck by this verse of Anacreon: Who did sculpt the blue sea? Instantaneously a terse blue sea expanded in front of me. It arose in an apotheosis culminating in the radiant form of Venus. I was shaken with joy as if I had suddenly discovered a treasure long sought for. Thrilled by the idea of possession, I was assaulted by a violent desire quickly to realize this idea in a painting for my joy, and for the joy of others. But long and difficult is the road leading to conquest. . . .

With the painstaking zeal of the true lover I tried every means to render my artistic ability worthy of the arduous task. I went to the sea. I breathed its free air. I watched and questioned every ripple of the waves. I went to the Museum of Natural History to be initiated by my ardent curiosity into the strange lore of the marine Flora. . . .To refresh and rebuild my chromatic vision I went to the flowers to learn the secret of the vibration of their colors, and having gathered a harvest of material fit for the background and surroundings of my picture, I unfolded before me all these wonders as appealing gifts for the Advent of the Goddess.

And Venus arose in all the glory of her prime as the culminating point of the spiral forces of the shell . . .the essence of a miraculous lotus. I selected the lotus as the source of Beauty (the myth of Venus is the myth of Beauty) because its color, so intense at the point where. . .its petals converge, is the true echo of the rosy birth of dawn. . .I gave her a distant look, a dominating attitude, and I put two birds (symbols of the flight and the singing of Love) upon her arms poised on a forehead which I tried to endow with the holy purity of an altar or a shrine.

I divided my composition into two main colors: the blue of the sky and the green sea. My sky was drawn from the serenity of my youth in Italy, displaying a cloudless purity of blue and arched as a protecting benediction pouring flowers from its celestial gardens. And in rivalry I gave the sea a terse crystalline transparency for a clear definition of the shells. . .shells opening at the bottom, at the corners, as the winged phrases of the untold poem of the sea. And as ministers presiding and officiating at the festa, I imagined the fishes—those stars and flowers of the sea—as seraphs playing the music of their gliding movements in an oblique ascentional rhythm of joy on both sides of their Goddess.

AAA, JSP. Privately printed by Stella, 1941; published in Jaffe, pp. 167–68.

Barbados (1941)

For the daring, adventurous painter Barbados is a magic island.

Unheralded, the enchantment of its beauty dazzles as the golden vehemence of the unexpected rising of a NEW SUN. The intense chromatic wealth—joyous high notes of pure vermilion soaring upon vast dramatic orchestration of luscious deep green—is the proper ornament for the imposing temples elevated by the columns of the majestic trees darting from the sculpturesque coralline pedestal.

And periodically—as a climax to this everlasting celebration of THE JOY OF LIVING—gorgeous rainbows unfold all the glory of celestial hues, unsealed from Paradise, to clasp in divine unity the terse blue and the vivid emerald resplendent from sky and sea.

Original typescript, AAA, JSP; privately printed by Stella with "The Birth of Venus", 1941.

Jottings (1941)

When emotion does not seize the artist, the work of Art lacks fire. Fire is the creator of Art—Fire generated by emotion. Technic alone produces nothing else but inanimate puppets. In many cases Art scorns display of technic and says great things practically with nothing. The most humble words become the most precious with the high significance that they convey. Often pompous glittering appearances mask void.

Original typescript, AAA, JSP; privately printed by Stella with "The Birth of Venus", 1941.

For the American Painting (1943)

Jellaladin Mohammed Akbar (1542–1602) greatest and wisest of the Mogdull emperors of India, once remarked: There are many who hate painting, but such men I dislike. It appears to me as if a painter had peculiar means of recognizing God.

We assert a firm belief in the Advent of American Painting: too strenuous is our own work to indulge in any doubt. Besides, the world wide recognition already won by American Literature gives us the unfailing guarantee for an identical success inevitably bound to be achieved by American Painting. In a country like America, where civilization is ever ascending, all arts will flourish, one after the other, for they all spring from the vitality of the same tree. But, to our knowledge, American Painting, before establishing her enduring work among vital affirmations of all times, has to recognize for her true masters and adopt them as unfailing guides in order for her to go forward. The three giants towering in the American Olympus of Literature are Poe, Walt Whitman, and Thoreau.

Let us consider the work of three masters. Poe, one of the very first to advocate purity in Art, has intensified the obstinacy of the will and he has proclaimed mathematics—the terse clairvoyance of intelligence that can be found at the base of every work of art—as the sole arbiter of the discipline to be used for the fruitful efficiency of those art generative forces derived from intuition and imagination. He has discovered that only infinite prudence can allow the most daring flights. And consequently he has been able to search new heights and sound new bottoms. The lucid plasticity of his idiom radiates compactness and indissolubility, against blue green hyperbolic fluctuations through which the dynamic ebony of his design projects Drama.

New meanings dash out of his unexpected chromatic blending. The Medusa of Mystery leaps to light with a new physiognomy: new aspects are revealed, new enigmatic blazing hieroglyphics are shrieked by thunder and lightning in livid upheavals of earth and sky.

One moves, breaths uplifted to a superhuman atmosphere, to the regions where candor of the domes elevated by Art perpetually radiate against the flaming gold of eternity, where everything becomes redeemed with the transfiguration practiced by abstraction. Enduring in our memory remains engraved in that painting in "The Fall of the House of Usher," that tunnel where a flood of intense rays rolled throughout and bathed the whole in a ghastly and inappropriate splendor. A sibillyne music rings through numberless echoes. Suddenly the Raven rises out of the unknown as the Impersonation of Fate. The yellow-green refrain "Nevermore"—ultimate sob dying on the threshold of eternity—lingers on the darkness of the cruel permanent shadow thrown by the "sitting dreaming demon" as the proper finale to the fever of Life. Poe, using abstraction, remains, till our day, the point of departure of all of the glorious modern French literature. Justly he has been

sanctified by all the leading daring artists, for he has enriched literature with that "nouveau frisson"—new shudder—which Victor Hugo magnifies in his letter addressed to Baudelaire.

With Walt Whitman, we are awakened, seized, excited by his morning crystalline hymn celebrating the Redemption of Art. All of a sudden we are struck by a revelation: we are astounded at the candor of the world magically unsealed for us, virginal again. Carried by the intoxicating speed of his free verses, lightly running with the agility of waves, we are thrilled by the vivid pageant of joyful visions storming in front of our bewildered eyes. Sky and earth are united in their simultaneous display of wonders. Smiling with the generosity of a God, modern Prometheus unbound, Whitman rouses and guards a new sacred fire of inspiration. He renders space boundless: he opens infinite fields to future harvests. Even the sky appears enlarged for new constellations to appear. A powerful new element is urged to direct our multiplied artistic faculties lashed to a forceful unity, the element of simultaneousness creator of oceanic Poliphony.

In rapture, smiling because hopeful of an immediate revelation of the many worlds succeeding us—we hook for good omen our ideals to the sky, and with keen delight, as to an invigorating baptism, we abandon ourselves to the refreshing flow of this vast stream of eternally green Poetry: POETRY now proceeding calm with the majestic splendor of a Cavalcade of Gods along the fragrant Elysian Fields, now tumultuous—the foaming waves speeding with winged velocity of clouds—thundering with the infernal clamor of a plutonian bacchanal or the gallop of numberless white horses at once lashed to the great leap of a legendary race in rivalry to the brilliant flight of the aerial waters of Niagara Falls.

Thoreau is the creator of a new virgilian intimacy. He takes us to the very heart of the forest. His acute sensibility—sharpened by the keenest observation flowing undisturbed in his hermitage—unseals for our delight hidden treasures of green recesses. The transparent calmness of his fresh pure style clearly reflects all the secrets confided to him by Pan.

American painting with wings forged by this poetical lore—the only lore, to perceive with, to see with, the genuine aspects of things—cannot be but myriad-minded. In rivalry to the wonderlands of prairies and parks, she cannot remain enclosed in a petty provincialism, inevitably she has to find oceanic latitudes.

Unquenched burning remains the thirst for new adventures. Science is continually discovering new elements to surprise the world with, and nowhere else, like in America, the latest mechanical innovations are realized. Two factors—steel and electricity, are transforming the physiognomy of the world. Darkness, animated by electricity, becomes a limitless scene for Drama to act in, while steel, domineering in constructing skyscrapers and bridges, creates the perspective of a new world.

American painting—the freedom of her path assured by the conquests of MODERN ART—can render the full capacity of her resources. Adopting severe control of her forces, far from contamination of any sort of prejudice, she will interpret the essentials of a new civilization storming around her. In order to be valiant to open the safe containing the precious stones of Art, she will use for a key the idiom which will have the precise ductility of steel and the fulgency of electricity.

Published in Stella, 1943 *(exhibition catalogue). New York: ACA Galleries, 1943.*

Autobiographical Notes (1946)

After my classical education (*classi liceali*) in Italy, I came to New York in 1896 and with the greatest admiration for Walt Whitman and Edgar Allen Poe. My elder brother, the well-known Dr. Antonio Stella, wanted me to study medicine, but after two years, I gave up chisel and scalpel and devoted myself entirely to painting. Well informed about the true training in painting, I avoided the cold copy from the casts and soon I became very busy drawing from the most striking characters that I could hunt in the streets, in the parks and in the lodging houses of the slums. My chief concern then, in rivalry to the stunning revelations of the triumphing Parisian Impressionism, was to catch life flowing unaware with its spontaneous eloquent aspects, not stiffened or deadened by the pose.

My preference was going to curious types, revealing, with the unrestrained eloquence of their masks, the crude story of their life. The forceful penetrating characterization of Mantegna's engravings and the powerful dramas depicted for eternity by Giotto and Masaccio, so much admired in the mother country, were ever present in front of me, urging me to search for tragic scenes.

To get familiar with the nude, I frequented the unacademic New York School of Art, at the corner of Fifty-seventh Street and Sixth Avenue. After winning the scholarship for one year of free tuition, I began to exhibit and my first work that came to the public eye was the portrait of a poor

old man painted on the Bowery, a study in blacks. It hung in the Vanderbilt Gallery in one of the American Artists' shows at Fifty-seventh Street. Besides I drew for several periodicals, for the *Century Magazine, Everybody's Magazine* and for *Outlook.* I made several scenes of immigrants at the Barge Office, scenes liked very much by the Rev. Lyman Abbott, an expert in Impressionistic paintings. In 1902 I was sent to Pittsburgh by *The Survey* to draw steel mill workers and miners. I was greatly impressed by Pittsburgh. It was a real revelation. Often shrouded by fog and smoke, her black mysterious mass—cut in the middle by the fantastic, tortuous Allegheny River and like a battlefield, ever pulsating, throbbing with the unnumerable explosions of its steel mills—was like the stunning realization of some of the most stirring infernal regions sung by Dante. In the thunderous voice of the wind, that at times with the most genial fury was lashing here and there fog and smoke to change the scenario for new, unexpected spectacles, I could hear the bitter, pungent Dantesque *terzina*.

I worked with fury for the *Survey* and for myself. More than one hundred drawings were exhibited with great success in Pittsburgh, Chicago and New York.

In the meanwhile, to be satisfied, I was always painting, because always painting was my chief concern. To avoid the superficial effects of virtuosity, I became very inquisitive in regard to the marvelous results obtained by the great masters of the past. After reading Cennino Cennini, I took up glazing.

In 1909 I went to Florence, Italy, to renew and rebuild the base and structure of my art. My glazing became very effective, especially in the portraits. A figure of mine, shown in the International Exhibition in Rome in 1910, was acquired by the Campidoglio, the City Hall of Rome. And later, the portrait of the architect, now in the possession of the Brooklyn Museum, was taken for an original old Venetian painting by the expert of the Nulla Osta of Rome.

But in spite of this growing success, I was feeling that glazing was old and not my genuine language. And when in my native town, one morning in front of a rosy mountain, I felt unable to realize my vision quickly, without waiting for the preparations required by glazing. I tossed out this method without any stupid regret. I was getting more and more convinced that the true lesson given by the old masters is an ethical one, how to organize the personal capacities in order to be true to his own self, how to derive his credit by his own experience lived at his own time, if not to project his vision into the future instead of walking back to the past.

Paris had become the Mecca for any ambitious artist in search of the new verb in art—and in 1911, with great joy I flew to the *Ville Lumière*. The monumental work of Cézanne had been achieved and so, the great efforts of Renoir, van Gogh and Gauguin—efforts summing up the conquests obtained by the luminous Impressionism.

At my arrival, Fauvism, Cubism and Futurism were in full swing. There was in the air the glamor of a battle, the holy battle raging for the assertion of a new truth. My youth plunged full in it.

I began to work with real frenzy. What excited me the most was the vista in front of me of a new panorama, the panorama of the most hyperbolic chromatic wealth. No more inhibition of any kind for the sake of inanimate sobriety, camouflaged poverty derived by the leavings of the past art, but full adventure into a virgin forest of thrilling visions, heralded by alluring vivid colors, resonant as explosions of joy, the vermilion, green, violet and orange high notes soaring upon the most luscious tonalities. To feel absolutely free to express this adventure was a bliss and rendered painting a joyful source, spurring the artist to defy and suffer any hardship in order to obtain his goal.

History proves that a true artist needs an art center for the full growth of his work. A beneficent spirit of emulation seizes him and spurs him toward the most ambitious heights. By that time, anyone in Paris could meet and know the most prominent artists right in their studios, without the need of any red tape of introduction. I took full advantage of this great chance. I met and conversed with Matisse. I was enchanted with the intense freshness of his alert color and his keen perception of Cimabue and Giotto. At the Cirque Medrano I had the pleasure to tell Picasso in company with the poet Max Jacob how much I admired his Blue Period. Every Friday I went to the Closerie Des Lilas at Montparnasse, near the Observatoire, crowded with the leading painters and writers led by the prince of poets, Paul Fort. I became the friend of many promising young men: Gromaire, Pascin, Dubreuil, the Futurists Boccioni, Carrà, Severini. Modigliani was painting at the Impasse Falguière, in a studio near mine. By that time Modigliani, unrecognized, was struggling very hard, and many times, going together through the Boulevard Pasteur, my large frame emphasized by my large American overcoat properly shielded his figure from the inquisitive sight of his ferocious creditors standing at the doors of their groceries.

The work advanced rapidly with the singing strides of a triumphing march leading to victory. And when in 1912 I came back to New York I was thrilled to find America so rich with so many new motives to be translated into a new art.

Steel and electricity had created a new world. A new drama had surged from the unmerciful violation of darkness at night, by the violent blaze of electricity and a new polyphony was ringing all around with the scintillating, highly colored lights. The steel had leaped to hyperbolic altitudes and expanded to vast latitudes with the skyscrapers and with bridges made for the conjunction of worlds. A new architecture was created, a new perspective.

In 1913 I contributed three pictures to the famous Armory Show, that memorable exhibition which remains epic as the resurrection of modern art in this country.

Soon after I got very busy in painting my very first American subject: *Battle of Lights, Mardi Gras, Coney Island*. I felt that I should paint this subject upon a big wall, but I had to be satisfied with the hugest canvas that I could find. Making an appeal to my most ambitious aims—the artist in order to obtain the best results has to exasperate and push to the utmost his faculties—I built the most intense dynamic arabesque that I could imagine in order to convey in a hectic mood the surging crowd and the revolving machines generating for the first time, not anguish and pain, but violent dangerous pleasures. I used the intact purity of the vermilion to accentuate the carnal frenzy of the new bacchanal and all the acidity of the lemon yellow for the dazzling lights storming all around. . . . In 1918 I seized the other American theme that inspired in me so much admiration since I landed in this country, the first erected Brooklyn bridge.

To realize this towering imperative vision in all its integral possibilities, I lived days of anxiety, torture and delight alike, trembling all over with emotion as those railings in the midst of the bridge vibrating at the continuous passage of the trains. I appealed for help to the soaring verse of Walt Whitman and to the fiery Poe's plasticity. Upon the swarming darkness of the night, I rung all the bells of alarm with the blaze of electricity scattered in lightnings down the oblique cables, the dynamic pillars of my composition, and to render more pungent the mystery of the metallic apparition, through the green and the red glare of the signals I excavated here and there caves as subterranean passages to infernal recesses.

At the same time, another canvas of the same huge size, kept afresh and renewed my artistic faculties, the canvas dealing with "The tree of my life."

From the sudden unfolding of the blue distances of my youth, enjoyed in Italy, golden serene light dashed, transfiguring the vision of everything around. And one morning of April, to my amazement, against the infernal turmoil of a huge factory raging just in front of my house emitting in continual ebullition smoke and flame, a towering tree arose up to the sky with the glorious ascenting vehemence of the rainbow after the tempest.

Rose singing broke out from the tender foliage of the new-born tree, as a propitious omen of happy events soon to arrive, and the sky blossomed in a refulgent benediction.

At the top of my canvas, I painted a terse blue to protect the candor of the flowers symbolic of the daring flights of our spiritual life and in the middle, I recalled scenes and places lived in my youth in Italy, transfigured, exalted by the nostalgic remoteness. A sonorous floral orchestration follows the phases of the ascension with the proper tunes. At the base my composition is marked by the vermilion of a flaming lily acting as the seal of the blood generating the robust trunk of the tree—robust but already contorted by the first snares laid down upon our path by the Genius of evil.

In 1920 I gathered all my strength to assault with the theme that for years had become an obsession: THE VOICE OF THE CITY OF NEW YORK INTERPRETED.

For years I was dreaming of this tremendous subject and many times I feared that my idea was impossible to be realized in painting. The prism was composed of so many facets and above all what to begin with was the most difficult problem to solve. The idea of finding the right approach was keeping me hesitating and so desperate of this hesitation. But in spite of all the difficulties to vanquish, I felt sure that some day I would grasp what I was looking for. My faith sprang from my full knowledge of the subject. In fact I had witnessed the growth and expansion of New York proceeding parallel to the development of my own life, and therefore I was feeling entitled to interpret the titanic efforts, the conquests already obtained by the imperial city in order to become what now She is, the center of the world.

Continually I was wandering through the immense metropolis, especially at night, in search of the most salient spectacles to derive from the essentials truly representative of her physiognomy. And after a long period of obstinate waiting, while I was at the Battery, all of a sudden flashed in front of me skyscrapers, the port, the bridge, with the tubes and the subways. I got hold of five big canvases to be clasped in a long rectangular one. I selected this most elementary geometrical form as the most appropriate frame for the simultaneous action of these mechanical essentials chosen.

The vertical line dominates because everything arises and ascends with exasperated impetus. I could define New York as a monstrous steely bar erected by modern cyclops to defy the Gods with the dazzling of a thunderbolt.

I used the skyscrapers, the port, the bridge, and the white waves as the five movements of a big symphony—a symphony free in her vast resources, but firm, mathematically precise in her development, the abstract opportunity inserted to realism, highly spiritual and crudely materialistic alike.

The depth of night tempers and renders mysterious the geometrical severity of the skyscrapers, of the bridge, of the port, while the deep Antwerp blue of the sky, in the white ways, is raging madly in the whirlwind of the simultaneous mimic advertisement animated by the polychromatic riot of a new poliphony.

The skyscrapers—the giants of modern architecture—dominate in the central canvas, purposely made the highest to break the rectangular monotony, and induced by electricity, blazing at their base with the outburst of two wings ready for flight, embark in adventurous sailing, guided by the luminous edge of the Flatiron Building acting in the middle as the opportune prow.

The bridge arises imperturbable with the dark inexorable frame among the delirium raging all around of the temerarious heights of the skyscrapers and emerges victorious with the majestic sovereignty seated on his arches upon the subjugated fluvial abyss roaring below with the moanings of appeal of the tugboats.

In the port the horizontal line traverses the emeraude of the waters, obliquely intersected, here and there and upon the blue green of the whole, funnels of factories and ships ring the bells of a new religion. Pure vermilion is lighted up at the vertex of a pyramid of black chords—hanging like the ropes of a scaffolds—as the burning offering of human labor, while telegraphic wires rush to bind distances in.

The flux of the metropolitan life continually flows as the blood in the arteries, through the subways and the tubes used for the predella of my composition, and from arcs and ovals darts the stained glass fulgency of a cathedral.

These five canvasses were exhibited by the Société Anonyme (organized by Miss Dreier and Marcel Duchamp) and later by the Brooklyn Museum and the Whitney Museum. In 1937 the Newark Museum acquired them. They were highly lauded and reproduced by leading art periodicals, here and abroad. . .

Besides these large canvases, I painted many others of limited size: *Factories* (in the possession of the Museum of Modern Art); *Pittsburgh* and *Man in the Elevated* (two oils painted on glass); *New Jersey Gas Tanks* (acquired by the Newark Museum in 1934) to name a few.

In the meantime I deepened my researches regarding the human figure and all the natural forms (animals and plants alike) to keep alert my interest.

It is essential for the artist to detach himself from all limitations due to formulas or to schools. Absolute freedom alone can reap new harvests in new fields. In the *Broom* in 1921, to this effect, a speech of mine—delivered at the Société Anonyme—is published.

From 1921 on I was swinging as a pendulum from one subject to the opposite one. With sheer delight I was roaming through different fields spurned by the inciting expectation of finding thrilling surprises, especially going through the luxuriant botanical garden of the Bronx. I was seized with a sensual thrill in cutting with the sharpness of my silverpoint the terse purity of the lotus leaves or the matchless stem of a strange tropical plant.

Inumerable visions of pictures were storming around like chimeric butterflies or those unexpected floral gems starring the nocturnal vaults of the virgin forests.

I employed the watercolor and the pastel, besides the oil, and for drawing I found the unbending inexorable silverpoint the efficacious tool to seize with out of reality integral caustic evidences of life.

I complied without any reserve with every genuine appeal to my artistic faculties and with joy I was trampling those infantile barricades erected by tottering self-appointed dictators infesting the art fields.

In 1922 I went to Naples and I was so happy to paint there *The Virgin* (donated by Adolph Lewisohn to the Brooklyn Museum) with the same mystical rapture that seized me in my early childhood after reading in Vasari's book about the holy marvels sung by Lippi and THE DIVINE FRA ANGELICO. The Hellenic miracles of the Neapolitan Museum (for sculptures with the Cairo Museum the greatest in the world) kept me spellbound. I was in heavenly ecstacy visiting Pompei, Herculaneum, Paestum. And when in Capri I was shrouded by a miraculous blue flooding both sky and sea, all of a sudden sprung in front of me the myth of *The Birth of Venus* (now in possession of Mr. Carl Weeks, Des Moines, Iowa). At dusk, in the breaking of the waves on the dunes, I was

hearing the Sirens and *Undine* (in the collection of Stephen Clark) was appearing in front of me with the matchless purity of her form reclining upon corals, a lily among lilies. From the elysian lyricism of the Italian spring I gathered the elements of *The Dance of Spring*. . .

I was in a state of grace, painting from morning until night, living a life of complete bliss.

Around 1924 I came back to New York.

I was struck by the conquests obtained in every domain by the American woman. My admiration for her became keener, and I painted, in her homage a canvas entitled *Amazon* (the amazon of our time).

To celebrate her beauty and her efficiency I employed precious chromatic attributes: blue, gold, silver, ivory, vermilion. I lavished gold with fire reverberations upon the royal mass of her hair winding down the intact ivory of her face—clean-cut profile of cameo—and at the base of her long imperial neck I did spread a silvery ethereal veil, veined of rose and smiling with spring flowers, in the shape of wings opened for flight.

To uplift her PRESENCE in a legendary realm, for her background I painted a rich ultramarine blue sea, compact as a crystal, containing the elongated carved image of CAPRI. THE ETERNAL SIREN, and to proclaim her as GODDESS, with vermilion I rendered her bust a volcanic pedestal refulgent of power as an ORIFLAMME.

Published in Art News, *59 (November 1960), pp. 41–42, 64–67.*

Jottings (undated)

The first need of the artist is absolute freedom—freedom from schools, from critics, advisors and the so called friends. The artist that will please himself will please others. The audience should exist while the work of art is done. Birds sing to pour out their joy of living.

Truly speaking there is no such thing as modern art or old art. "A joy of beauty is a joy forever," and the true artist living thousands of years before Christ is the contemporary of the true one living to-day. There is only one distinction to be made, between the false production (born dead) and the real one (living immortal).

Modern should mean that the artist of to-day derives his "motive" from his own life and from his own surroundings, just like the old masters did at their own time. The true lesson that one derives from the masters is an ethical one; how to be independent, sincere to ourselves and above all strenuous workers.

The goal is reached only after a long and hard uphill journey.

Painting is action—and grotesque becomes the painter who warbles his credo in long high sounding essays.

The picture is the only essay that a painter is entitled to.

Lately it has been a fad of the "Smart Set" to denounce the old masters; and groups or individuals in quest of a cheap notoriety, have tried to swell their poor age with some revolutionary pamphlets advertising their wares.

Result: The work of the master shines above, sacred and intangible, and the warblers fall down, one by one, into deep oblivion—where they belong.

The time has passed, let us hope, when the artist over here turned his back to America in pilgrimage along the roads abroad full of footprints of generations of artists. More and more clear becomes the conviction that the only genuine American art must be the expression and outcome of american life which is in itself rich and dynamic beyond words.

Original typescript, AAA, JSP.

My Sermon About Christ (undated)

During the first period of the great war, in 1916, Art came to a standstill, hardly any exhibition and hardly any sale. I felt desperate and at the same time urged by an absolute need of finding something to do for the gain of my living. When my brother offered me the position of a teacher of the Italian language in a Baptist seminary somewhere in Williamsburg, Brooklyn, although the remuneration was scanty. . .I accepted with joy, because I realized that occupied only in the morning (from 9 to 12) I would have the whole afternoon to. . .be able to enjoy my art work, exactly what I wanted without having to submit. . .to the approval of anyone, my brother included. I was in the most heroic. . .period of my artistic development. . . .The keen thirst of new adventures. . .kept

me awake with a throbbing energy. . . .Art was always my only reason of existence, everything was centered and focussed on her, and no hardship or difficulties of any sort with events and human beings, would have the power of extinguishing this sacred fire always burning into me. . . .I fixed the day and the hour for the meeting of the Baptist pastor that was going to appoint me teacher. . . .

It was one of those gloomy days, the sun concealed by a dense heavy sheet of steel covering tightly the sky, that I went to the meeting. A little preoccupied about the result of this meeting, I felt very hopeful nevertheless: I mostly feel strong in advance. Soon I was confronted with the Pastor. His black raven appearance impressed me quite familiar: where, and when I had seen him before? Perhaps in some bad dream. . .He did not put me to any ordeal of. . .investigation about my knowledge. He told me, with a solemn air, pointing his index finger, that he was only interested in the perfection of the soul. . . .The pupils affidato [entrusted] to him could be indulged in being ignorant, but not impure. . .he invited me to the supper for some day the following week in order to solemnly introduce me to my future pupils.

. . .that evening I was ushered in a room full of clergymen discussing aloud various topics of the Bible. . . .The gathering. . .brought to my recollection the usual crowd of peasants gathered in the square of my little village every Sunday for the sale of their pigs. I felt that I should evade everybody. . .I put up the usual idiotic smile. . .and I began to roam, circle around, . . .turning right or left whenever I felt the danger to be dragged into a discussion. . .showing. . .the lack of my knowledge in the Bible. . . .[T]he Director appeared with his fulgent smile. . . .With a scream of real triumph he trumpeted my name and as the crowd suddenly became still he announced my next appointment as a teacher.

AAA, JSP. Published in Jaffe, pp. 49–50.

Autobiography: Muro Lucano (undated)

I thank the Lord for having had the good fortune to be born in a mountain village. Light and space are the two most essential elements of painting, and my eager art took its first flights there in that free, light-filled radiant space. My native village, Muro Lucano, in the harsh Basilicata, wedges its stubborn roots in the torturous viscera of a rocky hillside. Its sturdy houses are constructed of living rock and fieldstone, and, pulled together of rocks scattered all around, they stand in the form of an amphitheater, back to back, leaning against each other like rows of sentinels ready for an attack, protected from above and watched over by the crenellated towers of the medieval castle that encloses within its sad dark walls the mystery of the frightful martyr of Queen Giovanna. At its side the mother church raises its short stocky bell tower, and the tolling of its bell that floods the air with joyous clangor at Easter counts the rosary of hours for the small village, marking out with appropriate notes the happy or sad events of life, ringing, pealing out, setting the air ablaze with sparks that herald glad nuptials on the eve of magnificent festivities, or accompanying with laments and long, tormented sighs the intoning of psalmodies in the streets for death as she goes by. An immense valley stretches out at its feet and loses itself in the far reaches of the hazy blue distance.

AAA, JSP. Italian text published in Jaffe, p. 135, as "Autobiografia: Muro Lucano."

White and Vermilion (undated)

I was in Pittsburgh and winter was raging. It had been snowing day and night, and a sharp wind was blowing, unmercifully lashing the poor mortals. The candor of the snow was intensified, magnified by the black sky eternally black and throbbing with black smoke luridly sincopated here and there by bloody spots. The tragic town of the steel mills seemed transformed. She had lost that oppressive atmosphere of a damned infernal city. But the black imprint on the snow [was] becoming more and more conspicuous. The true dark personality of the town was ever asserting itself, and this ermine dress was like an ironical white dress of the first communion, barely concealing the hard-boiled structure of a civic arpy.

It was midday, and. . .I went to the first restaurant I came across. . .The place seemed forlorn, silent, nobody talking, and I felt chilled. It was more like a funeral parlor than a place where the gargantuan joy of life was supposed to be celebrated.

AAA, JSP. Published in Jaffe, p. 136.

My Birthplace (undated)

The moment we catch sight of our native village again, how tenuous the thread that bind us to the life of exile endured for years—more tenuous than mist that vanishes in the wind—when suddenly there leaps before our eyes, intact, clear, and distinct, our birthplace, engraved in our unfaltering memory. It is a clear engraving, a full, complete, resonant shape, but lacking any volume, with its profile of sharp points incised on the pure blue of the Dawn of our life. And with the swallows' agile flight and insistent cries greeting the luminous morning, we are surrounded, gripped, and enveloped by the warm and persuasive caresses of remembered early visions. These visions had lifted our dreamy soul and held it suspended in heavenly heights, like the yearning embrace of my mother, wild with joy, who suddenly recovers her lost son and presses him violently to her breast, almost as though she would drive him into her heart to keep him there forever. All around us nature smiles like a friend, joyfully celebrating our return, and seems to have decked herself in blossoms for the occasion, like the window sills in May for the Feast of Corpus Domini.

AAA, JSP. Italian text published in Jaffe, p. 136, as "La casa paterna."

The New Effort in Art (undated)

The new effort in art appears in a sudden flash, unexpected, like a turning on a mountain peak, intense. But to be brought to realization, to mature and be ready to pick from the tree, it needs time. It dawns, like the promise of morning over the tree of our hopes, and all at once our spirit rises [it takes flight suddenly at dawn, like the bird that leaves its nest with a burning desire to conquer the sky]. But one must be patient. . . .

Silently, in the shadows, one acquires each day greater strength and form—and one fine morning, our energy ready for the test, calm in the heaven of our soul, to our great surprise the flower becomes mature fruit, pouring out, breaking out into the open, luminous.

AAA, JSP. Italian text published in Jaffe, p. 138, as "Il nuovo conato in arte."

Homeland (undated)

The mountains are a perpetual source of profound feelings and lofty ideas. Over their immovable profiles, drawn with firmness and incisive precision, exuding the power of a deity miraculously come down from heaven, the airy, agile clouds move incessantly as though holding and caressing them in ever changing shapes of dream and fantasy across the immense blue loom of the sky.

And flowing down from them towards us like a stream come the silvery flocks which brightened our childhood and made us rejoice as though in the presence of a procession of fairies bringing with them all Mother Nature's scents, all the perfumes of the forest. Our soul opened out to all the white lights.

AAA, JSP. Italian text published in Jaffe, p. 139, as "Casa paterna, III."

Awareness of Art (undated)

I remember the bursting out of art in my early childhood. It was like a sudden flash of light, thunderous as some celestial torrent—and my poor soul, overwhelmed, trembled like one of those slender stalks in the furious explosion of an autumnal golden sunset, atop one of my mountains. My soul leaped with joy, as at the unexpected discovery of a real treasure, the treasure of the Holy Friend, the consolatrix whom I must always have loved, and who must always have been smiling upon me, who must always have strewn with roses the path of my life. And overflowing like a filled vase, I thrilled with the secret delight of one who knows that for him alone there exists an eternal fountain of heavenly joy, of one who keeps hidden, for the consummate pleasure of his senses, a hopeless love, unknown to anyone. The secret of that pleasure—its possessiveness, to which he remains bound with jealous tenacity.

AAA, JSP. Italian text published in Jaffe, p. 139, as "L'arte.

Budding Passion (undated)

From the tree of my young budding life, fragrant with flowers and harmonious with shining angels intoning the psalms of spiritual joy, there suddenly broke out, bristling and spiky with thorns, the first red fruit of passion, acrid, sharp, bitter, but heavy with delicious, woody perfume. Into the tender blue and yellow of spiritual happiness this red poured itself with violence, intense, thick, bloody, and my whole being, possessed as if by a sudden storm, shook, churned, twisted like a slender tree trunk in March, in the violence, the shocking fury of every new tempestuous gust. Many blossoms fell.

Desire rose, imperious, demanding, becoming more acute, sharper each day, urgently claiming the immediate satisfaction of its needs. And all at once, spurred by hunger and thirst, the conquest of my prey became the daily objective of my life. In the torment of the breathless, stubborn chase, the woman hunt, a dumb numbness would hold me still, and I would feel myself turning violently red. In the sleepless nights there burned like an eternal flame before me, like a lure, the vision of virgin breasts, firm as shining crystal globes, the nipples erect, pink, temptingly displayed before me on a marble table. In my excited imagination I held them in my hands, my trembling fingers tracing the full, velvety modeling of their contours. Secretly I sharpened my knife, the knife of my violent desire. I cut them, and as I opened the mysterious fruit I felt the violent spasm of relief and liberation.

AAA, JSP. Italian text published in Jaffe, p. 140, as "Puerizia acerba di volutà."

My Birthplace (undated)

With ever-heightening eagerness during my long period of exile, I awaited this return to my native land. Toward the end, the waiting tore my tormented soul completely to shreds, tortured by the constant pain of an enforced stay among enemies, in a black, funereal land over which weighed, like a supreme punishment, the curse of a merciless climate. What a tremor of joy erupted at last! And how my spirit soared in the radiant light of this supreme happiness. Like an urn overflowing with honey, my heart filled instantly with good feeling. Before my ecstatic eyes everything seemed sprinkled over with rose. Smiling visions arose like white clouds shining with laughter, and a great chorus of rejoicing, friendly voices intoned a hymn to my return to the land of ancestors. All my green hopes reawakened. I felt so humble: a true Franciscan humility clothed my soul. It seemed to me freed for the first time of every useless burden of ambition and worldly care, to feel for the first time the breathing, pulsing earth, like an infant awakening to the awareness of its own mother, and all the grace of the holy beggar of Assisi came coursing and poured itself into my soul, imparting life to all the stores of rare goodness which lay slumbering in the most hidden and unknown corners of our soul.

AAA, JSP. Italian text published in Jaffe, p. 141, as "La casa paterna, IV."

Memories (undated)

In 1910, after having been both spectator and actor in the revolution of modern art (the explosion of Fauvism and Cubism) in Paris, I set sail for New York. New York, whose growth I had witnessed during my earlier years there, stood revealed to me as a fabulous mine of truly extraordinary motifs for the new kind of art. The bandages of stale prejudices torn from my eyes, the shackles of every school broken, I was in full possession of a great freedom of movement to start off the race through new fields that opened before me, to pursue and possess every new adventure that offered itself.

AAA, JSP. Italian text published in Jaffe, p. 144, as "Ricordi."

The Beacons (undated)

Today, here in America after ominous black days in which in June the lugubrious winter returned with its terrible fiendish sneer, the sun burst out like a flash of lightning and spread over all creation like a Hosanna of Resurrection. All my thoughts rose with the vigorous assertiveness of virgin stalks and my memory intoned, loud and clear as the bells at Easter, a hymn to the golden art,

the triumphant art of Italy. On the slopes of the incorruptible Olympus that is Art, in the heavens, there appeared the glorious vision of the glorious army of all the prodigious artists of Italy, guided by a diamondlike Giottesque brilliance. . . .Giotto, the standard bearer of every illustrious virtue of the race that was raised to heaven in order to dispel the darkness in which poor humanity struggles, torn to shreds by the savage harassments of everyday life. And as a guardian angel, an inflexible sentinel standing at the Sanctuary of this artistic patrimony, the most valuable estate that Jove has bequeathed to humanity, for its salvation, I place on this proud pure throne the effigy of Mantegna. The face of Mantegna, his hair tumbled like a Medusa of Art, his features lit as if by the thunder and lightning of biblical wrath. . . .Mantegna, ripened and formed in purest steel. That face with the severity of its Godlike gaze drives out of the temple of Italian art all the jealous, howling barbarians with their evil plots, all those barbarians belonging to those races of gnomes that in all periods, livid with rage and jealousy because of their base spiritual slavery, because of the misery that crushed them and holds them in subjection, spur themselves on to befoul in various ways. . . .the ever-glittering golden stairway of the glorious art of Italy.

AAA, JSP. Italian text published in Jaffe, p. 145, as "I fari."

New York (undated)

New York. . .monstrous dream, chimeric reality, Oriental delight, Shakespearian nightmare, unheard of riches, frightful poverty. Gigantic jaw of irregular teeth, shiny black like a bulldozer, funereal gray, white and brilliant like a minaret in the sunlight, dull, cavernous black, like Wall Street after dark. Clamorous with lights, strident with sounds—that's Broadway, the White Way—at night, blazing and mad with pleasure-seeking. Imperial metropolis, childish Babel—sometimes flimsy, derisory, ephemeral, insignificant as a child's tracing in the sands, sometimes grotesque and common, bulky with middle-class heaviness, the skyscrapers like bandages covering the sky, stifling our breath, life shabby and mean, provincial, sometimes shadowy and hostile like an immense prison where the ambitions of Europe sicken and languish, sinister port where the energies drawn from all over the world become flabby and spent, enemy of every effort, ferocious with its enormous blocks of buildings, barring one's way like the Great Wall of China, with its dreadful, closed windows, barren of flowers. Oh, Smiling One, friend, benefactress, Alma Mater of the derelict of all the world, your houses, your factories like great treasure chests of booty, your streets like new furrows through fields newly fertilized and tilled, your bridges hang like aerial highways through the chimeric fortunes of the future.

It is an immense kaleidoscope—everything is hyperbolic, cyclopic, fantastic. From the domes of your temples dedicated to commerce one is treated to a new view, a prospect stretching out into the infinite. The searchlights that plow your leaden sky in the evening awaken and stimulate the imagination to the most daring flights. And the multicolored lights of the billboards create at night a new hymn of praise. Far away on the horizon, they radiate a silvery, daybreak clangor, or ring out in deep tones the hour of royal sunset. When fog obliterates the bases of the skyscrapers they seem suspended in air, like brilliant jewel cases of destiny, like flaming meteorites held momentarily motionless in their tracks, like stars flung into the darkness of a tempestuous sky. And wide, geometric bands of shadow, moving like and invisible procession, mass, deepen, form and unform, float into view and disappear, while the metallic skeleton of the gigantic metropolis flashes with sparkling light that breaks out suddenly like the foam of a wave, like the flight of seagulls in a storm. A constant roar from the subterranean depths of the sleepless city, marking its deep breath and rhythm, is a ceaseless commentary and setting for this poem.

AAA, JSP. Italian text published in Jaffe, p. 146, as "New York."

The White Way (undated)

The boundless, star-paled indigo of the night weighs down over the port city like a nightmare. Faded mirage of distant splendors, it overhangs with heavy slate-gray iciness the sharp black silhouettes of the huge square-bulking factories rising everywhere like gloomy prisons with their soundless, sinister echoes. Through the silent streets, darkness, punctuated by the flashing metal of tracks, fans out its funereal, batlike wings in alternate bands that disappear like fantasies into the infinite.

AAA, JSP. Italian text published in Jaffe, p. 148, as "La via bianca."

Thoughts, II (undated)

Life rushes on in tumult of uncertainty and worry. Bad luck runs alongside us, menacing our path with the most insidious traps.

In vain our every entreaty, in vain every attempt to combat Destiny.

Our only comfort, Art, the magic Flame. May it burn forever inextinguishable!

May our life shine forever with its purple and gold, and, cradled in its joyous din, forgetting all evil, may our life fall like incense into its purifying flames, to rise again as perfume into the pure blue.

In Assisi—I remember—the festive colors of flowers, freshly cut and constantly renewed, cordon every spot in which a miracle by Saint Francis and Saint Clare took place.

My devout wish: that my every working day might begin and end—as a good omen—with the light, gay painting of a flower.

AAA, JSP. Italian text published in Jaffe, p. 149, as "Pensieri, II."

Gardenia (undated)

It is of a snowy whiteness,
The petals open out sinuously, curled white blades
 like curved sabers.
Of an airy lightness, they seem to have alighted
 on the opal cavity of the cup
Like a miraculous butterfly in the calyx of a
 flower.
Two dark green leaves, veined and sharp, are opened
 up at the sides
Like wings poised, ready for flight.
One has almost the feeling that, touching it, it
 would fly away.
A vision so near, and so far away!
Clear well-defined, or else evanescent vision.
Immaculate and white, the pure sound of an angel's
 harp!
Numberless visions flow radiantly along the purified
 horizon of our soul.
And we fall into a reverie, as
at the spectacle of our native mountain peaks
white with snow against the golden sunset
 on
 Christmas Eve.

AAA, JSP. Italian text published in Jaffe, p. 150, as "Gardenia."

Confession (undated)

In order to avoid careless facility, I dig my roots obstinately, stubbornly in the crude untaught line buried in the living flesh of the primitives, a line whose purity pours out and flows so surely in the transparency of its sunny clarity. Rivaling the diamondlike block fashioned by the free, generous hand of the sovereign art of Tuscany—prodigious pollinator of life, I dedicate my ardent wish to draw with all the precision possible, using the inflexible media of silverpoint and goldpoint that reveal instantly the clearest graphic eloquence. . . .

AAA, JSP. Italian text published in Jaffe, p. 150–51, as "Confessione."

The Myth of Leda (undated)

It is the myth of creation, of joyful, ardent creation, blowing its divine breath into the wind and sun. The act is pure and simple, without pretext or pretense—and it is sanctified, raised high, as a

spur and example to human beings. The urgent need of fecundation, a kind of christening from which we are born in new splendor, arises, ascends, and is framed, set in the purest realms of the clearest blue heaven. Creative energy is clean and chaste, symbolized by the shimmering white of the swan which flings itself upon her as if upon an altar, to perform its rite upon the full, golden, incorruptible body of the goddess of fertility, Leda, the act of world creation.

AAA, JSP. Italian text published in Jaffe, p. 151, as "Il mito di Leda."

The Poinsettia (undated)

It was winter when I arrived in the tropics, and your high-flaming greeting filled my soul with a start of sudden elation.

My drowsing energy, tortured by the cold of northern countries, was reawakened as if by magic, set aglow by the radiance of gold and purple light. All the ardor of youth surged through me, with the overflowing, stinging, demanding desire for new conquests in the virgin lands of art. Your soaring song was like the cry of Bacchus reinstated as the new tutelary deity of my art. And I watched in trepidation as, right before my astonished eyes, the swaying Bacchic chorus wound its way through the green realms of sensual joy. Irrepressible joy, continuous energy and enthusiasm, a sleepless desire for endless mirth. My life an everlasting festival free of all discord: a long train of fruits and flowers framing and rendering unforgettable our every moment. The Dionysiac dream come true, the triumphant paean of the generative power of golden Joy.

O, poinsettia, your lanceolate leaves radiate from your heart which is tightly embroidered with golden berries, the fibers unchangingly green like hope and yet changeable as flames. What mighty artist pulled them from the sacred fire of Olympus and moulded and carved them with such incredible skill? Was it Prometheus?

AAA, JSP. Italian text published in Jaffe, p. 151, as "La poinsettia."

The Apotheosis of the Rose (undated)

May, shining and filled with the sounds of warbling,
 Proclaims its arrival with the vermillion joy bursts
 from the Rose
Radiating from the center of the canvas like
A Heart.
The clear serenity of the sky offers as an altar
The Queen of Heaven
With a silver Halo, the song that foretells the Mystic
 Dawn.
And from the base of the canvas arises, fluttering—
 propitious votive offering—
A dewy thicket of small roses and field flowers
Set in snowy whiteness,
The whiteness of two herons springs as if by magic out
 of the shining brook that echoes with heavenly
 resonance,
The brook toward which rush other birds, to bathe
 themselves
In the blue and the light,
To draw fresh energy for their joyous voices that they
 may strengthen, render more fully,
The ringing Chorus of Praise
Celebrating the divine union of
Sky and Earth
As they sing in Unison.

AAA, JSP. Italian text published in Jaffe, pp. 152, 188, as "L'apoteosi della rosa."

Purissima (undated)

Blue	White
Violet	Silver
Green	Rose
	Yellow

Clear morning chanting of Spring

BLUE intense cobalt of the sky—deep ultramarine of the Neapolitan sea, calm and clear as crystal—and alternating with zones of lighter blue, the mantle multicolored (an enormous lily blossom turned upside down).

SILVER quicksilver of spring water, quilted with the rose, green, and yellow of the gown—greenish silver, very bright—mystic DAWN-white—of the Halo.

WHITE as snow for the two herons, whose gleaming white necks enclose, like a sacred shrine, the prayer of the VIRGIN.

YELLOW very light—for the edges of the mantle—to bring it out clearly with diamond purity, and reveal the hard firm modeling of the virginal breast. The lines of the mantle fall straight over the long hieratic folds of the gown, forming a frame—and the full resonant yellow of unpeeled lemons at both sides of the painting like echoing notes of the propitious shrill laughter of SPRING.

VIOLET mixed with ultramarine for the zigzag motif in the panel along the edge of the mantle, and bright, fiery violet at the top of Vesuvius, near the white fountainhead of incense—light violet tinged with rose, for the distant Smile of Divine Capri.

GREEN soft, tender, like the new grass—intense green for the short pointed leaves that enclose the lemons—and a dark green, both sour and sweet, for the palms that fan out at the sides like mystic garlands.

PINK strong—rising to the flaming, pure vermillion borders—of the Rose, brilliant as a jewel, in contrasts to the waxy pallor of the hands clasped in prayer—and infinitely subtle, delicately modulated rose for the small flowers that with the others of various colors weave of dreams and promises the splendid bridal gown of the "Purissima."

AAA, JSP. Italian text published in Jaffe, pp. 152–53, as "Purissima."

Thoughts, IV (undated)

In the life of a true artist the decisive moment comes, sooner or later, when all his own world, lying hidden deep in his soul, begs to come out into the light and be revealed. The artist writhes as if an earthquake had passed through him, or like a mother in labor when the pains rack the whole framework of her being.

After the moment of revelation—the dazzling light on the road to Damascus—has passed, a heavy curtain seems to come down and obscure all his brilliant visions as though the casket had closed on them again. But his unflagging spirit of adventure, his one lively faith, brandishes his will as the best weapon with which to press forward undaunted, or as the most sharp-edged shovel with which to dig up the ground in search of the buried treasure of his personality.

And for the first time he becomes aware of all the weight and depth of the burdensome, obstructive, unfathomable mass which upbringing, customs, respect, convention, and prejudices have piled up in his soul, and which keeps his real self buried. This excavation work must be carried on assiduously, obstinately, in the frenzied desire to touch the virgin stratum of his soul. In the course of this work, as if to encourage him and keep his ardor bright, lamps light up in the gloomy shadows of the underground passages in which he penetrates: precursory visions, burning brightly, flashes of new worlds, leap to his view as he strains to see the great light, sharpening his sleepless eagerness for the quest.

AAA, JSP. Italian text published in Jaffe, p. 161, as "Pensieri, IV."

Ideas—Sensations (undated)

The cry, the shriek, of a swallow in flight races about in the sky's concavity like sparks from a sky-rocket.

The evil of the city is this: shut in as one is on all sides by the houses—which block out both sky and countryside—one feels besieged from morning till night by the motley crowd which presses against one, suffocatingly, like an obsession, a nightmare. For this reason all vital spirits feel the imperious, relentless desire to flee from this plague, from these diseased human beehives, take refuge in a hermitage and, gazing on the vast empty horizon, attach their soul to the sky. Because petty daily life is a shabby, mean thing. In order to live one must cover over the tragic and ugly appearances of one's life with the curtain of dreams and chimera bequeathed us by the Graces who keep beneficent watch over our destiny.

AAA, JSP. Italian text published in Jaffe, p. 161–62, as "Idee—sensazioni."

Petty, Everyday Life (undated)

Petty everyday life makes trouble for us; it is like a curtain which comes down on beauty, attention paid to it. . .So as not to let darkness descend, but instead keep our enthusiasm burning till the end of our days, we must work unceasingly. Only work can bring about the miracle of Light and Joy. Just as one sleeps well after a day well spent, one dies peacefully after a good life well spent. This is the advice which the great Master Leonardo gives us.

AAA, JSP. Italian text published in Jaffe, p. 162, as "La vita quotidiana."

American Landscape (undated)

This morning is as closed in and chilly as a coffin. Through the rectangle of baleful light which is my window—a faintly glowing recess—the tops of the bare trees trace a network of veins on the dense leaden curtain of the sky.

It is as if my heart were held tightly in a deadening vice. My intense nostalgia acknowledges with a languid smile the tremulous memory of the pink and the blue of my distant native sky—a sky which unfolds at dawn like a pure flower, while the church bells ring out merrily proclaiming and announcing the arrival of the light like a benediction.

Suddenly, on the horizon's dead pool, a bright, sharp yellow triangle lights up—the brilliant wake of a hidden constellation. Remote rituals are taking place in the heavens. The triangle becomes ever brighter, shining like the eye of God.

Then slowly the unexpected illumination dims, clouds over and closes like the eye of a dying man—and once again the sky's ashes take over and spread out icily like an immense shroud.

AAA, JSP. Italian text published in Jaffe, p. 162, as "Paesaggio americano."

Piero della Francesca (undated)

Today I am contemplating the Duchess of Urbino. A photograph purchased in Paris years ago provides a faithful reproduction of the famous painting. I came upon it again among some of my old drawings, and my heart leapt as if at an unexpected revelation. The image became Apparition. My heart was attracted, magnetized by this vortex of mystery.

It is an apparition of one of the faces of the Great Mystery. The head is graced with sumptuous yet sober adornment—a jeweled crown, the emblem of fabulous riches, reigns on top of her head and brings to mind a strange vegetation blossoming on the crest of a hill. And the face, white like the evanescent pallor of a ghost, stands out sharply, its holy-wafer whiteness set into the blue background with diamondlike precision. The curbed line of the cranium and forehead is perfect and flows uninterrupted, trickles down calmly, verbally but in silence, until it defines with exultant eloquence the slightly hooked nose and the hint of evil intention in the cut of the bile-tinged mouth; then, at the still babyish chin, it becomes rounded before collecting and retaining within firm edges the flooding solidity of the long and youthfully rounded neck. The headdress comes together at the base of the skull, encircling the ears with a mass which comes to an oblique point at its summit with a tangle of folds like coiled viscera, and then falls in straight bands spread out as though protecting the neck. Black pupils of a. . .

AAA, JSP. Italian text published in Jaffe, pp. 164–65, as "Piero della Francesca."

The House of Poe (undated)

Poe's life, like that of all those artists who reveal an unexpected world, is the unrelieved story of a martyr. Its swift course is suddenly arrested by death—death chokes it off in full blossom. When one thinks over the dramatic events of this life, cut short like a sob, Baudelaire's lines from the Albatross come to mind. It seems as though all the evil spirits had made a pact to undermine and strangle the creative spirit at its very inception.

The most atrocious and deadly effects of malicious and envious people conspire with the worst pressures of poverty to bind and bring to its knees the will to fly and to grow. But this will is of a divine nature, it rebels and breaks any chains the way high water bursts out and floods, destroying the useless embankments as if they were but feeble snares laid by an impotent iniquity.

His tight and compact prose is as precise and gleaming as a precious substance. Never hesitant, but firm and rigorous, it follows its steady course as if directed by fate. Shining out of the deep darkness, it frees the mysterious shapes and clearly etches their outlines. This realistic, unwavering precision accentuates and reinforces the vivid qualities of his visions, satisfyingly distilling their fascination and suggestiveness.

AAA, JSP. Italian text published in Jaffe, p. 165, as "La casa di Poe."

Ideas (undated)

The great evil of the city is this: the houses close it off from the sky and countryside, which are furthermore obstructed by thronging crowds from morning to evening. Everyday life is mean and low. In order to have the energy to live one must cover over its cruel wounds with our dreams, with our most intense striving for the highest realms of blessedness, where our weightless soul becomes immersed in the celestial blue. Our father's house is the sole link with the past. It is the solid, firm bridge. . .

AAA, JSP. Italian text published in Jaffe, p. 167, as "Idee."

Chronology

1877 June 13. Giuseppe Michele Stella, born to Michele and Vincenza Cerone Stella in his family's home in the hillside town of Muro Lucano, Italy, southeast of Naples. The fourth of five brothers (Antonio, Giovanni, Nicola, and Luigi), he was called "Beppino" until well into his thirties.

1894 Joseph's eldest brother, Antonio, is first in family to immigrate to the United States. Antonio sets up a medical practice in New York City and becomes eminent physician and leader in Italian-American community.

1895 Receives diploma from the Liceo Umberto I in Naples.

1896 March 1. Enters the United States at Ellis Island aboard the *S.S. Kaiser Wilhelm der Grosse* from Naples.

Fall. Enters medical school in New York City; attends for one year.

1897 November–December. Attends the antique class at the Art Students League, New York, while enrolled—through spring 1898—at the College of Pharmacy of the City of New York.

1898 Attends the New York School of Art, directed by William Merritt Chase, for three years. Receives a scholarship for the second year.

1900 Lives in the Lower East Side neighborhood of Manhattan (through 1909).

1901 Summer. Studies with Chase at his outdoor summer school in Shinnecock, Long Island.

c. 1902 Marries Mary Geraldine Walter French, a native of Barbados, whom he lives with for only a few years.

1905 December. *The Outlook* publishes seven of his drawings of immigrants on Ellis Island in "Americans in the Rough."

1906 March–April. First public recognition as a fine artist: the Society of American Artists includes his painting *Old Man* in its annual exhibition.

Six of his illustrations accompany Ernest Poole's novel *The Voice of the Street*; another six illustrate Poole's article on Ellis Island immigrants in the October issue of *Everybody's Magazine*.

1907 December. Goes to West Virginia with Paul Kellogg, managing editor of *Charities and The Commons*, to record Monongah mine disaster for the magazine; one month later, the magazine publishes Kellogg's article with four of Stella's drawings.

1908 Spring. Spends nine months in Pittsburgh as part of a group conducting an intensive sociological study of the Pittsburgh steel industry; results appear as "The Pittsburgh Survey" in January, February, and March 1909 issues of *Charities and The Commons*.

1909 January. Returns to Europe; after a brief visit to Paris, goes to Italy, where he spends time in Rome, Florence, Naples, and Muro Lucano.

1911 February. Travels to Paris at the urging of fellow artist Walter Pach.

1912 February. Attends exhibition of art by Italian Futurists at the Galerie Bernheim-Jeune, Paris.

Fall. Returns briefly to Italy before sailing back to America.

December. Returns to America; moves into apartment at 214 West 16th Street, New York.

1913 February–March. Exhibits two paintings in the "International Exhibition of Modern Art" (The Armory Show), New York.

April–May. One-artist exhibition at the Italian National Club, New York.

June. *The Trend* publishes his essay "The New Art."

1914 February. Participates in exhibition of modern American art at the Montross Gallery in New York, where his painting *Battle of Lights, Coney Island* is singled out by critics. Exhibition originated at the Carnegie Institute in December 1913 and traveled to The Detroit Museum of Art and The Cincinnati Art Museum.

Summer. Travels to Venice, Florence, Rome, and Naples as well as Algiers, the Greek port of Patras, the Dalmatian coast of Yugoslavia, and Horta, an island in the Azores.

Fall. Returns to New York.

1915 Becomes a regular guest at the salon hosted by collectors Walter and Louise Arensberg; develops friendship with Marcel Duchamp, Edgard Varèse, and artists associated with New York Dada.

1916 Moves to the Williamsburg neighborhood of Brooklyn; teaches Italian at a Baptist seminary.

1917 Elected as one of twenty directors of the Society of Independent Artists. Participates in the society's first exhibition in April.

1918 Moves back to Manhattan; lives at 451 West 24th Street through summer.

Winter. Travels to Bethlehem, Pennsylvania, to make illustrations of steelworkers for *The Survey*.

1919 May. Exhibits first major painting of factory subject at the Bourgeois Galleries, New York.

1920 February–March. Retrospective exhibition at the Bourgeois Galleries, includes *Tree of My Life* and first painting of the *Brooklyn Bridge*.

Appointed by Katherine Dreier to the exhibition committee of the Société Anonyme, along with Marcel Duchamp and Man Ray. Participates in the inaugural exhibition, April–June, and in subsequent exhibitions.

1921 April. Lives at 312 West 14th Street, New York.

November. Exhibits in two-artist show with Henry E. Schnakenberg at the Whitney Studio Club.

December. *Broom* publishes Stella's lecture, "On Painting," delivered in January at the Société Anonyme.

1922 March. Serves (until 1933) as one of forty directors of the Salons of America, founded by Hamilton Easter Field, an alternative to the Society of American Artists.

Spring. Travels to Naples; visits Pompeii, Herculaneum, Paestum, and Capri.

June. *The Little Review* devotes its autumn issue to Stella.

November. Returns to New York. Lives at 451 West 24th Street.

1923 Lives in New York with Helen Walser, her son Adrian and her daughter Denise (through 1926). Although not legally married, Helen uses the name Stella, as do her children.

January–February. Exhibits *New York Interpreted* at the Société Anonyme.

March. Designs set for one of producer Georgette Leblanc Maeterlinck's *soirées intimes*, entitled *Tree of My Life*; Stella's set is for the second of four performances, each of which is presented every evening for one week in Maeterlinck's theater in Greenwich Village.

August 30. Becomes a United States citizen.

1924 April–May. One-artist exhibition at The New Gallery, New York.

1925 April. One-artist exhibition at the Dudensing Galleries, New York; shows with Dudensing through 1935.

August. Visits collector Carl Weeks in Des Moines to make preparations for mural-size painting, *The Apotheosis of the Rose*, for Weeks' home.

1926 April. One-artist exhibition at the Dudensing Galleries, New York.

July 7. Leaves his work with Dudensing and returns to Europe, where he spends much of the next eight years. Stays one month in Paris before making a three-month pilgrimage to Florence, Siena, Perugia, Assisi, Ravenna; settles in Naples by November.

1927 July 2. Stella's eldest brother, Antonio, dies.

July–September. Takes up temporary residence in Paris before returning to New York, where he lives for one year at 218 East 12th Street.

1928 April. One-artist exhibition at the Valentine Gallery, New York, which includes the *Madonna* paintings and landscapes executed in Italy.

July. Privately prints monograph *New York,* with reproductions of *New York Interpreted* and his essay "The BROOKLYN BRIDGE (A Page of My Life)."

October 1. Sails for Paris; by December 15 is back in Naples, where he stays for six months in order to produce paintings for show there the following May.

1929 May. One-artist exhibition at Galleria Angiporto, Naples, of works completed in Naples.

June. On the recommendation of Hart Crane, *Transition* publishes Stella's essay "The BROOKLYN BRIDGE (A Page of My Life)."

June–December. Spends three months in France, followed by a four-month residence in Italy.

1930 January 15. Returns to Paris, where he lives for most of the next four years.

May. One-artist exhibition at the Galerie Sloden, Paris; includes recent works executed in Italy and Paris.

Visits North Africa, including Chad and Biskra in Algeria.

1931 June–July. One-artist exhibition, Galerie Jeune Peinture, Paris; includes North African paintings.

November–December. Valentine Gallery, New York, hosts his first New York exhibition in three years; includes his North African paintings.

1932 March–April. One-artist exhibition at Washington Palace, Paris.

August–October. Travels to Italy for three months.

November. Returns to New York for four months.

1933 Finding that economic conditions in the American art world are not favorable, sails to Paris on March 10.

1934 February. Visits Rome for "Second International Exhibition of Sacred Art," which features twelve of his paintings in a separate room.

October. Returns to New York; settles in the Bronx, across from the New York Botanical Garden, at 2431 Southern Boulevard, with his wife, Mary French Stella.

1935 January. One-artist exhibition at the Valentine Gallery; first New York show since 1931.

September. Employed by easel division of the Federal Art Project, Works Progress Administration (through July 1937).

1936 October. One-artist exhibition at the Cooperative Gallery, Newark; the gallery, later called Rabin & Krueger, shows his work through 1975.

1937 December. Arrives in Barbados with Mary French Stella.

1938 May 4. Returns to New York to renew passport.

May 24–summer. Exhibits in "Three Centuries of American Art" at the Jeu de Paume, Paris.

June 15. Sails for Paris; spends remainder of year in Milan, Venice, Muro Lucano, and Naples.

December. Returns to New York City; after temporary stay with his brother, Giovanni, in New Rochelle, settles in first-floor studio at 322 East 14th Street, New York.

1939 April–December. Retrospective exhibition at The Newark Museum, New Jersey.

1940 October. Elected member of the American Federation of Painters and Sculptors.

Fall. Develops heart disease.

1941 Privately prints his essay "The Birth of Venus."

January. One-artist exhibition at Associated American Artists, New York.

November. Moves into studio at 72 Macdougal Street, New York.

1942 March. Moves into studio at 13 Charlton Street.

April–May. One-artist exhibition at Knoedler Galleries, New York.

September. Illness confines him to bed. Forced to give up his studio, he moves into an apartment next to his sister-in-law and nephew in Astoria, Queens.

1943 Spring. Develops thrombosis in left eye. After recovery, takes studio in Manhattan at 104 West 16th Street, New York.

November. One-artist exhibition at ACA Galleries, New York; catalogue for the exhibition includes his essay "For the American Painting."

1944 June. Returns to Astoria for the summer.

Fall. Rents studio on West 14th Street, Manhattan.

1945 April 23. Falls down an open elevator shaft while serving on the jury for The Artists for Victory Exhibition "Portrait of America"; suffers serious injury and returns to Astoria.

1946 April. One-artist exhibition at the Egan Gallery, New York.

November 5. Dies of heart attack. Buried in Woodlawn Cemetery, Bronx, New York. Estate is divided among his four nephews: Sergio, Armand, Anthony, and Michael.

1958 April–May. One-artist exhibition at the Zabriskie Gallery, New York; gallery handles Stella's work for the next four years.

1960 October–November. One-artist exhibition of drawings at The Museum of Modern Art, New York; circulates to fourteen cities.

November. *Art News* publishes Stella's "Autobiographical Notes."

1963 January–February. First exhibition at the Robert Schoelkopf Gallery, New York; gallery represents his work until August 1991.

October–December. Retrospective exhibition at the Whitney Museum of American Art, New York.

1970 Publication of Irma B. Jaffe's monograph, *Joseph Stella*.

1971 Publication of John I.H. Baur's monograph, *Joseph Stella*.

1983 May–July. Exhibition of Stella holdings in the permanent collection of the Hirshhorn Museum and Sculpture Garden, Smithsonian Institution, Washington, D.C.

1988 October. One-artist exhibition at the Richard York Gallery, New York; gallery frequently exhibits Stella's work in subsequent years.

1990 February–November. Retrospective exhibition of Stella's works on paper at the Amon Carter Museum, Fort Worth; Museum of Fine Arts, Boston; and the National Museum of American Art, Smithsonian Institution, Washington, D.C.

Exhibition History

An asterisk (*) indicates a one-artist exhibition. Catalogues and brochures are cited within data on individual exhibitions; exhibition reviews mentioning Stella are listed immediately following each exhibition. Reviews from foreign periodicals and newspapers are selected.

The research papers compiled for this catalogue and exhibition have been organized into several notebooks, preserved in the Whitney Museum archives, containing photocopies of exhibition catalogues, brochures, announcements, reviews, and articles. In some cases, bibliographically precise information for this material could not be obtained, and the item appears either with incomplete data or with the indication "unidentified clipping."

1906 Galleries of the American Fine Arts Society, New York. "28th Annual Exhibition of the Society of American Artists." March 17–April 22 (catalogue).

> "In the Art Schools." *American Art News*, March 24, 1906, p. 2.

1908 Carnegie Art Galleries, Pittsburgh. "Pittsburgh Survey Civic Exhibit." November 16–20 (checklist).

1912 Société des Artistes Indépendants, Paris. "28e Exposition." March 20–May 16 (catalogue).

1913 69th Regiment Armory, New York. "International Exhibition of Modern Art" (The Armory Show). February 17–March 15 (catalogue and supplement). Traveled to The Art Institute of Chicago, March 24–April 17; Copley Hall, Copley Society of Boston, April 28–May 18.

*Italian National Club, New York. April 10–May 17.

> "Artistic Evolution of an Italo–American Painter: Exhibition of Works of Joseph Stella at Italian National Club Revelation to Americans and Italians." *The Sun*, May 25, 1913, pp. 11–12.

> "Art Notes." *The Evening Post*, April 12, 1913, p. 9.

> "Art Notes." *The New York Times*, April 11, 1913, p. 9.

> Dorr, Charles Henry. "News of the Art World….Return of Joseph Stella." *The World*, April 20, 1913, p. 2N.

> G., J.E. "An American-Italian Painter." *The Evening Mail*, April 16, 1913, p. 10.

> "In the World of Art. Joseph Stella: A Young Artist of Rare Talent." *The Trend*, 5 (May 1913), pp. 208–09.

> "Italian National Club to Show Art." *The New York Press*, April 11, 1913, p. 6.

> McBride, Henry. "Stella's Charcoal Drawings His Best." *The Sun*, April 11, 1913, p. 9.

> "Notes of the Art World." *New York Herald*, April 10, 1913, p. 8.

> "Paintings by Stella." *American Art News*, April 12, 1913, p. 2.

> "Stella's Art Is Like Old Masters." *New York American*, April 21, 1913.

> Valentini, Ernesto. "Il quadri di Peppino Stella esposti al Circolo Nazionale Italiano," *Bollettino della Sera*, April 26, 1913, p. 3.

The Art Society of Pittsburgh at the Carnegie Institute, Museum of Art, Pittsburgh. "American Cubists and Post-Impressionists." December 1–31 (checklist).

> Carrell, Maud. "Modern Art May Cause Furore." *Pittsburgh Dispatch*, December 2, 1913, p. 3.

> "Modernists in Art Exhibit Here." *The Pittsburgh Chronicle Telegraph*, December 2, 1913.

> "Pittsburgh." *American Art News*, December 20, 1913, p. 11.

1914 Montross Gallery, New York. "Exhibition of Paintings and Drawings." Version of 1913 Carnegie Institute exhibition. February 2–23 (catalogue). Traveled to The Detroit Museum of Art as "A Group of Modern Painters," March 1–15; The Cincinnati Museum, as "Special Exhibition, Modern Departures in Painting: 'Cubism,' 'Futurism,' Etc.," March 19–April 5.

> "Art Notes." *The Evening Post*, February 7, 1914, p. 7.

"Exhibition of Modernist Paintings at Montross Galleries Includes Many Interesting Productions." *The New York Times*, February 8, 1914, p. 15.

"Fifth Avenue Sees Extreme Art at Its Best." *New York Herald*, February 4, 1914, p. 12.

Fornaro, Carlo de. "Seeing New York with Fornaro." *The Evening Sun*, February 9, 1914.

McBride, Henry. "At the Montross Gallery." *The Sun*, February 8, 1914, p. 2. Reprinted in Daniel Catton Rich, ed. *The Flow of Art: Essays and Criticisms of Henry McBride*. New York: Atheneum Publishers, 1975, pp. 51–55.

"New York Galleries Show Modernist Art." *The Christian Science Monitor*, February 14, 1914, pp. 10–11.

"Notes of the Art World." *New York Herald*, February 20, 1914, p. 10.

"Notes of the Art World." *New York Herald*, February 24, 1914, p. 9.

"Pictures Puzzle and Colors Riot at Art Museum." *Detroit Evening News*, February 28, 1914.

T[ownshend], J[ames] B. "'Faddists' at Montross Gallery." *American Art News*, February 7, 1914, p. 3.

National Arts Club, New York. "Modern Exhibition." Through February 28.

"Modern Contemporary Art at Arts Club." *American Art News*, February 7, 1914, p. 6.

1915 Bourgeois Galleries, New York. "From Cézanne Till Today." 1915.

1916 Montross Gallery, New York. "Fifty Pictures by Fifty Artists." February–March 4.

Britton, James. "The 'Fifty' at Montross's (By the Second Viewer)." *American Art News*, February 19, 1916, p. 6.

_____."The High Jinks of Artistry." *American Art News*, February 12, 1916, p. 3.

"New York Art Exhibits and Gallery News: Fifty Moderns at Montross's." *The Christian Science Monitor*, February 19, 1916.

Bourgeois Galleries, New York. "Exhibition of Modern Art Arranged by a Group of European and American Artists in New York." April 3–April 29 (catalogue).

"More Modern Art at Bourgeois'." *American Art News*, April 8, 1916, p. 3.

McClees Galleries, Philadelphia. "Exhibition of Advanced Modern Art." Opened May 17 (catalogue).

McGowan, Kenneth. "Philadelphia's Exhibit of 'What Is It?'" *Boston Transcript*, May 27, 1916, part 3, p. 6.

1917 The People's Art Guild at the Parish House of the Church of the Ascension, New York. "Modern Art Exhibition." January–February (catalogue).

Bourgeois Galleries, New York. "Exhibition of Modern Art." February 10–March 10 (catalogue).

Grand Central Palace, New York. "1st Annual Exhibition of the Society of Independent Artists." April 9–May 6 (catalogue).

"An Attempt to Abolish Juries and Prizes for Works of Art." *Current Opinion*, 62 (March 1917), p. 202.

Coady, R.J. "The Indeps." *The Soil: A Magazine of Art*, 1 (July 1917), pp. 202–10.

Eddy, Frederick W. "News of the Art World." *The New York World*, April 8, 1917, p. 5.

"Independent Artists Break Conventions." *New York Morning Telegram*, April 21, 1917.

Kobbe, Gustav. "What Is It? 'Independent Art.'" *New York Herald*, April 11, 1917, p. 12.

"A Mile of Pictures: Independent Artists' Big Exhibit Opens in Grand Central Palace." *The New York Times*, April 11, 1917, p. 12.

Winchell, Anna Cora. Review. *San Francisco Chronicle*, April 8, 1917.

Bourgeois Galleries, New York. "Exhibition of Nine Landscape Painters." October 16–November 10 (checklist).

Review. *New York Herald*, October 21, 1917.

1918 The Penguin, New York. "Exhibition: Contemporary Art." Opened March 16 (checklist).

Bourgeois Galleries, New York. "Exhibition of Modern Art Arranged by a Group of European and American Artists in New York." March 25–April 20 (catalogue, with text by Oscar Bluemner).

> "Independents to Have Art Show in a Tent." *New York Herald*, March 31, 1918, section 3, p. 8.
>
> "Modern Art." *The New York Times*, March 31, 1918, section 7, p. 15.
>
> "Moderns at Bourgeois'." *American Art News*, March 30, 1918, p. 2.
>
> "Progressive Art Placed on View." *The Sun*, March 31, 1918, p. 9.
>
> "The Unflagging Art Industry." *The Christian Science Monitor*, April 1, 1918, p. 16.

Bourgeois Galleries, New York. "Exhibition of Modern Art." November 11–December 7 (checklist).

> Gregg, Frederick James. "Interesting Exhibition of Modern Art Shows a Reaction from Modernism." *New York Herald*, November 17, 1918, section 3, pp. 3–4.

1919 The Arts Club of Chicago. "Paintings by Joseph Stella, Oscar Bluemner and Jennings Tofel." May 2–16.

> "Arts Club Shows a Pleasing Group by Joseph Stella." Unidentified clipping, 1919.

Bourgeois Galleries, New York. "Annual Exhibition of Modern Art Arranged by a Group of European and American Artists in New York." May 3–24 (brochure, with introduction by Albert Gleizes and checklist).

> Gregg, Frederick James. "American and European Artists Join in a Group." *New York Herald*, May 25, 1919.

1920 Bourgeois Galleries, New York. "Annual Exhibition of Modern Art." February 28–March 20 (catalogue, with text by Jennings Tofel).

*Bourgeois Galleries, New York. "Retrospective Exhibition of Paintings, Pastels, Drawings, Silverpoints and Watercolors by Joseph Stella." March 27–April 24 (catalogue).

> Field, Hamilton Easter. "Joseph Stella's Brooklyn Bridge." *The Brooklyn Daily Eagle*, April 1, 1920.
>
> "Joseph Stella, Futurist." *The Christian Science Monitor*, April 5, 1920, p. 14.
>
> Kaufman, S. Jay. "Round the Town: Joseph Stella." *The Globe and Commercial Advertiser*, April 9, 1920, p. 20.
>
> Lloyd, David. "Current Exhibitions." *The Evening Post Magazine*, April 3, 1920, p. 11.
>
> "Modern Art." *The New York Times*, March 7, 1920, section 5, p. 10.
>
> "New Yorker Austellungen." *Der Cicerone*, 12 (1920), p. 450.
>
> "Paintings by Joseph Stella." *The New York Times*, April 4, 1920, section 7, p. 6.
>
> "A 'Subjective' Vision of Brooklyn Bridge." *Current Opinion*, 68 (June 1920), pp. 832–33.

Société Anonyme, New York. "1st Exhibition of Modern Art." April 30–June 15 (brochure).

Société Anonyme, New York. "5th Exhibition." November 1–December 15 (brochure).

> "America's Rebellious Painters and New Style." *The Globe and Commercial Advertiser*, November 22, 1920, p. 14.

1921 Pennsylvania Academy of the Fine Arts, Philadelphia. "Exhibition of Paintings and Drawing Showing the Later Tendencies in Art." April 15–May (catalogue).

> Rosenfeld, Paul. "The Academy Opens Its Doors." *The New Republic*, May 4, 1921, pp. 290–91.

Bourgeois Galleries, New York. "Annual Exhibition of Modern Art." May.

Galerie Montaigne, Paris. "Salon Dada." June 6–30 (catalogue).

Worcester Art Museum, Massachusetts. "Exhibition of Paintings by Members of the Société Anonyme." November 3–December 5 (catalogue, with text by Christian Brinton). Traveled to

Smith College, Northampton, Massachusetts, January 7–February 5, 1922; Detroit Institute of Fine Arts, March–April 5; MacDowell Club, New York, April 24–May 8.

Whitney Studio Club, New York. "Exhibition of Paintings by Joseph Stella and H.E. Schnakenberg." November 7–28 (checklist).

> "The Art Galleries." *New York Evening Post*, November 12, 1921.
>
> "Austellungen in New York." *Der Cicerone*, 14 (1922), p. 50.
>
> Boswell, Peyton. "Modern Trend Is Seen in New Exhibitions." *New York American*, November 13, 1921, pp. 4, 10.
>
> "Comment on the Arts." *The Arts*, 2 (November 1921), pp. 100–18.
>
> Field, Hamilton Easter. "In the Studios and Galleries." *The Brooklyn Daily Eagle*, November 13, 1921, p. 6.
>
> Review. *New York Evening Sun*, November 12, 1921.
>
> S., C.L. "Studio Notes." *The Greenwich Villager*, November 16, 1921, p. 4.
>
> "Stella and Schnakenberg." *American Art News*, November 12, 1921, p. 10.
>
> "Stella and Schnakenberg at the Whitney Studio." *New York Herald*, November 18, 1921.
>
> "Up Picture Lane." *The World*, November 13, 1921, p. M7.

The Arts Club of Chicago. "A Selected Group of American and French Paintings." November 21–December 12.

> Roberts, Katharine Eggleston. "At the Galleries." Unidentified clipping, November 23, 1921.

1922 Whitney Studio Club, New York. "Annual Exhibition of Painting and Sculpture by Members of the Club." April 6–May 6 (checklist).

> "Among the Exhibitions on the Art Lover's List." *New York Herald*, April 16, 1922, p. 11.
>
> Tyrrell, Henry. "Some Lesser Shows that Wax as the Full-Size Season Wanes." *The World*, April 23, 1922, p. M7.
>
> "Whitney Studio Club Members Show Work." *The New York Times*, April 10, 1922.

Bourgeois Galleries, New York. "Annual Exhibition of Modern Art." May 3–24 (catalogue, with text by Stephan Bourgeois).

1923 *Société Anonyme, New York. "12th Exhibition of Modern Art." January 10–February 5, 1923 (brochure, with text by Katherine S. Dreier).

> Brook, Alexander. "February Exhibitions: Joseph Stella." *The Arts*, 5 (February 1923), pp. 127, 130.
>
> Flint, Ralph. "New York Art News: Joseph Stella," *The Christian Science Monitor*, January 23, 1923, p. 6.
>
> Kaufman, S. Jay. "Round the Town." *The Globe and Commercial Advertiser*, January 31, 1923, p. 10.
>
> Loving, Pierre. "Joseph Stella—Extremist." *The Nation*, April 11, 1923, pp. 446, 448.
>
> McBride, Henry. "Modern Art." *The Dial*, 74 (April 1923), pp. 423–25. Reprinted in Daniel Catton Rich, ed. *The Flow of Art: Essays and Criticisms of Henry McBride*. New York: Atheneum Publishers, 1975, pp. 172–75.
>
> "La mostra del pittore Stella." *Corriere d'America*, January 13, 1923.
>
> Tyrrell, Henry. "Art Observatory: New York in Epic Painting." *The World*, January 21, 1923, p. M9.

Wanamaker Gallery of Modern Decorative Art, New York. "1st Annual American Exhibition." Through February 17.

> Brook, Alexander. "February Exhibitions: An American Group Exhibition." *The Arts*, 5 (February 1923), p. 130.

Wanamaker Gallery of Modern Decorative Art, New York. "2nd Annual Decorative Exhibition." March 1–21.

"Art Exhibitions of Illustrations, Sculpture, and Painting: Modern Decoration." *The New York Times*, March 4, 1923, p. 10.

"Art Observatory: Springtime Premonitions in Breezy Shows of March." *The World*, March 4, 1923, p. 11.

"Decorative Art." *New York Evening Post*, March 10, 1923, p. 9.

"Decorative Art Exhibit at Wanamaker Galleries." *New York Herald*, March 11, 1923, p. 7.

McBride, Henry. "Art News and Reviews." *New York Herald*, March 4, 1923, section 7, p. 7.

Pène du Bois, Guy. "A Notable Exhibition by Modern Decorative Artists." *Vogue*, 61 (May 11, 1923), pp. 80–81.

The New Gallery, New York. "New Pictures and The New Gallery." March (catalogue, with text by James N. Rosenberg).

"Art Exhibitions of the Week: A Group Exhibition." *The New York Times*, March 11, 1923, p. 11.

"A Group of Five Artists." *New York Evening Post*, March 24, 1923, p. 9.

"Studio and Gallery." *The Sun*, March 10, 1923, p. 9.

Whitney Studio Club, New York. "Annual Exhibition of Painting and Sculpture by the Members of the Whitney Studio Club." April 2–30 (checklist).

Vassar College, Poughkeepsie, New York. "Paintings by Modern Masters…Loaned by the Société Anonyme, New York." April 4–May 12 (brochure).

*The Arts Club of Chicago. "'New York Interpreted' by Joseph Stella." April 13–24 (brochure).

Wanamaker Gallery of Modern Decorative Art, New York. "Exhibition of Paintings, Watercolors, Drawings, Etchings, Lithographs, Photographs and Old Prints of New York City." May 19–June 15 (checklist).

1924 Architectural League of New York. "39th Annual Exhibition." February 3–March 2.

Société Anonyme, New York. "19th Exhibition of Modern Art." March 31–April 12 (brochure).

"Art." *The New York Times*, April 6, 1924.

Review. *New York American*, undated clipping.

Whitney Studio Club, New York. "Portraits and Religious Works." April 14–27.

Boswell, Peyton. "Art and Its Creators." *New York American*, April 20, 1924, p. 11.

"Portraits and Religious Works." *The New York Times*, April 20, 1924.

*The New Gallery, New York. "Spring Exhibition. Joseph Stella: Encaustique Paintings." April 16–May 1 (brochure, with checklist).

"Art Exhibitions of the Week." *The New York Times*, April 27, 1924, section 8, p. 10.

Boswell, Peyton. "Other Displays That Make Strong Bid to Lovers of Art." *New York American*, April 27, 1924, p. 11.

Breuning, Margaret. "In a New Process." *New York Evening Post*, April 26, 1924.

McBride, Henry. "Notes and Activities." *The Sun*, April 26, 1924.

"Varied Work by Joseph Stella." *The World*, April 27, 1924.

Dudensing Galleries, New York. Exhibition. October.

1925 The Cleveland Museum of Art. "2nd Exhibition of Watercolors and Pastels." January 15–February 15 (catalogue).

"At the Museum." *Town and Topics*, January 24, 1925.

Karr, Benjamin. "Watercolors Now Featured at Museum." *News Leader*, January 19, 1925.

"What Artists and Lovers of Art Are Talking About in Cleveland Circles." *Plain Dealer*, January 18, 1925.

*Dudensing Galleries, New York. April (brochure).

"Art." *The New Yorker*, April 18, 1925, p. 17.

"Art." *The New Yorker*, April 25, 1925, p. 15.

"Art." *The New Yorker*, May 2, 1925, p. 17.

[Cortissoz, Royal.] "Random Impressions in Current Exhibitions." *New York Herald Tribune*, April 19, 1925, p. 20.

McBride, Henry. "Joseph Stella's Startling Art." *The New York Sun*, April 11, 1925.

Review. *The New York Times Magazine*, April 12, 1925, p. 19.

Viafora, Gianni. "La mostra del pittore Stella." *Corriere d'America*, April 26, 1925.

1926 *Dudensing Galleries, New York. April.

[Cortissoz, Royal.] "Random Impressions in Current Exhibitions." *New York Herald Tribune*, April 18, 1926, section 6, p. 10.

Flint, Ralph. "Spring Shows in New York." *The Christian Science Monitor*, April 23, 1926.

"Joseph Stella." *New York Evening Post*, April 17, 1926.

McBride, Henry. "Daring Work of Joseph Stella Seen as an Effort to Interpret Ideals of the Time." *The New York Sun*, April 17, 1926.

_____. "Modern Art." *The Dial*, 80 (June 1926), pp. 525–27.

P[emberton], M[urdock]. "The Art Galleries." *The New Yorker*, April 24, 1926, p. 49.

"Il pittore Giuseppe Stella." *La Follia di New York*, April 25, 1926.

"A Vision of Color." *The New York Times Magazine*, April 18, 1926, p. 15.

*Des Moines Association of Fine Arts, City Library Gallery. "Exhibition of Paintings by Joseph Stella." May 9–June 1 (brochure, with checklist).

"Joseph Stella Paintings Go on Exhibition." *The Des Moines Register*, May 1926.

"Stella Exhibit Shocks City's Artistic Folk." *The Des Moines Register*, May 10, 1926.

The Brooklyn Museum, New York. "An International Exhibition of Modern Art Assembled by the Société Anonyme." November 19, 1926–January 1, 1927 (catalogue, and special catalogue, *Modern Art*, with text by Katherine S. Dreier). Traveled to Anderson Galleries, New York, January 25–February 7; Albright Art Gallery, Buffalo, February 25–March 20; Art Gallery of Toronto, April 1–24.

The Cleveland Museum of Art. "3rd Exhibition of Watercolors and Pastels."

1928 *Valentine Gallery, New York. "Joseph Stella." April 2–21 (brochure, with checklist).

"Easter Subjects Seen in Stella Inventions." *The World*, April 8, 1928.

Flint, Ralph. "Joseph Stella." *The Christian Science Monitor*, April 16, 1928, p. 8.

J[ewell], E[dward] A[lden]. "Joseph Stella, Lyricist." *The New York Times*, April 8, 1928, section 9, p. 18.

McBride, Henry. "Modern Art." *The Dial*, 84 (June 1928), pp. 533–35.

"News and Exhibitions of the Week in Art." *New York Herald Tribune*, April 8, 1928, section 7, p. 11.

P[emberton], M[urdock]. "The Art Galleries: The Somewhat Different Americans." *The New Yorker*, April 14, 1928, pp. 82–83.

R., I.d. "The Exhibition of Joseph Stella." *Bulletin and Italiana*, 2 (May 1928), pp. 90–91.

The Brooklyn Museum, New York. "Summer Exhibition." June.

Cary, Elisabeth L. "Summer Art Activities in New York." *The New York Times*, June 24, 1928, section 7, p. 7.

1929 The Arts Club of Chicago. "Loan Exhibition of Modern Paintings Privately Owned by Chicagoans." January 4–18.

Daniel Galleries, New York. Société Anonyme exhibition. January 7–19.

*Italiani pel Mondo, Galleria Angiporto, Naples. "Mostra di arte del pittore Giuseppe Stella." May (brochure, with text by Ferdinando Santoro and checklist).

 "All'inaugurazione della mostra del pittore Stella." *Il Mattino*, May 15, 1929.

 Artieri, Giovanni. "Cronache napoletane." *Emporium*, 69 (June 1929), pp. 377–80.

 Cangiullo, Francesco. "La pittura di Giuseppe Stella." *Il Mattino*, May 18, 1929.

 "Cronache d'arte: Giuseppe Stella agli 'Italiani pel Mondo.'" *Il Mattino*, May 7, 1929.

 Dinella, Anna. "L'arte di Giuseppe Stella." *L'Arte Fascista*, 1929, pp. 346–54.

 "Mostra del pittore Giuseppe Stella." *La Tribuna*, May 18, 1929.

 Schettini, Alfredo. "Mostre d'arte: Giuseppe Stella." *Il Mezzogiorno*, May 19–20, 1929.

Brummer Gallery, New York. "Loan Exhibition Held by New York University Gallery of Living Art—Contemporary Paintings at the Brummer Gallery, Inc., 1929." November.

1930 *Galerie Sloden, Paris. "Joseph Stella: Peintures, aquarelles, pointes d'argent." May 7–26 (brochure).

 "Les arts." *L'Intransigeant*, May 27, 1930.

 Fierens, Paul. "Paris Letter. Two American Painters: Stella and Quincy." *The Art News*, 28 (June 14, 1930), p. 23.

 "Joseph Stella espone a Parigi." *Il Divolo dell'Età*, June 6, 1930.

 "Joseph Stella's Paintings." *Chicago Tribune* (Paris), undated clipping.

 Sauvage, Marcel. "Un peintre de New York: Joseph Stella." *Comœdia*, May 23, 1930, p. 8.

1931 Société Anonyme, New York. "Special Exhibition Arranged in Honor of the Opening of the New Building of the New School for Social Research." January 1–February 10 (checklist).

*Galerie Jeune Peinture, Paris. "Exposition Joseph Stella: Peintures." June 16–July 12 (brochure, with checklist).

 Kospoth, B.I. "Joseph Stella's Exposition." Unidentified clipping, June 28, 1931.

 "Stella's Show." *The Art Digest*, 5 (August 1931), p. 9.

*Valentine Gallery, New York. "Joseph Stella: Paintings Done in Africa and Europe During 1929–1931." November 30–December 19 (brochure, with checklist).

 "After an absence...." *The Brooklyn Daily Eagle*, November 29, 1931.

 "Exhibitions in New York: Joseph Stella." *The Art News*, 30 (December 5, 1931), p. 10.

 "The Immediate Horizon." *The New York Times*, November 29, 1931, section 8, p. 12.

 Jewell, Edward Alden. "New Colors in Stella's Palette." *The New York Times*, December 3, 1931, p. 32.

 "Joseph Stella Reappears." *The New York Times*, December 1, 1931, p. 22.

 Pemberton, Murdock. "The Art Galleries." *The New Yorker*, December 12, 1931, p. 57.

 "Stella Returns." *The Art Digest*, 6 (December 1, 1931), p. 15.

 "This Week in New York. Recently Opened Shows: Valentine Gallery." *The New York Times*, December 6, 1931, section 9, p. 18.

1932 Galerie Jeune Peinture, Paris. January.

 Harris, Ruth Green. "'Les Américains' in Paris." *The New York Times*, February 28, 1932, section 8, p. 10.

*Washington Palace, Paris. "Exposition Joseph Stella: Peintures à l'huile, aquarelles, dessins à la pointe d'argent." March 19–April 10.

 Contardi-Rhodio, E. "Un artiste de Montparnasse." *Le Mont-Parnasse*, August 13, 1932, p. 1.

 "L'exposition Joseph Stella." *Latinitas*, 2 (February–March 1932), pp. 1–2.

 "New Exhibition of Joseph Stella's Painting Draws Favorable Comment." *Chicago Tribune* (Paris).

"Pittori italiani in Francia: Antonio Pietroni e Giuseppe Stella." *Il Resto del Carlino*, May 19, 1932.

Whitney Museum of American Art, New York. "Summer Exhibition." May 3–October 12 (catalogue).

Cary, Elisabeth Luther. "Toward the Essential Modernism." *The New York Times*, May 15, 1932, section 8, p. 7.

S[herburne], E. C. "Whitney Museum's Summer Show." *The Christian Science Monitor*, May 14, 1932, p. 10.

Whitney Museum of American Art. "1st Biennial Exhibition of Contemporary American Painting." November 22, 1932–January 5, 1933.

Grafly, Dorothy. "The Whitney Museum's Biennial." *The American Magazine of Art*, 26 (January 1933), pp. 5–12.

1933 Whitney Museum of American Art, New York. "20th Century New York in Paintings and Prints." December 3, 1933–January 11, 1934.

1934 Palazzetto Governatoriale delle Esposizioni, Rome. "La II mostra internazionale d'arte sacra." February–May.

Biancale, Michele. *Il Popolo di Roma*, February 25, 1934.

Francini, Alberto. "La mostra mondiale d'arte sacra." *Gazzetta del Popolo*, February 10, 1934.

Neppi, Alberto. "La II mostra internazionale d'arte sacra." *Il Lavoro Fascista*, February 10, 1934.

Pensabene, Giuseppe. "La II mostra internazionale d'arte sacra." *Il Tevere*, February 12, 1934.

T., C. "L'arte sacra." *Il Giornale d'Italia*, February 10, 1934, p. 3.

1935 *Valentine Gallery, New York. "Exhibition of Paintings by Joseph Stella." January 7–26 (checklist).

Jewell, Edward Alden. "And Four One-Man Shows." *The New York Times*, January 13, 1935, section 9, p. 9.

M[orsell], M[ary]. "Exhibitions in New York: Joseph Stella." *The Art News*, 33 (January 12, 1935), p. 11.

Mumford, Lewis. "The Art Galleries." *The New Yorker*, January 19, 1935, p. 70.

"A New Display by Joseph Stella." *New York Herald Tribune*, January 13, 1935.

"Paintings by Stella at Valentine Gallery." *New York Post*, January 12, 1935.

"Stella, Dreamer, Back in America for Show." *The Art Digest*, 9 (January 15, 1935), p. 8.

Grand Central Galleries, New York. "Mural Paintings in America: Contemporary and Retrospective." February 4–16.

Jewell, Edward Alden. "American Murals on Exhibition Here." *The New York Times*, February 5, 1935, p. 17.

_____. "In the Realm of Art. Our Murals: National Survey of a Developing Art." *The New York Times*, February 10, 1935, section 8, p. 9.

"Mural Paintings Shown in Large Exhibit." *New York Post*, February 9, 1935.

Sherburne, E.C. "Transitional Shows." *The Christian Science Monitor*, February 16, 1935, p. 9.

Whitney Museum of American Art, New York. "Abstract Painting in America." February 12–March 22 (catalogue, with introduction by Stuart Davis).

Breuning, Margaret. "A Phase of Modern Art Shown by Museum Exhibit." *New York Evening Post*, February 16, 1935.

Jewell, Edward Alden. "Abstract Painting Revealed at Show." *The New York Times*, February 13, 1935, p. 17.

Kellogg, Elenore. "Abstractions Are Shown at Whitney Art Museum." [Cincinnati] *Enquirer*, February 24, 1935. Syndicated nationwide, under different titles, through the Associated Press.

Morsell, Mary. "Whitney Museum Holds Exhibition of Abstract Art." *American Art News*, February 16, 1935, pp. 3, 13.

Sherburne, E.C. "Transitional Shows." *The Christian Science Monitor*, February 16, 1935, p. 9.

Vaughan, Malcolm. "In the Art Galleries." *New York American*, February 16, 1935.

Englewood Gallery of Modern Art, New Jersey. "Recent Paintings by Joseph Stella and Sculpture by F.E. Hammargren." April 20–May 4 (checklist).

"City May Have Permanent Gallery; Noted Artists Open Show Tomorrow." Unidentified clipping, April 19, 1935.

Valentine Gallery, New York. "An American Group." May 13–June 1.

Jewell, Edward Alden. "In the Realm of Art: Activities of the Waning Season." *The New York Times*, May 19, 1935, section 9, p. 9.

_____. "New Group Shows for American Art." *The New York Times*, May 14, 1935, p. 19.

Valentine Gallery, New York. "An American Group, II." Opened September 10.

Jewell, Edward Alden. "In the Local Spotlight." *The New York Times*, September 15, 1935, section 9, p. 7.

1936 Whitney Museum of American Art, New York. "2nd Biennial Exhibition—Part Two: Watercolors and Pastels." February 18–March 18.

Cooperative Gallery, Newark, New Jersey. "Paintings by Living American Artists." May 1–30 (checklist).

Phillips Memorial Gallery, Washington, D.C. "National Exhibition of Mural Sketches, Oil Paintings, Water Colors and Graphic Arts: Federal Art Project, Works Progress Administration." June 15–July 5.

*Cooperative Gallery, Newark, New Jersey. Through October 31.

"Newark." *The New York Times*, October 11, 1936, section 10, p. 9.

Whitney Museum of American Art, New York. "3rd Biennial Exhibition of Contemporary American Painting." November 10–December 10 (catalogue).

Jewell, Edward Alden. "Americans: The Whitney Opens Third Biennial." *The New York Times*, November 15, 1936.

"Whitney Biennial Fails to Stir Much Enthusiasm Among Critics." *The Art Digest*, 11 (December 1, 1936), pp. 5–6.

Delphic Studios, New York. "A Small Collection Loaned through the Société Anonyme." November 23–December 5 (checklist).

Devree, Howard. "Among the Newly Opened Exhibitions." *The New York Times*, November 29, 1936, section 12, p. 10.

1937 The Jury of Living American Art, New York. "Forty-Eight American Pictures of the Year." April 9–May 9 (brochure, with checklist).

Cooperative Gallery, Newark, New Jersey. "Original Drawings." May (brochure, with text by N. Krueger and checklist).

Municipal Art Committee, City of New York (organizer). "2nd National Exhibition of American Art," American Fine Arts Society Galleries, New York. June 16–July 31.

*Cooperative Gallery, Newark, New Jersey. "Joseph Stella: Recent Paintings and Drawings." Through December 12 (brochure, with excerpt from essay by Hamilton Easter Field).

"Before He Sails." *The Art Digest*, 12 (November 15, 1937), p. 29.

Conklin, Franklin. "...Fearless Expression in Stella Painting." Unidentified clipping, November 27, 1937.

"One-Man Art Show Opens in Newark." *The Star Ledger* [Newark], November 10, 1937.

1938 The Art Institute of Chicago. "17th International Exhibition: Water Colors, Pastels, Drawings and Monotypes." April 28–May 30 (checklist).

The Museum of Modern Art, New York (organizer). "Three Centuries of American Art." Musée du Jeu de Paume, Paris, May 24–Summer.

"Esiste un' arte americana?" *La Voce d'Italia*, undated clipping.

Bel R. Berman, Jonas Brown Decorators Gallery, Newark, New Jersey. "An Exhibition of Paintings, Sculptures, Ceramics by Foremost American Contemporary Artists." Opened November 8 (checklist).

"The Arts: Popular Here." *Newark Evening News*, February 4, 1939.

1939 *The Newark Museum, New Jersey. "Joseph Stella: A Retrospective Exhibit." April 22–December (brochure, with text by Arthur F. Egner and checklist).

Aniante, Antonio. "Incontro con il pittore Stella." *Italia Letteraria-Roma*, April 12, 1939.

"Art." *Time*, July 10, 1939, p. 46.

"In the Decorative Vein: Newark." *The New York Times*, April 30, 1939, section 11, p. 10.

"Newark Reviews Career of Joseph Stella." *The Art Digest*, 13 (July 1, 1939), p. 11.

Romano, Armando. "Una esposizione di G. Stella." *Il Progresso Italo-Americano*, June 25, 1939.

Steinberg, David. "Museum to Feature Stella's Art Show." *The Newark Ledger*, May 14, 1939.

"Stella's Art on Exhibit at Newark Museum." *The Newark Sunday Call*, May 7, 1939, p. 2.

"Stella Show." *Newark Evening News*, April 22, 1939.

"Venti anni di attività del pittore G. Stella." *Cronaca di New York*, August 14, 1939, p. 9; *Corriere d'America*, August 14, 1939.

The Museum of Modern Art, New York. "Art in Our Time." May 10–September 30 (catalogue).

Kruse, A.Z. "At the Art Galleries." *The Brooklyn Daily Eagle*, May 14, 1939.

McBride, Henry. "The Museum of Modern Art: An Astonishing Edifice Filled with Astonishing Art." *The New York Sun*, May 13, 1939, p. 10.

Gallery of American Art Today, New York World's Fair. "American Art Today."

The George Walter Vincent Smith Art Gallery, Springfield, Massachusetts. "Some New Forms of Beauty 1909–1936: A Selection of the Collection of the Société Anonyme—Museum of Modern Art, 1920." November 9–December 24 (catalogue, with text by Katherine S. Dreier). Traveled to the Wadsworth Atheneum, Hartford, January 4–February 4, 1940.

Brooks, Richard S. "Some New Forms of Beauty, 1909–36 Shown at the Museum." *Springfield Daily Republican*, November 15, 1939, p. 7.

"'New Forms of Beauty' at G.W. Smith Gallery." *Springfield Union Republican*, November 12, 1939.

Rogers, W.G. "Local Color." *The Springfield Union*, November 15, 1939.

Rudkin, W. Harley. "Art in the News." *The Springfield Daily News*, undated clipping.

1940 Whitney Museum of American Art, New York. "1940 Annual Exhibition of Contemporary American Art." January 10–February 18 (checklist).

"Annual Exhibit to Open Today at the Whitney." *New York Herald Tribune*, January 10, 1940.

Jewell, Edward Alden. "Whitney Museum to Open New Show." *The New York Times*, January 10, 1940, p. 15.

The Museum of Modern Art, New York. "Italian Masters." January 26–April 7.

Stella, Joseph. "I capolavori italiana all 'Arte Moderna.'" *Corriere d'America*, February 18, 1940.

_____. "La mostra di maestri italiani: capolavori impareggiabili." *Corriere d'America*, February 11, 1940.

1941 *Associated American Artists, New York. "Joseph Stella." January 6–25 (checklist).

Burrows, Carlyle. "American Painters of Today: The Early Work of Edward Hopper and the More Recent Art of Joseph Stella." *New York Herald Tribune*, January 12, 1941.

"Fifty-Seventh Street in Review: The Need for Self-Editing." *The Art Digest*, 15 (January 15, 1941), pp. 18–19.

Genauer, Emily. "One-Man Exhibition: 60 by Joseph Stella." *New York World-Telegram*, January 11, 1941.

"Giuseppe Stella, nella sua esposizione newyorkese si rivela mago del colore." *Il Progresso Italo-Americano*, January 12, 1941, p. 4.

Jewell, Edward Alden. "In the Realm of Art. Diversity of Winter Activities: Current Group and One-Man Shows." *The New York Times*, January 12, 1941, section 9, p. 9.

Kruse, A.Z. "At the Art Galleries." *The Brooklyn Daily Eagle*, undated clipping.

L[owe], J[eanette]. "Vigor in Bold Forms by Joseph Stella." *The Art News*, 39 (January 11, 1941), p. 13.

McB[ride], H[enry]. "Joseph Stella's Power." *The New York Sun*, January 11, 1941.

Wiegand, Charmion von. "Opinions Under Postage" (letter). *The New York Times*, February 23, 1941, section 10, p. 9.

Whitney Museum of American Art, New York. "This Is Our City—An Exhibition of Paintings Watercolors, Drawings & Prints." March 11–April 13 (catalogue).

1942 Yale University Art Gallery, New Haven. "Modern Art from the Collection of the Société Anonyme: Museum of Modern Art, 1920." January 14–February 22 (catalogue, with text by George Heard Hamilton).

Olin Library, Wesleyan University, Middletown, Connecticut. "Special Exhibition of the Collection of the Société Anonyme." February 23–March 31.

*Knoedler Galleries, New York. "Joseph Stella: Exhibition of Paintings." April 27–May 16 (brochure, with text by Henry McBride and checklist).

Jewell, Edward Alden. "In the Realm of Art: Among the Local Shows." *The New York Times*, May 3, 1942, section 8, p. 5.

L[ane], J[ames] W. "The Passing Shows: Joseph Stella; C. Bennett Linder." *Art News*, 41 (May 15–31, 1942), p. 21.

McBride, Henry. "Attractions in the Galleries." *The New York Sun*, May 1, 1942.

"Solo Shows of the Week: Lyrical Landscapes by Joseph Stella." *New York World-Telegram*, May 2, 1942, p. 7.

"Stella Retrospective." *The Art Digest*, 16 (May 1, 1942), p. 15.

1943 *ACA Galleries, New York. "Stella, 1943." November 8–27 (catalogue, with preface by Katherine S. Dreier, essay by Joseph Stella, and checklist).

Devree, Howard. "A Reviewer's Notes: Joseph Stella's Work of Three Decades." *The New York Times*, November 14, 1943, section 2, p. 6.

"The Passing Shows." *Art News*, 42 (November 15–30, 1943), p. 21.

R[iley] M[aude]. "Stella in Review." *The Art Digest*, 18 (November 15, 1943), pp. 13, 24.

Upton, Melville. "Joseph Stella and Others." *The New York Sun*, November 12, 1943.

1944 Cincinnati Art Museum. "Abstract and Surrealist Art in the United States." February 8–March 12 (catalogue). Traveled to The Denver Art Museum, March 26–April 23; Seattle Art Museum, May 7–June 10; Santa Barbara Museum of Art, June–July; San Francisco Museum of Art, July.

The Brooklyn Museum, New York. "One Hundred Artists and Walkowitz." February 9–March 12 (brochure).

The Museum of Modern Art, New York. "Modern Drawings." February 16–May 10.

Jewell, Edward Alden. "Exhibition Traces Modern Art Trend." *The New York Times*, undated clipping.

The Museum of Modern Art, New York. "Art in Progress: A Survey Prepared for the Fifteenth Anniversary of The Museum of Modern Art." May 24–October 22 (catalogue, with text by James Thrall Soby et al.).

The Newark Museum, New Jersey. "A Museum in Action: 35th Anniversary Exhibition." November (catalogue, with text by Holger Cahill).

"A.C.A. News." *American Contemporary Art* (November 1944), pp. 9–11.

"Art Show at Newark Museum." *The New York Times*, November 1, 1944, p. 21.

Genauer, Emily. "This Week in Art: For Best Exhibit, Go to Newark!" *New York World-Telegram*, November 4, 1944.

McBride, Henry. "Newark Has a Museum." *The New York Sun*, November 4, 1944.

The Metropolitan Museum of Art, New York. "Portrait of America: 150 Paintings Selected from the National Pepsi-Cola Competition for American Artists." November–December 3 (catalogue). Traveled to the Museum of Fine Arts, Springfield, Massachusetts, December 15, 1944–January 15, 1945; Carnegie Institute, Pittsburgh, February 1–March 1; The Cleveland Museum of Art, March 15–April 15; The Detroit Institute of Arts, May 1–June 1; San Francisco Museum of Art, July 1–August 1; Los Angeles County Museum of Art, August 7–September 15; Dallas Museum of Fine Arts, October 1–November 1; William Rockhill Nelson Gallery, Kansas City, Missouri, December 1, 1945–January 1, 1946.

"It's Pepsi's Money." *Newsweek*, November 19, 1945.

1945 The Corcoran Gallery of Art, Washington, D.C. "Corcoran Gallery 19th Biennial Exhibition of Contemporary American Paintings, 1945." March 18–April 29.

Connecticut College, New London. April–May.

Mount Holyoke College, South Hadley, Massachusetts. "Modern Art from the Collection of the Société Anonyme: Museum of Modern Art, 1920." September 24–October 21 (checklist). Traveled to The George Walter Vincent Smith Art Gallery, Smith College, Northampton, Massachusetts, under the name "Abstract Paintings from the Collection of the Société Anonyme," October 25–November 30; Amherst College, Massachusetts, December 4–20; Lyman Allyn Museum, New London, Connecticut, January 6–31, 1946.

Pennsylvania Academy of the Fine Arts, Philadelphia. "43rd Annual Philadelphia Water Color and Print Exhibition." October 20–November 25 (checklist).

1946 Whitney Museum of American Art, New York. "1946 Annual Exhibition of Contemporary American Sculpture, Watercolors, and Drawings." February 5–March 13 (checklist).

*Egan Gallery, New York. "Joseph Stella." April 1–30.

Devree, Howard. "Among the New Exhibitions." *The New York Times*, April 7, 1946, p. 6.

Mc[Bride], H[enry]. "Attractions in the Galleries." *The New York Sun*, April 6, 1946, p. 9.

"Reviews and Previews: Joseph Stella." *Art News*, 45 (May 1946), pp. 58–59.

Whitney Museum of American Art, New York. "Pioneers of Modern Art in America." April 9–May 19 (catalogue by Lloyd Goodrich).

Burrows, Carlyle. "Pioneers of Modern Painting: American Artists and Chagall." *New York Herald Tribune*, April 14, 1946, p. 7.

Frankfurter, Alfred M. "O Pioneers!" *Art News*, 45 (April 1946), pp. 34–37, 65.

Genauer, Emily. "Paintings Bespeak Faith of Pioneers." *New York World-Telegram*, April 13, 1946, p. 11.

Gibbs, Jo. "The Whitney Museum Reviews American Pioneers in Modern Art." *The Art Digest*, 20 (April 15, 1946), pp. 6–7.

Jewell, Edward Alden. "Eyes on Modernism." *The New York Times*, April 14, 1946, p. 6.

Mc[Bride], H[enry]. "Attractions in the Galleries." *The New York Sun*, April 13, 1946, p. 9.

Rabin & Krueger Gallery, Newark, New Jersey. "10th Anniversary Exhibition of Paintings." Through July 31 (checklist).

Ogden, Dorothy. "Newark Galleries Foster Contemporary Art Works." Unidentified clipping, 1946.

Egan Gallery, New York. "5 Major Works: Stella, de Kooning, Smith, Benn, Hesketh." Through September 30.

Carlson, Helen. "Current Exhibitions." *The New York Sun*, September 14, 1946, p. 4.

"Reviews and Previews: Five Major Works." *Art News*, 45 (October 1946), p. 64.

1947 The Museum of Modern Art, New York. "Large-Scale Modern Paintings." April 1–May 4.

Genauer, Emily. "Modern Painting on a Large Scale." *New York World-Telegram*, April 5, 1947.

McBride, Henry. "Modernism Plentiful." *The New York Sun*, April 4, 1947, p. 19.

"Reviews and Previews: Large Paintings." *Art News*, 46 (April 1947), p. 42.

1949 The Denver Art Museum. "The Modern Artist and His World." March 6–April 27 (catalogue, with text by Otto Karl Bach).

The Institute of Contemporary Art, Boston. "The Société Anonyme Collection of 20th Century Painting." June 4–July 1 (checklist).

Whitney Museum of American Art, New York. "Juliana Force and American Art: A Memorial Exhibition." September 24–October 30 (catalogue, with texts by Hermon More, Lloyd Goodrich, John Sloan, Guy Pène du Bois, Alexander Brook, Forbes Watson).

Knoedler Galleries, New York. "To Honor Henry McBride: An Exhibition of Paintings, Drawings and Water Colours." November 29–December 17 (catalogue, with essay by Lincoln Kirstein).

1950 Yale University Art Gallery, New Haven. "An Exhibition Commemorating the 30th Anniversary of the Société Anonyme: Museum of Modern Art, 1920." Opened April 30.

The Metropolitan Museum of Art, New York. "100 American Painters of the 20th Century: Works Selected from the Collections of The Metropolitan Museum of Art." June 16, 1950–February 1951 (catalogue, with introduction by Robert Beverly Hale).

1951 The Museum of Modern Art, New York. "Abstract Painting and Sculpture in America." January 23–March 25 (catalogue by Andrew Carnduff Ritchie). Traveled as "Abstract Painting in America" to Dallas Museum of Fine Arts, October 1–22; St. Paul Gallery and School of Art, Minnesota, November 5–26; Winnipeg Art Gallery, Alberta, December 10–31; The Toledo Museum of Art, January 14–28, 1952; J.B. Speed Art Museum, Louisville, February 18–March 10; Southern Illinois University, Carbondale, March 24–April 14.

Devree, Howard. "Abstract Survey." *The New York Times*, January 28, 1951, p. 10.

_____. "Modern Museum Opening Exhibition Today of Abstract Painting and Sculpture Since '13." *The New York Times*, January 24, 1951.

Genauer, Emily. "Art and Artists: Why an Abstract Show?" *New York Herald Tribune*, January 28, 1951, section 4, p. 5.

Hess, Thomas B. "Is Abstraction Un-American?" *Art News*, 49 (February 1951), pp. 38–41.

The Dayton Art Institute. "The City by the River and the Sea: Five Centuries of Skylines." April 18–June 3 (catalogue by Esther Isabel Seaver).

"Dayton Views 500 Years of Cityscapes." *The Art Digest*, 25 (May 15, 1951), p. 15.

State University of Iowa, Iowa City. "Six Centuries of Master Drawings." Summer 1951 (catalogue, with introduction by William Sebastian Heckscher).

The Brooklyn Museum, New York. "Revolution and Tradition: An Exhibition of the Chief Movements in American Painting from 1900 to the Present." November 15, 1951–January 6, 1952 (catalogue by John I.H. Baur).

Institute of Contemporary Arts, Washington, D.C. (organizer). Selections from the Société Anonyme. Exhibition at The Corcoran Gallery of Art. November 24–December 31.

1952 Wildenstein Gallery, New York. "Loan Exhibition of Seventy Twentieth-Century American Paintings." February 21–March 22 (catalogue).

Truman Gallery, New York. "U.S. Watercolors and Drawings." Through October 11.

H[olliday], B[etty]. "Reviews and Previews: U.S. Watercolors and Drawings." *Art News*, 51 (October 1952), p. 48.

Yale University Art Gallery, New Haven. "In Memory of Katherine S. Dreier, 1877–1952: Her Own Collection of Modern Art," December 15, 1952–February 1, 1953 (catalogue in the *Bulletin of the Associates in Fine Arts at Yale University*, 20 [December 1952]).

1953　The Downtown Gallery, New York. "MDCLIII/MCMLIII: Celebrating the Tercentenary of the City of New York, Paintings of New York by Leading American Artists." February 17–March 7 (brochure, with checklist).

Wildenstein Gallery, New York. "Landmarks in American Art, 1670–1950: A Loan Exhibition of Great American Paintings." February 26–March 28 (catalogue).

Genauer, Emily. "Art and Artists." *New York Herald Tribune*, March 1, 1953, section 4, p. 7.

Richardson, E.P. "Landmarks in American Art." *The Art Quarterly*, 16 (Summer 1953), pp. 137–40.

Walker Art Center, Minneapolis. "The Classic Tradition in Contemporary Art." April 24–June 28 (catalogue, with text by H.H. Arnason).

The Slater Memorial Museum, The Norwich Free Academy, Norwich, Connecticut. "New Trends in 20th Century American Painting [from the Collection of the Société Anonyme]." November 8–29.

The Metropolitan Museum of Art, New York. "American Painting, 1754–1954." December 18, 1953–May 26, 1954.

1954　The Arts Club of Chicago. "Twentieth-Century Art Loaned by Members of the Arts Club of Chicago." October 1–30 (catalogue).

The Downtown Gallery, New York. "29th Annual Exhibition." October 5–30 (catalogue, with checklist).

Whitney Museum of American Art, New York. "Roy and Marie Neuberger Collection: Modern American Painting and Sculpture." November 17–December 19 (catalogue, with foreword by John I.H. Baur and introduction by Marie and Roy Neuberger). Traveled to The Arts Club of Chicago, January 4–30, 1955; Art Gallery of the University of California, Los Angeles, February 21–April 3; San Francisco Museum of Art, April 26–June 5; City Art Museum of St. Louis, June 27–August 7; Cincinnati Art Museum, August 29–September 25.

1955　Wadsworth Atheneum, Hartford. "Twentieth-Century Painting from Three Cities: New York, New Haven, Hartford." October 19–December 4 (catalogue, with text by Belle Krasne Ribicoff).

American Federation of Arts, New York (organizer). "Pioneers of American Abstract Art." Traveled to the Atlanta Public Library, December 1–22; Louisiana State Exhibit Museum, Shreveport, January 4–25, 1956; J.B. Speed Art Museum, Louisville, February 8–March 1; Lawrence Art Museum, Williamstown, Massachusetts, April 19–May 10; George Thomas Hunter Gallery, Chattanooga, Tennessee, May 24–June 14; Rose Fried Gallery, New York, December 19, 1956–January 9, 1957.

1956　28th Biennale, Venice. "American Artists Paint the City" (catalogue by Katharine Kuh).

1957　The Detroit Institute of Arts. "Painting in America: The Story of 450 Years." April 23–June 9.

"Americans for Americans." *Time*, April 29, 1957, p. 76.

Zabriskie Gallery, New York. "The City: New York, 1900–1930." June 17–July 31 (checklist).

1958　Whitney Museum of American Art, New York. "Nature in Abstraction." January 14–March 16 (catalogue by John I.H. Baur). Traveled to The Phillips Gallery, Washington, D.C., April 2–May 4; Fort Worth Art Center, June 2–June 29; Los Angeles County Museum of Art, July 16–August 24; San Francisco Museum of Art, September 10–October 12; Walker Art Center, Minneapolis, October 29–December 14; City Art Museum of St. Louis, January 7–February 8, 1959.

Salpeter Gallery, New York. "Mosca, Stella, and Quanchi." March 17–April 12.

M[unsterberg], H[ugo]. "In the Galleries." *Arts*, 32 (April 1958), p. 61.

*Zabriskie Gallery, New York. "Joseph Stella." April 15–May 17 (catalogue, with text by Milton Brown).

Burrows, Carlyle. "Art by Stella and Zerbe in Leading New Shows." *New York Herald Tribune Book Review*, April 20, 1958.

P[orter], F[airfield]. "Reviews and Previews: Joseph Stella." *Art News*, 57 (April 1958), p. 17.

Preston, Stuart. "Various Modern Veins." *The New York Times*, April 20, 1958, section 10, p. 11.

S[awin,] M[artica]. "In the Galleries: Joseph Stella." *Arts*, 32 (May 1958), p. 55.

Schiff, Bennett. "In the Art Galleries...." *New York Post*, April 27, 1958, p. 12.

The Brooklyn Museum, New York. "Brooklyn Bridge: 75th Anniversary Exhibition." April 29–July 27 (catalogue).

Burrows, Carlyle. "Bridge Art Theme of Brooklyn Museum Show." *New York Herald Tribune Book Review*, May 4, 1958.

Kaufmann, Edgar, Jr. "The Brooklyn Bridge and the Artist." *Art in America*, 46 (Spring 1958), pp. 56–59.

Mary Washington College, University of Virginia, Charlottesville. "3rd Annual Exhibition." November.

The Downtown Gallery, New York. Annual Christmas exhibition.

Preston, Stuart. "Art: Christmas Offerings Linger On." *The New York Times*, January 3, 1959.

1959 The Virginia Museum of Fine Arts, Richmond. "Paintings and Sculpture Collected by Mr. and Mrs. Larry Aldrich." January 16–March 1 (catalogue).

The Downtown Gallery, New York. "Spring Exhibition." May.

Davis Galleries, New York. "A Family Collection." May 5–30 (checklist).

*Zabriskie Gallery, New York. "Portraits by Joseph Stella." September 14–October 3 (brochure, with checklist).

J., D. "Reviews and Previews: Joseph Stella." *Art News*, 58 (September 1959), p. 10.

Levin, Meyer, and Eli Levin. "Stella: Portrait of a Modern." *The Sunday Star Ledger Every Week Magazine* [Newark], October 4, 1959, p. 6.

Schiff, Bennett. "In the Art Galleries...." *New York Post*, September 27, 1959, p. 12.

V[entura], A[nita]. "Joseph Stella Portraits." *Arts*, 33 (September 1959), p. 61.

Whitney Museum of American Art, New York. "Paintings and Sculpture from the American National Exhibition in Moscow." October 28–November 15 (brochure, with checklist).

Genauer, Emily. "Whitney Shows Art We Sent to Russia." *New York Herald Tribune*, November 1, 1959.

The Downtown Gallery, New York. "Christmas at The Downtown Gallery." November 17–December 5.

The Downtown Gallery, New York. "New Acquisitions." December 29, 1959–January 23, 1960.

1960 The Corcoran Gallery of Art, Washington, D.C. "A Loan Exhibition from the Edith Gregor Halpert Collection." January 16–February 28 (catalogue).

The Nordness Gallery, New York. "The Importance of the Small Painting." March 28–April 16.

Zabriskie Gallery, New York. "Early 20th Century American Water Color and Pastel." April 11–30.

Ashton, Dore. "At the Zabriskie Gallery...." *The New York Times*, April 18, 1960.

The Newark Museum, New Jersey. "Collage: Art in Scraps and Patchwork." April 28–June 12.

Davis Galleries, New York. "Pastels." May 10–28.

Munson-Williams-Proctor Institute, Utica, New York. "Art Across America." October 15–December 31 (catalogue).

*The Museum of Modern Art, New York. "The Drawings of Joseph Stella." October 26–November 13. Traveled to The Currier Gallery of Art, Manchester, New Hampshire, December 1–22; Addison Gallery of American Art, Phillips Academy, Andover, Massachusetts, January 6–27, 1961; Atlanta Art Association, February 13–March 13; The Dallas Museum for Contemporary Arts, March 28–April 18; Colorado Springs Fine Arts Center, May 2–23; Columbus Gallery of Fine Arts, Ohio, June 9–20; J.B. Speed Art Museum, Louisville, July 10–31; National Gallery of Canada, Ottawa, September 1–October 1; The Baltimore Museum of Art, October 17–November 7; William Rockhill Nelson Gallery of Art, Atkins Museum of Fine Arts, Kansas City, Missouri, November 22–December 13; City Art Museum of St. Louis, January 2–23, 1962; Seattle Art Museum, February 7–March 7; San Francisco Museum of Art, March 19–April 16; Phoenix Art Museum, April 30–May 21.

Burrows, Carlyle. "Stella, at Museum; New Moderns Show." *New York Herald Tribune*, October 30, 1960, section 4, p. 8.

Lenson, Michael. "Accent on Figure." *Newark Sunday News*, October 30, 1960, p. 13.

Preston, Stuart. "Art: American Futurist." *The New York Times*, October 26, 1960, p. 42.

_____. "Current and Forthcoming Exhibitions: New York." *The Burlington Magazine*, 102 (December 1960), p. 549.

_____. "Many Directions." *The New York Times*, October 30, 1960, section 10, p. 13.

Walker Art Center, Minneapolis. "The Precisionist View in American Art." November 13–December 25 (catalogue, with text by Martin L. Friedman). Traveled to the Whitney Museum of American Art, New York, January 24–February 28, 1961; The Detroit Institute of Arts, March 21–April 23; Los Angeles County Museum of Art, May 17–June 18; San Francisco Museum of Art, July 2–August 6.

*Zabriskie Gallery, New York. "Joseph Stella." In cooperation with Rabin & Kreuger Gallery, Newark, New Jersey. November 14–December 10 (checklist).

Preston, Stuart. "Paintings of Charles Shoup Displayed—Joseph Stella's Works on View." *The New York Times*, November 18, 1960, p. 63.

S[awin], M[artica]. "In the Galleries: Joseph Stella." *Arts*, 35 (November 1960), p. 62.

Schiff, Bennett. "In the Art Galleries." *New York Post*, November 27, 1960, p. M12.

1961 The Downtown Gallery, New York. "Aquamedia in American Art." February 15–March 11 (brochure).

Nordness Gallery, New York. "The Artist Depicts the Artist." February 21–March 11 (catalogue).

The Museum of Modern Art, New York. "America Seen—Between the Wars." April.

Canaday, John. "U.S.A., Current and Revived." *The New York Times*, April 30, 1961, section 2, p. 15.

Zabriskie Gallery, New York. "Americans on Paper." May 6–June 30.

Joslyn Art Museum, Omaha. "100 Works from the Collections at the University of Nebraska." October 1–29 (brochure, with checklist).

*Zabriskie Gallery, New York. "Collages: Joseph Stella." In cooperation with Rabin & Krueger Gallery, Newark, New Jersey. October 2–October 28 (checklist).

"Around the Galleries." *The New York Times*, October 8, 1961.

E[dgar], N[atalie]. "Reviews and Previews: Joseph Stella." *Art News*, 60 (November 1961), p. 15.

O'Doherty, Brian. "Art: 3 Exhibitions Deal in 'Dialectic of the Eye.'" *The New York Times*, October 3, 1961.

R[aynor,] V[ivien]. "In the Galleries: Joseph Stella." *Arts Magazine*, 36 (October 1961), p. 40.

The Museum of Modern Art, New York. "The Art of Assemblage." October 2–November 12 (catalogue by William C. Seitz). Traveled to The Dallas Museum for Contemporary Arts, January 9–February 11, 1962; San Francisco Museum of Art, March 5–April 15.

Cincinnati Art Museum. "American Painting." October 7–November 12.

J.B. Speed Art Museum, Louisville. "The American Scene Between the Wars." December 1–21.

1962 The Downtown Gallery, New York. "Abstract Painting in America, 1903–1923." March 27–April 21.

The Downtown Gallery, New York. "36th Spring Annual." May.

The New Gallery, Department of Art, University of Iowa, Ames. "Vintage Moderns: American Pioneer Artists, 1903–1932." May 24–August 2 (catalogue).

The Corcoran Gallery of Art, Washington, D.C. "The Edith Gregor Halpert Collection." September 28–November 11 (brochure, with checklist).

Rose Art Museum, Brandeis University, Waltham, Massachusetts. "American Modernism." October (catalogue by Sam Hunter).

American Federation of Arts, New York. "As Artists See Artists." October–May.

The Downtown Gallery, New York. "37th Anniversary Exhibition." October 16–November 10 (brochure, with checklist).

*G Contemporary Paintings Gallery, Buffalo. "Joseph Stella." October 23–November 3, 1962.

> Reeves, Jean. "Stella's Paintings Seek Out 'Blue Distances of Youth.'" *Buffalo Evening News*, October 17, 1962, section 3, p. 56.

Grand Rapids Art Gallery, Michigan. "University Art Museum of the Month: University of Nebraska." November 4–26.

> "New Attraction: Art Gallery to Exhibit Futuristic Work by Joseph Stella." *Grand Rapids Press*, October 31, 1962, p. 57.

The Museum of Modern Art, New York. "Annual Exhibition of New Acquisitions." November 21, 1962–January 13, 1963.

> Preston, Stuart. "Art: New Acquisitions." *The New York Times*, November 20, 1962, p. 32.

1963 *Robert Schoelkopf Gallery, New York. "Joseph Stella." January 2–February 9 (checklist).

> A., D. "Stella's Drawings, Collages." *The Christian Science Monitor*, February 2, 1963.

> F[aunce], S[arah] C. "Reviews and Previews: Joseph Stella." *Art News*, 61 (February 1963), p. 10.

> "Joseph Stella." *The Philadelphia Inquirer*, January 13, 1963.

> Luchars, Margaret. "Stella at Schoelkopf." *Manhattan East*, January 31, 1963.

> Tillim, Sidney. "In the Galleries: Joseph Stella." *Arts Magazine*, 37 (February 1963), p. 50.

*Montclair Art Museum, New Jersey. "Joseph Stella: 20th-Century Master." January 13–February 10.

> "Exhibition Planned of Works by Stella." *The Montclair Times*, January 17, 1963.

> "The Montclair Art Museum..." *The Newark Star-Ledger*, January 20, 1963.

Munson-Williams-Proctor Institute, Utica, New York. "1913 Armory Show: 50th Anniversary Exhibition, 1963." February 17–March 3 (catalogue, with text by Milton Brown). Traveled to the 69th Regiment Armory, New York, April 6–28.

> "Armory Show—50 Years Later" (editorial). *The New York Times*, April 6, 1963, p. 18.

> Genauer, Emily. "Echoes in an Old Armory." *New York Herald Tribune*, April 28, 1963.

*Drew University, Madison, New Jersey. "Joseph Stella." February 24–March 24 (brochure).

Whitney Museum of American Art, New York. "The Decade of the Armory Show, 1910–1920: Pioneers of Modern Art in America," February 27–April 14 (catalogue by Lloyd Goodrich). Traveled to the City Art Museum of St. Louis, June 1–July 14; The Cleveland Museum of Art, August 6–September 15; Pennsylvania Academy of the Fine Arts, Philadelphia, September 30–October 30; The Art Institute of Chicago, November 15–December 29; Albright–Knox Art Gallery, Buffalo, January 20–February 23, 1964.

University of Notre Dame, Art Gallery. "Sacred Art in America Since 1900." March 3–31.

The Corcoran Gallery of Art, Washington, D.C. "The New Tradition: Modern Americans Before 1940." April 27–June 2 (catalogue, with essay by Gudmund Vigtel).

The Newark Museum, New Jersey. "Exhibition of a Permanent Collection." Spring–Summer.

*Storm King Art Center, Mountainville, New York. "Paintings, Watercolors, Drawings, and Collages by Joseph Stella." June 2–27 (brochure, with checklist).

Whitney Museum of American Art, New York. "Between the Fairs: 25 Years of American Art, 1939–1964." June 24–September 23 (catalogue by John I.H. Baur).

Whitney Museum of American Art, New York. "Sixty Years of American Art." September 17–October 20.

> G[enauer], E[mily]. "'Discovery' and Jolts at Whitney." *New York Herald Tribune*, September 22, 1963, section 4, p. 6.

Preston, Stuart. "Whitney Displays U.S. Works of 60 Years." *The New York Times*, September 17, 1963, p. 32.

Rose Art Museum, Brandeis University, Waltham, Massachusetts. "American Modernism: The First Wave, Painting from 1903 to 1933." October 4–November 10 (catalogue).

*Whitney Museum of American Art, New York. "Joseph Stella." October 23–December 4 (catalogue by John I.H. Baur).

"The Art of Joseph Stella." *Pictures on Exhibit*, 27 (October 1963), pp. 4–5.

Baker, Elizabeth C. "The Consistent Inconsistency of Joseph Stella." *Art News*, 62 (December 1963), pp. 47, 62–63.

Baur, John I.H. "Joseph Stella Retrospective." *Art in America*, 51 (October 1963), pp. 32–37.

Canaday, John. "Art: Stella Retrospective." *The New York Times*, October 23, 1963, p. 38.

_____. "Stella Versus Stella." *The New York Times*, October 27, 1963.

Coates, Robert M. "The Art Galleries: One-Note Man." *The New Yorker*, November 23, 1963, pp. 184–87.

"The Galleries: A Critical Guide." *New York Herald Tribune*, October 26, 1963, p. 9.

Genauer, Emily. "Joseph Stella Art at the Whitney." *New York Herald Tribune*, October 23, 1963.

_____. "A Late Look at Stella's Futurism." *New York Herald Tribune*, *Living Section*, October 27, 1963, p. 31.

"New York Was His Wife." *Time*, November 8, 1963, p. 70.

O'Doherty, Brian. "Joseph Stella." *The New York Times*, November 2, 1963, p. 22.

Oeri, Georgine. "The Object of Art." *Quadrum*, 16 (1964), pp. 7–8.

Tillim, Sidney. "In the Galleries: Joseph Stella." *Arts Magazine*, 38 (December 1963), pp. 65–66.

The Corcoran Gallery of Art, Washington, D.C. "Progress of an American Collection." October 26–December 29.

*Robert Schoelkopf Gallery, New York. "Joseph Stella." October 29–November 16 (brochure, with checklist).

Baker, Elizabeth C. "The Consistent Inconsistency of Joseph Stella." *Art News*, 62 (December 1963), pp. 47, 62–63.

Tillim, Sidney. "In the Galleries: Joseph Stella." *Arts Magazine*, 38 (December 1963), pp. 65–66.

The Downtown Gallery, New York. Group show. October.

*Salpeter Gallery, New York. "Joseph Stella: Diverse Moods and Media." November 1–December 7 (catalogue).

Baker, Elizabeth C. "The Consistent Inconsistency of Joseph Stella." *Art News*, 62 (December 1963), pp. 47, 62–63.

O'Doherty, Brian. "Joseph Stella." *The New York Times*, November 2, 1963, p. 22.

Tillim, Sidney. "In the Galleries: Joseph Stella." *Arts Magazine*, 38 (December 1963), pp. 65–66.

1964 The Downtown Gallery, New York. "Aquamedia—Modern Masters." January.

City Art Museum of St. Louis. "200 Years of American Painting." April 1–May 31 (catalogue in *Bulletin: City Art Museum of St. Louis*, 48, nos. 1–2 [1964]).

Kresge Art Center Gallery, Michigan State University, East Lansing. "The Turn of the Century." April 10–May 4 (catalogue).

The Downtown Gallery, New York. "New York City." May 12–June 5 (checklist).

Zabriskie Gallery and Robert Schoelkopf Gallery, New York. "New York, New York." June 2–26 (checklist).

"The Galleries: A Critical Guide." *New York Herald Tribune*, June 6, 1964, p. 6.

The Downtown Gallery, New York. "39th Anniversary Exhibition." September–October.

Kay, Jane H. "Breaking Barriers." *The Christian Science Monitor*, October 2, 1964, p. 13.

Argus Gallery, Madison, New Jersey. "Tal Streeter, Joseph Stella." October 4–22 (brochure).

*Robert Schoelkopf Gallery, New York. "Drawings of Joseph Stella." October 6–31.

C[ampbell], L[awrence]. "Reviews and Previews: Joseph Stella." *Art News*, 63 (October 1964), p. 12.

"The Galleries: A Critical Guide." *New York Herald Tribune*, October 19, 1964.

R[aynor], V[ivien]. "In the Galleries: Joseph Stella." *Arts Magazine*, 39 (November 1964), p. 60.

The Baltimore Museum of Art. "1914: An Exhibition of Paintings, Drawings, and Sculpture." October 6–November 15 (catalogue, with texts by George Boas et al.).

*The Student Center Art Gallery, Seton Hall University, South Orange, New Jersey. "Stella." November 1–December 13 (catalogue).

1965
The Downtown Gallery, New York. Group show. January.

Forum Gallery, New York. "Artists by Artists." January 9–30 (brochure).

"The Galleries: A Critical Guide." *New York Herald Tribune*, January 16, 1965, p. 9.

Genauer, Emily. "Portrait of the Artist as a Social Lion." *New York Herald Tribune*, January 17, 1965, pp. 33–34.

New School for Social Research Art Center, New York. "Portraits from the American Art World." February 1–27.

The Metropolitan Museum of Art, New York. "Three Centuries of American Painting." April 9–October 17 (brochure, with checklist).

The Brooklyn Museum, New York. "The Herbert A. Goldstone Collection of American Art." June 15–September 12 (catalogue).

Gruen, John. "They Heard a Different Drum." *New York Herald Tribune*, July 11, 1965, p. 29.

Preston, Stuart. "Art: Two Major American Exhibitions." *The New York Times*, June 15, 1965, p. 47.

_____. "Paintings in America, Past and Present." *The New York Times*, June 20, 1965, section 2, p. 21.

The Leicester Galleries, London. "Six Decades of American Art." July 14–August 18 (catalogue).

Zabriskie Gallery, New York. "20th Century American Drawings." September 14–October 9.

M. Knoedler & Co., New York. "Synchromism and Color Principles in American Painting, 1910–1930." October 12–November 6 (catalogue by William C. Agee).

G[enauer], E[mily]. "The Art Tour." *New York Herald Tribune*, October 16, 1965, pp. 10–11.

Gallery of Modern Art, New York. "About New York, Night and Day, 1915–1965." October 19–November 15 (catalogue).

National Collection of Fine Arts, Smithsonian Institution, Washington, D.C. "Roots of Abstract Art in America, 1910–1930." December 2, 1965–January 9, 1966 (catalogue, with text by Adelyn D. Breeskin).

1966
Public Education Association, New York, with simultaneous exhibitions at M. Knoedler & Co. and nine other galleries. "Crosscurrents in Modern Art: Seven Decades, 1895–1965." April 26–May 21 (catalogue, with text by Peter Selz).

The Cleveland Museum of Art. "Fifty Years of Modern Art: 1916–1966." June 15–July 31.

ACA American Masters Gallery, Feigen/Palmer Gallery, and Terry De Lapp Gallery, Los Angeles. "American Masters: 1800–1966." June (catalogue).

Milwaukee Art Center. "The Inner Circle." September 15–October 23 (catalogue).

Whitney Museum of American Art, New York. "Art of the United States: 1670–1966." September 28–November 27 (catalogue, with text by Lloyd Goodrich).

The Sheldon Memorial Art Gallery, University of Nebraska, Lincoln. "The Howard S. Wilson Memorial Collection." October 11–November 13 (catalogue).

The Downtown Gallery, New York. Group show. November.

*Robert Schoelkopf Gallery, New York. "Joseph Stella: Water Colors, Drawings, Collages." November 1–19 (brochure).

> "Art in New York: Joseph Stella." *Time*, November 11, 1966.
>
> Gruen, John. "Friday Tour of Art: Joseph Stella." *World Journal Tribune*, November 11, 1966.
>
> Kramer, Hilton. "Joseph Stella." *The New York Times*, November 5, 1966.
>
> N[emser], C[indy]. "In the Galleries: Joseph Stella." *Arts Magazine*, 41 (November 1966), p. 62.
>
> W[hite], C[laire] N[icolas]. "Reviews and Previews: Joseph Stella." *Art News*, 65 (October 1966), p. 64.

*Galeria Astrolabio Arte, Rome. "Joseph Stella." December 1966–January 1967 (catalogue).

1967 Expo '67, Montreal. "Man and His World: International Fine Arts Exhibition." April–October.

The New Jersey State Museum, Trenton. "Focus on Light." May 20–September 10 (catalogue by Richard Bellamy, Lucy R. Lippard, and Leah P. Sloshberg).

The Art Association of Newport, Rhode Island. "The Second Harrison S. Morris Memorial Exhibition." August 4–September 4.

Center for Inter-Cultural Relations, New York. "Artists of the Western Hemisphere: Precursors of Modernism, 1860–1930." September–November.

The Downtown Gallery, New York. "42nd Anniversary Exhibition." September.

Amon Carter Museum of Western Art, Fort Worth. "Image to Abstraction." September 14–November 19.

The Downtown Gallery, New York. Group show. November.

Portland Art Museum, Oregon. "Seventy-five Masterworks." December 12, 1967–January 21, 1968.

University of New Mexico Art Museum, Albuquerque. "Cubism: Its Impact on the USA, 1910–1930." (catalogue). Traveled to the Marion Koogler McNay Art Institute, San Antonio, Texas; San Francisco Museum of Art; Los Angeles Municipal Art Gallery.

1968 Pennsylvania Academy of the Fine Arts. "Early Moderns." January 31–March 3 (brochure, with checklist).

Ackland Art Museum, University of North Carolina, Chapel Hill. "Fifty Years of American Art." February.

The Downtown Gallery, New York. Group show. February.

Cincinnati Art Museum. "American Paintings on the Market Today, V." April 9–May 12 (catalogue, with text by Richard J. Boyle).

The University of Connecticut Museum of Art, Storrs. "Edith Halpert and The Downtown Gallery." May 25–December 1 (catalogue by Marvin S. Sadik).

The Downtown Gallery, New York. "American Drawings." May.

Maxwell Galleries, San Francisco. "American Art Since 1850." August 2–31 (catalogue).

*Tawes Fine Arts Center, University of Maryland Art Gallery, College Park. "The Drawings of Joseph Stella." September 16–October 20 (catalogue, with text by William H. Gerdts).

> "Art." *Sunday Star*, October 20, 1968.
>
> Hammond, Vaughan. "Stella's Works Exhibited." *Prince George's Sentinel*, October 3, 1968, p. 12.

The Downtown Gallery, New York. "43rd Anniversary Exhibition." September.

Whitney Museum of American Art, New York. "The 1930's: Painting and Sculpture in America." October 15–December 1 (catalogue by William C. Agee).

> Gruen, John. "Art in New York: Art of the 1930's." *New York*, November 11, 1968, p. 19.

> Siegel, Jeanne. "The 1930's: Painting and Sculpture in America." *Arts Magazine*, 43 (November 1968), pp. 30–33.

1970 *Robert Schoelkopf Gallery, New York. "Joseph Stella: Oils, Watercolors, Drawings, Collages." January 3–29.

> Albertazzi, Mario. "Arte e artisti." *Il Progresso Italo-Americano*, January 19, 1970, p. 7.

> Glueck, Grace. "The New Decade...at Dawn." *Art in America*, 58 (January–February 1970), pp. 30–31

> L[evin], K[im]. "Reviews and Previews: Joseph Stella." *Art News*, 68 (February 1970), p. 62.

> Mellow, James R. "Adventure into a Virgin Forest." *The New York Times*, January 18, 1970, p. D25.

> Vinklers, Bitite. "New York." *Art International*, 14 (March 20, 1970), p. 94.

Indiana University Art Museum, Bloomington. "The American Scene, 1900–1970." April 6–May 17 (catalogue, with text by Henry R. Hope).

*American Masters Gallery, Los Angeles.

> Wilson, William. "Art-Tech-Concept Project by Sonnier...." *Los Angeles Times*, July 20, 1970, section 4, p. 8.

*Rutgers University Art Gallery, New Brunswick, New Jersey. "Paintings and Drawings by Joseph Stella from New Jersey Collections." October 3–November 1 (brochure, with text by Phillip Dennis Cate and checklist).

> Singer, Esther F. "Stella's Art at Rutgers." *The Jersey Journal*, October 23, 1970.

> S[pector], S[tephen]. "Joseph Stella at Rutgers." *Arts Magazine*, 45 (November 1970), p. 56.

National Gallery of Art, Washington, D.C. "Great American Paintings from the Boston and Metropolitan Museums." November 30–January 10, 1971 (catalogue by Thomas N. Maytham). Traveled to the City Art Museum of St. Louis, January 28–March 7; Seattle Art Museum, March 25–May 9.

> "Art Across the U.S.A.: Outstanding Exhibitions." *Apollo*, 93 (May 1971), pp. 428–29.

> Conroy, Sarah Booth. "A Nod Here to Other Towns' Centennials." *The Washington Daily News*, November 27, 1970.

> Getlein, Frank. "National Gallery Offers 100 'Great' American Paintings." *Washington Star*, November 29, 1970.

ACA Galleries, New York. "Art on Paper Exhibition." December.

1971 National Collection of Fine Arts, Smithsonian Institution, Washington, D.C. "Edith Gregor Halpert Memorial Exhibition." April.

ACA Galleries, New York. "Summer '71." June–August.

Joslyn Art Museum, Omaha. "The Thirties Decade: American Artists and Their European Contemporaries." October 10–November 28 (catalogue, with essay by Allen Porter).

Carnegie Institute, Museum of Art, Pittsburgh. "Forerunners of American Abstraction." November 18, 1971–January 19, 1972 (catalogue, with text by Herdis Bull Teilman).

Fine Arts Gallery of San Diego. "Color and Form, 1909–1914." November 20, 1971–January 2, 1972 (catalogue by Henry G. Gardiner, with texts by Joshua Taylor et al.). Traveled to The Oakland Museum, January 25–March 5; Seattle Art Museum, March 24–May 7.

1972 University Art Museum, University of Texas at Austin. "Not So Long Ago: Art of the 1920s in Europe and America." October 15–December 17 (catalogue, with texts by Donald B. Goodall and George S. Heyer, Jr.).

1973 Art Museum of South Texas, Corpus Christi. "American Paintings from the Estate of the Late Edith G. Halpert." January 19–February 11 (brochure, with checklist).

Robert Schoelkopf Gallery, New York. "Brooklyn Bridge…Celebrating the 90th Anniversary…" May–June.

Whitney Museum of American Art, Downtown Branch, New York. "Beginnings: Directions in Twentieth-Century American Painting." September 19–October 28.

B., R.L. "Culture Arrives Downtown." *Wall Street Journal*, September 20, 1973.

Kramer, Hilton. "Decentralized Art: Great." *The New York Times*, September 19, 1973, section 2, p. 1.

Heckscher Museum, Huntington, New York, and The Parrish Art Museum, Southampton, New York. "The Students of William Merritt Chase." Two-part joint exhibition, September 28–November 11 and November 18–December 30 (catalogue, with texts by Ronald G. Pisano).

Andrew Crispo Gallery, New York. "Pioneers of American Abstraction." October 17–November 17 (catalogue, with text by Andrew J. Crispo).

Canaday, John. "Art: Show of 'Pioneers of Abstraction.'" *The New York Times*, October 20, 1973, p. 19.

1974 International Exhibitions Foundation, Washington, D.C. (organizer). "American Self-Portraits: 1670–1973" (catalogue by Ann C. van Devanter and Alfred V. Frankenstein). Traveled to the National Portrait Gallery, Smithsonian Institution, Washington, D.C., February 1–March 15; Indianapolis Museum of Art, April 1–May 15.

Richard, Paul. "Mirror, Mirror on the Wall." *The Washington Post*, February 1, 1974, pp. D1, D13.

The Society of the Four Arts, Palm Beach, Florida. "Master Drawings and Watercolors from the Yale University Art Gallery." February 2–March 3 (catalogue).

Carnegie Institute, Museum of Art, Pittsburgh. "Celebration." October 1974–January 1975.

Hirshhorn Museum and Sculpture Garden, Smithsonian Institution, Washington, D.C. "Inaugural Exhibition." October 1, 1974–September 15, 1975.

The Saint Louis Art Museum. "American Watercolors and Drawings." October 6–November 17 (catalogue).

Washington State Pavilion, EXPO '74, Spokane, Washington. "Our Land, Our Sky, Our Water." Through November 3.

Hull, Roger. "Review of Exhibitions: Spokane." *Art in America*, 62 (September–October 1974), pp. 121–22.

1975 Yale University Art Gallery, New Haven (organizer). "Early Twentieth-Century American Realist Prints, Drawings and Watercolors: Selections from the Yale University Art Gallery" (catalogue by David Nathans). Traveled to the Root Art Center, Hamilton College, Clinton, New York, January 9–February 16; Lamont Gallery, The Phillips Exeter Academy, Exeter, New Hampshire, February 20–March 11; Yale University Art Gallery, New Haven, June 16–July 31; Museum of Fine Arts, Springfield, Massachusetts, Fall.

Delaware Art Museum, Wilmington. "Avant-Garde Painting and Sculpture in America, 1910–25." April 4–May 18 (catalogue, with texts by William Inness Homer et al.).

National Collection of Fine Arts, Smithsonian Institution, Washington, D.C. "Recent Acquisitions." Through May 18.

Richard, Paul. "Artistic Acquisitions of Note." *The Washington Post*, March 13, 1975, pp. B1, B15.

Whitney Museum of American Art, New York. "The Whitney Studio Club and American Art 1900–1932." May 23–September 3 (catalogue, with text by Lloyd Goodrich).

Genauer, Emily. "Whitney's Exhibit Is a Sentimental Journey." *Newsday*, June 2, 1975.

Hand, Judson. "As the Century Turns." *Daily News*, July 8, 1975, p. 45.

Vinci, Mona da. "Variety Ordered by Art." *The Soho Weekly News*, June 12, 1975, p. 14.

Whitney Museum of American Art, New York. "American Abstract Art." July 24–October 26.

Kramer, Hilton. "Art: Whitney Unpacks Abstracts." *The New York Times*, July 26, 1975.

Nash, James Alan. "The Art Scene." *After Dark* (October 1975).

Ratcliff, Carter. "New York Letter." *Art International*, 19 (October 20, 1975), pp. 56–57.

Vinci, Mona da. "American Abstract Art and the Fission of Form." *The Soho Weekly News*, August 28, 1975.

Hunter Museum of Art, Chattanooga, Tennessee. "A Southern Sampler: American Paintings in Southern Museums." September 21–October 31 (catalogue).

The Katonah Gallery, Katonah, New York. "American Paintings 1900–1976: The Beginning of Modernism." November 1, 1975–January 4, 1976 (catalogue, with essay by John I.H. Baur).

Terry Dintenfass Gallery, New York. "Shapes of Industry: First Images in American Art." November 4–29 (catalogue).

Savitt, Mark. "Shapes of Industry." *Arts Magazine*, 50 (November 1975), p. 9.

1976 The Solomon R. Guggenheim Museum, New York. "Twentieth-Century American Drawing: Three Avant-Garde Generations." January 23–March 23 (catalogue by Diane Waldman). Traveled to Kunsthalle Baden-Baden, May 27–July 11; Kunsthalle Bremen, July 18–August 29.

Hess, Thomas B. "The Great Paper Chase." *New York*, February 16, 1976, pp. 74–75.

Smith, Roberta. "Drawing Now (and Then)." *Artforum*, 14 (April 1976), pp. 52–59.

The Metropolitan Museum of Art, New York. "A Bicentennial Treasury: American Masterpieces from the Metropolitan." January 29–December 31.

Whitney Museum of American Art, Downtown Branch, New York. "Early Modernists: Selections from the Permanent Collection." March 4–31 (brochure, with checklist).

Hirshhorn Museum and Sculpture Garden, Smithsonian Institution, Washington, D.C. "The Golden Door: Artist-Immigrants of America, 1876–1976." May 20–October 20 (catalogue, with texts by Cynthia Jaffee McCabe et al.).

Minneapolis Institute of Arts. "American Master Drawings and Watercolors: Works on Paper from Colonial Times to the Present." September 2–October 24 (catalogue by Theodore E. Stebbins, Jr.). Traveled to the Whitney Museum of American Art, New York, November 23, 1976–January 23, 1977; Fine Arts Museums of San Francisco, February–April 1977.

1977 *Robert Schoelkopf Gallery, New York. "Joseph Stella: Paintings and Drawings." January 25–February 26.

"Joseph Stella." *Art/World*, 1 (February 1977), p. 7.

Karlins, N.F. "Gallery Guide: Joseph Stella." *East Side Express*, February 17, 1977, p. 17.

Kramer, Hilton. "Art: Joseph Stella, A Puzzling Show." *The New York Times*, February 8, 1977, section 3, p. 20.

Urdang, Beth. "Joseph Stella." *Arts Magazine*, 51 (February 1977), p. 5.

Whitney Museum of American Art, New York. "New York on Paper." April 7–May 22 (brochure).

Musée National d'Art Moderne, Paris. "Paris—New York." June 1–September 19 (catalogue, with texts by Pontus Hulten et al.).

Whitney Museum of American Art, New York. "Turn of the Century America: Paintings, Graphics, Photographs, 1890–1910." June 3–October 2 (catalogue by Patricia Hills). Traveled to The Saint Louis Art Museum, December 1, 1977–January 12, 1978; Seattle Art Museum, February 2–March 12; The Oakland Museum, California, April 4–May 28.

Royal Scottish Academy, Edinburgh. "The Modern Spirit: American Painting 1908–1935." August–September. Traveled to the Hayward Gallery, London, September–November.

Minnesota Museum of Art, St. Paul. "American Drawing, 1927–1977." September 6–October 29 (catalogue, with text by Paul Cummings). Traveled to the Henry Art Gallery, Seattle; The Santa Barbara Museum of Art; National Gallery of Iceland, Reykjavík; Musée des Beaux–Arts, Bordeaux; Museo Español de Arte Contemporaneo, Madrid; Museo de Bellas Artes, Caracas; Galeria Nacional, Santo Domingo; Museo National de Artes y Industrias Populares, Mexico City.

The Museum of Fine Arts, Houston. "Modern American Painting, 1910–1940: Toward a New Perspective." Through September.

Butler, Joseph T. "America." *The Connoisseur*, 196 (October 1977), p. 140.

The Grand Rapids Art Museum, Michigan. "Themes in American Painting." October 1–November 30 (catalogue by J. Gray Sweeney).

Andrew Crispo Gallery, New York. "Twelve Americans: Masters of Collage." November 17–December 30 (catalogue, with introduction by Gene Baro).

Hirshhorn Museum and Sculpture Garden, Smithsonian Institution, Washington, D.C. "The Animal in Art: Selections from the Hirshhorn Museum Collection." November 17, 1977–January 15, 1978 (catalogue).

1978 Hayward Gallery, London. "Dada and Surrealism Reviewed." January 11–March 27 (catalogue by Dawn Ades).

Whitney Museum of American Art, New York. "Synchromism and American Color Abstraction, 1910–1925." January 24–March 26 (catalogue by Gail Levin). Traveled to The Museum of Fine Arts, Houston, April 20–June 18; Des Moines Art Center, July 6–September 3; San Francisco Museum of Modern Art, September 22–November 19; Everson Museum of Art, Syracuse, December 15, 1978–January 28, 1979; Columbus Gallery of Fine Arts, Ohio, February 15–March 24.

> "Artists' Works of Early 1900s on Display in San Francisco." *Palo Alto Times*, September 25, 1978, section 2, p. 11.
>
> Chernow, Burt. "Art World Rediscovers Synchromism and James Daugherty." *Fairpress Do It!*, January 25, 1978, p. C4.
>
> Curtis, Cathy. "In Living Color." *The Daily Californian*, October 27, 1978, p. 15.
>
> Frank, Peter. "Art." *The Village Voice*, March 20, 1978, p. 73.
>
> Halasz, Piri. "American Synchromism: Pleasures and Peccadilloes of an Imperfect Show." *Art News*, 78 (January 1979), pp. 88–89.
>
> Ianco-Starrels, Josine. "Synchromism in San Francisco." *Los Angeles Times*, September 24, 1978.
>
> Kramer, Hilton. "Art: Dawn of Abstraction at Whitney." *The New York Times*, January 27, 1978.
>
> Mills, James. "Old 'Ism' Has New Impact in Exhibition at Whitney Museum." *Denver Post*, April 9, 1978, p. 74.
>
> "Rhythmic Hues." *Horizon*, 21 (February 1978), p. 34.
>
> "Synchronomism [*sic*] and American Color Abstraction at the Whitney." *The Newtown Bee, Antiques & Arts Weekly Supplement*, January 20, 1978, p. 6.

*Donald Morris Gallery, Birmingham, Michigan. "Joseph Stella." January 28–February 25.

Philadelphia Museum of Art. "Life with Dada: Beatrice Wood Drawings." March 11–April 9.

Grey Art Gallery and Study Center, New York University. "Changes in Perspective: 1880–1925." May 2–June 2 (brochure).

Heckscher Museum, Huntington, New York. "The Precisionist Painters 1916–1949: Interpretations of a Mechanical Age." July 7–August 20.

Whitney Museum of American Art, New York. "Twentieth-Century American Drawings: Five Years of Acquisitions." July 28–October 1 (catalogue by Paul Cummings).

Whitney Museum of American Art, Downtown Branch, New York. "Collage: Selections from the Permanent Collection." August 15–September 8.

*The Newark Museum, New Jersey. "Joseph Stella's Imperative Vision." November 4, 1978–March 30, 1979.

Whitney Museum of American Art, New York. "William Carlos Williams and the American Scene 1920–1940." December 12, 1978–February 4, 1979 (catalogue by Dickran Tashjian).

1979 Wellesley College Museum, Wellesley, Massachusetts. "Skyscraperism: The Tall Office Building Artistically Considered, c. 1900–c. 1930." February 1–March 15 (catalogue, with text by James F. O'Gorman).

*Robert Schoelkopf Gallery, New York. "Joseph Stella: Works on Paper." March 24–April 21.

> Lubell, Ellen. "Joseph Stella: Major Works on Paper." *The Soho Weekly News*, April 19, 1979, p. 41.

> Rhyne, Brice. "Arts Reviews: Joseph Stella." *Arts Magazine*, 53 (June 1979), p. 38.

Whitney Museum of American Art, Downtown Branch, New York. "Dada and New York." May 31–July 6 (brochure).

> Frank, Peter. "Storytelling." *The Village Voice*, July 9, 1979.

> "Voice Choices: Art." *The Village Voice*, June 4, 1979.

Whitney Museum of American Art, Downtown Branch, New York. "Stuart Davis, Charles Sheeler, Joseph Stella." July 16–August 17.

Whitney Museum of American Art, New York. "Tradition and Modernism in American Art." September 11–November 11.

> "Whitney to Display 1900–30 Art." *The New York Times*, September 5, 1979.

Barbara Mathes Gallery, New York. "Acquisitions from Private Collections." October–November.

The Saint Louis Art Museum, "American Drawings and Watercolors from the Collection."

The Tate Gallery, London. "Abstraction: Towards a New Art." (catalogue)

1980 Hirshhorn Museum and Sculpture Garden, Smithsonian Institution, Washington, D.C. "The Intimate Scale." February 15–July 27.

New Jersey Bell Telephone Company Headquarters, Newark. "Masterworks from the Collection of the New Jersey State Museum." March.

National Portrait Gallery, Smithsonian Institution, Washington, D.C. "American Portrait Drawings." May 1–August 3 (catalogue by Marvin Sadik and Harold Francis Pfister).

Terra Museum of American Art, Evanston, Illinois. "Treasures from the Hirshhorn: American Painting, 1880–1930." July 29–September 30 (catalogue).

Philadelphia Museum of Art. "Futurism and the International Avant-Garde." October 26, 1980–January 4, 1981 (catalogue by Anne d'Harnoncourt, with essay by Germano Celant).

Hirschl & Adler Galleries, New York. Through November 29, 1980.

> Goldberger, Paul. "Art: Architectural View by American Painters." *The New York Times*, October 30, 1980.

> Scully, Sean. "Architecture in Painting: American Modern Benefit." *Art/World* 5 (November 20–December 20, 1980), p. 14.

Akademie der Künste, West Berlin. "Amerika: Traum und Depression, 1920/40." November 9–December 28 (catalogue by Joshua C. Taylor et al.). Traveled to the Kunstverein Hamburg, January 11–February 15, 1981.

Kunstmuseum Winterthur, Switzerland. "'Rot konstruiert' und 'Super Table': Eine schweizer Sammlung moderner Kunst, 1909–1939" (catalogue) .

1981 Smithsonian Institution Traveling Exhibition Service, Washington, D.C. (organizer). "Collages: Selections from the Hirshhorn Museum and Sculpture Garden" (catalogue by Howard N. Fox). Traveled to Santa Fe Community College, Gainesville, Florida, January 10–February 14; Marion Koogler McNay Art Museum, San Antonio, Texas, March 7–April 11; Anchorage Museum of History and Art, May 2–June 6; The Art Museum of Florida International University, Miami, June 27–August 1; Pensacola Museum of Art, Florida, October 17–November 21; Gibbes Art Gallery, Charleston, South Carolina, April 3–May 15, 1982; Leigh Yawkey Woodson Art Museum, Wausau, Wisconsin, June 12–July 24; Krannert Art Museum, University of Illinois, Champaign, August 21–September 25; Munson-Williams-Proctor Institute, Utica, New York, October 16–November 20.

Whitney Museum of American Art, New York. "Visions of New York City: American Paintings, Drawings and Prints of the Twentieth Century." March 27–May 24.

Whitney Museum of American Art, Fairfield County, Stamford, Connecticut. "Pioneering the Century: Selections from the Permanent Collection of the Whitney Museum of American Art." July 14–August 26 (brochure, with checklist).

Whitney Museum of American Art, New York. "Drawing Acquisitions: 1978–1981." September 17–November 15. Traveled to Whitney Museum of American Art, Fairfield County, Stamford, Connecticut, December 18, 1981–February 3, 1982 (catalogue).

"NYC Museums." *New Jersey Art Form* (September–October 1981).

Preston, Malcolm. "Review: Drawings at Whitney Museum." *Newsday*, November 4, 1981.

White, Claire Nicolas. "Whitney Drawings." *Art/World*, 6 (September 26–October 17, 1981), pp. 1, 7.

Whitney Museum of American Art, New York (organizer). "American Art of the 1930s: Selections from the Collection of the Whitney Museum of American Art" (brochure). Traveled to the Cedar Rapids Art Center, Iowa, October 4–November 29; Ackland Art Museum, University of North Carolina at Chapel Hill, December 16, 1981–February 7, 1982; The Art Gallery, University of Maryland, College Park, February 24–April 18; San Antonio Museum of Art, Texas, May 5–June 27; Phoenix Art Museum, July 14–September 5; Minnesota Museum of Art, St. Paul, September 22–November 14; Columbus Museum of Art, Ohio, December 4, 1982–January 16, 1983; Edwin A. Ulrich Museum of Art, Wichita State University, Kansas, April 20–June 12; Whitney Museum of American Art, Fairfield County, Stamford, Connecticut, July 8–August 31.

The Saint Louis Art Museum. "A Collector's Choice." November.

*Robert Schoelkopf Gallery, New York. "Joseph Stella: The Artist and Nature." December 1–23.

Fort, Ilene Susan. "Arts Reviews: Joseph Stella." *Arts Magazine*, 56 (February 1982), p. 30.

1982 Grey Art Gallery and Study Center, New York University. "American Watercolors and Drawings, 1870–1920." January 12–February 13 (brochure, with checklist).

National Museum of American Art, Smithsonian Institution, Washington, D.C. "Recent Trends in Collecting: Twentieth-Century Painting and Sculpture from the National Museum of American Art." February 12–March 28 (catalogue, with text by Harry Rand).

San Francisco Museum of Modern Art. "Images of America: Precisionist Painting and Modern Photography." September 9–November 7 (catalogue by Karen Tsujimoto). Traveled to The Saint Louis Art Museum, December 6, 1982–January 30, 1983; The Baltimore Museum of Art, February 28–April 25; Des Moines Art Center, May 23–July 17; The Cleveland Museum of Art, August 15–October 9.

Albright, Thomas. "Precisionist Images of America: An Ambivalent Modernism." *Art News*, 82 (January 1983), pp. 86–88.

Nassau County Museum of Fine Art, Roslyn Harbor, New York. "Long Island Collects." April 28–July 18.

Richard York Gallery, New York. "The Natural Image: Plant Forms in American Modernism." November 6–December 4 (catalogue, with texts by Richard T. York and Alanna Chesebro).

*Donald Morris Gallery, Birmingham, Michigan. "Joseph Stella: Paintings, Works on Paper." December 4, 1982–January 8, 1983 (brochure).

1983 The Brooklyn Museum, New York. "The Great East River Bridge, 1883–1983." March 19–June 19 (catalogue, with essays by Deborah Nevins et al.).

Filler, Martin. "The Brooklyn Bridge at 100." *Art in America*, 71 (Summer 1983), pp. 140–52.

Goldberger, Paul. "Brooklyn's Bridge in Paintings, Photos and Words." *The New York Times*, March 18, 1983, pp. C1, C11.

Museum of the Borough of Brooklyn at Brooklyn College, New York. "'Crossing Brooklyn Ferry': The River and the Bridge." April 12–May 10 (brochure, with essays by Shelly Mehlman Dinhofer, Maurice Kramer, and checklist).

Museum of Fine Arts, Boston. "The Lane Collection: 20th-Century Paintings in the American Tradition." April 13–August 7 (catalogue by Theodore E. Stebbins, Jr., and Carol Troyen). Traveled to the San Francisco Museum of Modern Art, October 1–December 1; Amon Carter Museum, Fort Worth, January 7–March 5, 1984.

Whitney Museum of American Art, Fairfield County, Stamford, Connecticut. "Modern Still Life." April 22–June 29 (brochure with checklist).

*Hirshhorn Museum and Sculpture Garden, Smithsonian Institution, Washington, D.C. "Joseph Stella." May 12–July 17 (catalogue by Judith Zilczer). Traveled to the Columbus Museum of Art, Ohio, February 11–March 25, 1984.

"Actualités. Washington: Stella, Joseph." *Connaissance des Arts*, no. 376 (June 1983), p. 20.

"Another Look at the Other Stella." *House & Garden*, 155 (July 1983), p. 152.

Richard, Paul. "Joseph Stella, Picture Puzzler." *The Washington Post*, May 12, 1983, pp. E1, E13.

Schjeldahl, Peter. "Thumbs Up, Thumbs Down: Art." *Vanity Fair*, 46 (July 1983), p. 20.

Heckscher Museum, Huntington, New York. "Late Nineteenth Century and Early Modernist American Art: Selections from the Baker/Pisano Collection." June 19–July 31 (catalogue). Traveled to The Art Gallery, University of Maryland, College Park, September 2–October 16; Elvehjem Museum of Art, University of Wisconsin, Madison, October 30–December 11; Montclair Art Museum, New Jersey, January 15–February 26, 1984.

*Cheekwood Botanical Gardens and Fine Arts Center, Nashville. "Joseph Stella: Botanical Drawings." Through September 4.

*Visual Arts Museum, School of Visual Arts, New York. "Joseph Stella: Selected Works on Paper." October 31–November 19.

Hirschl & Adler Galleries, New York. "Realism and Abstraction: Counterpoints in American Drawing, 1900–1940." November 12–December 30 (catalogue, with text by Douglas Dreishpoon).

Gallati, Barbara. "Realism and Abstraction: American Drawing, 1900–1940." *Arts Magazine*, 58 (January 1984), p. 49.

Musée d'Art Moderne de la Ville de Paris. "Electra: l'électricité et l'électronique dans l'art du XXe siècle." December 10, 1983–February 5, 1984.

Prat, Marie-Aline. "La fée électricité et la fée électronique." *L'Oeil*, no. 341 (December 1983), pp. 46–53.

1984 The Arkansas Arts Center, Little Rock (organizer). "Twentieth-Century American Drawings from The Arkansas Arts Center Foundation Collection" (catalogue by Townsend Wolfe). Traveled to The Eastern Shore Art Association, Fairhope, Alabama, January 15–February 29; The Arkansas Arts Center, Little Rock, April 27–September 30; Louisiana Arts and Science Center, Baton Rouge, May 7–June 30, 1985; Bass Museum of Art, Miami Beach, July 5–August 18; Art Institute for the Permian Basin, Odessa, Texas, September 8–October 31; Jacksonville Art Museum, Florida, November 14, 1985–January 5, 1986; Cornell Fine Arts Center, Rollins College, Winter Park, Florida, March 14–April 27; Meadows Museum, Southern Methodist University, Dallas, June 8–August 3; Sangre de Cristo Arts and Conference Center, Pueblo, Colorado, September 12–October 24; Alexandria Museum, Visual Art Center, Alexandria, Louisiana, November 3, 1986– January 3, 1987; Columbus Museum of Art, Ohio, January 17–March 8; Alaska State Museum, Juneau, March 19–April 26; University of Alaska Museum, Fairbanks, May 8–June 21.

Whitney Museum of American Art, New York. "Reflections of Nature: Flowers in American Art." March 1–May 20 (catalogue by Ella M. Foshay).

Ashbery, John. "America Bursts into Bloom." *Newsweek*, March 19, 1984, p. 95.

Dorsey, John. "Exhibit Traces the Blossoming of Flowers in American Art." [Baltimore] *Morning Sun*, March 15, 1984, p. B1+.

Edinberg, Joyce. "Beauty of Flowers Featured in NY." *The Daily Journal* [Caracas], April 3, 1984.

"Flowers in Art." *The Martha's Vineyard Times*, June 7, 1984, p. 1.

Fressola, Michael J. "Whitney Abloom in 'Reflections of Nature.'" *Staten Island Sunday Advance*, March 4, 1984, p. 21.

Loney, Glenn. "Some Flowers, Courtesy of the Whitney Museum." *The Westsider, Chelsea-Clinton News*, April 19–25, 1984.

"Museum Today: Reflections of Nature." *USA Today/Magazine of the American Scene*, 112 (May 1984), pp. 26–31.

Wolff, Theodore F. "Finest in Floral Paintings." *The Christian Science Monitor*, April 9, 1984.

Yale University Art Gallery, New Haven. "Art for a New Era: The Société Anonyme 1920–1950." April 25–August 31 (brochure).

Museum of the Borough of Brooklyn at Brooklyn College, New York. "Fun and Fantasy: Brooklyn's Amusement Parks and Leisure Areas." April 26–June 5.

Nassau County Museum of Fine Art, Roslyn Harbor, New York. "The Shock of Modernism in America." April 29–July 29.

*Robert Schoelkopf Gallery, New York. "Joseph Stella: Drawings for the Underground Cathedral and Other Works on Paper." May 19–June 15 (brochure).

 Raynor, Vivien. "Joseph Stella." *The New York Times*, June 1, 1984, p. C20.

Heath Gallery, Atlanta. "Twentieth Century American Masters: Works on Paper." June 19–23.

Kalamazoo Institute of Art, Michigan. "American Modernist Paintings and Graphics from West Michigan Collections." September 4–November 4.

1985 Norton Gallery and School of Art, West Palm Beach, Florida. "The Fine Line: Drawing with Silver in America." March 23–May 5 (catalogue by Bruce Weber, with an essay by Agnes Mongan). Traveled to the Pensacola Museum of Art, Florida, July 15–September 16; The Arkansas Arts Center, Little Rock, October 4–November 17; Museum of Fine Arts, Springfield, Massachusetts, December 7, 1985–January 19, 1986.

 Dreishpoon, Douglas. "The Fine Line: Drawing with Silver." *Arts Magazine*, 60 (September 1985), p. 17.

The Taft Museum, Cincinnati. "Night Lights." May 2–June 30.

Museum of the Borough of Brooklyn at Brooklyn College, New York. "From Brooklyn to the Sea: Ships, Seafarers and New York Harbor." October 16–December 4 (brochure, with essays by Shelly Mehlman Dinhofer and Arnold Markoe).

Hirschl & Adler Galleries, New York. "American Masterworks on Paper: Drawings, Watercolors, and Prints." November 23, 1985–January 4, 1986 (catalogue, with text by Douglas Dreishpoon).

1986 The High Museum of Art, Atlanta. "The Advent of Modernism: Post-Impressionism and North American Art, 1900–1918." March 4–May 11 (catalogue, with essays by Peter Morrin, Judith Zilczer, and William C. Agee). Traveled to the Center for the Fine Arts, Miami, June 22–August 31; The Brooklyn Museum, New York, November 26, 1986–January 19, 1987; Glenbow Museum, Calgary, Alberta, February 21–April 19.

Palazzo Grassi, Venice. "Futurismo & Futurismi." May 3–October (catalogue by Pontus Hulten).

Heath Gallery, Atlanta. "Nature in Early Modern American Art." May 17–May 31 (brochure).

Robert Schoelkopf Gallery, New York. "The Modernist Movement in America." June 23–July 25.

 Raynor, Vivien. "The Modernist Movement in America." *The New York Times*, July 4, 1986.

Museum of the Borough of Brooklyn at Brooklyn College, New York. "Tides of Immigration: Romantic Visions and Urban Realities." October 7–December 2 (brochure, with essay by Shelly Mehlman Dinhofer).

Bergen Museum of Art and Science, Ridgewood, New Jersey. "Plants: Aesthetics and Applications."

1987 Hirshhorn Museum and Sculpture Garden, Smithsonian Institution, Washington, D.C. "Bridging the Century: Images of Bridges in the Hirshhorn Museum and Sculpture Garden." March 11–April 24.

National Gallery of Art, Washington, D.C. "New York Interpreted: Joseph Stella, Alfred Stieglitz." April 16–September 1.

 Loughery, John. "Arts Reviews: New York Interpreted." *Arts Magazine*, 62 (September 1987), pp. 106–07.

Terra Museum of American Art, Chicago. "A Proud Heritage: Two Centuries of American Art." April 21–June 21 (catalogue, with essays by D. Scott Atkinson, Judith Russi Kirshner, Elizabeth Milroy, et al.).

Hirschl & Adler Galleries, New York. "Painters in Pastel: A Survey of American Works." April 25–June 5 (catalogue, with text by Dianne H. Pilgrim).

The Saint Louis Art Museum. "The Ebsworth Collection: American Modernism 1911–1947."

November 20, 1987–January 3, 1988 (catalogue by Charles F. Buckley, William C. Agee, and John R. Lane). Traveled to the Honolulu Academy of Arts, February 3–March 15; Museum of Fine Arts, Boston, April 6–June 5.

1988 Whitney Museum of American Art at Philip Morris, New York. "Precisionist Perspectives: Prints and Drawings." March 2–April 28 (brochure, with text by Susan Lubowsky and checklist).

Isetan Museum, Tokyo. "Visions of Tomorrow: New York and American Industrialization in the 1920s and 1930s." April 21–May 9, 1988 (catalogue). Traveled to the Daimaru Museum, Osaka, May 19–June 17; Fukuoka Prefectural Museum of Art, Fukuoka, July 15–August 15; Tochigi Prefectural Museum of Fine Arts, Utsunomiya, August 27–October 2.

Sheldon Memorial Art Gallery, University of Nebraska, Lincoln (organizer). "Face to Face" (brochure, with text by Daphne Anderson Deeds and checklist). Traveled to the High Plains Museum, McCook, Nebraska, September; North Platte Mall, North Platte, Nebraska, October; Dawson County Historical Society, Lexington, Nebraska, November; Museum of Nebraska Art, Kearney, Nebraska, December; First National Bank, Aurora, Nebraska, January 1989; Columbus Library Art Gallery, Columbus, Nebraska, February; Western Nebraska Art Center, Scottsbluff, March; and Morton-James Library, Nebraska City, Nebraska, April.

*Richard York Gallery, New York. "Joseph Stella: The Tropics." October 1–29 (catalogue, with text by Irma B. Jaffe).

> Kramer, Hilton. "The Other Tropics." *Art & Antiques*, 6 (January 1989), pp. 97–98.

> Russell, John. "Joseph Stella: The Tropics." *The New York Times*, October 28, 1988, p. C30.

*Heath Gallery, Atlanta. "Joseph Stella: Botanical Drawings." November 22–December 24.

The Arkansas Arts Center, Little Rock. "The Face." December 1, 1988–January 28, 1989 (catalogue by Townsend Wolfe).

> Freeman, June. "The Face Has 110 Viewpoints in Wolfe-Assembled Exhibit." *Pine Bluff Commercial*, December 11, 1988, p. 9A.

> Morris, Dan. "Art Center's 'Face' Exhibit Transcends Media, Movements." *Arkansas Gazette*, December 2, 1988, p. 6E.

Montclair Art Museum, New Jersey, The Newark Museum, and the New Jersey State Museum, Trenton (organizers). "American Paintings from Three New Jersey Museums" (brochure). Traveled to the IBM Gallery of Science and Art, New York. December 13, 1988–February 25, 1989.

1989 *Parkerson Gallery, Houston. "'Botanical': Works on Paper by Joseph Stella." February 23–March 31.

Pennsylvania Academy of the Fine Arts, Philadelphia. "American Art from the Collection of Vivian and Meyer P. Potamkin." June 10–October 1 (brochure, with checklist).

> Bantel, Linda, with Susan Danly and Jeanette Toohey. "The Potamkin Collection of American Art." *Antiques*, 136 (August 1989), pp. 292–93.

> Quinn, Jim. "Hanging Out with the Potamkins." *Philadelphia*, 80 (July 1989), pp. 61–65.

The Saint Louis Art Museum. "American Drawings and Watercolors, 1900–1945" (catalogue, with text by Ruth L. Bohan, in *The Saint Louis Art Museum Bulletin*, 19 [Summer 1989]).

Sid Deutsch Gallery, New York. "Late Nineteenth- and Twentieth-Century American Masters." October 3–25 (catalogue).

Princeton Gallery of Fine Art, New Jersey. "Two American Masters: Milton Avery, Joseph Stella." October 3–November 4.

The Arkansas Arts Center, Little Rock. "Early Twentieth-Century Modernists from The Arkansas Arts Center Foundation Collection." October 8, 1989–February 11, 1990 (catalogue).

Richard York Gallery, New York. "The Italian Presence in American Art, 1860–1920." November 17–December 29 (catalogue, with text by Judith Hayward).

Hirschl & Adler Galleries, New York. "A Sense of Line: American Modernist Works on Paper." November 25, 1989–January 6, 1990 (catalogue, with text by James L. Reinish).

Barbara Mathes Gallery, New York. "American Moderns." November 28, 1989–January 6, 1990.

> Roberta Smith. "American Moderns." *The New York Times*, December 22, 1989.

Sheldon Memorial Art Gallery, University of Nebraska, Lincoln. "Of Time and the City: American Modernism from the Sheldon Memorial Art Gallery." January 9–March 11 (catalogue by Daphne Anderson Deeds). Traveled to the J.B. Speed Art Museum, Louisville, April 1–May 27; Paine Art Center and Arboretum, Oshkosh, Wisconsin, June 24–August 19; The Art Museum at Florida International University, Miami, September 16–November 11; Crocker Art Museum, Sacramento, December 9, 1990–February 3, 1991; The Society of the Four Arts, Palm Beach, Florida, March 3–April 28; Louisiana Arts and Science Center, Baton Rouge, May 26–July 21; Tacoma Art Museum, Washington, August 18–October 18; Cummer Gallery of Art, Jacksonville, Florida, November 10, 1991–January 5, 1992; Terra Museum of American Art, Chicago, January 25–March 22.

Laguna Art Museum, Laguna Beach, California (organizer). "American Impressionism." Traveled to the Galleries of the Philharmonic Performing Arts, Naples, Florida, January 14–February 25; Fine Arts Gallery, Federal Reserve Bank of Kansas City, Missouri, March 11–April 22; The Fine Arts Museum of the South, Mobile, Alabama, May 6–24; The Dixon Gallery and Gardens, Memphis, July 15–August 26; Minnesota Museum of Art, St. Paul, September 16–November 4; The R.W. Norton Art Gallery, Shreveport, Louisiana, November 18, 1990– January 8, 1991; Charles H. MacNider Museum, Mason City, Iowa, March 21–May 15.

*Amon Carter Museum, Fort Worth, and the National Museum of American Art, Smithsonian Institution, Washington, D.C. (organizers). "Visual Poetry: The Drawings of Joseph Stella" (catalogue by Joann Moser). Traveled to the Amon Carter Museum, February 23–April 22; Museum of Fine Arts, Boston, May 19–July 22; National Museum of American Art, September 7–November 12.

> Allen, Jane Addams. "The Span of Imagination: Joseph Stella's Uneven 'Poetry.'" *The Washington Post*, October 16, 1990, pp. E1, E4.
>
> Burchard, Hank. "Self-Made Stella's Art." *The Washington Post*, September 7, 1990, p. WW55.
>
> Chapman, Cheryl. "Retrospective of Stella Drawings on View at Amon Carter Museum." [Tyler, Texas] *Courier Times-Telegraph* March 25, 1990.
>
> "Drawings on Exhibition." *Drawing*, 11 (January–February 1990), pp. 107–08.
>
> Gibson, Eric. "Stella Show May Inspire New Regard for His Work." *The Washington Times*, September 11, 1990.
>
> "Joseph Stella Exhibition at the National Museum of American Art." *Washington Print Club Newsletter*, 26 (Autumn 1990).
>
> Kramer, Hilton. "Visual Poetry: The Drawings of Joseph Stella." *MD* (September 1990), pp. 14–18.
>
> Kutner, Janet. "Joseph Stella: A Reassessment." *Dallas Morning News*, February 23, 1990.
>
> _____. "Rescued from Obscurity." *Dallas Morning News*, March 14, 1990, pp. 1–2C.
>
> May, Stephen. "Stella Alternatives." *Museum & Arts Washington*, 6 (September–October 1990).
>
> McCreary, Douglas. "Exhibits." *Crystal City Magazine* (Fall 1990).
>
> "Stella Exhibit at D.C. Museum." *Antiques and Auction News*, September 21, 1990.
>
> Temin, Christine. "Stella's Dramatic Forms." *The Boston Globe*, May 28, 1990, p. 35.
>
> Tyson, Janet. "An Eclectic Mix of Subject Matter and Media." *Forth Worth Star-Telegram*, February 23, 1990.
>
> _____. "Variety in Artist's Work Defies Categorization." *Forth Worth Star-Telegram*, March 15, 1990, pp. 1, 3.
>
> "Visual Poetry: The Drawings of Joseph Stella." *Drawing*, 12 (July–August 1990), p. 41.
>
> "Visual Poetry: The Drawings of Joseph Stella." *Journal of the Print World*, 13 (Spring 1990).

Princeton Gallery of Fine Art, New Jersey. "Important Works on Paper." March 21–April 28.

Whitney Museum of American Art at Equitable Center, New York. "Early-Later: Selected Works from the Permanent Collection of the Whitney Museum of American Art." March 1990–March 1991 (brochure, with texts by Adam D. Weinberg and Ani Boyajian and checklist).

Krasl Art Center, St. Joseph, Michigan. "Flowers in Art." June 27–August 5.

Heckscher Museum, Huntington, New York. "A Point of View: 20th-Century American Art from a Long Island Collection." September 8–November 4 (catalogue, with text by Anna C. Noll).

Hirshhorn Museum and Sculpture Garden, Smithsonian Institution, Washington, D.C. "Images of American Industry from the Hirshhorn Museum and Sculpture Garden." September 26, 1990–February 14, 1991.

Snyder Fine Art, New York. "Modern American Art: 1920–1955." October 2–November 10 (catalogue).

Richard York Gallery, New York. "Joseph Stella: 100 Works on Paper." October 5–November 17 (brochure, with checklist).

> Russell, John. "Joseph Stella and Arthur Dove." *The New York Times*, November 9, 1990, p. C17.

Sid Deutsch Gallery, New York. "Gertrude Stein: The American Connection." November 3–December 8 (catalogue by Gail Stavitsky). Traveled to the Terra Museum of American Art, Chicago, January 12–March 10, 1991; University Art Museum, University of Minnesota, Minneapolis, April 14–May 24; The Butler Institute of American Art, Youngstown, Ohio, June 23–August 2; Kalamazoo Institute of Arts, Michigan, September 3–October 27.

*Pensler Galleries, Washington, D.C. "Joseph Stella: Paintings and Works on Paper." Through November 15 (catalogue).

> Fleming, Lee. "Pleasing Himself." *Museum & Arts Washington*, 6 (September–October 1990), pp. 51–52.

The University of Arizona Museum of Art. "The Jan Perry Mayer Collection of Works on Paper." December 9, 1990–January 13, 1991 (catalogue).

1991 Margo Leavin Gallery, Los Angeles. "20th Century Collage." January 12–February 16 (checklist).

Louis Stern Galleries, Beverly Hills. "Toward Abstraction: American Art Between the Wars." May 15–June 29.

> Curtis, Cathy. "Abstract Beginnings." *Los Angeles Times*, May 24, 1991, p. F16.

Snyder Fine Art, New York. "Modern American Painting: 1925–1950." September 12–October 19 (catalogue). Traveled to Harcourts Modern and Contemporary Art, San Francisco, November 7–December 7.

1992 Sheldon Memorial Art Gallery, University of Nebraska-Lincoln. "American Impressionism from the Sheldon Memorial Art Gallery." April 28–August 8 (catalogue). Traveled to Flint Institute of Arts, Michigan, September 15–November 31, 1992.

Nassau County Museum of Fine Art, Roslyn Harbor, New York. "An Ode to Gardens and Flowers." May 10–August 9.

Barbara Mathes Gallery, New York. "The Pioneering Decade: 1910–1920." November 16–December 31 (brochure).

1993 *Snyder Fine Art, New York. "Joseph Stella's Madonnas and Related Works." March 5–April 10 (catalogue, with text by Irma B. Jaffe). Traveled to The Snite Museum of Art, University of Notre Dame, Indiana, October 31, 1993–January 2, 1994.

> Cotter, Holland. "Joseph Stella's Madonnas." *The New York Times*, March 26, 1993.

> Glueck, Grace. "Sopwiths and Fokkers at Mary Boone; *Playboy*-Pointy Madonnas." *The New York Observer*, March 29, 1993, p. 19.

> Heartney, Eleanor. "Joseph Stella at Snyder Fine Art." *Art in America*, 81 (December 1993), pp. 99–100.

> Jaffe, Irma B. "Joseph Stella: Madonnas and Related Works." *American Art Review*, 5 (Winter 1994), pp. 154–59, 173, 175.

Richard York Gallery, New York. "New York, New York." September 7–October 30.

Illustrations for Books and Journals

<p style="margin-left:2em">

1905 Stella, Joseph. "Americans in the Rough: Character Studies at Ellis Island" (pictorial essay). *The Outlook*, 81 (December 23, 1905), pp. 967–73.

> *Untitled (Street Scene)* (p. 967)
> *A Native of Poland* (p. 968)
> *Italians* (p. 969)
> *A German* (p. 970)
> *Irish Types* (p. 971)
> *Hungarian Types* (p. 972)
> *A Russian Jew* (p. 973)

1906 Poole, Ernest. "The Men Who Are to Vote." *Everybody's Magazine*, 15 (October 1906), pp. 435–44.

> *A Hungarian Mother* (p. 436)
> *A Russian Giant—A Figure of Power, Purity, Dignity* (p. 437)
> *The Dreaded Inspector with His Big List of Questions* (p. 438)
> *A Common Type* (p. 439)
> *A Typical Sicilian Lad* (p. 439)
> *The Crowd Hurrying By Me, Into the Great Red Building Beyond—The Gateway Into America* (p. 440)

Johnson, E.S. "The Younger Generation." *American Magazine*, 62 (September 1906), pp. 468–77.

> *Gracie* (p. 469)
> *Mrs. Walconitis* (p. 470)
> *Mr. Walconitis* (p. 471)
> *Cass Knight* (p. 474)
> *Francie* (p. 475)

Poole, Ernest. *The Voice of the Street*. New York: A.S. Barnes & Company.

> *The Voice of the Street* (frontispiece)
> *"The sweet, crude voice of Lucky Jim crept on softly and uncertain—following the fiddle."* (facing p. 24)
> *"Dago Joe's big dull eyes looked straight at the proprietor."* (facing p. 56)
> *The Romance of Roland—"Each act was full of gay ladies and knights, of terrible fights and gallant love speeches."* (facing p. 92)
> *A new plan—from where?* (facing p. 180)
> *"Playing the music of his life, the result of his life, the climax at the end."* (facing p. 264)

1908 Kellogg, Paul U. "Monongah." *Charities and The Commons*, 19 (January 4, 1908), pp. 1313–28.

> *Untitled (Head of a Woman)* (facing p. 1312)
> *Morning Mist at the Mine Mouth* (facing p. 1313)
> *Rescue Workers* (facing p. 1328)
> *Untitled (Head of a Woman)* (facing p. 1329)

1909 For the three-part *Pittsburgh Survey*, which appeared in successive issues of *Charities and The Commons*, Stella produced two kinds of illustrations: one set illustrating specific articles; and a second set spread throughout the issues and printed as separate plates (indicated below as "facing p. 592," etc.). Some of the latter seem to have been inserted where they best matched a particular essay; others, however, bear no clear-cut relationship to the essay in which they appeared.

Charities and The Commons, 21 (January 2, 1909). Special issue: *The Pittsburgh Survey. I: The People*.

> *Untitled (Head of a Man)* (cover)
> *As Men See America. I.* (frontispiece, facing p. 592)

 Realf, Richard. "Hymn of Pittsburgh," p. 515.

> *Untitled (Factories)* (p. 515)

 Roberts, Peter. "The New Pittsburghers: Slavs and Kindred Immigrants in Pittsburgh," pp. 533–52.

</p>

Direct from the Fields of Mid-Europe (p. 535)
In the Church of the Double Cross (facing p. 548)
A Slavic Laborer (p. 552)
Pittsburgh Types: In the Light of a Five-Ton Ingot (facing p. 552)

Fitch, John Andrews. "Some Pittsburgh Steel Workers," pp. 553–60.

Pittsburgh Types: Of the Old Time Irish Immigration (facing p. 556)
Pittsburgh Types: British Born (facing p. 560)

Eastman, Crystal. "The Temper of the Workers Under Trial," pp. 561–69.

Pittsburgh Types: Lad from Herzegovina (facing p. 564)

Koukol, Alois B. "The Slav's a Man For A' That," pp. 589–98.

Untitled (Figure of a Man) (p. 589)
Pittsburgh Types: Old Worlds in New (facing p. 593)
Pittsburgh Types: Immigrant Out of Work (facing p. 594)
Pittsburgh Types: Russian (facing p. 596)
Pittsburgh Types: The Strength of the New Stock (facing p. 598)

Charities and The Commons, 21 (February 6, 1909). Special issue: *The Pittsburgh Survey. II: The Place.*

As Men See America. II. (frontispiece)

Woods, Robert A. "A City Coming to Itself," pp. 785–800.

Pittsburgh Types: Italian Leader (facing p. 800)

Crowell, F. Elisabeth. "Painters' Row: The United States Steel Corporation as a Pittsburgh Landlord," pp. 899–912.

Untitled (Street Scene) (facing p. 898)
Painters' Row As It Stood in the Spring of 1908 (facing p. 899)
The "Hole in the Wall" (p. 910)

Leroy Scott, "Little Jim Park," pp. 911–12.

Pittsburgh Types: An Old Slav (facing p. 912)

Charities and The Commons, 21 (February 27, 1909).

As Men See America. III. (frontispiece)

Charities and The Commons, 21 (March 6, 1909). Special issue: *The Pittsburgh Survey. III: The Work.*

Untitled (A Breathing Spell) (cover)

"Pittsburgh: Labor in the Steel District," facing p. 1050.

Before the Furnace Door (facing p. 1050)

Commons, John R. "Wage Earners of Pittsburgh," pp. 1051–64.

Pittsburgh Types: Tired Out (facing p. 1062)
Pittsburgh Types: Slav in Bread Line (facing p. 1064)

Fitch, John Andrews. "The Process of Making Steel," pp. 1065–78.

Untitled (Making Steel) (p. 1065)
Pittsburgh Types: Italian Steel Worker (facing p. 1082)
Pittsburgh Types: A Breathing Spell (facing p. 1086; also published on the cover)
In the Glare of the Converter (facing p. 1090)
At the Base of the Blast Furnace (facing p. 1092)

Eastman, Crystal. "A Year's Work Accidents and Their Cost," pp. 1143–74.

Pittsburgh Types: In the Bread Line at Wood's Run (facing p. 1174)

The Survey, 21 (April 3, 1909).

Strong Backs Go into Steel (frontispiece)

1910 Byington, Margaret F. *Homestead: The Households of a Mill Town*. New York: The Russell Sage Foundation.

Of the Old Time Irish Immigration (p. 12; previously published as *Pittsburgh Types: Of the Old Time Irish Immigration*)
Head: Slavic Day Laborer (p. 16)
Slav: Calling (p. 129; previously published as *In the Church of the Double Cross*)
Old Worlds in New (p. 164; previously published as *Pittsburgh Types: Old Worlds in New*)

Eastman, Crystal. *Work-Accidents and the Law*. New York: The Russell Sage Foundation.

A Greener: Lad from Herzegovina (p. 85; previously published as *Pittsburgh Types: Lad from Herzegovina*)

Fitch, John Andrews. *The Steel Workers*. New York: The Russell Sage Foundation.

In the Light of a Five-Ton Ingot (p. 20; previously published *Pittsburgh Types: In the Light of a Five-Ton Ingot*)
A Breathing Spell (p. 78; previously published as *Pittsburgh Types: A Breathing Spell*)
A New Comer (p. 140; previously published without title [*Untitled (Figure of a Man)*])
In the Glare of the Converter (p. 232; previously published)

1916 Howe, Frederic C. "Turned Back in Time of War: Ellis Island Under War Conditions." *The Survey*, 36 (May 6, 1916), pp. 147–56.

Untitled (Back of a Man) (p. 147)
At the Threshold of the New World (p. 148)
Listeners at an Ellis Island Concert (p. 149)
Music as a Common Language Outstrips All the Station's Interpreters (p. 149)
Man and Wife from South Italy (p. 150)
An Aged Rumanian War Refugee (p. 150)
An Albanian (p. 150)
An Irishman (p. 150)
A Polish Consumptive (p. 150)
Russian Jew (p. 150)
Hungarian Lad (p. 151)
A Calabrian (p. 151)
A Young Negress from the Barbados (p. 151)
A Slovak (p. 151)
A Norwegian (p. 151)
A Russian Cossack (p. 151)
Untitled (Figure of a Man) (p. 151)
Bulgarian War Refugee (p. 152)
Untitled (Figure of a Man) (p. 152)
Wreckage (p. 153)
From the Campagna (p. 154)
French Maid (p. 155)
Jewish Girl (p. 155)
Jewish Girl (p. 155)
French Woman (p. 155)
The World's Tallest Man, An Ellis Islander for a While (p. 156)

1918 *The Independent*, 95 (July 20, 1918).

The Sacrifice: A Caproni Battleplane Ramming a German Balloon (cover)

Stella, Joseph. "The Shipbuilders" (pictorial essay). *The Survey*, 41 (November 30, 1918), pp. 259–62.

3000 Miles from the Trench Helmets (cover)
The Launching (p. 259)
Untitled (Hog Island Types—Laborer) (p. 260)
Untitled (Hog Island Types—Head of a Man) (p. 260)
Untitled (Hog Island Types—Man Working) (pp. 260–61)
Untitled (Hog Island Types—Laborer) (p. 261)
Untitled (Hog Island Types—Men Working) (p. 261)
The New Race of the New World (p. 262)

1919 *The Survey*, 41 (January 4, 1919).

Untitled (Three Male Heads) (cover)

Stella, Joseph. "The Garment-Workers" (pictorial essay), pp. 447–50.

> *A Jewish Home-Worker* (p. 447)
> *A Swedish Presser* (p. 447)
> *A Slovak Machine Operator* (p. 448)
> *British Born: A Girl in a New Jersey Clothing Factory* (p. 448)
> *An Italian Stitcher* (p. 449)
> *A Jewish Knitter of Socks* (p. 449)
> *In a New York Loft-Building Workshop* (p. 450)

Stella, Joseph. "Bethlehem, Sketches" (pictorial essay). *The Survey*, 41 (February 1, 1919), pp. 615–18.

> *Night on the Industrial Front* (cover)
> *The "Insides" of the Clock of War—Interior of a Pennsylvania Mill* (p. 615)
> *Handling a Shell* (p. 616)
> *The Night Watchman* (p. 616)
> *The Blow* (p. 617)
> *The Link* (p. 617)
> *The Furnaceman* (p. 618)

Stella, Joseph. "Makers of Wings" (pictorial essay). *The Survey*, 41 (March 1, 1919), pp. 781–83.

> *A Maker of Wings* (cover)
> *The Swarming* (p. 781)
> *Monotypes of a Buffalo Air-Plane Factory:*
> > *Fixing Wings* (p. 782)
> > *Stitching the Irish Linen Covering for the Planes* (p. 782)
> > *Untitled (Sewing)* (p. 782)
> > *A Punch Operator* (p. 782)
> > *Where the Parts Are Assembled* (p. 783)
> > *Filing Fittings for Wing Spar* (p. 783)
> > *At a Work Bench* (p. 783)

The Survey, 43 (November 8, 1919).

> *The Steel Worker* (cover)

1922 *The Survey*, 49 (October 15, 1922).

> *Laid Off* (p. 72)

The Survey, 49 (December 1, 1922).

Stella, Joseph. "Earth's Noblest Thing" (pictorial essay), pp. 296–99.

> *The Immigrant Madonna* (cover)
> *Untitled (Old Serbian Woman)* (p. 296)
> *Untitled (Sicilian)* (p. 297)
> *Untitled (Roman Donna)* (p. 298)
> *Untitled (Irish Granny)* (p. 299)

Whiteside, Mary Brent. "Eve," pp. 300–01.

> *Untitled (Female Portrait)* (p. 300)
> *Untitled (Female Portrait)* (p. 300)
> *Untitled (Female Portrait)* (p. 301)
> *Untitled (Female Portrait)* (p. 301)

1923 Brooks, William E. "Refuge." *The Survey*, 49 (January 1, 1923), p. 457.

> *Untitled (Landscape)* (p. 457)
> *Untitled (Factories)* (p. 457)

1924 Stella, Joseph. "The Coal By-Product Oven" (pictorial essay). *The Survey*, 51 (March 1, 1924), pp. 563–68.

> *Coal By-Product Oven* (p. 563)
> *Bituminous Coal Storage Piles* (p. 564)
> *The Crusher and Mixer Building* (p. 565)

The Traveling Pusher, Which Lifts the Doors from the Oven, Pushes Out the Hot Coke, and Levels the New Charge of Coal (p. 566)
The Quencher, to Which the Glowing Coke Is Conveyed in Steel Cars for the Water Douche That Ends Combustion (p. 567)
The By-Product Storage Tanks That Receive the Distilled Ammonia and Tar from the Ovens (p. 568)

Selekman, Ben M. *Employes [sic] Representation in Steel Works*. New York: The Russell Sage Foundation.

Untitled (cover)

Stella, Antonio. *Some Aspects of Italian Immigration to the United States*. New York: G.P. Putnam's Sons.

An Italian Schoolmaster from Calabria in the United States (p. 49; published previously as *Pittsburgh Types: Italian Leader*)
Contadina (Peasant Woman) from Basilicata (p. 89)
Woman from Perugia (p. 93)

1925 "Men and Steel: The Art of Joseph Stella." *The Independent*, 114 (May 9, 1925), pp. 525–28.

Untitled (Chimneys) (p. 525; published previously without title [*Untitled (Factories)*])
Untitled (Old Man) (p. 525; published previously as *Pittsburgh Types: The Strength of the New Stock*)
Man Shouting to His Fellow Worker, Pitching His Voice to Carry Over the Turmoil of the Engines (p. 526; published previously as *In the Church of the Double Cross* and *Slav: Calling*)
Worker at Rest, Away for a Few Moments from the Hot Breath of the "Burning Fiery Furnace" (p. 527; published previously as *Laid Off*)
Towering Black Structures Menacingly Surge Around (p. 528; published previously as *Night on the Industrial Front*)
Smoke—Like a Thunderous Black Storm Governing the Infernal Regions (p. 528; published previously as *Coal By-Product Oven*)

Walker, Charles R. "Peace or War in Steel?" *The Independent*, 114 (May 9, 1925), pp. 529–31, 540.

Shall He Stay Behind the Frontier? (p. 530)

Stella, Joseph. *Miners* (drawing of c. 1908). *The Fight Against War and Fascism*, 4 (August 1937), p. 37.

Selected Bibliography

Apter, Eleanor S., Robert L. Herbert, and Elise K. Kenny. *The Société Anonyme and the Dreier Bequest at Yale University: A Catalogue Raisonné*. New Haven: Yale University Press, 1984.

Baur, John I.H. *Joseph Stella*. New York and London: Praeger Publishers, 1971.

_____. "A Newly Discovered Painting by Joseph Stella." *Whitney Review 1972/73*, p. 20.

Billingsley, Paula. "*Battle of Lights, Coney Island, Mardi Gras*, un dipinto futurista a New York." *Richerche di Storia dell'Arte*, no. 45 (1991).

Bohan, Ruth. "Joseph Stella's *Man in Elevated (Train)*." In Stephen C. Foster, ed. *Dada/Dimensions*. Ann Arbor, Michigan: UMI Research Press, 1985, pp. 187–219.

_____. "Katherine Sophie Dreier and New York Dada." *Arts Magazine*, 51 (May 1977), pp. 97–101.

_____. *The Société Anonyme's Brooklyn Exhibition: Katherine Dreier and Modernism in America*. Ann Arbor, Michigan: UMI Research Press, 1982.

Conrad, Peter. *The Art of the City: Views and Versions of New York*. New York: Oxford University Press, 1984.

Cooper, Helen. "Stella's *Miners*." *Yale University Art Gallery Bulletin*, 35 (Fall 1975), pp. 8–13.

Corn, Wanda M. "In Detail: Joseph Stella and *New York Interpreted*." *Portfolio*, 4 (January–February 1982), pp. 40–45.

_____. "The New New York." *Art in America*, 61 (July–August 1973), pp. 58–65.

Craven, Thomas. "Joseph Stella." *Shadowland*, 7 (January 1923), pp. 11, 78.

Drawings of Joseph Stella from the Collection of Rabin & Krueger. Newark, New Jersey: Rabin & Krueger Gallery, 1962.

Field, Hamilton Easter. "Joseph Stella." *The Arts*, 2 (October 1921), pp. 24–27.

Fillin-Yeh, Susan. "Three Heads and Other Mysteries: Man Ray's Photographs of Marcel Duchamp and Joseph Stella." *Arts Magazine*, 62 (April 1988), pp. 96–103.

Foley, Kathy K. "Joseph Stella: Enigmatic Painter." *Dayton Art Institute Bulletin*, 36 (October 1977), pp. 4–11.

Fornaro, Carlo de. "A Forceful Figure in American Art." *Arts & Decoration*, 19 (August 1923), pp. 17, 60–61.

Freund, Frank E. Washburn. "Joseph Stella." *Der Cicerone*, 16 (October 1924), pp. 963–71.

Glaubinger, Jane. "Two Drawings by Joseph Stella." *The Bulletin of The Cleveland Museum of Art*, 70 (December 1983), pp. 382–95.

Hand, John Oliver. "Futurism in America: 1909–14." *Art Journal*, 41 (Winter 1981), pp. 337–42.

Harnoncourt, Anne d'. *Futurism and the International Avant-Garde* (exhibition catalogue). Philadelphia: Philadelphia Museum of Art, 1980.

Hulten, Pontus. *Futurismo & Futurismi* (exhibition catalogue). Venice: Palazzo Grassi, Società Azioni Palazzo Grassi, 1986. English ed., New York: Abbeville Press, 1986.

"Italian Artists of Today: Joseph Stella." *Italy-America Monthly*, 2 (April 25, 1935), p. 14.

Jaffe, Irma B. "Forum: Joseph Stella's Study for 'New York Interpreted.'" *Drawing*, 10 (March–April 1989), pp. 131–32.

_____. *Joseph Stella*. Cambridge, Massachusetts: Harvard University Press, 1970.

_____. "Joseph Stella and Hart Crane: The Brooklyn Bridge." *The American Art Journal*, 1 (Fall 1969), pp. 98–107.

_____. "Joseph Stella's Tropical Paintings: Ode to Nature." In *Joseph Stella: The Tropics* (exhibition catalogue). New York: Richard York Gallery, 1988, pp. 7–30.

_____. "Stella's Madonnas." In *Joseph Stella's Madonnas and Related Work* (exhibition catalogue). New York: Snyder Fine Art, 1993, pp. 2–5, 16–19.

"Joseph Stella: Painter of the American Melting Pot." *Current Opinion*, 64 (June 1918), pp. 423–24.

Knox, George. "Crane and Stella: Conjunction of Painterly and Poetic Worlds." *Texas Studies in Literature and Language*, 12 (Winter 1971), pp. 689–707.

Kramer, Hilton. "The Other Tropics." *Art & Antiques*, 6 (January 1989), pp. 97–98.

Kuspit, Donald B. "Individual and Mass Identity in Urban Art: The New York Case." *Art in America*, 65 (September–October 1977), pp. 66–77.

Lancellotti, Arturo. "Un pittore di avanguardia: Giuseppe Stella." *Emporium*, 71 (February 1930), pp. 66–76.

Lavin, Irving. "Abstraction in Modern Painting: A Comparison." *The Metropolitan Museum of Art Bulletin*, 19 (February 1961), pp. 166–69.

Loving, Pierre. "Joseph Stella—Extremist." *The Nation*, April 11, 1923, pp. 446, 448.

Marino, Emilio. "Un'ora dinamica col più dinamico pittore italo-americano: Giuseppe Stella." *Il Mezzogiorno*, September 1–2, 1925.

May, Stephen. "Joseph Stella's Pittsburgh." *Carnegie Magazine*, 9 (July–August 1991), pp. 30–39.

"A Morning with Joseph Stella." *Barbados Advocate*, March 1, 1938, pp. 1f.

Moser, Joann. "The Collages of Joseph Stella: *Macchie/Macchine Naturali*." *American Art*, 6 (Summer 1992), pp. 59–77.

_____. "Visual Poetry: The Drawings of Joseph Stella." *Antiques*, 138 (November 1990), pp. 1060–73.

_____. *Visual Poetry: The Drawings of Joseph Stella* (exhibition catalogue). Washington, D.C.: National Museum of American Art, Smithsonian Institution; Forth Worth: Amon Carter Museum, 1990.

Naumann, Francis. *New York Dada: 1915–1923*. New York: Harry N. Abrams, 1994 (in press).

_____. "The New York Dada Movement: Better Late Than Never." *Arts Magazine*, 54 (February 1980), pp. 143–49.

Parker, Edwin S. "An Analysis of Futurism." *The International Studio*, 58 (April 1916), pp. 59–60.

Porpora, Antonio. "Giuseppe Stella: Un pittore futurista di Basilicata a New York." *La Basilicata nel Mondo*, 3 (September 1926), pp. 226–30.

The Precisionist View in American Art (exhibition catalogue). Minneapolis: Walker Art Center, 1960.

Romano, Armando. "Un sinfonista del colore." *Il Progresso Italo-Americano*, March 21, 1937.

Salpeter, Harry. "Stella: Art's Poetic Gladiator." *Esquire*, 16 (July 1941), pp. 92–93, 107.

Santoro, Ferdinando. "Giuseppe Stella." *Italiani pel Mondo*, 1 (August 1928), pp. 803–11.

Saunders, Robert J., and Ernest Goldstein. *Joseph Stella: The Brooklyn Bridge*. Champaign, Illinois: Garrard Publishing Company, 1984.

"16 Reproductions of the Work of Joseph Stella." *The Little Review*, 9 (Autumn 1922), n.p.

Southgate, M. Therese. "The Cover." *The Journal of the American Medical Association*, 263 (March 2, 1990), p. 1255.

"Stella, Dicksee and Watrous." *The Art News*, 26 (February 4, 1928), p. 9.

Stewart, Patrick L. "The European Art Invasion: American Art and the Arensberg Circle, 1914–1918." *Arts Magazine*, 51 (May 1977), pp. 108–12.

Tashjian, Dikran. *Skyscraper Primitives: Dada and the American Avant-Garde, 1910–1925*. Middletown, Connecticut: Wesleyan University Press, 1975.

Thompson, Jan. "Picabia and His Influence on American Art, 1913–17." *Art Journal*, 39 (Fall 1979), pp. 14–21.

Tsujimoto, Karen. *Images of America: Precisionist Painting and Modern Photography* (exhibition catalogue). San Francisco: San Francisco Museum of Modern Art, 1982.

"The Voice of the City." *Survey Graphic*, 51 (November 1923), title page and pp. 142–47.

Williams, Helen Lorenz. "The Art of Joseph Stella in Retrospect." *International Studio*, 84 (July 1926), pp. 76–80.

Zilczer, Judith. *Joseph Stella* (exhibition catalogue). Washington, D.C.: Hirshhorn Museum and Sculpture Garden, Smithsonian Institution, 1983.

DISSERTATIONS AND UNPUBLISHED MATERIAL

Burke, Margaret Reeves. "Futurism in America, 1910–1917" (Ph.D. dissertation). Newark, Delaware: University of Delaware, 1986.

Cassidy, Donna M. "The Painted Music of America in the Works of Arthur G. Dove, John Marin, and Joseph Stella" (Ph.D. dissertation). Boston: Boston University, 1988.

Eilshemius, Louis M. "Joseph Stella," July, 1921. Joseph Stella Papers, Archives of American Art, Smithsonian Institution, Washington, D.C.

Fornaro, Carlo de. "Joseph Stella: Outline of the Life, Work, and Times of a Great Master," n.d. Bernard Rabin Papers, Cranberry, New Jersey.

Keck, Albert. "Joseph Stella" (Fine Arts thesis), April 1965. Bernard Rabin Papers, Cranberry, New Jersey.

Lazzari, Pietro. "Giuseppe Stella." Joseph Stella artist's file, Whitney Museum of American Art, New York.

Lenfest, Marie. "Joseph Stella—Immigrant Futurist" (M.A. thesis). New York: Columbia University, 1959.

McCarthy-Mott, Eileen. "Joseph Stella: An Evolution of Style" (M.A. thesis). College Park: University of Maryland, 1978.

Mosca, August. "Memories of Joseph Stella," 1961. August Mosca Papers, Archives of American Art, Smithsonian Institution, Washington, D.C.

Nicolini, Simonetta. "L'arte di Joseph Stella tra Italia e U.S.A." (Ph.D. dissertation). Bologna: Università di Bologna, 1980.

Piron, Alice Marie O'Mara. "Urban Metaphor in American Art and Literature, 1910–1930" (Ph.D. dissertation). Evanston, Illinois: Northwestern University, 1982.

Wiegand, Charmion von. "Joseph Stella—Painter of Brooklyn Bridge," n.d. Joseph Stella Papers, Archives of American Art, Smithsonian Institution, Washington, D.C.

ARCHIVES

Archives of American Art, Smithsonian Institution, Washington, D.C.
 Bourgeois Gallery Papers
 Kenneth Hayes Miller Papers
 August Mosca Papers
 Walter Pach Papers
 Robert Schoelkopf Papers
 Joseph Stella Papers
 Virginia Zabriskie Papers

Paul Kellogg Papers, Folder 194, Social Welfare History Archives, University of Minnesota Libraries, Minneapolis.

The Little Review, Records, 1914–64, University of Wisconsin-Milwaukee Manuscript Collection 1, Golda Meir Library, University of Wisconsin-Milwaukee.

Bernard Rabin Papers, Cranberry, New Jersey.

Collection of American Literature, Beinecke Rare Book and Manuscript Library, Yale University, New Haven.
 Henry McBride Papers
 Société Anonyme Papers

Joseph Stella artist's file and archival files, The Museum of Modern Art, New York.

Joseph Stella artist's file, Whitney Museum of American Art, New York.

Carl Weeks Papers, Iowa State Education Association, Des Moines

Works in the Exhibition

Dimensions are in inches followed by centimeters; height precedes width.

PAINTINGS

The Voice of the Past, 1909–10
Oil on canvas, 72 x 41 (182.9 x 104.1)
Private collection

Battle of Lights, 1913 (later inscribed "1914")
Oil on canvas mounted on cardboard,
20¼ (51.4) diameter
The Museum of Modern Art, New York;
Elizabeth Bliss Parkinson Fund

Luna Park, 1913
Oil on composition board, 17½ x 23⅜
(44.5 x 59.4)
Whitney Museum of American Art, New York;
Gift of Mrs. Charles A. Goldberg 72.147

Battle of Lights, Coney Island, 1913–14
Oil on canvas, 39 x 29½ (99.1 x 74.9)
Sheldon Memorial Art Gallery, University of
Nebraska, Lincoln; F.M. Hall Collection

Battle of Lights, Coney Island, Mardi Gras,
1913–14
Oil on canvas, 76⅞ x 84⅝ (195.3 x 214.9)
Yale University Art Gallery, New Haven;
Bequest of Dorothea Dreier to the Collection
Société Anonyme

Der Rosenkavalier, 1913–14
Oil on canvas, 24 x 30 (61 x 76.2)
Whitney Museum of American Art, New York;
Gift of George F. Of 52.39

Coney Island (Madonna of Coney Island), 1914
Oil on canvas, 41¾ (106) diameter
The Metropolitan Museum of Art, New York;
George A. Hearn Fund

Study for *Battle of Lights*, 1914
Oil on canvas, 12 x 9½ (30.5 x 24.1)
Collection of Mr. and Mrs. William C. Janss

Spring (The Procession—A Chromatic Sensation),
1914–16
Oil on canvas, 75⅜ x 40¼ (191.5 x 102.3)
Yale University Art Gallery, New Haven; Gift
of Collection Société Anonyme

Man in Elevated (Train), 1916
Oil and collage on glass, 14¼ x 14¾
(36.2 x 37.5)
Washington University Art Gallery, St. Louis;
University purchase, Kende Sale Fund

Prestidigitator, 1916
Oil and wire on glass, 13⁵⁄₁₆ x 8½
(33.8 x 21.6)
Whitney Museum of American Art, New York;
Daisy V. Shapiro Bequest 85.29

Chinatown, 1917
Oil on glass, 19¼ x 8⅜ (48.9 x 21.3)
Philadelphia Museum of Art; The Louise and
Walter Arensberg Collection

American Landscape (Gas Tanks), 1918
Oil on canvas, 40½ x 30 (102.9 x 76.2)
Neuberger Museum of Art, State University of
New York at Purchase; Gift of Roy R.
Neuberger

Brooklyn Bridge, 1919–20
Oil on canvas, 84 x 76 (213.4 x 193)
Yale University Art Gallery, New Haven; Gift
of Collection Société Anonyme

Tree of My Life, 1919–20
Oil on canvas, 83½ x 75½ (212.1 x 191.8)
Mr. and Mrs. Barney A. Ebsworth Foundation
and Windsor, Inc., St. Louis

Waterlilies, 1919–20
Oil on glass, 12 x 7 (30.5 x 17.8)
Private collection

Lotus Flower, 1920
Oil on glass, 11 x 7¼ (27.9 x 18.4)
Collection of Dr. and Mrs. Martin Weissman

Factories, c. 1920–21
Oil on burlap, 56 x 46 (142.2 x 116.8)
The Museum of Modern Art, New York; Lillie
P. Bliss Bequest

Smoke Stacks, c. 1920–21
Oil on canvas, 41⁵⁄₁₆ x 35⁵⁄₁₆ (104.9 x 89.7)
Turman Art Gallery, Indiana State University,
Terre Haute; WPA Federal Art Project
Allocation

New York Interpreted (The Voice of the City),
1920–22
Oil on canvas, 5 panels: *The Port (The Harbor,
The Battery)*, 88½ x 54 (224.8 x 137.2); *The
White Way I*, 88½ x 54 (224.8 x 137.2); *The
Skyscrapers (The Prow)*, 99¾ x 54 (253.4 x
137.2); *The White Way II (Broadway)*, 88½ x 54
(224.8 x 137.2); *The Bridge (Brooklyn Bridge)*,
88½ x 54 (224.8 x 137.2)
The Newark Museum, New Jersey; Purchase
1937 Felix Fuld Bequest Fund

Tropical Sonata, 1922
Oil on canvas, 48 x 29 (121.9 x 73.7)
Whitney Museum of American Art, New York;
Purchase 63.63

By-Products Plants, c. 1923–26
Oil on canvas, 24 x 24 (61 x 61)
The Art Institute of Chicago; Gift of Mr. and
Mrs. Noah Goldowsky in memory of Esther
Goldowsky

Dance of Spring (Song of the Birds), 1924
Oil on canvas, 42⅜ x 32⅜ (107.6 x 82.2)
Collection of Mr. and Mrs. William C. Janss

The Waterlily, 1924
Oil on glass, 16 x 14 (40.6 x 35.6)
Private collection

Sirenella, 1924–25
Oil on canvas, 21⅜ x 15⅛ (54.3 x 38.4)
Private collection

Undine, 1924–25
Oil on board, 36 x 38 (91.4 x 96.5)
Collection of Jane Forbes Clark

White Swan, 1924–25
Oil on canvas, 39 x 48¾ (99.1 x 123.8)
Private collection

The Birth of Venus, 1925
Oil on canvas, 85 x 53 (215.9 x 134.6)
Iowa State Education Association, Des Moines

The Heron, 1925
Oil on canvas, 48 x 29 (121.9 x 73.7)
The Warner Collection of Gulf States Paper
Corporation, Tuscaloosa, Alabama

The Amazon, 1925–26
Oil on canvas, 27 x 22 (68.6 x 55.9)
The Baltimore Museum of Art; Purchase with
exchange funds from the Edward Joseph
Gallagher III Memorial Collection

A Vision, 1925–26
Oil on canvas, 80 x 40 (203.2 x 101.6)
The Art Institute of Chicago; through prior gift
of the Albert Kunstadter Family Foundation

Apotheosis of the Rose, 1926
Oil on canvas, 84 x 47 (213.4 x 119.4)
Iowa State Education Association, Des Moines

The Virgin, 1926
Oil on canvas, 39⁹⁄₁₆ x 38¾ (100.5 x 98.4)
The Brooklyn Museum, New York; Gift of
Adolph Lewisohn

Virgin of the Rose and Lily, 1926
Oil on canvas, 57½ x 44¾ (146.1 x 113.7)
Collection of The Honorable Joseph P. Carroll
and Mrs. Carroll

Purissima, 1927
Oil on canvas, 76 x 57½ (193 x 146.1)
Snyder Fine Art, New York

The Little Lake, 1927–28
Oil on canvas, 40 x 34 (101.6 x 86.4)
The Montclair Art Museum, New Jersey;
Gift of Bernard Rabin in memory of
Nathan Krueger

Neapolitan Song, 1927–28
Oil on canvas, 34¼ x 28¼ (87 x 71.8)
Collection of Harvey and Françoise Rambach

Palm Tree and Bird, 1927–28
Oil on canvas, 54 x 40¼ (137.2 x 102.2)
Collection of Mrs. Sergio Stella

Black Swan (The Swan of Death), 1928–29
Oil on canvas, 20¾ x 31 (52.7 x 78.7)
Private collection

American Landscape, 1929
Oil on canvas, 79⅛ x 39⁵⁄₁₆ (201 x 99.9)
Walker Art Center, Minneapolis; Gift of the
T.B. Walker Foundation

Factories at Night—New Jersey, 1929
Oil on canvas, 29 x 36¼ (73.7 x 92.1)
The Newark Museum, New Jersey; Purchase
1936 Thomas L. Raymond Bequest Fund

Fountain, 1929
Oil on canvas, 49 x 40 (124.5 x 101.6)
Collection of Drs. Sandy M. Bushberg and
Michelle B. Rabin

Lotus, 1929
Oil on canvas, 21½ x 25¾ (54.6 x 65.4)
Hirshhorn Museum and Sculpture Garden,
Smithsonian Institution, Washington, D.C.;
Gift of Joseph H. Hirshhorn

Nocturne, 1929
Oil on canvas, 34 x 24½ (86.4 x 62.2)
Collection of Mr. and Mrs. William C. Janss

The Ox, 1929
Oil on canvas, 20 x 19 (50.8 x 48.3)
Bayly Art Museum, University of Virginia,
Charlottesville

Red Flower, 1929
Oil on canvas, 57½ x 38⅜ (146.1 x 97.5)
Collection of Felisa and Nick Vanoff

Sirens, 1929
Oil on canvas, 40 x 28½ (101.6 x 72.4)
Private collection

Tropical Flower, c. 1929
Oil on canvas, 25½ x 21½ (64.8 x 54.6)
Private collection

The Crèche, c. 1929–32
Oil on canvas, 61 x 77 (154.9 x 195.6)
The Newark Museum, New Jersey; Purchase
1940 Wallace M. Scudder Bequest Fund

Flowers, Italy, c. 1930
Oil on canvas, 75 x 75 (190.5 x 190.5)
Phoenix Art Museum; Gift of Mr. and Mrs.
Jonathan Marshall

Tree of Nice, c. 1930
Oil on canvas, 26 x 32 (66 x 81.3)
Collection of Mr. and Mrs. Meyer P.
Potamkin

Peasants (Paris), c. 1930–32
Oil on canvas, 24½ x 19¾ (62.2 x 50.2)
Private collection

Metropolitan Port, 1935–37
Oil on canvas, 36 x 30⅛ (91.4 x 76.5)
National Museum of American Art,
Smithsonian Institution, Washington, D.C.;
Transfer from General Services Administration

Bridge, 1936
Oil on canvas, 50⅛ x 30⅛ (127.3 x 76.5)
San Francisco Museum of Modern Art; WPA
Federal Art Project Allocation

Serenade: A Christmas Fantasy (La Fontaine), 1937
Oil on canvas, 43⅛ x 37⅛ (109.5 x 94.3)
Hirshhorn Museum and Sculpture Garden,
Smithsonian Institution, Washington, D.C.;
Gift of Joseph H. Hirshhorn

Joy of Living, 1938
Oil on canvas, 44¼ x 31 (112.4 x 78.7)
Collection of Andrew Crispo

Song of Barbados, 1938
Oil on canvas, 58 x 37 (147.3 x 94)
Collection of Mr. and Mrs. James A. Fisher

The Brooklyn Bridge: Variation on an Old Theme,
1939
Oil on canvas, 70 x 42 (177.8 x 106.7)
Whitney Museum of American Art, New York;
Purchase 42.15

Full Moon, Barbados, 1940
Oil on canvas, 36 x 24 (91.4 x 61)
Richard York Gallery, New York

In the Jungle, 1940
Oil on canvas, 37 x 27¼ (94 x 69.2)
Collection of Michael Stella

WORKS ON PAPER

Italian Immigrant, 1898
Graphite and chalk on paper, 8¾ x 7½
(22.2 x 19.1)
Thomas Colville Fine Art, New Haven and
New York

Old Man, 1898
Ink on paper, 8½ x 8⅛ (21.6 x 20.6)
The Museum of Modern Art, New York;
Gift of Mrs. Bliss Parkinson

Face of an Elderly Person, c. 1898 (later
inscribed "1907")
Charcoal and chalk on paper, 9½ x 7½
(24.1 x 19.1)
Collection of Albert Keck

Old Man IX, c. 1900 (later inscribed "1898")
Graphite on paper, 7¹⁵⁄₁₆ x 4¼ (20.2 x 10.8)
Collection of Caesar P. Kimmel

Old Man XI, c. 1900
Graphite, crayon, and charcoal on paper,
9½ x 7 (24.1 x 17.8)
Collection of Caesar P. Kimmel

Head of an Old Man, c. 1905
Crayon on paper, 11½ x 9⅛ (29.2 x 23.2)
Collection of Dr. and Mrs. Eugene Arum

Head of an Old Man, c. 1905
Charcoal and chalk on paper, 14½ x 9¾
(36.8 x 24.8)
Private collection

Head of an Old Man III, c. 1905
Crayon on paper, 10³⁄₁₆ x 7¾ (25.9 x 19.7)
Collection of Caesar P. Kimmel

Old Woman, c. 1905
Etching, 5½ x 5 (14 x 12.7)
Collection of Bernard and Dorothy Rabin

Morning Mist at the Mine Mouth (Monongah),
1907
Charcoal on paper, 17½ x 23 (44.5 x 58.4)
Jordan-Volpe Gallery, New York

Back of a Man Working, 1908
Graphite on paper, 9¼ x 6⅝ (23.5 x 16.8)
Collection of Bernard and Dorothy Rabin

Head of a Man (A New Comer, The Croatian),
1908
Graphite on paper, 8 x 5¾ (20.3 x 14.6)
Hirshhorn Museum and Sculpture Garden,
Smithsonian Institution, Washington, D.C.;
Gift of Joseph H. Hirshhorn

Head of a Woman, 1908
Charcoal and pastel on paper, 19 x 15
(48.3 x 38.1)
Collection of Mrs. Sergio Stella

Mill Interior, 1908
Charcoal on paper, 13½ x 17¾
(34.3 x 45.1)
Spanierman Gallery, New York

*Painters' Row As It Stood in the Spring of 1908
(Pittsburgh)*, 1908
Charcoal on paper, 12 x 18¼ (30.5 x 46.4)
Private collection

Pittsburgh Types: Immigrant Out of Work, 1908
Charcoal on paper mounted on board, 25 x 19
(63.5 x 48.3)
Collection of Dr. and Mrs. Eugene Arum

Pittsburgh Types: In the Bread Line at Wood's Run,
1908
Charcoal on paper, 18¼ x 34⅜ (46.4 x 87.3)
Collection of Caesar P. Kimmel

Pittsburgh Types: Italian Leader, 1908
Crayon on paper, 17½ x 13¾ (44.5 x 34.9)
Private collection; courtesy Vanderwoude
Tananbaum Gallery, New York

*Pittsburgh Types: Lad from Herzegovina
(A Greener)*, 1908
Graphite and gouache on paper, 6 ⅜ x 4 ¾
(16.2 x 12.1)
The St. Louis Art Museum; Purchase, Friends
of The St. Louis Art Museum

Pittsburgh, Winter, 1908
Charcoal on paper, 17 ⅛ x 23 (43.5 x 58.4)
Collection of Rita and Daniel Fraad

Portrait of Old Man, 1908
Graphite and colored pencil on paper,
11 ¾ x 9 ¼ (29.8 x 23.5)
Sheldon Memorial Art Gallery, University
of Nebraska, Lincoln; Howard S. Wilson
Memorial Collection

The Sewing Lesson, 1908
Graphite on paper, 22 x 14 (55.9 x 35.6)
Private collection

Strong Backs Go into Steel, 1908
Pastel and charcoal on paper, 19 x 26
(48.3 x 66)
Collection of Susan and Herbert Adler

Underpass, Allegheny, 1908
Charcoal on paper, 11 ⁷⁄₁₆ x 16 ⁵⁄₁₆
(29.1 x 41.4)
Museum of Art, Rhode Island School of
Design, Providence; Anonymous Gift

Worker at Rest (Laid Off), 1908
Charcoal on paper, 28 x 22 (71.1 x 55.9)
Collection of Michael Stella

Manhattan Nocturne, c. 1908
Pastel on paper mounted on board,
10 ½ x 8 ½ (26.7 x 21.6)
Collection of Charles B. Tyler

Miners, c. 1908
Charcoal on paper, 14 ½ x 19 ½ (36.8 x 49.5)
Yale University Art Gallery, New Haven;
H. John Heinz III, B.A. 1960, Fund

The Bagpipers, 1909
Charcoal, pastel, and varnish on paper,
26 ¾ x 35 ½ (67.9 x 90.2)
Richard York Gallery, New York

Boy Playing Wind Instrument, c. 1909
Charcoal and sanguine on paper, 14 ½ x 19 ½
(36.8 x 49.5)
Collection of Mrs. Herbert A. Goldstone

Boy with Bagpipe, c. 1909
Charcoal, pastel, and graphite on paper,
21 ¾ x 16 ⅜ (55.2 x 41.6)
Whitney Museum of American Art, New York;
50th Anniversary Gift of Lucille and Walter
Fillin 86.59

Portrait of Bearded Man, c. 1909
Silverpoint on paper, 11 ⅝ x 8 ⅜
(29.5 x 21.3)
Amon Carter Museum, Fort Worth

Church and Lake, c. 1909–10
Charcoal and pastel on paper,
11 ¼ (28.6) diameter
Spanierman Gallery, New York

Portrait of a Young Man, c. 1909–10
Crayon, oil, and varnish on paper, mounted
on paperboard, 12 x 9 ¾ (30.5 x 24.8)
National Museum of American Art,
Smithsonian Institution, Washington, D.C.;
Transfer from S.I., National Portrait Gallery

Seated Old Man, c. 1909–10
Graphite on paper, 20 ½ x 19 ⅛
(52.1 x 48.6)
Collection of Jeffrey and Rhoda Kaplan;
courtesy Richard York Gallery, New York

Head of a Woman, 1910
Charcoal and pastel on paper, 22 x 19
(55.9 x 48.3)
Collection of Dr. Lyle Victor and Diane Victor

Woman Resting, 1910
Graphite and crayon on paper, 9 ½ x 7 ⅜
(24.1 x 18.7)
Jordan-Volpe Gallery, New York

Bearded Old Man, 1912
Monoprint, 13 ¼ x 11 ⅜ (33.7 x 28.9)
Collection of Mrs. Sergio Stella

Futurist Composition, 1914
Pastel and graphite on paper, 16 ⅜ x 21 ⅞
(41.6 x 55.6)
Barbara Mathes Gallery, New York

Country Church, c. 1914
Pastel and charcoal on paper, 22 x 17
(55.9 x 43.2)
The Metropolitan Museum of Art, New York;
Bequest of Katherine S. Dreier

Abstraction, Mardi Gras, c. 1914–16
Watercolor, gouache, graphite, and paint on
paper mounted on paper, 11 ⅛ x 13 ¹³⁄₁₆
(28.3 x 35.1)
Hirshhorn Museum and Sculpture Garden,
Smithsonian Institution, Washington, D.C.;
Joseph H. Hirshhorn Bequest

Hippodrome (Ballet), 1915
Pastel on paper, 17 ⅛ x 23 (43.5 x 58.4)
Private collection

From the Campagna (Immigrant Girl: Ellis Island),
1916
Charcoal on paper, 29 x 14 ⅛ (73.7 x 35.9)
Hirshhorn Museum and Sculpture Garden,
Smithsonian Institution, Washington, D.C.;
Joseph H. Hirshhorn Bequest

Young Woman Reading, 1916
Graphite on paper, 8 ⅝ x 6 ¾ (21.9 x 17.1)
Collection of Robert H. Jaffe

At the Threshold of the New World, c. 1916
Charcoal and sanguine on paper, 24⅛ x 20
(61.3 x 50.8)
Collection of Mr. and Mrs. Hy Temkin

Head of an Old Woman, c. 1916
Graphite and watercolor on paper,
4 (10.2) diameter
Collection of Dr. and Mrs. Harold Rifkin

Old Serbian Woman (War Refugee), c. 1916
Chalk and pastel on paper, 18 x 19
(45.7 x 48.3)
The Art Institute of Chicago; Gift of Mr. and
Mrs. Gaylord Donnelley, Print and Drawing
Club Fund

Brooklyn Bridge, 1917
Graphite and wash on paper, 17 x 15½
(43.2 x 39.4)
Private collection

Aquatic Life (Goldfish), c. 1917–18
Pastel on paper, 30 x 23⅜ (76.2 x 59.4)
Watkins Collection, The American University,
Washington, D.C.; Gift of the Katherine S.
Dreier Estate

A Child's Prayer, 1918
Pastel on paper, 23½ x 18¼ (59.7 x 46.4)
The Lachaise Foundation care of John B.
Pierce, Jr., Boston

Song of the Nightingale, 1918
Pastel on paper, 18 x 23⅛ (45.7 x 58.7)
The Museum of Modern Art, New York;
Bertram F. and Susie Brummer Foundation
Fund

Three Heads, 1918
Charcoal on paper, 17 (43.2) diameter
Private collection; courtesy James Graham &
Sons, Inc., New York

Abstraction, c. 1918
Pastel on paper, 23³⁄₁₆ x 18 (58.9 x 45.7)
Pensler Galleries, Washington, D.C.

Bethlehem, c. 1918
Pastel on paper, 12 x 16½ (30.5 x 41.9)
The Metropolitan Museum of Art, New York;
Arthur H. Hearn Fund

Nocturne, c. 1918
Pastel on paper, 23¼ x 17¹⁵⁄₁₆ (59.1 x 45.6)
The Toledo Museum of Art; Museum
Purchase Fund

Untitled Abstraction, c. 1918
Pastel on paper, 28½ x 20⅞ (72.4 x 53)
Richard York Gallery, New York

Industrial Scene, New Jersey, 1918–19
Charcoal on paper, 18½ x 23⅜ (47 x 59.4)
The Carnegie Museum of Art, Pittsburgh;
Director's Discretionary Fund

The Stoker, 1918–19
Charcoal on paper, 23½ x 25½ (59.7 x 64.8)
Private collection

Abstraction, c. 1918–19
Pastel on paper, 39¼ x 29¼ (99.7 x 74.3)
The Newark Museum, New Jersey; Gift of
Mrs. Rhoda Weintraub Ziff

Abstraction, c. 1918–19
Pastel on paper, 26⅜ x 20⅛ (67 x 51.1)
Private collection; courtesy Pensler Galleries,
Washington, D.C.

Factory Landscape, Bethlehem, c. 1918–19
Charcoal on paper, 21 x 16¾ (53.3 x 42.5)
Collection of Mrs. Sergio Stella

Futurist Abstraction, c. 1918–19
Pastel on paperboard, 15⁹⁄₁₆ x 8⁷⁄₁₆
(39.5 x 21.4)
Pensler Galleries, Washington, D.C.

Jungle Foliage, c. 1918–19
Pastel on paper, 25 x 18½ (63.5 x 47)
Collection of George Hopper Fitch

Bituminous Coal Storage Piles, c. 1918–24
Charcoal on paper, 20 x 26 (50.8 x 66)
The Metropolitan Museum of Art, New York;
The Elisha Whittelsey Collection, The Elisha
Whittelsey Fund

The By-Products Storage Tanks, c. 1918–24
Charcoal on paper, 21⅞ x 28 (55.6 x 71.1)
Santa Barbara Museum of Art; Gift of Wright
S. Ludington

The Crusher and Mixer Building, c. 1918–24
Charcoal on paper, 34¼ x 22⅞ (87 x 58.1)
Santa Barbara Museum of Art; Gift of Wright
S. Ludington

The Quencher (Night Fires), c. 1918–24
Pastel on paper, 22½ x 29 (57.2 x 73.7)
Milwaukee Art Museum; Gift of Friends of Art

The Traveling Pusher (By-Product Plant),
c. 1918–24
Pastel, charcoal, and paint on paper, mounted
on paperboard, 22⅞ x 29 (58.1 x 73.7)
Hirshhorn Museum and Sculpture Garden,
Smithsonian Institution, Washington, D.C.;
Gift of Joseph H. Hirshhorn

Berries, 1919
Silverpoint and crayon on paper, 11 x 9
(27.9 x 22.9)
Richard York Gallery, New York

Lilies and Blue Hydrangea, 1919
Silverpoint and crayon on paper, 28 x 21½
(71.1 x 54.6)
Collection of Aaron I. Fleischman

Lupine, 1919
Silverpoint and crayon on paper, 27½ x 21½
(69.9 x 54.6)
Private collection

The Peacock, 1919
Pastel on paper, 25¼ x 18¼ (64.1 x 46.4)
Richard York Gallery, New York

Rhododendron Cluster, 1919
Silverpoint and crayon on paper, 9⅜ x 13⅛
(23.8 x 33.3)
Private collection

Slender Green Stalk, 1919
Silverpoint and crayon on paper, 21 x 7
(53.3 x 17.8)
The Huntington Library, Art Collection and
Botanical Gardens, San Marino, California

Peaches, c. 1919
Silverpoint and crayon on paper, 10 x 13
(25.4 x 33)
Collection of Remak Ramsay

Peonies, c. 1919
Silverpoint and crayon on paper, 23⅛ x 18½
(58.7 x 47)
Amon Carter Museum, Fort Worth; Gift of
Ruth Carter Stevenson

Study for *Brooklyn Bridge*, c. 1919
Pastel on paper, 21 x 17½ (53.3 x 44.5)
Whitney Museum of American Art, New York;
Gift of Miss Rose Fried 52.36

Study for *New York Interpreted: The Bridge*,
c. 1919 (later inscribed "1917")
Watercolor and graphite on paper, 24 x 18
(61 x 45.7)
Hirshhorn Museum and Sculpture Garden,
Smithsonian Institution, Washington, D.C.;
Gift of the Federal Bureau of Investigation

Nativity, 1919–20
Pastel on paper, 37 x 19⅛ (94 x 48.6)
Whitney Museum of American Art, New York;
Purchase 31.469

Gladiolus and Lilies, c. 1919–20
Silverpoint and crayon on paper, 28½ x 22⅜
(72.4 x 56.8)
Mr. and Mrs. Barney A. Ebsworth Foundation
and Windsor, Inc., St. Louis

Portrait of Eilshemius, 1920
Silverpoint, crayon, and graphite with chinese
white on paper, 22⅞ x 18¹¹⁄₁₆ (58.1 x 47.5)
Hirshhorn Museum and Sculpture Garden,
Smithsonian Institution, Washington D.C.; Gift
of Joseph H. Hirshhorn

Head of a Woman in Profile, c. 1920
Silverpoint on paper, 21⅜ x 17½
(54.3 x 44.5)
The Arkansas Arts Center Foundation
Collection, Little Rock

Louis Eilshemius, c. 1920
Graphite on paper, 28⅜ x 21⅝ (72.1 x 54.9)
Whitney Museum of American Art, New York;
Gift of Gertrude Vanderbilt Whitney 31.581

Portrait of Edna St. Vincent Millay, c. 1920
Silverpoint and crayon on paper, 10½ x 8½
(26.7 x 21.6)
Collection of Mrs. Sergio Stella

Portrait of Joe Gould, c. 1920
Silverpoint and crayon on paper, 13 x 10
(33 x 25.4)
Collection of Mrs. Sergio Stella

Sparrow and Lilies, c. 1920
Crayon, graphite, silverpoint, and gouache
on paper, 28½ x 22½ (72.4 x 57.2)
The Cleveland Museum of Art; The Delia E.
Holden Fund

Lily and Green Squash, c. 1920–22
Silverpoint and crayon on paper, 21¼ x 28
(54 x 71.1)
Private collection

Black-Eyed Susan, c. 1920–25
Silverpoint and crayon on paper, 23 x 18
(58.5 x 45.8)
Private collection

Flower and Butterfly, c. 1920–25
Metalpoint and crayon on paper, 14⅛ x 11⅛
(35.9 x 28.3)
Yale University Art Gallery, New Haven; Gift
from the Estate of Katherine S. Dreier

Flowers, c. 1920–25
Graphite and crayon on paper, 10⅝ x 11
(27 x 27.9)
Yale University Art Gallery, New Haven; Gift
from the Estate of Katherine S. Dreier

Gladiolus, c. 1920–25
Graphite and crayon on paper, 28½ x 22
(72.4 x 55.9)
Yale University Art Gallery, New Haven; Gift
from the Estate of Katherine S. Dreier

Magnolia, c. 1920–25
Crayon and silverpoint on paper, 18⅝ x 24⅞
(47.3 x 63.2)
Collection of Lois and Jerry Magnin

Rhododendrons, c. 1920–25
Silverpoint and crayon on paper, 12¾ x 11½
(32.4 x 29.2)
Collection of Mr. and Mrs. Bruce D. Benson

Star Flowers, c. 1920–25
Silverpoint and crayon on paper, 11 x 13¼
(27.9 x 33.7)
Private collection

Portrait of Marcel Duchamp, c. 1921
Silverpoint on paper, 27¼ x 21 (69.2 x 53.3)
The Museum of Modern Art, New York; The
Katherine S. Dreier Bequest

Nocturne I, c. 1922
Pastel and charcoal on paper, 18⅞ x 24⅝
(47.9 x 62.5)
Courtesy Doris Bry

Portrait of Edgard Varèse, c. 1922
Silverpoint on paper, 20¼ x 14⅝
(51.4 x 37.1)
The Baltimore Museum of Art; Purchase Fund

Hyacinth and Sparrow, c. 1922–25
Silverpoint and colored pencil on paper,
27 x 10¼ (68.6 x 26)
Southwestern Bell Corporation, San Antonio,
Texas

Portrait of Marcel Duchamp, c. 1923–24
Silverpoint and oil on paper, 27½ x 21
(69.9 x 53.3)
Private collection

Portrait of Kathleen Millay, c. 1923–24
Crayon and graphite on paper, 27⅜ x 22⅜
(69.5 x 56.8)
The Lowe Art Museum, The University of
Miami, Coral Gables; Bequest of Ann Eckert
Keenen

Portrait of Kathleen Millay, c. 1923–24
Crayon and metalpoint on paper, 28 x 22
(71.1 x 55.9)
Cheekwood Museum of Art, Nashville; Gift of
the 1989 Collectors' Group with matching
funds through the bequest of Anita Bevill
McMichael Stallworth

Mrs. Stella (Portrait of the Artist's Wife), 1925
Crayon, colored pencil, and graphite on paper,
27 x 21 (68.6 x 53.3)
Yale University Art Gallery, New Haven;
Anonymous Gift

Tropical Flowers, c. 1925–30
Oil on paper mounted on canvas, 29 x 22
(73.7 x 55.9)
Private collection

Cypress Tree, c. 1927
Gouache and graphite on paper, 41 x 27⁵⁄₁₆
(104.7 x 71)
Hirshhorn Museum and Sculpture Garden,
Smithsonian Institution, Washington, D.C.;
Gift of Joseph H. Hirshhorn

Tree, Cactus, Moon, 1927–28
Gouache on paper, 41 x 27 (104.1 x 68.6)
Reynolda House, Museum of American Art,
Winston-Salem, North Carolina

Self-Portrait, c. 1928
Charcoal, pastel, ink, and graphite on paper,
14 x 10¹³⁄₁₆ (35.6 x 27.5)
Hirshhorn Museum and Sculpture Garden,
Smithsonian Institution, Washington D.C.;
Gift of Joseph H. Hirshhorn

Tropical Flower, c. 1928–29
Oil on paper mounted on canvas, 20 x 14
(50.8 x 35.6)
Private collection

Lilies and Water, c. 1929
Watercolor on paper, 22 x 16 (55.9 x 40.6)
Collection of Mrs. Sergio Stella

Self-Portrait, c. 1929
Watercolor and wax on paper, 20 x 15½
(50.8 x 39.4)
Collection of Mrs. Herbert A. Goldstone

Tropical Flowers, c. 1929
Watercolor and casein on paper, 25 x 18
(63.5 x 45.7)
Private collection

Self-Portrait, c. 1930
Mixed media on paper, 25 x 20½
(63.5 x 52.1)
New Orleans Museum of Art; Gift of
Mr. and Mrs. Richard Kaufmann

Tropical Plants, 1938
Pastel on paper, 23⅛ x 17¾ (58.7 x 45.1)
Collection of Mr. and Mrs. William C. Janss

Flowering Tropical Cactus, c. 1938
Watercolor on paper, 24¾ x 18½
(62.9 x 47)
Courtesy Doris Bry

Portrait of Clara Fasano, 1943
Pastel on paper, 27⅛ x 15 (68.9 x 38.1)
National Museum of American Art,
Smithsonian Institution, Washington, D.C.;
Transfer from the S.I., Archives of
American Art

Purple Water Lilies, 1944
Pastel and charcoal on paper, 17½ x 23⅜
(44.5 x 59.4)
Richard York Gallery, New York

Water Lilies, 1944
Pastel on paper, 23½ x 17¾ (59.7 x 45.1)
Collection of Irene R. Shapiro

COLLAGES

Stella executed collages from 1918 to shortly
before his death. Few are dated, but many
contain datable fragments of letters, newspa-
pers, magazines, or other printed material.

Man Reading a Newspaper, 1918
Collage with graphite, charcoal, and newspaper
on paper, 15 x 15½ (38.1 x 39.4)
Gallery Gertrude Stein, New York

Macchina Naturale #4 (Skyscrapers),
after November 1923
Collage on paper, 11⅝ x 9⅛ (29.5 x 23.2)
Private collection

Macchina Naturale #25 (Transition),
after summer 1928
Collage on paper, 10⅛ x 7½ (25.7 x 19.1)
Private collection

Macchina Naturale #30, after summer 1928
Collage on paper, 15¼ x 11 (38.7 x 27.9)
Private collection

Hardy/Proust, after 1930
Collage on paper, 12⅞ x 9¹¹/₁₆ (32.7 x 24.6)
Collection of Jarrett A. Lobell

Collage, Number 11, c. 1933
Collage on paper, 11½ x 17 (29.2 x 43.2)
Whitney Museum of American Art, New York;
Gift of Mrs. Morton Baum 68.23

Macchina Naturale #9, after August 1936
Collage on paper, 11¾ x 13 (29.8 x 33)
Private collection

Adriatic Figs, after 1937
Collage on paper, 14 x 15¹⁵/₁₆ (35.6 x 40.5)
Whitney Museum of American Art, New York;
Gift of Mr. and Mrs. Benjamin Weiss 79.66.61

Macchina Naturale #28 (Griebl Flees Country),
after May 1938
Collage on paper, 14 x 11 (35.6 x 27.9)
Private collection

Macchina Naturale #13 (Reich Hits Back), after
November 1938
Collage on paper, 12¾ x 7½ (32.4 x 19.1)
Private collection

Macchina Naturale #18 (American Number),
after November 1938
Newspaper and photo mounted on paper,
12⅜ x 9⅛ (31.4 x 23.2)
Private collection

Mecca I, 1940
Collage with paper, tinfoil, and tempera on
paper, 13⅛ x 14¹⁵/₁₆ (33.3 x 37.9)
National Museum of American Art,
Smithsonian Institution, Washington, D.C.

Macchina Naturale #11, 1942
Collage on paper, 11 x 8½ (27.9 x 21.6)
Private collection

Collage with Stucco, n.d.
Collage with stucco, 9¾ x 6½ (24.8 x 16.5)
Private collection

*Homme en armure tenant une lance de la main
gauche*, n.d.
Collage on paper, 12⅞ x 9¹¹/₁₆ (32.7 x 24.6)
Collection of Amanda Lobell

Macchina Naturale #5, n.d.
Collage on paper, 12½ x 8¼ (31.8 x 21)
Private collection

Macchina Naturale #12, n.d.
Collage on paper, 17¼ x 10 (43.8 x 25.4)
Private collection

Macchina Naturale #15, n.d.
Collage on paper, 19¼ x 14¾ (48.9 x 37.5)
Private collection

Untitled, n.d.
Collage on paper, 9½ x 14 (24.1 x 35.6)
Collection of Mrs. Sergio Stella

Untitled, n.d.
Collage on paper, 7¾ x 7⅝ (19.7 x 19.4)
Collection of Dr. and Mrs. Harold Rifkin

Untitled (Mantegna as a Mystic), n.d.
Collage on paper, 10⅝ x 13⅜ (27 x 34)
Collection of David Nisinson

Arnold Newman
Portrait of Joseph Stella,
New York, 1943
Silver gelatin print,
10 x 8 (25.4 x 20.3)
Copyright © 1994 Arnold Newman

Acknowledgments

Joseph Stella has remained, since his death in 1946, an elusive figure in the history of twentieth-century American art. His view that the wide sweep of art history was an appropriate mine for aesthetic inspiration liberated him from the narrow constraints of a single style or subject matter. But the resulting diversity made tracking the evolution of his art difficult for scholars—a problem compounded by his habit of obscuring or even concealing the facts of his life and the chronology of his work.

In attempting to decipher this chronology and place Stella's art in the context of his experiences, I have built on the work of John I.H. Baur and Irma Jaffe, whose research laid the ground for subsequent scholarship. My own research was greatly facilitated by their efforts as well as those of other scholars. I am especially grateful to Francis M. Naumann for undertaking an investigation of Stella's life in Muro Lucano; to Joann Moser for her own work on Stella and her unflagging generosity in sharing material; to Naomi Sawelson-Gorse, Judith Zilczer, and Ester Coen for providing archival material on Walter Arensberg, Carl Weeks, and Gino Severini, respectively; and to Bernard Rabin for graciously making available the archives Stella gave him. I am equally indebted to William C. Agee, Leon Botstein, Gianclaudio Macchiarella, Allan Martin, Nancy Milford, August Mosca, Charles Stuckey, William Weaver, Richard York, Michael Young, and Rebecca Zurier. I also wish to thank the archivists and librarians who extended themselves on behalf of the project: Patricia C. Willis and William Hemmig at the Collection of American Literature, Beinecke Rare Book and Manuscript Library, Yale University; Judy Throm at the Archives of American Art; Victoria Garvan, Laura Rosenstock and Robert Evren at The Museum of Modern Art; Holly Haswell, Eileen McIlvaine, and Howard Dillon at the Humanities and History Libraries, Columbia University; Trevor Dawes, head of information and library privileges, Columbia University; Beth Alvares at the University of Maryland at College Park; and Mark A. Vargas at the Milwaukee Urban Archives, University of Wisconsin. I equally appreciate the expertise of Stefano Baratti, Moyra Byrne, Karla Wadeson, and Anthony Zecca in translating Italian and German texts. Finally, the family of Joseph Stella—Mary Stella, Dr. Armand Stella, Michael Stella, Jr., and Andrea Tambourino—has been enormously helpful and generous in facilitating my search for works and information.

I owe a special debt of gratitude to the interns and assistants who worked with me to gather research data on Stella and the whereabouts of his works: Tamara Bloomberg, Jennifer Case, Joanna Dreifus, Sherrie Gauley, Lam Khong, Cathleen Kiebert-Gruen, Rebecca Lawton, Thea Wedepohl McSherry, Jeannie Merritt, Sarah Powers, Eva Schorr, and Tanya Steffan. The project would have been neither as complete nor as seamless without their participation. Four people worked closely with me in assembling and verifying research materials and preparing the exhibition: Elizabeth A. Gibbens, Marilyn S. Kushner, Eunei Lee, and Kari E. Steeves; without their diligent and expert assistance this project could not have been realized.

My colleagues at the Whitney Museum, in particular David A. Ross, director, and those in the publications department, extended themselves to an extraordinary degree to ensure the success of the project. I am also extremely grateful to the donors, whose support made possible both the exhibition and catalogue: the National Endowment for the Arts, the New York State Council on the Arts, and The Norman and Rosita Winston Foundation, Inc. I particularly wish to acknowledge the considerable financial aid given by The Henry Luce Foundation, whose willingness to finance research on American art has contributed not only to the scholarship of this project but of American art in general. My final debt is to the lenders, who graciously set aside their own institutional and private needs in order that Joseph Stella's art might be given its due; without their commitment and support, this reconsideration of Joseph Stella would not have been possible.

B. H.

This publication was organized at the Whitney Museum by Pamela Gruninger Perkins, Head, Publications; Sheila Schwartz, Editor; Penny Jones, Copyeditor; Mary DelMonico, Production Manager; Marion Delhees, Assistant.

Photograph credits

Armen, pp. 90–91; Ben Blackwell, p. 63; Cathy Carver, p. 25 (bottom: right); Geoffrey Clements, pp. 16; 21; 23 (top and center); 24 (top: left, center: left and right, bottom: right); 25 (top: left); 27; 28; 57 (bottom); 70 (top); 82; 83; 84 (top and bottom); 89; 127; 153 (bottom); 162 ; Sheldon Collins, p. 35 (bottom); Jim Frank, p. 86; Paula Goldman, p. 164; Greg Heins, p. 168; Helga Photo Studio, p. 56 (center); Tom Jenkins, p. 122; Carl Kaufman, p. 87; Robert E. Mates, pp. 14 (top and center); 23 (bottom); 25 (top: right); 75; 81 (top); 84 (center); 165; John D. Schiff, p. 26 (top); Craig Smith, p. 174; Lee Stalsworth, pp. 78; 88; 161; Joseph Szaszfai, p. 14 (bottom); Jerry L. Thompson, pp. 15 (bottom); 26 (center); 26 (bottom); 36; 40; 51; 66; 68; 85; 93; 121; 129; 130 (bottom); 131 (bottom); 132; 133; 134; 135; 137; 143 (bottom); 156; Sarah Wells, p. 172; Katerine Wetzel, p. 48; Bruce White, p. 81 (bottom); Patrick Young, p. 76

Design and Typesetting: Katy Homans and Sayre Coombs
Printing: Herlin Press

Printed in the U.S.A.